W9-BWG-182

WITHDRAWN

WITHDRAWN

Artists Communities

SECOND EDITION

Artists Communities

A Directory of Residencies in the United States That Offer Time and Space for Creativity

Introduction by
Stanley Kunitz

Edited by
Tricia Snell

ALLIANCE OF ARTISTS' COMMUNITIES

ALLWORTH PRESS
NEW YORK

© 2000 Alliance of Artists' Communities

05 04 03 02 01 00 5 4 3 2 1

Published by Allworth Press
An imprint of Allworth Communications
10 East 23rd Street, New York, NY 10010

Cover design by Douglas Design Associates, New York, NY

Page composition/typography by Sharp Des!gns, Lansing, MI

ISBN: 1-58115-044-X

LIBRARY OF CONGRESS CATALOGING-IN-PUBLICATION DATA
Artists communities: a directory of residences in the United Sates offering time and space for creativity / introduction by Stanley Kunitz; edited by Tricia Snell; Alliance of Artists' Communities. — 2nd ed.
p. cm.
Includes index.
ISBN 1-58115-044-X (pbk.)
1. Artist colonies—United States—Directories.
I. Snell, Tricia. II. Alliance of Artists' Communities.
NX110 .A767 2000
700.973—dc21
99-058837

Editor: Tricia Snell
Research and Database Management: Katherine R. Deumling
Cover Photo (of White Pines, at Woodstock Guild's Byrdcliffe Arts Colony) by Les Walker

This directory was funded by grants from the National Endowment for the Arts, the John D. and Catherine T. MacArthur Foundation, Elizabeth Firestone-Graham Foundation, the Bank of America, and the Fulton County Arts Council (Atlanta, Georgia). Funding for the first edition of this directory was provided by The Pew Charitable Trusts.

The opinions expressed in this report are those of the authors and do not necessarily reflect the views of the grant-making institutions listed above.

Printed in Canada

In memory of
Anthony Vasconcellos,
1959–1995

Contents

Directory of Artists' Communities

Other Venues

Indices

Acknowledgments

I would like to express my thanks to:

The staffs of all of the artists' communities listed in this directory—for their cooperation in filling out our forms and answering our many questions.

Suzanne Fetscher, President of Tryon Center for the Visual Arts and the Chair of the Alliance's Board of Trustees from November 1996 until November 1999—for guiding the Alliance to a new level of professionalism, devoting her time and energy to others in the field of artists' communities, and for helping to find funds to support production of this second edition of the directory, among many other generous acts too numerous to describe here. The Alliance has been truly blessed by her steadfast and ambitious leadership.

The Alliance's current Board of Trustees: **Linda Bowers** (chair), **Peter Richards** (vice chair), **James Baker, Sonja Carlberg, Lynn Drury, Guillermo Gómez-Peña, Roger Mandle, Kathleen Merrill, Harriet Sanford, Ree Schonlau, Don Stastny,** and **Cheryl Young** (see affiliations on page 215)—for raising the Alliance's standards of excellence, and for creating the stability that has allowed us to publish a second edition of this directory.

Katherine R. Deumling, the Alliance's Membership Director—for wading through all the details of the research with me and for managing the database that was so crucial to the development of this second edition. Also thanks to **Miriam Z. Feuerle** (formerly of the Alliance) for her invaluable consulting help in designing our survey and database, and for her friendly advice on general matters since she left the staff of the Alliance.

David Biespiel, my co-editor on the first edition of this directory—for conducting the primary research on that first edition, helping me to design the format that I have retained for this second edition, and for combing through every

X in the indices that we created together with the help of Miriam Feuerle. As David is also my husband, he was subject to my on-the-spot recruitment to look over various parts of this second edition, too.

Ree Schonlau and staff at the Bemis Center of Contemporary Arts—for their early compilation of information on artists' communities in the United States, and for Ree's help in finding funds to support production of this second edition of the directory.

Harriet Sanford (Director of the Fulton County Arts Council)—for helping to find funds to support production of this second edition of the directory.

Michael Wilkerson (currently a member of the Alliance's National Advisory Board, and formerly Executive Director of Ragdale and of the Fine Arts Work Center) and **Mary Carswell** (currently a member of the Alliance's National Advisory Board, and formerly Executive Director of The MacDowell Colony and Chairman of the Alliance)—for their invaluable help in the development of the first edition of the directory, among other projects.

Theodore S. Berger and Mary Griffin of the New York Foundation for the Arts—for completing the 1995 study that provided the basis of our research for the first edition of this directory.

Tad Crawford, Robert Porter, Anne Hellman, Jamie Kijowski, and the staff at Allworth Press—for their excellent advice and the care with which they have treated our directory.

The National Endowment for the Arts—for providing crucial funding on several major projects of the Alliance, including this second edition of our directory, and for continuing to provide funding to the field during this time of crisis for arts funding in the United States.

The John D. and Catherine T. MacArthur Foundation—for conducting their special initiative on artists' communities that led to the founding of the Alliance of Artists' Communities, and for continuing their invaluable support by funding our education and outreach activities.

The Pew Charitable Trusts—for their support of the first edition of this directory, as well as our 1996 symposium entitled "American Creativity at Risk" (see the "Blueprint for Action," which was developed at the symposium, contained in this edition of the directory).

The Elizabeth Firestone-Graham Foundation, the Bank of America, and the Fulton County Arts Council (Atlanta, Georgia) for funding the research and production of this second edition of our directory.

All of the people and institutions above, as well as others too numerous to name here, have allowed us to present you with this book. Thank you all for helping artists and other innovators find the time and space to pursue their work.
—*Tricia Snell, Editor*

Port of Embarkation, Ports of Call: Notes from Memory

In Henry James's seventieth year a young man wrote to him inquiring what early force or circumstance had impelled him to embark on his arduous creative voyage. James's reply resonates with the eloquence and vehemence of language welling up from a great depth.

> The port from which I set out was, I think, that of the *essential loneliness of my life*—and it seems to me the port, in sooth, to which again finally my course directs itself. This loneliness (since I mention it!)—what is it still but the deepest thing about one? Deeper about me, at any rate, than anything else, deeper than my "genius," deeper than my "discipline," deeper than any pride, deeper above all than the deep counter-minings of art.

Whenever I recall that passage, it summons up an image of myself at twenty-two, early in 1928, packing my single suitcase with all my worldly possessions for the train-ride from Worcester, Massachusetts, to New York, the magnet city of the arts, where I was eager, despite my qualms, to submit myself to the testing. I was leaving Worcester without regrets, for in my hometown I felt, somehow, trapped and isolated, and I was hungry for the taste of cosmopolitan excitement and freedom. In the months that followed I moved into an affordable basement apartment in Greenwich Village and a nondescript editorial job in the Bronx that challenged me to make it bearable. At night I wrote unhappy poems. When I sent them out, they invariably came back to me, but sometimes with an encouraging comment. I was much too reclusive and shy to acquire the new friends I had hoped for.

My life abruptly changed when I was invited, out of the blue, to be one of the first guests at Yaddo in Saratoga Springs, on the estate left in service to the arts by Spencer and Katrina Trask. In that magnificent setting it seemed appropriate to recall Yeats's praise of beauty and high ease. Liberated from my workaday cares and

stresses, and stimulated by the conversation at the dinner table as much as by the wine, I dared to think I might soon be done with my apprenticeship.

In my tower room I wrote poem after poem and began to put together the manuscript of my first collection, *Intellectual Things*, published by Doubleday, Doran in 1930. By then most of its contents had appeared in *Poetry, The Dial, The Nation, The New Republic, Commonweal*, and other periodicals. The editor who broke the news to me on the phone of the acceptance of my book turned out to be the poet Ogden Nash. For a fleeting moment I enjoyed the sensation of being fortune's child.

* * *

At The MacDowell Colony, in the mid-fifties, I wrote a poem, "As Flowers Are," that I cannot separate from the eventfulness of my visit there and the timeless panorama of those rolling New Hampshire woods and fields. The closing stanza recaptures for me the bliss I knew in the course of one of my late afternoon walks, when I believed I was dissolving into the surrounding landscape, along with my cluster of tangled feelings:

> Summer is late, my heart: the dusty fiddler
> Hunches under the stone; these pummelings
> Of scent are more than masquerade; I have heard
> A song repeat, repeat, till my breath had failed.
> As flowers have flowers, at the season's height,
> A single color oversweeps the field.

I had just been through a year of mingled transport and turmoil. At work in my cabin, I felt that I had found the peace and order and privacy that I desperately needed. My fellow-guests, I soon discovered, included three couples from the New York world of painters—Paul and Peggy Burlin, Giorgio Cavallon and Linda Lindeberg, James Brooks and Charlotte Park—to whom I immediately became attached, with what proved to be a lasting bond. It was these new friends who, after our return to the city, introduced me to the artist Elise Asher; and it

was my marriage to Elise that led to my intimate association with the master generation of American Abstract Expressionist painters just before they stepped into the brilliant limelight. The poems I wrote in Peterborough that summer were among the latest, in their final form, to be included in my *Selected Poems 1928–1958* (Atlantic–Little, Brown, 1958). When the book was rewarded with more than usual attention, I felt guilty about having failed to make due acknowledgement of my indebtedness to The MacDowell Colony. I trust it is not too late to do so now.

* * *

"A poem is solitary and on its way," said Paul Celan, the poet of the Holocaust, without pausing to explain his cryptic remark. A poem is on its way, I think, because it is in search of people, for only a human response will complete its existence. Most artists—and above all, most poets—need and love their solitude, but no more than they need and love the idea of a community. Even the most highly personal work of art has a social premise. In my own experience, when I have suffered from the absence of a community, I have felt obliged to do something about creating one.

The reason I spend a good part of the year on Cape Cod—aside from the sea, the sky, the dunes, our garden, our house, our friends—is my attachment to The Fine Arts Work Center in Provincetown.

Each year, on the first of October, twenty Fellows—ten visual artists, ten writers—arrive in town from every section of the country and sometimes from abroad, to begin their seven-months' residency. They are emerging artists, at the very beginning of their career, selected from hundreds of applicants on the basis of the quality of their submitted work. Soon they are settled into the Center's compound on the historic site of Day's Lumberyard, where in earlier periods the painters Charles Hawthorne, Edwin Dickinson, Hans Hofmann, George McNeil, Myron Stout, and Fritz Bultman, among others, could be found working in their cheap rented studios. The concept of a workplace in a community of peers remains the actuating principle of the Center today.

Despite its hardscrabble beginning—the Center was founded in 1968 with little more

than a dime and a prayer to assure its survival—its Fellows have gone out into the world and consistently won nearly all the major honors and prizes, including the MacArthur "Genius" Award and the Pulitzer Prize for Poetry (twice in a row, in fact, 1993–1994).

A few years ago, as one of the founding fathers, I spoke at the dedication of the new Common Room, whose construction required the sublimation of the massive coal bins inherited from the lumberyard era. "Through all the years of my involvement here," I said, "I have never thought of the Work Center as an institution, but as an adventure, an exhilarating bet on the future of the arts in America. Originally the bins were used for storing coal; now they will be dedicated to a higher form of energy, the imagination."

* * *

Postscript: The Arts in Crisis

Like all cultural organizations in the United States, our artists' communities are suffering from dwindling federal and state support and seriously threatened by the apparent success of the campaign for the total elimination in the near future of the National Endowment for the Arts. Contrary to popular misconception, other advanced industrial countries routinely spend five to fifteen times more per head on the arts than we do. The latest available statistics show that such expenditures amount to only $4 per head per year in the United States, compared with $19 in Britain, $43 in France, and $55 in Sweden.

What are we to make of this discrepancy? In the history of nations, the neglect or suppression of the arts is an augury of national decline. Poetry and myth—to which all the arts contribute—are the element that from generation to generation holds a people together and keeps alive the spirit of their covenant.

"Degrade first the Arts," wrote William Blake, "if you'd Mankind Degrade."

—*Stanley Kunitz*

The Alliance of Artists' Communities' first edition of this directory was warmly received by thousands of artists, from all around the world. We've heard from many artists who used the directory to identify the right residency program for themselves, and who then went on to complete new bodies of work, or to forge completely new directions in their art, within their residencies.

Putting information into the hands of more artists around the country (and the world) was and is our primary reason for publishing this directory. A secondary reason is to improve general understanding of the field among government and private policy-makers, funders, media representatives, arts networks and organizations, educational institutions, and the general public. The directory has served this purpose well, too. It is our most powerful education tool, the one item that can be presented with the words: "This book will show you what artists' communities are, and why they are important."

Because artists' communities focus on innovation, experimentation, and the creative process (the creation of art), rather than the presentation of products (such as finished books, exhibits, performances, films, etc.), and because they do it in so many different ways, the organizations presented in this book are hard to categorize, hard to explain. It is our hope that this directory will shed some light on the need for open-ended, creative research in the arts, the exploration of new ways of thinking and seeing—which is the vital work of artists' communities.

So far, the directory has been reprinted three times as a result of its popularity. Because of this, and because details of programs change so quickly, a second edition was in order. We are delighted to present you with this expanded edition, and we are dedicated to continuing to update it in future editions.

If you are an artist or scholar looking for an artists' community that fits your special needs, please read the next few paragraphs and "How to Use this Directory," below, to help take full advantage of the information contained in this directory.

If your interest leans toward our second purpose, you might best begin by reading Stanley Kunitz's eloquent introduction, or the testimonial essays written by artists about their residency experiences. Then, for a look at the history, challenges, and needs of the field of communities, see "An Overview of the Field of Artists' Communities," by Michael Wilkerson, who has a long and dedicated relationship with the field.

Some Generalizations about the Communities Listed in this Directory

The criteria for inclusion in this directory come from the Alliance's guidelines for institutional membership. (Membership in the Alliance, however, was not a requirement for inclusion; our goal was to present as comprehensive a view of the field as possible). The criteria are as follows:

- A primary purpose of the organization is support for artists in the creation of work
- The organization brings artists together into a community, removing them from their everyday obligations and providing uninterrupted time to work, in a specific site that is dedicated to that mission
- The organization selects artists for residencies through a formal admissions process that is rigorous in terms of artistic quality and regional, national, and international in scope
- The organization is not-for-profit, has artists represented in its governance, and maintains a paid professional staff

In short, the seventy-nine communities featured here provide working space and housing for artists (and sometimes scholars) in a community environment that supports more than one artist at a time.

The list of seventy-nine communities included in this second edition has evolved from the seventy listed in our first edition (published in 1996):

- Thirteen programs either opened their doors for the first time, or started or expanded their residency program as an addition to the programs they had already been running, including: 18th Street Arts Complex, American Academy in Berlin, Anderson Center for Interdisciplinary Studies, Brandywine Graphic Workshop, International Arts Center, Mesa Refuge, Peters Valley Craft Education Center, Portland Institute for Contemporary Art, Saltonstall Arts Colony, Triangle Artists' Workshop (NY), Tryon Center for Visual Art, Villa Aurora, and Weir Farm Trust
- Four communities evolved into different programs or disbanded, including: Art Awareness (no response to our calls), Capp Street Project (still an Alliance member but now operating a single-person residency program under the auspices of California College of Arts and Crafts), Walker Woods (no response to our letters), and Yellow Springs (closed by its curator, John Clauser)

In addition, eleven communities are in serious planning stages or almost ready to open their doors (these have been included in our "Other Venues in the United States" list).

If we have omitted any artists' communities from this edition, it is because we have not yet learned about them (except for Bellagio, Wurlitzer, and Civitella Ranieri, who opted not to be included in this directory for various reasons), or the community does not fit the four criteria listed earlier in this preface. We would appreciate receiving suggestions for additions or improvements that we can add to our next edition.

Regarding the communities we contacted that did not fit the Alliance's four criteria for an artists' community: In order not to confuse our definition, as well as not to miss the opportunity to publicize these programs to artists, we included them in a separate list called "Other Venues in the United States." These organizations provide a variety of valuable services, for instance: single-person residencies (where a community environment is not part of the experience), fellowship grants (where no studio or housing is provided) or studio collectives (where no housing is provided, and studios are rented by artists).

Please keep in mind that "Other Venues in the United States" is merely an overflow list and does not represent comprehensive research. The same is true of the list of international artists' communities, which, with the addition of a few communities we know about ourselves, comes directly from the International Association of Residential Arts Centres and Networks, known as Res Artis. These two lists are presented here to further help artists in need of support, and no doubt they could be expanded. The Alliance's main focus, however, is artists' communities in the United States.

How the Directory Is Organized

The seventy-nine communities are arranged alphabetically. Representatives from each community provided information concerning their residency program and approved the final version of their entry. Each entry includes basic facts (address, phone, e-mail), facilities and housing descriptions, residency statistics (the average number of artists present at one time, the ratio between artists applying and artists accepted, etc.), fee/stipend and financial assistance information, a list of former artists, and a statement by a former resident and by the community's director. The entries also identify which communities are members of the Alliance of Artists' Communities.

All of the information is listed concisely in a standard format to help you quickly find the information you want and compare specific attributes that are important to you. Despite our efforts to provide some uniformity, however, you will find that each community has a unique approach to the support of their artists, as well as a wide range of environments, facilities, and programs. The question is only: *Which are best for you?*

Many artists' communities must charge residency fees in order to cover some of their operating costs. Some, however, offer stipends, fellowships, financial assistance, or work exchanges. Be sure to check to see what a community may be able to provide. All communities with fees are working to reduce them through a variety of other programs and fundraising campaigns. However, a stay at an artists' com-

munity is a bargain when you consider the tangible benefits: time, space, facilities, the company of peers, and freedom from domestic chores. Not to mention the less tangible benefits—the positive, long-term effects on your work.

Because this directory comes from within the field—conceived and compiled by the Alliance of Artists' Communities, with each artists' community approving its own entry—we believe it to be the most accurate reflection of the field to date. Still, deadlines change, fees rise or fall, funding for fellowships comes and goes. Application forms and requirements (such as manuscript pages, slides, tapes, recommendation letters) seem to change the most often of all, and this is why we have not included specific information about them in this directory. *Artists should contact the communities directly to find out exact, up-to-date requirements for applications, fees, and documentation necessary to apply and attend.*

Indices

At the back of the directory, several indices in the form of charts will help you target a community suitable for your needs. You may want to select communities based on an artistic category, geographical region, season, admission deadline, costs, available stipends, or accommodation for a disability.

If, for example, you are a sculptor with limited funds and only three weeks free in February, consult the "Seasons and Deadlines" index. There you'll find the communities that are open during the winter, and you can then consult the "Artistic Categories" index to see which of these support sculptors. Then, cross-reference to the "Fees and Stipends" chart to see what's available from those communities.

If you are in need of wheelchair-accessible facilities, check the "Accessibility" index. All of the artists' communities in this directory, even if they do not have specific equipment or facilities, reported a willingness to adapt facilities to accommodate disabled artists. Since some communities are in rural areas with rough terrain, though, it's important to find out what adaptations are possible.

Our Hopes for this Directory

The Alliance of Artists' Communities regularly receives calls and letters from artists requesting information about residency programs. These are hard economic times for most artists, and finding time and space in which to work is more difficult than ever.

We also receive, however, a remarkable number of calls from people, many of them artists, who have decided to establish new artists' communities. These decisions are not made lightly, given the time, labor, and fundraising involved. In updating this directory, we have added thirteen new artists' communities to our two-page spreads, and at least eleven more (included in "Other Venues in the United States") will be opening their doors within the next few years. Many more are still in the early, visionary stages. A quiet, grassroots movement is afoot, in response to the falling-off of public programs that support artists, to create new residencies that directly serve artists' most immediate needs.

Collectively, artists' communities represent a century-old, national support system for artists and thinkers. U.S. artists' communities support an impressive four thousand residencies each year. It's the Alliance's mission to strengthen and expand this support system, encourage more artists to participate in it, and by doing so, nurture the new cultural work of our country.

All of us who have worked on producing this book hope that it will help you find the support you need in your work, your career, and your ability to grow as an artist.

—*Tricia Snell, Editor*

What Are Artists' Communities?

Artists' communities are professionally run organizations that provide time, space, and support for artists' creative research and risk-taking in environments rich in stimulation and fellowship. Whether they are located in pastoral settings or in the middle of urban warehouse districts, artists' communities have been founded on the principle that through the arts, culture flourishes and society's dreams are realized. Some of America's most enduring classics have been created at artists' communities: Thornton Wilder's *Our Town,* Aaron Copland's *Appalachian Spring,* James Baldwin's *Notes of a Native Son,* and Milton Avery's paintings, to name a few.

Artists apply for residencies at a community by submitting a variety of materials, such as slides, manuscripts, or tapes, illustrating their work and intentions to the community's jury or panel.* If their application is successful, they arrange the details of their residency with the community's staff. They may receive a stipend or be required to pay a fee, depending on the community, and details about equipment and materials needs, accommodations, and reimbursement for expenses vary.

Once at a community, artists are given studios or workspaces, housing (or reimbursement for the cost of housing), and often meals. Their residencies may last anywhere from a few weeks to a year or more, depending on the type of community. During their residency, they are free to work twenty-four hours a day if they choose, though some communities may require some light duties to be performed.

About 4,000 artists are residents at American artists' communities each year. This 4,000 includes painters, writers, composers, sculptors, filmmakers, photographers, performance artists, storytellers, choreographers, installation artists, architects, art historians, scientists, and scholars. (See the Artistic Categories index at the back of the directory for a comprehensive list.) To engender ideas and dialogues that cross disciplinary, aesthetic, cultural, gender, social, and geographic barriers, most artists' communities aim for a broad mix of residents at any one given time.

Artists' communities and those who support them are committed to the principle that art stimulates new ways of thinking and new ways of seeing. It should come as no surprise then that the voices and visionaries of our own time continue to be cultivated at artists' communities: poets like Gwendolyn Brooks and Louise Glück, fiction writers Fae Myenne Ng and Allan Gurganus, nonfiction writers Alex Kotlowitz and Stanley Crouch, composers Ned Rorem and John Adams, visual artists Lawrence Wiener and Portia Munson, choreographer Bill T. Jones, performance artist Guillermo Gomez-Peña, and the experimental theatre company Mabou Mines, all created work during residencies at artists' communities. Many lesser known artists are working at artists' communities now, and in the months and years to come their books, exhibitions, pieces, performances, and productions will become known to us.

The future of American culture depends on supporting a broad array of artists today. Providing this support is the fundamental, vital work of artists' communities.

*See also "Some Generalizations About the Communities Listed in this Directory," contained in the preface.

Artists' communities are the nation's research and development laboratories for the arts. Founded almost exclusively by artists and occupying virtually every kind of imaginable space—from grand country estate to abandoned military base to renovated urban factory—they spring from many different roots, but they serve exclusively to nurture art and to support artists at the most vulnerable and invisible junctures of the creative process.

The field's origins go back to the beginning of art. There is written record of ancient Greek and Roman writers and artists retreating to the countryside to places where they could work, free of the influences of the marketplace. Throughout more recent eras, artists' work places were typically organized by wealthy patrons, who would provide a studio and a haven for the artist to create a work the patron had commissioned. In the United States around the end of the 19th century, several country estates were made into artists' communities by their owners, and in order to take advantage of the opportunities they offered, one had to know or be a member of the owner's family. Sometimes, though, artists joined together on their own to seek not only a special place, but a community of like-minded souls who understood the fragility of the work in progress and the concomitant need for affirmation, support, and enlightened critique from their peers.

The artists and writers of these early American communities participated in everything from feeding chickens to landscape painting to writing novels to editing literary magazines to putting on plays in the adjacent outdoor theater. The environments were beautiful and the physical and emotional support levels outstanding. But still, an artist couldn't just apply to go to one of them, and, for many years, only two places in the United States—MacDowell and Yaddo—accepted applications from artists without family connections in what we would now consider a standard selection process.

Today, artists still need places to work and other artists to commune with, but the mechanisms for support of the creation of new work have changed dramatically. In the United States, the impulse to support artists has been democratized, both by government- and foundation-sponsored individual fellowships, and by the creation of artists' communities that are open to all by application and supported by a variety of sources. And, as has been discovered by the founder of every artists' community so far, once the doors are open, the artists will come.

The standard evolution of an artist community is that at first, no one knows about it outside of the founder's circle of friends and acquaintances. Within a few years, hundreds are applying, the management is more professional, there is at least a semblance of a sustaining development effort, and the consuming questions change from household maintenance to cultural diversity, sufficient fairness in the panel process, and fundraising.

Today, based on the Alliance of Artists' Communities' definition of an artists' community (see Preface), we estimate that at least eighty-two formally organized artists' communities exist in the United States, serving thousands of artists annually. The seventy-nine communities listed in this directory (the missing three being Bellagio, Wurlitzer, and Civitella, who opted not to be in this directory for various reasons) collectively provide residencies to over four thousand artists each year. By contrast, the National Endowment for the Arts' Literature Fellowships, at their pinnacle, supported approximately seventy-five writers a year; the Lila Wallace and Lannan Fellowships between ten and twenty each; and most state arts council fellowships a similarly small number.

The field of artists' communities is growing so rapidly that since the first edition of this directory was published in 1996, thirteen new residency programs have been born, eleven more will soon be opening their doors and accepting their first artists' applications, and many others are in the early development stages. Still other communities are likely up and running that we have not heard about. (It is certain that, as with the first edition, this second edition of the directory will require updat-

ing almost as soon as it is published; the Alliance is committed to producing future editions in order to keep abreast of the rapid changes.)

New artists' communities, for the most part, tend to serve emerging artists. As the organization becomes better known, it serves artists at more advanced stages in their development and careers, so that at maturity—where MacDowell and Yaddo and a few others now stand—admission is much more difficult than at a newer place. Other organizations focus on particular art forms or offer specialized facilities, such as filmmaking, computer graphics, sound recording, printmaking, or ceramics. This does not mean that one community is "better" than another—there are drawbacks to popularity and the long odds on admission—but it points out that the continual emergence of new artists' communities is providing a system of support to a greater number of artists each year.

The expansion of the field of artists' communities is demand-driven, the demand coming *from* the artists. This reverses the usual context, in which much is demanded *of* artists: teaching in the schools, working with prisoners and in nursing homes, reading at numerous bookstores to promote the novel once it's finally published, serving as a volunteer editor/curator/producer-director, raising a family, making a living. Not one of these worthy tasks has much to do with what the artists themselves want and need most, which is the opportunity to create new art.

In recent years, there has been much discussion of "the support system for artists." But this is not an organized or even vestigial system. Even in the art world, little is known about artists as creators or about the nature of the creative process, and little support is offered to artists. To remedy this lack of a support system, artists' community founders and directors (like myself) joined together in the early 1990s to form the Alliance of Artists' Communities, which has since become a strong voice for this growing field. Together, we are trying to build a more organized system to understand the needs of artists, and to offer help where it is most critically required. Clearly, time and space to work (i.e., residency programs) are still a primary need. And more and more these days, artists' communities are offering production,

exhibition, performance, and publication as an outgrowth of their residency programs, recognizing that the "products" of the creative process are also in need of support.

Artists' communities are not the only support or even the primary support available to artists. But those of us who run artists' communities do know artists very well, perhaps uniquely well, since we live as well as work with them. We believe that artists' communities can serve as a support system as well as a voice for the needs, lives, and hopes of a great many artists.

The continued growth of the field of artists' communities will make it increasingly possible for artists to find the proper match in terms of level of intensity, types of colleagues, disciplines served, atmosphere, length of residency, convenience of access, urban or rural environment, equipment and facilities available, curatorial stance of the board and/or staff, and other variables. In other words, to serve as a real support system for artists in this country.

Along with the demand by artists for opportunities to create new work, there is a second motivation for starting an artists' community: the preservation and stewardship of exceptional places. Artists' communities own, lease, or manage thousands of acres of nature preserve, woodlands, prairie, oceanfront, wetlands, and mountains. Some also occupy and care for a vast range of beautiful buildings, many of which are on the National Register of Historic Places. But, as Ragdale's founder Alice Reyerson Hayes explained, "It wasn't just the house and the land I wanted to save [by starting an artists' community]; I wanted to save the feeling that went with it. There's a spirit to this place which is uniquely inspiring, and I thought it too valuable to lose."

That spirit, derived from the place but infused by the creative endeavors of, in some cases, generations of distinguished occupants, suggests that artists' communities are doing something that needs to be replicated in areas outside of the arts: the creation of bonds much like those of a new extended family. The informal, professional relationships and interdisciplinary insights artists derive from their residencies suggest possibilities for reaching solutions in other fields and for opening the field up to people outside the arts. Some artists'

communities are already doing this, and many more are in the process of expanding their programs to embrace creative individuals who are not artists. The American Academy in Rome accepts a variety of scholars in its program, as do many other artists' communities (usually without fanfare, as part of their "writers" category). The primary focus of both the Exploratorium and the STUDIO for Creative Inquiry is to bring together artists and scientists. The Hambidge Center for Creative Arts and Science, Mesa Refuge, and Sitka Center for Art and Ecology focus on a blend of art and environmental/biological research. Headlands Center for the Arts and Blue Mountain Center encourage social activists to apply. New programs like the American Academy in Berlin, Anderson Center for Interdisciplinary Studies, International Art Center, and Tryon Center for Visual Art have made interdisciplinary exploration a central part of their missions. These are just a few examples of the interdisciplinary nature of artists' communities. A glance at the artistic categories index at the back of this book shows the many communities that support creative individuals in other disciplines.

Artists' communities may be in a position to take a leadership role in a number of critical efforts: restoring the centrality of artists to our culture; developing new ideas of community and extended family; giving the creative process the same measure of esteem and significance as the end product—something that is badly needed in all sectors of our society, not just in the arts. (For an overview of the Alliance's work in pursuit of these goals, see "A Blueprint for Action," which was developed at the Alliance's 1996 symposium entitled "American Creativity at Risk.") At this point, those of us with experience in the field—not just administrators, but artist-alumni as well—know the importance of these efforts, and of what artists' communities, simply by fulfilling their mission of supporting groups of artists at work, have achieved.

Despite these achievements, artists' communities, like all arts organizations, are in a difficult environment today. Artists' communities face several unique challenges:

- Artists' communities are financially insecure in large part because they have few opportunities to earn income (e.g., through admission fees) unless they cre-

ate public programs that are separate from the residency program. Public programs are no guarantee of financial stability either, but without them, an artists' community's revenue sources are slim.

- Artists' communities' emphasis on process (rather than product) creates an invisibility problem, which in turn further exacerbates the income problem. Because support for an artists' community does not immediately lend visibility or status to the donor (as, for instance, support for an exhibition, performance, or publication does), it is difficult to attract donors.

- The first concerted effort to advocate for the field of artists' communities began in 1992, when the Alliance of Artists' Communities was founded. Despite the Alliance's progress, the field has not had enough time to work together to develop a foundation of strong national support that can be relied upon during the current period of general austerity in the arts.

It is not surprising that the 1995 New York Foundation for the Arts' *Study of Artists' Communities and Residency Programs* (funded by the National Endowment for the Arts and The Pew Charitable Trusts) described the entire field as, in general, "stuck, often for many years, at the emerging organization level, unable financially to take the next step." The most obvious cause of the field's economic problems is its lack of visibility. Though Internet searches for "artists communities," "artist colonies," and "artist residencies" yield lists and lists of Web pages (some relevant, some not) library searches yield very few articles and no books at all on the field, save this directory, as well as a handful of other guides that are good-intentioned but out-of-date, incomplete, inaccurate, or that misrepresent the field's core values.

Furthermore, some artists' communities are so committed to the creative process that they are reluctant to play the famous alumni card as a strategy for visibility and the funding that follows it, even though all of the Alliance of Artists' Communities' members and most others have had major artists in residence and significant, lasting works created on their grounds. Fame and external reward are the very opposite of the quiet, internal work that artists' commu-

nities support. Therefore, an institutional personality transplant sometimes may be needed before artists' communities can seek recognition for the famous artists that they have supported.

There will be no real progress for artists and artists' communities until they are better known and understood. By exposing others to the ways of artists' thinking during the creative process, they may gain esteem and respect, and society, in turn, will be investing that respect in people who may carry within them the basis for solving difficult problems. A better organized field of communities actively communicating with each other will help the field create both large and small opportunities for continued expansion and influence. That is one of the central missions of the Alliance of Artists' Communities.

The brief history of the Alliance of Artists' Communities is a story of attempting to solve difficult problems. Eighteen artists' communities were included in the John D. and Catherine T. MacArthur Foundation's one-time funding initiative of 1990. These eighteen communities met in early 1991 at the invitation of Doris Leeper, founder of Atlantic Center for the Arts, and with the support of A Friends Foundation. This first meeting led to the formal founding of the Alliance of Artists' Communities in 1992. The Alliance was aided in its founding by the MacArthur Foundation, which underwrote our first two meetings and gave us a small start-up grant, and by the National Endowment for the Arts, which gave us an initial grant and, perhaps more significantly, challenged us to define artists' communities as "a dynamic field, not just a list of grantees."

In the past seven years, we have largely fulfilled that challenge. We have created a communication network for artists' communities that provides for the exchange of information, ideas, and resources; convened a national symposium on the subject of American creativity (see "A Blueprint for Action"); compiled information and statistics on the field that are helpful to artists and artists' community directors; raised the level of visibility of artists' communities in the national arts and political landscapes; established ties with international artists' communities; established field-wide standards for artists'

communities; and launched a campaign to broaden the diversity of artists served at artists' communities.

The Alliance has made it possible, for the first time, for the many organizations under its umbrella to move from "emerging" status toward the kind of long-term stability enjoyed by only a few communities, yet critical to all. That stability is important, not only in terms of preservation of environments and histories, but also to ensure that artists everywhere will have a solid national network of diverse places to work. As the economics of making art continues to become more difficult, the widespread availability of artists' communities becomes more central to the lives of more artists.

The Alliance's priority is to become a voice for the entire field. As we do this, we will work to make artists' communities better known and understood. In the past, artists' communities themselves have had little opportunity to learn of or about each other. And our own supporters have at times displayed a weak understanding of the size and breadth of our field, of the nature of the artists we serve, and of the ways we serve them. Toward both visibility and unification, we will continue to update and publish the directory that is now in your hands. This volume is a tool that we will use to increase knowledge of our field among artists, arts organizers, funders, and patrons.

Obviously, these efforts toward advocacy and visibility represent the groundwork for adequate funding. It's important to note how important more funding is to this field. Many of us charge a daily fee to the artists we support, some on a sliding scale, some at a fixed rate, only because other funding sources won't bring the operating budget into balance. We can serve an even better and broader body of artists without such fees, but now they tend to be rising, not falling. And even organizations that don't charge a fee have, at times, immense capital needs or limitations on how many months their programs operate due to lack of resources (one of our members has no electricity in its buildings, for instance).

Programmatically, the field is moving toward more curating of special, themed residencies, more international work, and more blending of artists with thinkers of other disci-

plines, particularly for the purpose of creating more visibility and respect for artists as problem-solvers, visionaries, and decision makers.

We would like to produce more publications, exhibitions, and documentation of what goes on at our communities. We would like to utilize our reservoir of talented alumni to create books, articles, films, videos, exhibitions, and CD-ROMs about our field. We would like to forge links with broadcasting, cable, computer technologies, and the new national information infrastructure that is rapidly developing.

To do any of the above, we will need to develop significant new sources of revenue. Even if we make no dramatic program changes, the demand for our services by artists so far outstrips available space and time that we know we must grow. As awareness of our field grows, we hope to encourage the creation of new, multi-million-dollar funding programs to which any artists' community can apply and that are dedicated to fulfilling some of our best ideas. We would like to look back at this time, as we define our field and values, as the catalytic beginning of a new era for artists' communities and, by extension, for artists in America.

—*Michael Wilkerson, National Advisory Board, Alliance of Artists' Communities*
(former Executive Director of Ragdale Foundation, former Executive Director of Fine Arts Work Center in Provincetown, and former Chairman of the Alliance of Artists' Communities)

Cultivating American Creativity and Interdisciplinary Innovation: A Blueprint for Action

In November 1996, at Brown University and the Rhode Island School of Design, the Alliance of Artists' Communities convened a group of brilliant American leaders and thinkers from all sectors of society—the arts, business, science, education, philanthropy, and government—to address what the Alliance saw as a national "crisis of confidence" in the arts, creativity, individual innovation, and research. In a symposium titled "American Creativity at Risk," to emphasize the gravity of the broad, societal problem it perceived, the Alliance challenged six speakers, twenty-four panelists, and eighty-five registrants in attendance to:

- Define the nature of creativity in historical, psychological, and cultural terms
- Measure the significance of creativity to the health and growth of American society
- Identify societal factors that encourage or stifle creativity, in both children and adults
- Conceive new, innovative strategies to encourage the flourishing of American creativity, taking artists' communities as a model and metaphor for fostering pure research and innovation
- Set forth their ideas in a "Blueprint for Action" to *restore creativity as a priority in public policy, cultural philanthropy, and education*

The following "Blueprint for Action" is a broad summary of the ideas expressed in the symposium. It is directed toward opinion leaders, policy makers, and creative thinkers in all sectors of our society:

1. Recognize that creativity is not discipline-specific but transcends age, gender, race, and culture; its sustenance is a societal issue, one vital to the future of American society. Recognize that creativity is an innate quality in all individuals, and work towards a society that unleashes that creativity for the common good.

2. Identify the ingredients that nurture and expand the creativity of individuals. Widen the debate on the nature of creativity to include educators, policy-makers, and practitioners from all disciplines.

3. Continue to support creative activities, environments, programs, and projects that move society forward. Work vigilantly to keep healthy the infrastructures that nurture the development of creativity in individuals in all sectors of society.

4. Become an advocate and practitioner of bringing the disciplines together to address the issues of our times. Look to the collective skills and wisdom of all individuals in our society to bring about a creative renaissance in the new millennium.

5. Urge parents to take responsibility for the education of their children. Advocate the development and maintenance of informed educational systems, ones that emphasize universal access and that reward innovation, educational excellence, and social responsibility, rather than the "right answers."

6. Recognize the role that artists play in society. Collaborate with institutions, businesses, unions, government, and the media, establishing national and international linkages to enhance opportunities for artists to serve society as creative problem solvers. Extend public understanding and respect for artists' skills and insights, and their abilities as citizens to work with other problem solvers to advance humanity.

7. Recognize that with innovation comes the possibility of failure; creativity and risk are strange bedfellows whose progeny cannot be predicted. Advocate for research and development budgets with the understanding that they are the bedrock of innovation, ensuring that the concern for the bottom line does not mortgage our future.

The Alliance is now in the planning stages of a second symposium that will help implement the Blueprint. It will be held at the School of the Art Institute of Chicago, November 2–4, 2001, and it will focus on steps number 6 and 7 listed above. Please contact the Alliance for further information.

Sharon Greytak, Filmmaker

As a filmmaker, I have been in residence at the MacDowell Colony several times since 1987 to work on scripts and, most recently, to film several sections for the feature film, *The Love Lesson.* My experiences there have been some of the most important and gratifying of my professional life.

I can best describe the great affection I hold for MacDowell through a parallel between my first residency there and the most recent one.

In April 1987, I arrived at the colony just before the dinner bell. I had seen only the wooded path to my studio, dropped my bags, and wandered down to Colony Hall. "No 24-hour Korean delis here," I thought. The dining room was in full swing. Table conversations were lively and friendly and pleasant. So far so good.

For several weeks prior, I had wondered if I could be productive in what I thought would be an artificial environment for creativity. Urban life had always fed my work. I worried that nature would soften me. But my New York City apartment was full of distractions, and the writing was slow.

After a hearty New England supper, the group gravitated down a narrow hallway and into a large room where residents played Ping-Pong, shot pool, and read by the fire.

I thought: "Oh, I've made a terrible mistake. I must have been working too hard. Someone's sent me away for a long rest."

The rustic scent of mahogany, the pinging and ponging, made me yearn for some familiar concrete beneath my feet.

The next morning, however, I began writing with a clarity and energy I had not felt in a long time. Within three days I had written what would have otherwise taken two weeks. I was taking more risks with the content of the piece. The environment was influencing me, and I could not believe the enormous gift I had been given of time and faith in the value and direction of my work.

And not just my work. Residencies at the MacDowell Colony have enabled me to collaborate with other artists outside of my field. Music for my first feature film, *Hearing Voices,* was written by New York composer Wes York, and German composer Cord Meijering composed the score for *The Love Lesson.* Collaborations like these are not rare at the colony. It is staggering to watch such strong connections develop between artists who live thousands of miles apart, or merely two blocks from one another. There is a basic level of trust and common purpose that fosters these joint creations. Outside of the MacDowell environment, these collaborations would be difficult, at best, to create.

MacDowell works a magic of its own. Years later, during a residency to work on the script for *The Love Lesson,* I wrote a scene involving a snowball fight between two people in the woods. For the sake of blocking camera direction and general atmosphere, I visualized the scene using the layout and environment of my studio at MacDowell. Two years later, at 5:30 A.M., in deep March snow, I found myself filming that scene at the colony. Setting up an exterior wide shot of Watson Studio, I had rehearsed the actors several times running downstairs and breaking into their snowball fight. In the last few moments of preparation, I sat alone, taking in the image of this glorious and elegant studio. Set slightly on a hill and surrounded by pine trees, it is symmetrical in proportion, with stately columns, a crisp white picket fence, and a centered doorway inset with an oval portrait glass. Daylight was just beginning to brighten the sky as we prepared for the take. The silence of the woods and the muffled presence that snow permits made me acutely aware of having come full circle. Never would I have imagined that something written within those walls would later be realized on screen in the place of its origin. It was a rare moment of clarity, a tangible window in time where I felt comfortable with, and understood better, the purpose of my artistic life.

Jane Hamilton, Novelist

I was twenty-five when I first went to Ragdale. It was years before I would receive a grant or sell a novel, but that four weeks in Lake Forest was the first time I thought that maybe, possibly, I could actually justify spending time writing, that I could give a name, perhaps even out loud, to this thing I needed to do. Professionally, so to speak, I had only waitressed and picked apples. Writing was in the category of an idle fancy to grow out of, a hobby, something on par with counted cross-stitch or checkers. After a month of quiet by day at Ragdale, and by night the good conversation of artists in all stages of their careers, I came home believing I could write.

Rilke said that in order to write he needed "unconfined solitude . . . (a daily routine) without duties, almost without external communication." As a mother and the wife of a farmer, those specifications for the writing life have alternately made me want to weep into a five gallon drum and laugh my head off.

For any artist, there is the profound problem of integrating the life of the imagination with the noise, the mess, the details, and the relationships of real life. Over the years, Ragdale, both psychologically and physically, has made it possible for me to write novels. Whether an artist has a job or a family, or both, on top of the responsibilities to the artist's real work, there are always the incessant demands of the ordinary world.

Without money for time and space, there were weeks, months, years when I had to hold that thought. And then, eons later, there was the bitter work of trying to find the thought that had seemed important—No, that was important! Wasn't it?—on the scrap of paper, on my desk, in the bedroom, where there were also piles of laundry, bills to be paid, shoes to be taken to the repair. Better to look on the floor, where the scrap surely had fluttered among the dust and catalogs, unread books, last year's tax returns.

I have spent many moments through the years, as my children have gone through their wonderful stages, most of which involve a great deal of noise, and in the face of the unrelenting chaos of real life, closing my eyes, shutting out the disaster at hand, and thinking of myself walking down Green Bay Road, taking the turn into the drive, walking into the Ragdale house, smelling, seeing, feeling the stillness, and best of all, listening and hearing absolutely nothing. It is at Ragdale that Rilke's prescription for the creative life is secure. It is at Ragdale that I escaped real life long enough to gather all of the scraps that had gathered on my desk, and begin the long work of turning the various and myriad thoughts into one novel.

I've felt at Ragdale, more than any place I've ever been, that the individual voice and vision of the painter, the sculptor, the poet, is still important, and indeed essential. It is not always easy to believe that our lone voices matter or are being heard in the modern age. Above all, what Ragdale gives the artist, for the weeks or months we are staying, is the confidence that anything, all things are possible. If we are lucky, we carry that priceless feeling back to real life.

Marcus Schubert, Photographer and Sculptor

To maintain an existence back home, I free-lance as a photographer, instruct sculpture programs, and fabricate large-scale corporate displays. Beyond that, I try to maintain visibility as someone who creates and exhibits artwork. However, immediate needs often take my attention away from my own focused creative development. Oftentimes, personal projects are postponed while I fulfill my commitments to feed mouths, take care of the house, fix the car, pay the mortgage, and so on. Good ideas emerge but remain unexplored, until their brilliance fades into a growing set of projects not realized.

Coming to the Tryon Center in Charlotte has removed this conflict from my life for three full months. With the gift of a state-of-the-art facility, time, space, a stipend, and the professionalism of a devoted staff, I've been able to generate a concentrated stream of work. Things get done. I didn't have much of an agenda when I arrived, save a loosely identified project about constructing big still lifes and photographing them. But let me tell you what's happened to me since I arrived.

I'm working on a theme inspired by the history of the Tryon Center. Though Tryon is a state-of-the-art facility now, it was once a church that had stood abandoned for many years, the object of numerous real estate speculations. Back then, the empty church sheltered countless squatters and vagrants. One chilly night on November 14, 1984, a female transient and escapee from a Texas mental institution piled a heap of wooden chairs onto a warming fire inside the building while others slept. They ignited the pews and in four hours only stone walls remained.

Downtown Charlotte was also neglected. Since the fifties, its inner city practically vanished except for some run-down stores, old factories, and seedy housing projects. Everyone had moved to the suburbs. In the 1980s, Bank of America bought major sections of downtown property, and since then, they have been rebuilding the core of Charlotte. Signs of a vigorous recovery are now everywhere. The reconstruction of the "Burning Church" (its old nickname) into the Tryon Center for Visual Art was the brainchild of (and was funded by) Bank of America's CEO, Hugh L. McColl and his bank, to the tune of 7.5 million dollars.

By chance, near the beginning of my residency, I happened to be seated at Hugh McColl's table for the gala opening of the Tryon Center. The following week he visited my studio. I told him that I found, in the history of the church's destruction, the expression of a poetic moment. I saw the burning as a key turning point in the building's life, and, by extension, of Charlotte itself. As a result of our conversations, McColl has taken a personal interest in my current project.

At sunset on the fifteenth anniversary of the "Burning Church," I am organizing an event to which the public is invited. In a large, empty lot immediately adjacent to the Tryon Center (which forms the backdrop) imagine a thirty-foot-high, conical tower built of old wooden chairs. A soundtrack composed of one single tolling church bell signals the beginning of action. A bag lady, who has until now been mingling in the crowd, enters the staging area. She acts out a mimetic characterization of the Texan madwoman, ignites the tower with a flaming broom, sheds her raggedy clothes and tosses them into the fire, then runs off as the flames gain strength. As the fire grows, so does the soundtrack (delivered on a concert-sized PA system). More and more bells ring out, increasing in texture and layering, until at the peak of the inferno we have a cacophony of bells, loud, rhythmic, and glorious. The burning chairs compress, revealing a plate-steel scale replica of the church perched atop a central armature (a twenty-eight-foot telephone pole scavenged from a nearby train yard). The ringing bells reach their peak of musical density.

On my signal, a fire truck is called to the scene and extinguishes the flames, leaving a smoking mass of charred chairs with a newly forged, spotlit church on top. The staging area is opened up, and spectators are allowed to enter the burn site for a one-hour reception of baked potatoes and hot cider. I plan to sell the metal church and establish a bursary to fund future affiliate artists at the Tryon Center.

During the event, I will be photographing the towering inferno with an eight-by-ten-inch camera. Students of architecture and photogra-

phy will also be photographing the event with small, medium, and four-by-five format cameras (I buy the film, I keep the negatives, I use the images). Three videographers will capture the event as well, and a live Web-cast is being produced courtesy of the Tryon Center media lab. The photographic material gathered from this event will be the source for large-scale ink-jet prints of electronically assembled images on watercolor paper. So, I'm realizing my still-life project, but in ways I could never have imagined before coming to the Tryon Center. My concepts and resources feel fully exercised and I've released tons of pent-up creative energy.

Meanwhile, we resident artists are getting along famously. It feels like family. Often, we spend very long evenings together, cooking, eating, drinking, and above all talking. We go to shows, watch films, make studio visits, and get into mischief. Life is good. I almost dread the thought of leaving, but new artistic horizons have opened for me and I've made lasting friendships with sensitive, intelligent, and responsive people. I'll be returning to Toronto energized and with enough source material for an intense period of printmaking.

Linda Tarnay, Choreographer

A day in the life: Being an early riser, I am the first to greet the rabbits and guinea hens who populate The Yard grounds. I bicycle down the hill to the Menemsha dock, where I buy coffee and doughnuts at the gas station. I join the fishermen and the boating people in an early inspection of the day—the wind, the water, the weather—these things *matter* here.

During my reverie on the jetty, I think about the dance I'm working on: What do I want to accomplish at today's rehearsal? How can I keep the third section from sagging in the middle? What will the total shape of the dance be? It is delicious to have the time and tranquillity for these reflections.

Returning to The Yard, I see that some dancers are sitting on the front steps, hugging their coffee cups. They will not have to do battle on the subway to get to their morning class; they need only cross the driveway to the cool and spacious Barn Theater. I am teaching company class this morning. Tomorrow I will be a student. Quietly we begin coaxing our bodies into warmth and flexibility. I love this time when we all come together to practice, to submit our muscles and our egos to the demands of the work.

After class we meet with Yard founder/director Patricia Nanon to discuss the week's schedule and other business. Who will go grocery shopping in Vineyard Haven? Who will drive to the beach?

I rehearse first, a two-hour slot before lunch. The dancers, the space, and the time are all there, waiting for me. I have not had to squeeze in rehearsal time between my own teaching job and my dancers' other obligations. I have not had to call all over town looking for studio space. The dancers are not exhausted from waitressing at nights and weekends, while still keeping their dance lives going. I feel prepared for the rehearsal. I am able to work efficiently. The dancers (wonderful, all of them) are ready to try anything.

I have asked another choreographer, David Dorfman, to come watch a run-through at the end of my rehearsal. He gives me some useful suggestions: Bring in the central figure sooner. Overlap two of the sections.

We lunch on fruit and yogurt, what's left of last night's casserole, and bread baked by one of the dancers. After lunch, while another group rehearses, I climb up to my little gabled room and, using a stopwatch, time the remaining music of the dance and think about how to shape that time. Elsewhere in the house, dancers are doing laundry, sewing costumes, or sunbathing on the deck.

There are no group rehearsals this afternoon between 2:00 P.M. and 4:00 P.M., so some of us head for Lucy Vincent Beach. I have come to know by heart the humpbacked curve of the clay cliffs, the rich smell of the vegetation that encloses the path to the beach, the way the waves slurp around the slippery black boulders at the edge of the sea.

Rehearsals resume. Meanwhile, choreographer H. T. Chen, our cook for the evening (we take turns), is fishing from the Menemsha jetty. Later, he presents us with a sushi extravaganza. We eat family style around a long table. There's a lot of noise and laughter, even through the washing up. Our group is becoming closer.

After supper, I return alone to the theater. The grass is damp, and the rabbits are out again. A cricket, lodged in the rafters somewhere, rasps away. I plug in the tape deck, play my music, and wander around the studio in a sort of trance, plotting traffic lines, peopling the space with ghost dancers performing wondrous feats. Some of my visions may find their way into my dance; more likely, something more interesting will emerge unexpectedly in tomorrow's rehearsal. I sleep blissfully. No sirens, no screaming crazies on the street. Only the soft clanging of the Menemsha buoy and the delicate rustle of the fog creeping through the trees.

Ingrid Wendt, Poet

What I was looking for at the Mary Anderson Center I found: a room of my own, in which to remove myself from the clamor of everyday demands; a gently rolling, wooded landscape, in which to take long afternoon walks; freedom from cooking (and shopping and cleaning and all the mental fragmentation that goes with these tasks); and the luxury of uninterrupted time to write new poems.

What I hadn't expected was the exhilaration of finding a poem I didn't know was waiting to be written: a long, sustained, 16-part construction I would never have attempted without the opportunity to live twenty-four hours a day, for three weeks, surrounded by piles of paper all over the floor (they could stay there all night!) and to work at a desk long and wide enough for me to spread out five or six rough drafts at a time, and see them all at a glance.

Even more important: What I hadn't expected was that, in writing this poem, I would be venturing into waters too dangerous, too murky, to be approached in the context of everyday life—subjects and themes that had been shaping themselves in my unconscious mind but that were still visible only as fragments in my journals: hastily-jotted impressions collected during the previous year, which I had spent at the University of Frankfurt am Main, Germany, as a Fulbright professor. What I hadn't expected was that, before I could approach this poem, I had some grieving to do. I was needing time and space and, more crucially, a non-judgmental, caring, and encouraging environment in which I could allow my deepest concerns to surface, in which I could let myself mourn and not have to turn, five minutes later, to the needs of others.

At the Mary Anderson Center—located on a wooded knoll in southern Indiana, not far from the Ohio River—housed in an upstairs room of a large, red-brick house on the grounds of a Franciscan friary, I found myself surrounded by a bevy not of stimulating and ambitious artists (who might have distracted me from my own hidden agenda) but by Roman Catholic brothers and priests, most of them in lay clothing, with whom I and the one, or two, or (rarely) three other artists would share the noon meal in the central dining room. Conversation was optional and casual, the atmosphere not "religious" (which I would have found intimidating) but warm, with the sense that good things were waiting to happen. No one pressed me to talk about my work, no one knew (or cared) about my list of publications. I, like everyone in the room, was there on a highly personal and absolutely essential quest that needed no explanation, no justification, no tangible results.

Perhaps it was a combination of all these things—the time, the space, the fields and woods with their nearly-wilderness trails, the deer I'd watch crossing the meadow between my window and the pond below, and especially the anonymity and the atmosphere of belief in the potential for human, not just artistic goodness—that allowed my long poem *Questions of Mercy* to find its way onto the page, and that led me into a conscious, new direction in future work. For all of these gifts, I shall always be grateful.

Lynne Yamamoto, Sculptor

In the years since I left Sculpture Space, I have been appreciating more and more the richness of my experience. I realize how important it was to have access to the assortment of materials that can be found in Utica. When I was there in 1993, one of the projects I was working on was an installation for *Construction in Process IV*, to be exhibited in Lodz, Poland, and which concerned women who worked in the textile industry there. The installation was entitled *"Let Them Eat Cake": For the textile workers in Lodz*. In the title card, I mentioned that the forks and wool had been brought from Utica, New York: the forks from Empire Recycling, the wool from Waterbury Felt.

The connection between Lodz, textile workers, and my residency at Sculpture Space began when I visited an exhibit at the Oneida County Historical Society in Utica. The Director, Douglas Preston, creates well-researched exhibits, though the text panels are never as interesting as speaking to him in person. Name a subject, and he will quickly pull out several books on it for you, as well as give you a synopsis and critique of the books' contents. He is generous with his time and knowledge, and I found him genuinely enthusiastic about helping me. Our encounter influenced my work dramatically.

After describing my Lodz project to him, he handed me the book *United We Stand: The Role of Polish Workers in the New York Mills Textile Strikes, 1912 and 1916*. The book describes Polish Americans as the second largest ethnic group in Utica. The majority are immigrants, or descended from immigrants, who came to work in the textile mills in Utica and its environs in the late 19th century. After reading the book, I contacted one of the authors, who lives in nearby Deerfield. He suggested that I contact someone at the Waterbury Felt for a tour to see what the interior of a functioning textile mill looks like.

Waterbury Felt is probably the only textile mill still functioning in this area. Sid Copperwheat, the plant manager, gave me a stunning tour. He's worked there for decades, as have several other members of his family. Many floors were strangely empty (in fact, his son's band practices on one of them, amongst the boxes of felt). Several hundred people must have worked there during the factory's height; thirty-five people work there now. Mr. Copperwheat showed me the enormous machines' rollers through which pass sheets of cloudlike felt. The rollers are wood, and they still use wood bobbins and thistles. Shuttles fly on looms as long as twenty feet. In the older building, bits of wool still hang from ceiling beams. The wood partitions have darkened with age, though they remain sturdy, and the stairs show the wear of thousands of footsteps. The modern and the ancient coexist in the mill: In the dim light, as I explored, I saw half-opened bales of raw wool and synthetic fluff alongside large wicker baskets belonging to past eras.

The tour, my encounters with Mr. Preston, my work at Sculpture Space—the privacy, and the quiet and concentrated time I enjoyed during my residency—was crucial to immersing myself in the work and lives I was exploring.

Artists'
Communities
Directory

FOUNDED Organization 1988, Residency 1988.

LOCATION Santa Monica. One block north of Olympic Boulevard. Five minutes from downtown Santa Monica and the Pacific Ocean.

ELIGIBILITY Visual artists, writers, performance artists, designers/architects, scholars (see indices for more specific types of artists served). International artists selected through partner organizations of 18th Street. American artists by invitation. Open application for Los Angeles–based emerging and mid-career artists only. Work with organizations dedicated to issues of community and diversity. No repeat residencies.

FACILITIES 1-acre site. Buildings 35,000 square feet. Theatre, exhibition space, kiln. Macintosh computers with Internet access and Adobe Photoshop and Quark software.

HOUSING/MEALS/ACCESSIBILITY

Housing/Services: Includes kitchen facilities, laundry facilities, and linens. Spouse or children possible.
Meals: Artists purchase their own food and prepare their own meals.

FOR CURRENT APPLICATION REQUIREMENTS:

1639 18th Street
Santa Monica, CA 90404

TEL
(310) 453-3711

FAX
(310) 453-4347

E-MAIL
arts18thst@aol.com

WEB
artswire.org/arts18st

Accessibility: Artists in wheelchairs can be accommodated. Housing, housing bathrooms, studios, public bathrooms, and theatre are wheelchair accessible. Ramps. No special facilities for artists with vision or hearing impairment.

RESIDENCY STATISTICS

Application deadline: Ongoing.
Resident season: Year-round.
Average length of residencies: 2–5 months.
Number of artists in 1998 (and total applicant pool): 18 (total pool unknown).
Average number of artists present at one time: 3.
Selection process: International artists are selected by interactive curatorial processes or nominating committees based in each of the host countries. One American Invitational Artist per year is invited by 18th Street's Selection Committee. Two Los Angeles–based artists are selected from an open application pool by the Selection Committee on three criteria ranked in order of importance: artistic merit, financial need, and artistic discipline.

ARTIST PAYS FOR International and American Invitational artists pay no fee. Los Angeles–based artists pay $1,200/month for live/work spaces (call for residency details). All artists pay for food and materials.

INSTITUTION PAYS FOR International and American Invitational residencies (including housing and studio costs, and stipend for additional costs) funded by the institution (call for residency details); facilities; program administration.

ARTIST ELIGIBLE FOR Limited subsidies for International Artists only.

ARTIST DUTIES None, though there are voluntary opportunities to give lectures and/or slide presentations at local K–12 schools, art colleges, and universities.

PUBLIC PROGRAMS Educational programs, open house/tours, international exchanges, festivals,

"Your help made possible what was probably the most influential artistic experience of my life." —Dan Forcey

readings/lectures, exhibitions/presentations. 18th Street Arts Complex has, in addition to its residency and international artist-in-residence programs, an education program wherein artists are trained to work with students and are provided with residencies in area schools. 18th Street also has a presenting program that includes a gallery and an annual arts festival.

HISTORY Since 1988, 18th Street Arts Complex has been home and host to hundreds of artists who hail from many continents, countries, and cultures. On national and international levels, 18th Street is a respected destination for artists wishing to work, exhibit, publish, and/or perform in Los Angeles.

MISSION 18th Street Arts Complex is a nonprofit arts community in Santa Monica dedicated to issues of community and diversity in contemporary society. Our support services seek to enable emerging artists and arts organizations to reach their professional goals. As an incubator for emerging artists and arts organizations, 18th Street maintains two residency programs, one for Los Angeles–based artists and one for international artists; a public events program; and an arts education program.

PAST RESIDENTS INCLUDE Guillermo Gómez-Peña, Cornerstone Theater Company, Phranc, Miwa Yanagi.

FROM THE DIRECTOR "Contemporary artists are conditioned, if not programmed, to examine all aspects of authority. It doesn't always make for the kind of person who can function comfortably within a community. And it may even be that the instinct to challenge and deconstruct is part of a modernist model that is just becoming antiquated for reasons we are not able to truly grasp. Yet the experiment that remains 18th Street will continue to remain on the edges of this conversation because, at the very least, artists of the here-and-now need to be part of and understand community more than ever." —*Clayton Campbell (Co-Director)*

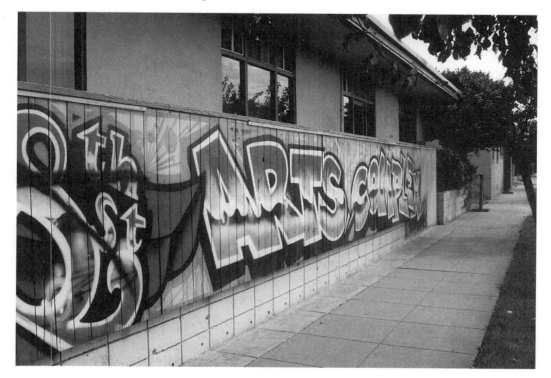

FOUNDED Organization 1997, Residency 1998.

LOCATION Hans Arnhold Center, an historic lakeside villa, in the Wannsee district of Berlin, Germany.

ELIGIBILITY U.S. citizens only. Novelists, historians, critics, playwrights, theater scholars, visual artists (see indices for more specific types of artists served). No repeat residencies.

FACILITIES Archive/collection, rehearsal space, exhibition space. Equipment and facilities are coordinated with other organizations in Berlin. Compaq computers available with word processing, Internet access, audio visual equipment, and teleconferencing capability.

HOUSING/MEALS/ACCESSIBILITY

Housing/Services: Furnished suites with small, equipped kitchen units, TVs, VCRs. Spouse possible (small fee charged for spouse's meals). *Meals:* Two meals a day (breakfast and dinner) provided and served in the dining room; fellows who wish to take meals in their rooms may do so. Most take lunch at their institutional affiliation, outside the Academy. *Accessibility:* Artists in wheelchairs can be accommodated. Housing, housing bathrooms, and public bathrooms are wheelchair accessible. Elevator. No special facilities for artists with vision or hearing impairment.

RESIDENCY STATISTICS

Application deadline: February 1.
Resident season: September 1–May 15.
Average length of residencies: 1–2 academic semesters.
Number of artists/scholars in 1998 (and total applicant pool): 16 (150).
Average number of artists present at one time: 8–10.
Selection process: Applicant submits proposal for independent study or work, as well as work samples and references. Proposals are reviewed by staff and then by a distinguished fellows selection committee (made up of scholars, artists, professionals) that makes final recommendation. Separate jury evaluates artists and refers choices to selection committee.

ARTIST PAYS FOR Materials.

INSTITUTION PAYS FOR Housing, studios, food, travel, facilities, program administration.

ARTIST ELIGIBLE FOR Stipends, fellowships/awards. Regular Berlin Prize Fellowships, plus one Emerging Artists Fellowship and one Advanced Studies Fellowship.

ARTIST DUTIES Make a formal presentation and attend weekly fellows' seminars.

PUBLIC PROGRAMS Workshops, community outreach, readings/lectures, exhibitions/presentations. The Academy sponsors biannual "New Traditions" conferences for leaders in the arts, business, government, and education, as well as other occasional topical conferences, seminars, lectures, readings, and film programs.

HISTORY Originally proposed as a Central European humanities institute in 1991 and 1994, the Academy was reconstituted as an institute for

FOR CURRENT APPLICATION REQUIREMENTS:

14 East 60th Street, Suite 604
New York, NY 10022-1001

TEL
(212) 588-1755

FAX
(212) 588-1758

E-MAIL
amacberlin@msn.com

> *"Offering a comfortable, even elegant, environment, the American Academy in Berlin also provides a perfect setting for cohesive and rewarding exchange among the fellows. Some of these are primarily social—a dinner, for example—others involve lectures, readings, meetings, and the invited presence of guests and others who bring their own special gifts to the life of the academy. Beyond this there is Berlin itself—a great city, at the center of modern history—undergoing still another crucial change in its evolution. A powerful experience for all the fellows and an incomparable opportunity."* —Robert Kotlowitz

the advanced study of art, culture, and public affairs in 1997 under the leadership of diplomat and investment banker Ambassador Richard C. Holbrooke. Dr. Henry Kissinger and former German President Richard von Weizsaecker are honorary chairmen. Berlin Prize Fellows' residencies began in September of 1998.

MISSION The Academy is an institute for the advanced study of the arts, culture, and public affairs dedicated to the promotion of cultural and commercial relations between the United States and Germany through artistic, scholarly, and professional fellowships and related programs.

PAST RESIDENTS INCLUDE Arthur Miller, Ward Just, Robert Kotlowitz, Diana Ketchum, Gerald Feldman, Brian Ladd, C. K. Williams, Marianne Fulton, Gautam Dasgupta, Donald Shriver, Anthony Sebok, Kendall Thomas.

FROM THE DIRECTOR "The Berlin Prize Fellow program is both collegial and interactive with Berlin and Germany. Fellows include artists, scholars, and professionals at all levels of attainment from promising early and mid-career people to eminent senior persons. All establish an association or affiliation with a Berlin area institution, whether an artists' enclave, film studio, museum, archive, university, or firm. Fellows do their own independent projects and typically give a lecture or presentation in Berlin or elsewhere in Germany. In addition to the fellow's program, the Academy sponsors conferences, seminars, lectures, and readings as well as an occasional film program." *—Everette E. Dennis*

FOUNDED Organization 1894, Residency 1896.

LOCATION 11 acres atop the Janiculum, the highest hill within the walls of Rome.

ELIGIBILITY U.S. Citizens only. Visual artists, writers, composers, performance artists, architects/designers, scholars (see indices for more specific types of artists served). No repeat residencies.

FACILITIES 11-acre site. Studios, darkroom, exhibition space, library, pianos, photographic archive, small computer lab (though artists are encouraged to bring their own computer equipment).

HOUSING/MEALS/ACCESSIBILITY

Housing/Services: Private room and bath in the McKim, Mead, and White Building. Spouse or children possible. Fellows with children are not housed in the Academy's main building, but in outside apartments.
Meals: Two meals per day, except Sunday and holidays, in dining hall.
Accessibility: Artists in wheelchairs can be accommodated. Housing, housing bathrooms, studios, and public bathrooms are wheelchair accessible. Elevator. No special facilities for artists with vision or hearing impairment.

RESIDENCY STATISTICS

Application deadline: November 15.
Resident season: September–August.
Average length of residencies: 11 months.
Number of artists in 1998 (and total applicant pool): 14 (660).
Average number of artists present at one time: 12–14.
Selection process: Outside panel of prominent professionals in each discipline, drawn from all regions of the country, and changed annually.

ARTIST PAYS FOR Application fee of $40, travel, materials.

INSTITUTION PAYS FOR Housing, studios, food, facilities, program administration.

ARTIST ELIGIBLE FOR Stipends of $9,000–$15,000 depending on length of term.

ARTIST DUTIES None.

PUBLIC PROGRAMS Exhibitions, concerts, readings, lectures, symposia—both in Rome and in the United States. The Academy's residential community includes artists and scholars, and encourages artistic and intellectual exchange among its representatives of many different disciplines and fields.

HISTORY The Academy sprang from the vision of American architect Charles Follen McKim, abetted by the artists with whom he had collaborated at the 1893 Worlds Columbian Exposition in Chicago: architects Daniel Burnham and Richard M. Hunt, painters John LaFarge and Francis Millet, and sculptors Augustus Saint-Gaudens and Daniel Chester French.

MISSION The American Academy in Rome is dedicated to advancing and enriching American culture and scholarship. It accomplishes this mission by maintaining a residential cen-

FOR CURRENT APPLICATION REQUIREMENTS:

7 East 60th Street
New York, NY 10022-1001

TEL
(212) 751-7200

FAX
(212) 751-7220

WEB
www.aarome.org

ter for independent study, research, and creative work in the fine arts and the humanities, while fostering cross-disciplinary exchange.

PAST RESIDENTS INCLUDE David Hammons, Roy Lichtenstein, Nancy Graves, Mary Miss, Frank Stella, Philip Guston, Samuel Barber, Aaron Copland, Lukas Foss, David Lang, Michael Graves, Richard Meier.

FROM THE DIRECTOR "The Academy is by no means a luxurious place, but we have an inconceivably luxurious educational offering—the heart of which is a community of interesting people." —*Adele Chatfield-Taylor*

Anderson Center for Interdisciplinary Studies

ALLIANCE OF ARTISTS' COMMUNITIES MEMBER

FOUNDED Organization 1995, Residency 1995.

LOCATION 5 miles north of Red Wing, Minnesota, on 320 acres of farm and bottomlands, near the confluence of the Cannon and Mississippi Rivers. All buildings are on the National Historic Register and contain a rich, storied history. The Center is involved in environmental conservation.

ELIGIBILITY Writers of all kinds, painters, composers/musicians, historians, photographers (see indices for more specific types of artists served). Criteria for selection include: excellence of artistic samples (writing, slides, etc.); a clearly defined focus of project to be worked on while at the Center; genre or discipline; geography (some priority given to Midwest artists). Both emerging and established artists are welcome. Also, during non-residency months, Anderson Center rents houses and studios out to artists for $500 per month. Repeat residencies permitted.

FACILITIES 320-acre site. Buildings 55,000 square feet. 6 studios. Darkroom, library, exhibition space, piano, full darkroom equipment, dry-mounting press, computer and Internet access.

FOR CURRENT APPLICATION REQUIREMENTS:

P.O. Box 406
Red Wing, MN 55066

TEL
(651) 388-2009

E-MAIL
acis@pressenter.com

WEB
www.pressenter.com/~acis

HOUSING/MEALS/ACCESSIBILITY

Housing/Services: Residents are given free room (and board for 5 days per week) and a quiet workplace in a room or in studios. Center has 6 bedrooms (each with a desk, chair, bed, ajoining bathrooms, etc.). All linens provided as well as a washer, dryer, and refrigerator. Collaborative groups can be accommodated only if they apply as a group for 2 weeks or one month. Spouse possible; two bedrooms can accommodate couples; one partner would work in separate studio or room. Transportation to and from St. Paul/Minneapolis Airport provided. *Meals:* Breakfast (coffee, muffins, the occasional pancake) and dinner provided. Lunch is responsibility of residents. Meals served 5 days a week; weekends are responsibility of residents. *Accessibility:* Vision- or hearing-impaired residents can be accommodated. Fire alarms with flashing lights as well as sound. Not completely accessible to artists in wheelchairs. Public bathrooms, kitchen, and darkroom are wheelchair accessible, though not housing as yet. Elevator/lift. The Center will be providing ramps to the main residence house, to screen porch in main house. In the next few years, when they have the opportunity to build more studios, they will provide accessible entrances, facilities, and equipment.

RESIDENCY STATISTICS

Application deadline: March 1.
Resident season: May–September.
Average length of residencies: 2 weeks–1 month, with some longer (call for details).
Number of artists in 1998 (and total applicant pool): 25 (75).
Average number of artists present at one time: 6.
Selection process: Residence-Application Committee carefully reviews all applications, résumés, supporting materials, and workplan, then selects according to criteria listed above.

ARTIST PAYS FOR Application fee $15, travel, materials.

INSTITUTION PAYS FOR Housing, studios, food, facilities, program administration.

ARTIST ELIGIBLE FOR A. P. Anderson award for contributions in literature and the arts; fellowship programs with University of Minnesota, Mankato State University, and The Loft Writing Departments.

ARTIST DUTIES To engage in interdisciplinary life of the Center. All residents are asked to perform some sort of community service to civic groups or at schools, etc., such as a reading, recital, performance, or lecture.

PUBLIC PROGRAMS Workshops, educational programs, open house/tours, community outreach, festivals, readings/lectures, exhibitions/presentations. Studios for artists, classrooms, laboratories, and public meeting spaces enable artists and scholars of every discipline to pursue their work and share it in a public setting. The Center has a number of partners with whom it works to fulfill mutual goals, including the Environmental Learning Center, Tower View Alternative High School, the Institute for Minnesota Archaeology, Sheldon Theatre, the Public Library, the Goodhue County Historical Society, the Arts Association, and local schools.

HISTORY The Anderson Center was established in 1995 on 320 acres of historic property in the Mississippi River Blufflands region.

MISSION A gathering place rich in historical significance, the Anderson Center is a regional resource that provides a setting conducive to the pursuit of creative projects and solutions, acting as a forum for significant contributions of community service.

PAST RESIDENTS INCLUDE Maggie Anderson, John Broich, Michael Fedo, Margot Galt, Phyllis Golden, Jeffrey Robinson, Mary Thompson, Steven Keillor, Madeline Wallach, Mary Barrett.

FROM THE DIRECTOR "The Anderson Center is the home of several working artists (potters, filmmakers, sculptors, and painters) who maintain permanent, working studios. The Center also publishes the *Great River Review,* Minnesota's oldest continuously published literary magazine." —*Robert Hedin*

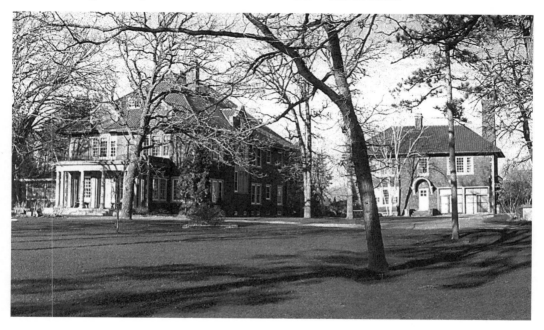

Anderson Ranch Arts Center

ALLIANCE OF ARTISTS' COMMUNITIES MEMBER

FOUNDED Organization 1966, Residency 1986.

LOCATION In the resort community of Snowmass Village, 10 miles west of Aspen, 200 miles west of Denver.

ELIGIBILITY Visual artists, multi-media, performance artists (visiting artists' program only). Please call to inquire about specific genres served (also, see indices for more specific types of artists served). Emerging or nationally established artists accepted. Repeat residencies permitted.

FACILITIES 4-acre site. 18 studios. Fully equipped photography darkrooms, digital imaging facility, metalshop, woodshop, ceramics, and print-making facilities with additional equipment for bronze/aluminum casting and welding. Art library, art collection, exhibition space. IBM compatible PC with modem, printer, access to the Internet, and basic Microsoft programs.

HOUSING/MEALS/ACCESSIBILITY

Housing/Services: Single-occupancy dorm-style rooms, shared bath, and cafeteria/meeting building. Additional people can attend only if they also apply and are accepted through the jury process. Occasionally for the visiting artists program, family members can be accommodated.

Meals: Five dinners and five continental breakfasts provided per week. Artists make all their other meals.

Accessibility: Artists in wheelchairs can be accommodated. Housing, housing bathrooms, studios, public bathrooms, wood shop, darkroom, ceramics facilities, and painting/print-making facilities are wheelchair accessible. Elevator in the print/paint building. Most other buildings are accessible at least on one floor. Most studios and bathrooms are accessible, all will be soon. No special facilities for artists with vision or hearing impairment.

RESIDENCY STATISTICS

Application deadline: Mid-March (exact date varies year to year).

Resident season: Mid-October to mid-April for residents. Visiting artist projects are year-round.

Average length of residencies: For residents: 2, 3, or 6 months. Visiting artists: 1–4 weeks.

Number of artists in 1998 (and total applicant pool): 13 (170).

Average number of artists present at one time: 20.

Selection process: Outside panel of nationally recognized professionals.

ARTIST PAYS FOR Application fee $10, travel, some food (resident pays only for food other than the 10 meals per week the Ranch provides). Resident pays for materials that cost over and above the $100 monthly materials stipend. Benefits for visiting artists differ from those of residents. Please contact Anderson Ranch for details.

INSTITUTION PAYS FOR Housing, studios, food (10 meals per week), materials ($100 per month), facilities, program administration. Benefits for visiting artists differ from those of residents. Please contact Anderson Ranch for details.

ARTIST ELIGIBLE FOR $100/month materials sti-

FOR CURRENT APPLICATION REQUIREMENTS:

P.O. Box 5598
Snowmass Village, CO 81615

TEL
(970) 923-3181

FAX
(970) 923-3871

E-MAIL
info@andersonranch.org

WEB
www.andersonranch.org

pend; Pam Joseph Fellowship for Artists of Color.

ARTIST DUTIES 10 hours per month of volunteer work in the respective residents' departments. If a visiting artists' project produces saleable work, artist gives half of the proceeds to the Ranch.

PUBLIC PROGRAMS Summer workshops, gallery exhibitions, lectures, art auction, field expeditions, community outreach.

HISTORY Founded as an artist retreat in 1966, Anderson Ranch was envisioned by ceramicist Paul Soldner as an alternative to graduate school where artists would work collaboratively and learn "through osmosis." In 1973, the organization was incorporated as a nonprofit, and by the early 1980s a formal residency program was initiated.

MISSION The program is designed to encourage creative, intellectual, and personal growth by providing a stimulating, supportive environment for committed individuals to explore their work and to interact with a community of artists working in a broad range of media.

PAST RESIDENTS INCLUDE Laurie Anderson, Larry Bell, Garry Knox Bennett, Deborah Butterfield, Judy Dater, Red Grooms, Dennis Hopper, Sally Mann, Takashi Nakazato, Ed Paschke, Ken Price, Jaune Quick-Fo-See Smith, James Rosenquist, Alexis Smith, Mike and Doug Starn, Calvin Tomkins, Jerry Uelsmann, and Peter Voulkos.

FROM THE DIRECTOR "Anderson Ranch is about process more than product and the *making* of art. Our daily task is to cultivate relationships by encouraging interaction among the broad range of creative individuals that are drawn to the Ranch campus with a commitment to taking the next step in their growth." —*James Baker*

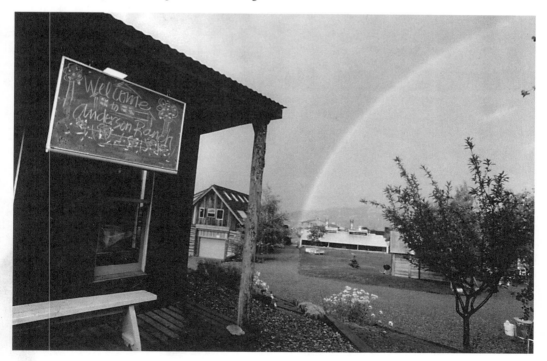

FOUNDED Organization 1951, Residency 1951.

LOCATION On the site of the former Western Clay Manufacturing Company, three miles from Helena, Montana.

ELIGIBILITY Artists working in clay, bringing together artists with diverse approaches to the medium, whether functional, sculptural, or experimental. Repeat residencies permitted.

FACILITIES 26-acre site. 19 studios. Studio space (electric and gas kilns, wood, salt, soda, raku). Slide-taking facility set-up. Macintosh computer with MS Word, etc., and Maclabel slide label program.

HOUSING/MEALS/ACCESSIBILITY

Housing/Services: Provides a resource for obtaining local rentals or house-sitting. Collaborative groups, spouse, children possible.
Meals: Artists purchase their own food and prepare their own meals.
Accessibility: Artists with disabilities cannot be accommodated. Any new facility buildings will be designed to be wheelchair accessible, though no definite date for construction at this time.

FOR CURRENT APPLICATION REQUIREMENTS:

2915 Country Club Avenue
Helena, MT 59601

TEL
(406) 443-3502

FAX
(406) 443-0934

E-MAIL
archiebray@archiebray.org

WEB
www.archiebray.org

RESIDENCY STATISTICS

Application deadline: March 1 (due in Archie Bray's offices).
Resident season: Year-round.
Average length of residencies: 2 months–2 years.
Number of artists in 1998 (and total applicant pool): 14 (72).
Average number of artists present at one time: 19 in summer; 9 during rest of the year.
Selection process: Resident director and committee of two professionals.

ARTIST PAYS FOR Application fee $20, fixed residency/studio fee $75 per month for long-term and $150 per month for short-term residencies, housing, materials, firing fees, food, travel.

INSTITUTION PAYS FOR Facilities, program administration.

ARTIST ELIGIBLE FOR The Taunt Fellowship, a $5,000 award for a one-year residency.

ARTIST DUTIES Unspecified communal duties. Public slide show, leave a piece of work for permanent collection, leave slides of work created during residency.

PUBLIC PROGRAMS Community classes, children's program, workshops, open house, resident slide shows.

HISTORY The Archie Bray Foundation was founded in 1951 by Archie Bray, Sr., as a place for serious ceramic artists to work.

MISSION To make available for all who are seriously and sincerely interested in any of the branches of the ceramic arts, a fine place to work.

PAST RESIDENTS INCLUDE Peter Voulkos, Richard Notkin, Ken Ferguson, Kurt Weiser, Chris Staley, Carlton Ball, Val Cushing, John Gill, Andreas Gill, Clary Illian, Warren MacKenzie, Akio Takamori, Jun Kaneko, Rudy Autio.

FROM THE DIRECTOR "When the Archie Bray Foundation was established over forty years ago, the idea was clear—to make available for all who are seriously and sincerely interested in any of the branches of the ceramic arts, a fine place to work. The legacy created at the Foundation has developed through this idea by the people who have come here to work . . . The artistic freedom offered at the Bray encourages diversity and continues to attract fine ceramic artists from all over the world." *—Josh DeWeese*

FOUNDED Organization 1912, Residency 1991.

LOCATION 70 acres of wooded hillside, in East Tennessee, three miles from the entrance to the Great Smoky Mountains National Park, 40 miles from Knoxville. Atlanta, Georgia and Asheville, North Carolina are within easy driving distance.

ELIGIBILITY Clay, metals, textiles/fiber, painting, wood (see indices for more specific types of artists served). Pre-professional, self-directed, strong portfolio. Repeat residencies permitted.

FACILITIES 5 private studios, air-conditioned with skylights. Darkroom, metalshop, pottery/ceramics facility, printshop, library/collection, exhibition space, computer equipment and limited software and Internet access. Residents have limited access to specialized equipment such as kilns, press, woodshop, etc.

HOUSING/MEALS/ACCESSIBILITY

Housing/Services: New facility with private bedrooms and bathrooms, shared kitchen, dining, and living area.
Meals: Provided when school is operating with kitchen use (7 months out of the year). For all other meals, artists purchase their own food and prepare own meals.
Accessibility: Arrowmont is an accessible facility and can accommodate artists in wheelchairs. No special facilities for artists with vision or hearing impairment.

RESIDENCY STATISTICS

Application deadline: February 1.
Resident season: June–May.
Average length of residencies: 11 months.
Number of artists in 1998 (and total applicant pool): 4 (65).
Average number of artists present at one time: 5.
Selection process: Panel of professionals review applications, followed by phone interviews with semifinalists and campus visits/interviews with finalists.

ARTIST PAYS FOR Application fee $25, fixed residency/studio fee $200 per month, $175 damage deposit, materials, some food, rental of specialized equipment.

INSTITUTION PAYS FOR Housing, facilities, program administration. Institution offers meals when classes/conferences are in session. Arrowmont offers a visiting artist program within the residency program to 5 artists each year for one weekend. Also some travel-related expenses may be paid to support attendance at media-specific conferences.

ARTIST ELIGIBLE FOR Scholarships. One fellowship presently offered for a professional woman resident. Other fellowships currently being researched.

ARTIST DUTIES 8 hours per week performing various duties at Arrowmont, in studios, gallery, schools/outreach programs, office, or public.

PUBLIC PROGRAMS Opportunities for teaching in the community and children's classes. Elderhostel programs, spring and summer workshops, national conferences, concert series programs, ongoing gallery/exhibition program.

FOR CURRENT APPLICATION REQUIREMENTS:

556 Parkway
Gatlinburg, TN 37738

TEL
(423) 436-5860

FAX
(423) 430-4101

E-MAIL
arrowmont@aol.com

WEB
arrowmont.org

Other opportunities include group exhibition in one of our galleries; interaction/critique, dialogue with any of our visiting artists/faculty (over 120 faculty per year).

HISTORY In 1945 college level courses in the visual arts began to be offered at the site of the Pi Beta Phi Settlement School. In 1967, the School became known as the Arrowmont School of Arts and Crafts, and the residency program was initiated in 1991.

MISSION To enrich lives through art by developing aesthetic appreciation and fostering self expression through practical experiences.

PAST RESIDENTS INCLUDE Jeff Brown, Johanna Paas, Sondra L. Dorn, Kristen Keiffer, Jill Oberman, James Jones.

FROM THE DIRECTOR "The artist-in-residence program gives pre-professional, self-directed artists time and space to develop a major body of work in a creative community environment. Our residents involve themselves in all factors of our program. The eleven-month residency provides residents with an understanding of how a facility like Arrowmont operates while further developing their skills as professional artists and educators." —*Bill Griffith*

ArtCenter/South Florida

ALLIANCE OF ARTISTS' COMMUNITIES MEMBER

FOUNDED Organization 1984, Residency 1985.

LOCATION Lincoln Road open-air, pedestrian mall in Miami Beach. Located in South Beach, the mall attracts 20,000 persons weekly to visit the galleries, shops, and restaurants, many of whom also visit the studios and galleries of ArtCenter/South Florida.

ELIGIBILITY Painting, photography, conceptual art, sculpture, new genre (see indices for more specific types of artists served). Artists awarded juried-artist status for a period of 2 years at a time; maximum term 6 years.

FACILITIES 2 buildings, one block apart, comprising 36,000 usable square feet. 52 studios. 2 exhibition spaces, printmaking facility, classroom, darkroom.

HOUSING/MEALS/ACCESSIBILITY

Housing/Services: ArtCenter artists obtain their own housing. Artists selected by National Foundation for the Advancement of the Arts as Fellows in the Visual Arts (FIVA) are provided local studio apartments.
Meals: All artists purchase their own food and prepare their own meals.

FOR CURRENT APPLICATION REQUIREMENTS:

924 Lincoln Road, Suite 205
Miami Beach, FL 33139

TEL
(305) 674-8278

FAX
(305) 674-8772

Accessibility: Artists with disabilities can be accommodated. Housing, housing bathrooms, studios, and public bathrooms are wheelchair accessible. Elevator.

RESIDENCY STATISTICS

Application deadline: Ongoing (call for information).
Resident season: Year-round.
Average length of residencies: ArtCenter artists, 4 years; FIVA artists, 4 months per year for 3 years.
Number of artists in 1998 (and total applicant pool): 76 ArtCenter artists (100 applicants); 9 FIVA artists (applicant pool unknown).
Average number of artists present at one time: 76 ArtCenter artists, 3 FIVA artists.
Selection process: Outside jury of professionals in each category.

ARTIST PAYS FOR Application fee $40, sliding scale studio rental fee based on income level, ranging from $7–10 per square foot, energy surcharge, housing, food, travel, materials.

INSTITUTION PAYS FOR Facilities, program administration, costs of exhibitions.

ARTIST ELIGIBLE FOR ArtCenter artists receive some level of subsidized rent (the rent paid is one-tenth of the rents now charged on Lincoln Road). FIVA artists receive a monthly stipend and housing in addition to receiving their studio rent-free.

ARTIST DUTIES Annually, ArtCenter artists must work in their studios a minimum of 30 hours a week for 47 weeks or 35 hours a week for 40 weeks.

PUBLIC PROGRAMS Community arts education to over 1,500 children and 1,500 adults per year. All ArtCenter artists are invited to participate in the adult art studies programs and in the children's Art Adventures and summer Art Camp programs. ArtCenter offers monthly exhibitions in each of its galleries which are free

"ArtCenter provides me with affordable studio space on an otherwise innacessible high-profile Lincoln Road." —William Robb

and open to the public. Opportunities are also available to participate in Artist as Mentor and Artist Stewardship programs.

HISTORY ArtCenter/South Florida was founded in 1984 by a group of artists to provide affordable workspace for artists and to combat the problem of artists working in isolation.

MISSION ArtCenter/South Florida, a not-for-profit organization, advances the knowledge and practice of contemporary visual arts and culture in South Florida. ArtCenter exists to provide affordable workspace in the Lincoln Road Mall in Miami Beach for outstanding visual artists in all stages of career development. ArtCenter provides access to resources and sup-

port, creates opportunities for experimentation and innovation, and encourages the exchange of ideas across cultures and artistic disciplines. ArtCenter serves the diverse residents and visitors of South Florida through open studios, exhibitions, and education.

PAST RESIDENTS INCLUDE Eduard Duval-Carrie, Juan Si, Carol Brown, Tag Purvis, Theresita Fernandez (FIVA), Nicole Eiseman (FIVA).

FROM THE DIRECTOR "ArtCenter/South Florida is an arts incubator for emerging, mid-career, and established visual artists in an environment that permits gallerists, curators, collectors, and the general arts-interested public to interact directly with our artists." —*Gary Knight*

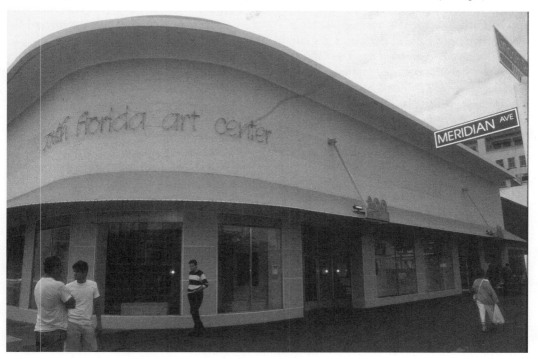

Art Farm

FOUNDED Organization 1993, Residency 1992.

LOCATION On a working farm, two miles from the clay bluffs of the Platte River, 140 miles west of Omaha. Ongoing prairie restoration.

ELIGIBILITY Sculptors, painters, ceramicists, and installation and environmental artists (see indices for more specific types of artists served). Also, fee-based winter residencies are available during non-resident season: Farmhouse and winterized studio (600 sq. ft.) for monthly fee plus utilities. Please contact Art Farm for more details. Repeat residencies permitted.

FACILITIES 40-acre site. Buildings 16,000 square feet. 3 studios. Studio space in 3 farmyard barns, plus a converted Nebraska school house which acts as a studio/exhibition/public events space. Up to 20 acres of land available for environmental projects. Electric and gas kilns, woodworking and metalworking equipment, tractor loaders and trucks. Computer (PC) with Internet access, CAD, image editing and drawing programs, word processing.

FOR CURRENT APPLICATION REQUIREMENTS:

1306 West 21st Road
Marquette, NE 68854-2112

TEL
(402) 854-3120

FAX
(402) 854-3120

E-MAIL
artfarm@hamilton.net

HOUSING/MEALS/ACCESSIBILITY

Housing/Services: Room in a more-than-a-century-old, 3-bedroom farmhouse, equipped with shared kitchen, bathroom, and laundry facilities. Short-term visitors welcome based on accommodation space.

Meals: Artists purchase own food and prepare own meals. Vegetable garden grown for residents' use.

Accessibility: Artists with disabilities cannot be accommodated at present. Art Farm is a working farm with turn-of-the-century buildings that are slowly being renovated and upgraded. As renovations progress, Art Farm is attempting to make some facilities and accommodations accessible for residents with disabilities.

RESIDENCY STATISTICS

Application deadline: April 1 for residencies between June 1 and November 1. September 1 for fee-based winter residencies.

Resident season: June 1–November 1, November 15–April 30.

Average length of residencies: 2–3 months.

Number of artists in 1998 (and total applicant pool): 5 (50).

Average number of artists present at one time: 3 (4 maximum).

Selection process: Currently, selections made by directors.

ARTIST PAYS FOR Small maintenance fee for use of equipment; food, travel, materials. June 1–November 1 residencies receive free accommodation and studio space in exchange for 3 hours work each weekday. Winter rental residents pay $450 per month plus utilities for farmhouse and winterized studio (no work-exchange).

INSTITUTION PAYS FOR Housing, studios, facilities, program administration. For June 1–November 1 residencies, some on-site materials are available free to artists (e.g. clay, wood, scrap metals).

ARTIST ELIGIBLE FOR No stipends or fellowships/awards.

ARTIST DUTIES 15 hours per week assistance to Art Farm in general construction and carpentry, grounds maintenance, or office work. Artist leaves one piece of artwork for Art Farm Collection.

PUBLIC PROGRAMS Group visits/tours from schools, colleges, art clubs, etc. Children's art camp in July. Art Harvest Open House and artist-in-residence exhibition are annual events.

HISTORY Incorporated in 1993 by artists Ed Dadey and Janet Williams. In search of studio space, Dadey moved a number of barns in the area to his family farm. The work of restoring, repairing, and converting barns for studio space continues.

MISSION To provide a worksite, resources, and support for artists, providing them with time to experiment with new ideas or projects while working and living in a rural environment.

PAST RESIDENTS INCLUDE Theresa Handy, Johnny Walker, Susan Francis, Seung Jae Choi, Debbie Siegel, Samantha Fields, Brian McArthur, Megan van Wagoner, Stephanie Bowman, Gerald Weckesser.

FROM THE DIRECTOR "Art Farm's physical presence is in its buildings and land. More elusive to describe is the ambiance, the subtle influence of the environment's impact on time and space. Time is kept by sun and night sky, not by clock and calendar. Space is marked by proximity to sound and silence. The sky and your ears will be filled with the sound and shapes of an incredible number of birds and insects. And, like it or not, the weather will be your collaborator in all undertakings." —*Ed Dadey*

FOUNDED Organization 1992, Residency 1992.

LOCATION A converted 1830 farmhouse in New York's historic Hudson River Valley, near the town of Chatham.

ELIGIBILITY International Artists' Colony: painters, sculptors, installation artists (see indices for more specific types of artists served). Ledig House International Writers' Colony: writers, poets, translators. Music/OMI: Jazz and innovative musicians. No repeat residencies.

FACILITIES 150-acre site. 28 studios and dormitory rooms. Darkroom, metalshop, woodshop, library/archive/collection, exhibition space, 1-week monotype session by visiting master printer, limited computer access.

HOUSING/MEALS/ACCESSIBILITY

Housing/Services: Rooming on campus. Linens provided, laundry machines available, transportation to town provided.
Meals: All meals provided.
Accessibility: Artists in wheelchairs can be accommodated. Housing, housing bathrooms, studios are wheelchair accessible. Temporary wheelchair ramps are installed as needed. No special facilities for artists with vision or hearing impairment.

RESIDENCY STATISTICS

Application deadline: Visual artists, March 1. Writers, November 30. Musicians, May 1.
Resident season: Writers, year-round. Musicians, in August. Visual artists, 3 weeks in July .
Average length of residencies: 3–4 weeks.
Number of artists in 1998 (and total applicant pool): 29 (370).
Average number of artists present at one time: 30.
Selection process: Outside panel of professionals in each category.

ARTIST PAYS FOR Travel, materials.

INSTITUTION PAYS FOR Housing, studios, food, facilities, program administration.

ARTIST ELIGIBLE FOR Fellowship opportunities may change yearly. Fellowships for visual artists in 1999 supported African-American or Native-American, Polish, Australian, Danish, Korean, and Chinese artists (6 fellowships in all).

ARTIST DUTIES Donate a piece of art work.

PUBLIC PROGRAMS International exchanges, Open Day exhibitions, Invitational Sculpture Exhibition, lectures, readings, concerts, critic-in-residence, The Fields Sculpture Park, tours, and workshops for children.

HISTORY Founded in 1992 by a small group of individuals, ART/OMI immediately began bringing together artists from around the world. The success of the first program led to acquiring a nearby farmhouse and establishing Ledig House International Writers' Colony. In 1997, the residencies for jazz musicians were inaugurated, and in 1998, The Fields Sculpture Park opened on the grounds of ART/OMI.

MISSION To facilitate communication and build community among the world's artists, writers, and musicians, their peers, and the general pub-

FOR CURRENT APPLICATION REQUIREMENTS:

55 Fifth Avenue, 15th Floor
New York, NY 10003

TEL
(212) 206-5660

FAX
(212) 727-0563

E-MAIL
artomi55@aol.com

lic by offering an international working environment.

PAST RESIDENTS INCLUDE Toshihiro Yashiro, Cecily Brown, Dumisani Mabaso, Joana Prezybyla, Karsten Wittke, Elena Beriolo, Cheryl Donegan, Ad Jong Park, Atsushi Yamaguchi, Michael Bramwell, Wenda Gu, Diego Toledo, Ryszard Wasko, Geng Jianyi.

FROM THE DIRECTOR "ART/OMI welcomes the participation of outstanding artists from as many countries as possible. By bringing together creative individuals from all over the world, ART/OMI hopes to foster a cultural forum where ideas and perspectives about art and life can be exchanged. The interaction of the artists with one another is as important as the art that they create. In an age riven with increasing factionalism and tribalism, ART/OMI hopes to contribute to greater international understanding and tolerance." *—Linda Cross*

ArtPace

FOUNDED Organization 1993, Residency 1994.

LOCATION Downtown San Antonio, Texas.

ELIGIBILITY Artists accepted only by nomination or curatorial selection. Visual artists, film- and videomakers, directors, media artists, audio artists, architects (see indices for more specific types of artists served). No repeat residencies.

FACILITIES Buildings 18,000 square feet. 3 studios. Complete metal and woodworking facilities (other technical facilities available through co-operative exchanges such as darkroom, film/video editing facility, ceramics facility, print-shop, theatre or performance space, and rehearsal space), art collection, Macintosh and PC computers with standard software.

HOUSING/MEALS/ACCESSIBILITY

Housing/Services: 3 apartments.
Meals: Artists responsible for own groceries and meals, but they are provided with a living stipend of $500 per week while in residence.
Accessibility: Artists in wheelchairs or with vision or hearing impairment can be accommodated. Housing, housing bathrooms, studios, and public bathrooms are wheelchair acces-

FOR CURRENT APPLICATION REQUIREMENTS:

445 North Main Avenue
San Antonio, TX 78205

TEL
(210) 212-4900

FAX
(210) 212-4990

E-MAIL
info@artpace.org

WEB
www.artpace.org

sible. Elevator. When artists are selected, every effort is made to accommodate them.

RESIDENCY STATISTICS

Application deadline: By nomination only, every 2 years (dates vary).
Resident season: Year-round.
Average length of residencies: 2 months (plus 1-month exhibition).
Number of artists in 1998 (and total applicant pool): 12 (800).
Average number of artists present at one time: 3.
Selection process: By nomination to an outside international panel of professionals in each category.

ARTIST PAYS FOR Nothing.

INSTITUTION PAYS FOR Housing, studios, food (stipend), travel, materials, facilities, program administration.

ARTIST ELIGIBLE FOR $500 stipend per week. The foundation provides travel, materials, photo-documentation, and exhibition brochure.

ARTIST DUTIES None.

PUBLIC PROGRAMS International exchanges, symposia, exhibitions/presentations, lectures, artist dialogues, workshops, open house, tours.

HISTORY ArtPace was founded in 1993 by Linda Pace as a site for the creation of pivotal art projects. Since its inaugural exhibition in 1995, ArtPace has brought 12 artists annually from around the world to participate in its residency program.

MISSION ArtPace, a foundation for contemporary art in San Antonio, serves as an advocate for contemporary art and a catalyst for the creation of significant art projects. We seek to nurture emerging and established artists and to provide opportunities for inspiration, experimentation, and education. Through our Inter-

national Artist-in-Residence Program, we invite twelve artists annually to participate in a two-month residency, which supports the evolution of new ideas in art. Our broad range of symposia, lectures, artist talks, and studio visits cultivates diverse audiences for contemporary art and provides a forum for ongoing dialogue.

PAST RESIDENTS INCLUDE Laura Aguilar, Jesse Amado, Joan Bankemper, Xu Bing, Alex deLeon, Alejandro Diaz, Leonardo Drew, Anya Gallacio, Kendell Geers, Felix Gonzalez-Torres, Antony Gormley, Mona Hatoum, Henrik Plenge Jakobsen, Glenn Ligon, Bill Lundberg, Inigo Manglano-Ovalle, Esko Manniko, Cesar Martinez, Tracey Moffatt, Cornelia Parker, Nancy Rubins, Hale Tenger, Diana Thater, Kathy Vargas.

FROM THE FOUNDER "At ArtPace, artists and art viewers have charged every inch of our facility with energy, commitment, and ideas. Still there is room for more. We welcome all those who dare to expand their vision and dream new dreams to share in the experience of ArtPace." —*Linda Pace*

Atlantic Center for the Arts

ALLIANCE OF ARTISTS' COMMUNITIES MEMBER

FOUNDED Organization 1977, Residency 1982.

LOCATION 69 acres on tidal estuary, fronting Turnbull Bay, on the east coast of central Florida.

ELIGIBILITY Visual arts (painting, sculpture, photography, video installation), architecture, music (composition, performing), literature, dance (ballet and modern), theater. (See indices for more specific types of artists served.) Repeat residencies permitted.

FACILITIES 69-acre site. Buildings 17,000 square feet. Painting/drawing studio, sculpture studio with kiln, darkroom, video editing suite, printshop, woodshop, dance studio with sprung-wood floor, music/digital recording studio (pianos and keyboards), black box theater with sprung-wood floor, library, exhibition space, IBM-compatible computer with Internet access.

HOUSING/MEALS/ACCESSIBILITY

Housing/Services: For Associate Artists: 28 individual bedrooms with private bath, small refrigerator, and desk area. Communal living, eating, and kitchen space. 4 living spaces de-

signed for artists with disabilities. Collaborative groups, spouse possible. *For Master Artists:* 3 cottages with living room, kitchen, bedroom, bath, and extra bed.

Meals: Artists purchase own food and prepare own meals.

Accessibility: Artists in wheelchairs can be accommodated. Housing, housing bathrooms, studios, public bathrooms, and kitchen are wheelchair accessible. Four living spaces specially equipped for residents with disabilities. Ramps. No special facilities for artists with vision or hearing impairment at this time. Atlantic Center will do all they can to accommodate any disability, and they continue to look at ways to improve accessibility.

RESIDENCY STATISTICS

Application deadline: Varies; approximately 3 months prior to start of residency.
Resident season: Year-round.
Average length of residencies: 3 weeks.
Number of artists in 1998 (and total applicant pool): 100 (800).
Average number of artists present at one time: 21.
Selection process: Master Artists set criteria and select 6–9 Associate Artists with whom to work.

ARTIST PAYS FOR Residency/studio fee $100 per week, housing fee $25 per night (optional), food, travel, materials.

INSTITUTION PAYS FOR Facilities, program administration.

ARTIST ELIGIBLE FOR Scholarships, fellowships/awards on a limited basis. Exchange programs to Asia and Europe.

ARTIST DUTIES Meet with Master Artist and fellow Associate Artists 3 hours per day, 5 days per week to discuss issues relative to the discipline and contemporary art discourse, and each other's work.

PUBLIC PROGRAMS Artists-in-residence program: exhibitions, receptions, INsideOUT (residen-

FOR CURRENT APPLICATION REQUIREMENTS:

1414 Art Center Avenue
New Smyrna Beach, FL 32168

TEL
(904) 427-6975

FAX
(904) 427-5669

E-MAIL
program@atlantic-centerarts.org

WWW
www.atlantic-centerarts.org

cy's culminating presentation), outreaches. Also, in-town facility conducts exhibitions, receptions, adult/children workshops, gallery talks, lectures, tours, outreaches, internships.

HISTORY The idea of an interdisciplinary residence facility where "you can't see anything man-made, where people, if they wish to think creatively, can" blossomed in the mind of Doris Leeper, sculptor, painter, and environmentalist, in 1977. In 1979, the Rockefeller Foundation provided a planning grant. In 1982, poet James Dickey, sculptor Duane Hanson, and composer David Del Tredici were the community's first residents.

MISSION To empower artists, educate the public, and encourage exchange between the two.

PAST RESIDENTS INCLUDE Edward Albee, Louis Andriessen, John Ashbery, Trisha Brown, Wendell Castle, John Chamberlain, John Corigliano, Merce Cunningham, Morton Feldman, Allen Ginsberg, Nan Goldin, Martha Graham Dance Company, Charlie Haden, Duane Hanson, Arata Isozaki, Alex Katz, Howard Nemerov, Robert Rauschenberg, Terry Riley, Allison Saar, Sonia Sanchez, Carolee Schneeman, Ntozake Shange, William Wegman.

FROM THE DIRECTOR "Atlantic Center for the Arts is unique in its emphasis on the interaction and collaboration among Master Artists and their associates. Three Master Artists and up to twenty-four Associate Artists work together in a process of cross-discipline exchange, while all artists are also encouraged to spend time on their own private projects. The ideal setting—Turnbull Bay and our international, award-winning studio complex—allows artists to focus on their work without distraction." —*Paul Markunas*

Bemis Center for Contemporary Arts

FOUNDED Organization 1981, Residency 1985.

LOCATION In 2 urban warehouses and a half-block of open urban property on the fringe of downtown Omaha.

ELIGIBILITY Painters, mixed media artists, photographers, installation artists, sculptors (see indices for more specific types of artists served). No repeat residencies.

FACILITIES Buildings 100,000 sq. ft. 6 studios with apartments. 10,000-square-foot installation workspace. 10,000-square-foot sculpture facility with 15-foot ceilings. Fabrication studio spaces, use of professional darkroom, print-making workshop, film/video editing facility, woodshop, archive/collection, exhibition space.

HOUSING/MEALS/ACCESSIBILITY
Housing/Services: Apartments.
Meals: Artists purchase own food and prepare own meals.
Accessibility: Artists in wheelchairs can be accommodated. Housing, housing bathrooms, studios, public bathrooms, installation space, and fabrication studio spaces are wheelchair accessible. Elevator. No special facilities for artists with vision or hearing impairment. Plans for expanding accessibility.

RESIDENCY STATISTICS
Application deadline: September 30 and April 30.
Resident season: Year-round.
Average length of residencies: 3–6 months.
Number of artists in 1998 (and total applicant pool): 34 (426).
Average number of artists present at one time: 7.
Selection process: Outside panel of professionals in each category.

ARTIST PAYS FOR Application fee $25, food, travel, materials.

INSTITUTION PAYS FOR Housing, studios, facilities, program administration.

ARTIST ELIGIBLE FOR Stipends $500 per month.

ARTIST DUTIES 1 public slide lecture.

PUBLIC PROGRAMS Exhibitions, slide shows, lectures, performances, concerts. Encounters Education Program, Gallery Talks, Bemis Urban Mural Project.

HISTORY Founded by artists Jun Kaneko, Tony Hepburn, Lorne Falke, and Ree Schonlau. In 1985, Bemis moved to the former Bemis Bag Company building, hence the choice of the name. In 1996, Bemis moved into a new permanent home, the McCord Brady Building.

MISSION To support exceptional talent, and to provide well-equipped studios, living accommodations, and a monthly stipend to visual artists.

PAST RESIDENTS INCLUDE Manuel Neri, David Finn, Miriam Bloom, Alice Aycock, David Nash, Sue Rees, Emma Rushton, Susan Harrington, David Maab, Kyoto Ota Okuzawa, Phyllis McGibbon, Albert Ebert, Mark Joyce.

FOR CURRENT APPLICATION REQUIREMENTS:

724 South 12th Street
Omaha, NE 68102

TEL
(402) 341-7130

FAX
(402) 341-9791

E-MAIL
bemis@novia.net

WEB
www.novia.net/bemis

FROM THE DIRECTOR "The Bemis has had a distinctive role as a curator of artists. Our main interest lies in the creative development of the artists themselves. To that end, we offer long periods of supported time for residencies, giving artists large studios and well-equipped work facilities. Bemis is a place for artists to make work." —*Ree Schonlau*

Blue Mountain Center

FOUNDED Organization 1982, Residency 1982.

LOCATION In the central Adirondacks in New York state.

ELIGIBILITY Writers of fiction, nonfiction/journalism, poetry, plays; visual artists (see indices for more specific types of artists served). Blue Mountain Center encourages applications from environmental and social justice activists, but discourages applications from those who are still attending college or graduate school. Repeat residencies permitted.

FACILITIES 14 rooms; 5 studios for visual artists and composers. Piano for composers. Darkroom.

HOUSING/MEALS/ACCESSIBILITY

Housing/Services: Room and board provided. Linens and a weekly room cleaning provided; laundry facility available; trips to town are possible; spouse possible but must apply separately.
Meals: All meals provided.
Accessibility: Artists in wheelchairs cannot be fully accommodated at this time. Possible to accommodate vision- or hearing-impaired residents, but no related special facilities.

FOR CURRENT APPLICATION REQUIREMENTS:

P.O. Box 109, Route 28
Blue Mountain Lake, NY 12812

TEL
(518) 352-7391

E-MAIL
bmc1@telenet.net

WEB
www.bluemountaincenter.org

RESIDENCY STATISTICS

Application deadline: February 1.
Resident season: June–October.
Average length of residencies: 1 month.
Number of artists in 1998 (and total applicant pool): 45 (311).
Average number of artists present at one time: 14.
Selection process: Outside panel of professionals in each category.

ARTIST PAYS FOR Application fee $20, travel, materials. Residency fee not required but voluntary contributions accepted.

INSTITUTION PAYS FOR Housing, studios, food, facilities, program administration.

ARTIST ELIGIBLE FOR No stipends or special fellowships.

ARTIST DUTIES None.

PUBLIC PROGRAMS Conferences and seminars for groups of up to 25 people concerned with social, economic, and environmental issues.

HISTORY Founded in 1982 by Adam Hochschild, in an 1899 Adirondack "great camp," which was built by William West Durant.

MISSION To offer time, peace, and community to writers and artists, especially those with an interest in environmental and social justice issues.

PAST RESIDENTS INCLUDE James Lardner, Bill McKibben, Valerie Maynard, Josip Novakovich, Oliver Sacks, Christine Jerome, Leslie Savan, Bill Finnegan, Phyllis Bennis, Richard McCann, Ethelbert Miller, Tom Athanasiou, Mark Dowie.

FROM THE DIRECTOR "Blue Mountain Center is a community of commitment and practice where generous humor and the willingness to 'pitch in' are highly valued." —*Harriet Barlow*

"*I got back to some form of balance there at Blue Mountain, with the lovely people, heavenly lake, and being spoilt rotten with care.*" —Sally Belfrage

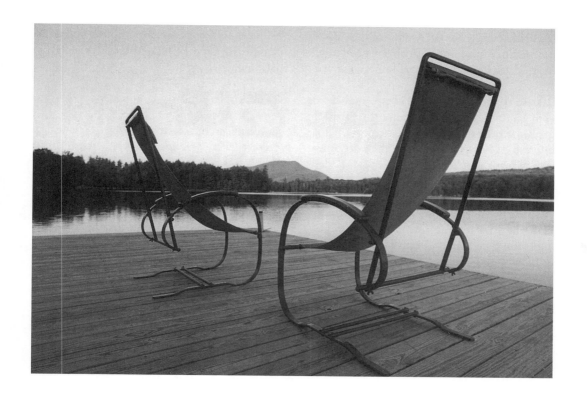

Brandywine Graphic Workshop

FOUNDED Organization 1972, Residency 1975.

LOCATION Located on the "Avenue of the Arts" in downtown Philadelphia, in close proximity to major museums and cultural centers.

ELIGIBILITY Printmakers. Serious visual artists who want to explore or advance their work in printmaking are encouraged to apply. Those interested only in reproducing their art or images in print should not apply. Repeat residencies permitted.

FACILITIES Buildings 40,000 square feet. 3 studios. Printshop with large-format offset presses, darkroom, woodshop, library/archive/collection, exhibition space, PC computer with Page-Maker, Premiere, Illustrator.

HOUSING/MEALS/ACCESSIBILITY

Housing/Services: 2-bedroom apartment with kitchen and full baths, located within walking distance. Spouse possible.
Meals: Residents receive a per diem to purchase own food and prepare own meals.
Accessibility: Artists in wheelchairs may be accommodated. Public bathrooms, kitchen, and studio facilities are fully wheelchair accessible, though artist apartment is not (call for details). Ramps, elevator. Artists with hearing impairment can be accommodated, though no special facilities for them or for artists with vision impairment.

RESIDENCY STATISTICS

Application deadline: October 15.
Resident season: Year-round.
Average length of residencies: 1–2 weeks.
Number of artists in 1998 (and total applicant pool): 12 (65).
Average number of artists present at one time: 2.
Selection process: Peer review panel of former artists in residence and local curators.

ARTIST PAYS FOR Nothing.

INSTITUTION PAYS FOR Housing, studios, food, travel, materials, facilities, program administration.

ARTIST ELIGIBLE FOR Per diem for meals. Please call to request fellowship application.

ARTIST DUTIES Residents make a presentation as well as donate to Brandywine half the number of each edition printed.

PUBLIC PROGRAMS Workshops, educational programs, international exchanges, lectures, exhibitions/presentations.

HISTORY Brandywine Workshop is a nonprofit, culturally diverse institution dedicated to promoting interest and talent in printmaking and other fine arts. Brandywine was founded in 1972 in Philadelphia.

MISSION Brandywine programs provide artists with specialized training and services in printmaking while encouraging collaboration on creative production and innovative approaches to printed images.

PAST RESIDENTS INCLUDE Louis Delsarte, Mel Edwards, Paul Keene, Michi Itami, Norie Sato,

FOR CURRENT APPLICATION REQUIREMENTS:

730 South Broad Street
Philadelphia, PA 19146

TEL
(215) 546-3675

FAX
(215) 546-2825

WEB
www.blackboard.com/brndywne

" . . . The results (prints) displayed are a clear testament to the stylistic variety, imagistic richness, and the expressive singularity that . . . evolve from Brandywine Graphic Work-shop." —Phillip Simkin

Evangeline Montgomery, Rick Bartow, John T. Scott, Lori Spencer, Tony Wong, Murray Zimiles.

FROM THE DIRECTOR

"Brandywine's location, in the core of Philadelphia, is central to its mission and work. Artists from diverse cultural and ethnic backgrounds have the opportunity to see a wealth of art both in Brandywine's own gallery and permanent collection and in the many museums in Philadelphia. The strength of the program is its diversity in all aspects." —*Allan L. Edmunds*

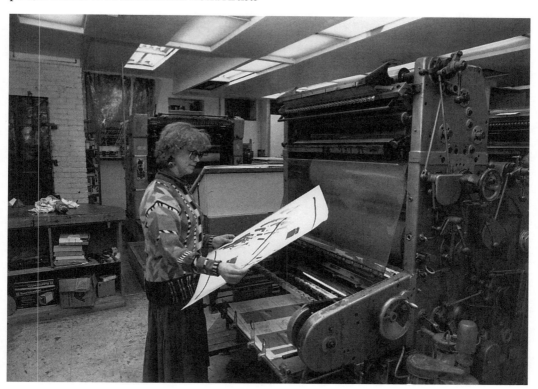

Carving Studio and Sculpture Center

FOUNDED Organization 1986, Residency 1986.

LOCATION A rehabilitated, extinct marble quarry in the Green Mountains in central Vermont.

ELIGIBILITY Sculptors, installation artists. No repeat residencies.

FACILITIES Studio space; compressed air gantry crane, pneumatic tools, forklift crane, foundry, clay studio, 40-acres of stone and granite.

HOUSING/MEALS/ACCESSIBILITY
Housing/Services: Apartment rooms.
Meals: Artists purchase own food and prepare own meals.
Accessibility: Artists with disabilities cannot be accommodated, though studios and public bathrooms are wheelchair accessible. Housing is not accessible.

RESIDENCY STATISTICS
Application deadline: Ongoing.
Resident season: Year-round.
Average length of residencies: 2 months.
Number of artists in 1998 (and total applicant pool): 8 (unknown).

FOR CURRENT APPLICATION REQUIREMENTS:

P.O. Box 495, Marble Street
West Rutland, VT 05777

TEL
(802) 438-2097

FAX
(802) 438-2097

E-MAIL
carving@vermontel.com

WEB
vermontel.net/~carving

Average number of artists present at one time: 2.
Selection process: Independent jury.

ARTIST PAYS FOR Food, travel, materials.

INSTITUTION PAYS FOR Housing, studios, facilities, program administration.

ARTIST ELIGIBLE FOR No stipends or fellowships/awards are available.

ARTIST DUTIES None.

PUBLIC PROGRAMS None.

HISTORY Founded in 1986 by B. Amore, the Carving Studio and Sculpture Center is a re-creation of the salient carving experiences still practiced by sculptors and artisans in northern Italy. Residents, visiting artists, and workshop participants share studio facilities and evening meals. Nestled in a valley, the post-industrial quarry site is alive with materials to ignite the artist's imagination.

MISSION To provide an educational program for the creation and presentation of sculpture and explore the potent language of sculptural expression. Towards that goal, we create a unique studio environment that encourages individualism at varying levels of artistic and technical expertise.

PAST RESIDENTS INCLUDE Jesus Moroles, Claire McCardle, Sue Nees, Manuel Neri, Robert Sindorf, B. Amore, Takai Ogai, Matthew Nesbitt, Sidney Giest, Carrol Driscoll, Bart Hanna, Mitsonori Koike.

FROM THE DIRECTOR "Our program has attracted a permanent arts community and is revitalizing the historic downtown of West Rutland."
—*Carol Driscoll*

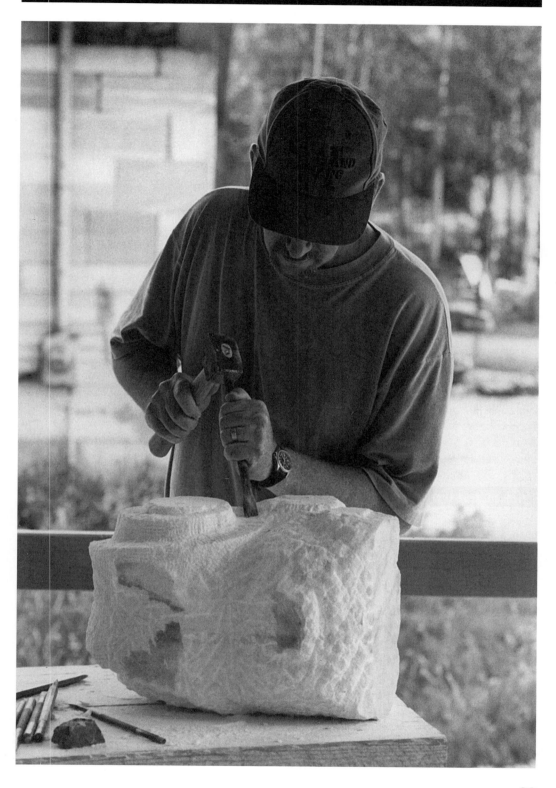

Centrum

FOUNDED Organization 1973, Residency 1982.

LOCATION On 440 acres in historic Fort Worden State Park in Washington.

ELIGIBILITY Printmakers, visual artists, writers/poets, composers, choreographers (see indices for more specific types of artists served). Repeat residencies permitted.

FACILITIES 440-acre site. Printshop for etching and monoprints (no letter press), theatre, rehearsal space, exhibition space, several very old PC computers for basic word processing.

HOUSING/MEALS/ACCESSIBILITY

Housing/Services: Detached cabins and 3 apartment units with 2–3 bedrooms, kitchens, and living areas. Linens are provided; residents are responsible for their own laundry (laundromat on site). The local transit service connects Fort Worden State Park with the town of Port Townsend. Collaborative groups, spouse, children possible; each artist has his or her own cabin or apartment and are welcome to bring family or have guests.
Meals: Artists purchase own food and prepare own meals.

FOR CURRENT APPLICATION REQUIREMENTS:

P.O. Box 1158
Port Townsend, WA 98368

TEL
(206) 385-3102

FAX
(206) 385-2470

E-MAIL
marlene@centrum.org

WEB
www.centrum.org

Accessibility: Cottages are not yet wheelchair accessible; however, they are in a State Park that does have wheelchair accessible facilities. No special facilities for artists with vision or hearing impairment. However, every effort is made to accommodate artists with disabilities within constraints of the facilities. Plans for improving accessibility.

RESIDENCY STATISTICS

Application deadline: Early September.
Resident season: September–May.
Average length of residencies: 1 month.
Number of artists in 1998 (and total applicant pool): 45 (235).
Average number of artists present at one time: 5–7.
Selection process: Outside panel of professionals in each category.

ARTIST PAYS FOR Application fee $10, food, travel, materials.

INSTITUTION PAYS FOR Housing, studios, facilities, program administration.

ARTIST ELIGIBLE FOR Stipends of $300 available to approximately 15 artists each year.

ARTIST DUTIES None.

PUBLIC PROGRAMS Concerts, performances, writers' conference, workshops, readings, lectures. Contact Centrum for detailed information.

HISTORY Established in 1973, Centrum began its residency program in 1982 and developed its print center in 1985.

MISSION To provide artists with time, space, and solitude to pursue their discipline . . . in a serene and beautiful setting, so that they can finish works in progress or experiment with new ideas.

PAST RESIDENTS INCLUDE John Haines, Linda

Gregg, Josip Novakovich, John Anderson, Bill Knott, Michael Spafford, Ed Ruscha, Kay Rook, Robert Priest, Juan Alonso, Jeff Bickford, Shirley Scheier.

FROM THE DIRECTOR "Centrum's program is founded on the ideals of quality, integrity, and vision, and to assist those who seek creative and intellectual growth." —*Carol Shiffman*

FOUNDED Organization 1990, Residency 1990.

LOCATION In the Berkshires of Western Massachusetts, 3 hours north of New York City.

ELIGIBILITY Mixed media, painting and sculpture, printmaking, conceptual (see indices for more specific types of artists served). Very open invitation. Repeat residencies permitted.

FACILITIES 28-acre site. Buildings 43,000 square feet. 15 studios. Large, open painting, sculpture, and mixed media studios; woodshop; metalshop; black-and-white darkroom; printshop with monotype "monster press" (4' × 8' images) and other presses; silkscreen facilities; performance space; exhibition space; galleries; café (when lectures or events are held). Computers and Internet access available nearby at MASS MoCA; C4 computer.

HOUSING/MEALS/ACCESSIBILITY

Housing/Services: Some on-site, several guest apartments in town, above CAC's downtown gallery. Collaborative groups, spouse, children possible. Children have limited access to CAC's facilities, but can stay in the area. Private and double rooms (share bathrooms) in the Mill (share kitchen). Private apartments with kitchens and baths downtown, near MASS MoCA. Bicycles available.

Meals: Artists purchase own food. Artists often congregate for meals in CAC's dining room or café, or use CAC's kitchen facilities and private kitchens in apartments.

Accessibility: Artists with disabilities cannot be accommodated. Public bathrooms and galleries are wheelchair accessible. All CAC's facilities will be 100 percent accessible once freight elevator is built into passenger elevator (currently CAC is fundraising for this improvement); however, housing will still not be accessible.

RESIDENCY STATISTICS

Application deadline: Ongoing.
Resident season: June through August.
Average length of residencies: 1 week–2 months.
Number of artists in 1998 (and total applicant pool): 30 (40).
Average number of artists present at one time: Summer: 15. Independent Work Stays: 1 or 2 for 2 to 6 weeks.
Selection process: Advisory board members or other organizations select residency grants; CAC's resident artists select summer residents. Guggenheim curator selects CAC/Guggenheim artist's residency grants.

ARTIST PAYS FOR Fixed residency fee $200 per week (plus $50 for printmaking studios, 50 percent off for returning artists), housing, food, travel, materials.

INSTITUTION PAYS FOR Studios, facilities, program administration, some supplies (including paper), some help from interns and staff, gallery talks, and visiting gallery and museum directors.

ARTIST ELIGIBLE FOR Some financial assistance may be available (call CAC for details).

ARTIST DUTIES None except to work in a safe, professional manner.

FOR CURRENT APPLICATION REQUIREMENTS:

Contemporary Artists Center
Historic Beaver Mill
189 Beaver Street
North Adams, MA 01247

TEL/FAX
(413) 663-9555

EMAIL
cacart@together.net

WEB
cacart.org

PUBLIC PROGRAMS Gallery exhibitions and openings, guided tours, discussions, lectures, workshops, international exchanges, festivals. Exhibition opportunities in 6 galleries: open exhibitions, invitations to create installations. "Downtown Installations," a site-specific show in the Main Street area.

HISTORY Founded in 1990 by artist Eric Rudd in what was a mostly vacant 130,000-square-foot mill. Artists began attending that summer.

MISSION To provide a unique environment for the creation of contemporary art and its exhibition by (1) utilizing the vast mill space that, as a legacy of the Industrial Revolution, is available throughout North Adams, to create a physical environment conducive to making art; (2) supplying the physical and technical resources necessary for the production of art; (3) encouraging creative diversity and the generation and dissemination of ideas; (4) inviting convocations of artists and others from the international art world to promote a lively exchange of ideas; (5) fostering an appreciation of contemporary art through education, exhibitions, and multimedia events; (6) publishing and documenting the activities of CAC; and (7) integrating CAC's program into the community.

PAST RESIDENTS INCLUDE Eleen Auvil, Robert Dilworth, Glenn English, Douglas Geiger, Marion Held, Tim Merrick, Kathleen Sidwell, Ron Snapp, Susannah Strong, Daizo Tajima, Heather Thomas, Rosa Vasquez, Otis Tamasaukas.

FROM THE DIRECTOR "The Contemporary Artists Center has energized people's lives. It could energize yours. With MASS MoCA's (Guggenheim) 1999 opening, and with the Williams College Museum of Art and the Clark Art Institute nearby, the CAC is in a rich environment, and is an international hub for contemporary art." —*Eric Rudd*

Creative Glass Center of America/Wheaton Village

FOUNDED Organization 1983, Residency 1983.

LOCATION On 88 acres at Wheaton Village in rural southern New Jersey.

ELIGIBILITY Glass artists only. Repeat residencies permitted.

FACILITIES 88-acre site. Glass studio.

HOUSING/MEALS/ACCESSIBILITY

Housing/Services: 4-bedroom house.
Meals: Artists purchase own food and prepare own meals.
Accessibility: Artists in wheelchairs cannot be accommodated (housing is not wheelchair accessible). Studios and public bathrooms are wheelchair accessible. Ramps. Hearing-impaired individuals can be accommodated only in the museum. No special facilities for artists with vision impairment.

RESIDENCY STATISTICS

Application deadline: September 15.
Resident season: January–March; April–July; September–December.
Average length of residencies: 3 months.

FOR CURRENT APPLICATION REQUIREMENTS:

1501 Glasstown Road
Millville, NJ 08332

TEL
(609) 825-6800

FAX
(609) 825-2410

E-MAIL
mail@wheatonvillage.org

WEB
www.wheatonvillage.org

Number of artists in 1998 (and total applicant pool): 12 (62).
Average number of artists present at one time: 4
Selection process: Outside panel of professionals.

ARTIST PAYS FOR Food, travel, house phone, shipping costs.

INSTITUTION PAYS FOR Housing, studios, materials, facilities, program administration.

ARTIST ELIGIBLE FOR Stipends of $1,500, fellowships (call for details).

ARTIST DUTIES 12 hours per week working in hot glass studio during visiting hours. Residents are asked to donate one piece to the Museum of American Glass.

PUBLIC PROGRAMS Museum tours.

HISTORY The Creative Glass Center of America, established in 1983, is a division of Wheaton Village, Inc.

MISSION To provide artists with an opportunity to work out their concepts (without many of the restrictions imposed by production costs and sales needs) to establish a body of work, regardless of personal financial limitations.

PAST RESIDENTS INCLUDE Mark Abildgaard, Susan Anton, Patricia Davidson, John de Wit, Garry Jacobson, Eileen Jager, Fred Kahl, Ruth King, David Levi, Karen Naylor, Leslie O'Brien, Kingsley Parker.

FROM THE DIRECTOR "The Creative Glass Center of America is a unique international resource center that awards fellowships to emerging and mid-career artists working in glass. CGCA provides the facilities, resources, and funds that allow the artists the opportunity to spend an uninterrupted, concentrated period devoted exclusively to their art—to collaborate and ex-

change ideas, to experiment, to develop and refine their artistic conceptions, skills, and techniques—free of charge." —Denise Gonzalez-Dendrinos

FOUNDED Organization 1979, Residency 1979.

LOCATION The Djerassi Resident Artists Program is located on a 637-acre, former cattle ranch in Northern California about 35 miles south of San Francisco. The ranch is in a spectacular setting in the secluded Santa Cruz Mountains between Palo Alto and the Pacific Ocean. Part of Djerassi's mission is to preserve these lands.

ELIGIBILITY Writers, visual artists, composers, choreographers, performance artists, media artists, and other artists working in new genres (see indices for more specific types of artists served). The program strives for a mix of emerging and established artists of both sexes from all parts of the country and around the world. Repeat residencies permitted.

FACILITIES 637-acre site. Two buildings totaling 14,000 square feet. 8 studios. A quiet, private "retreat" atmosphere is maintained. Writers' rooms in Artists' House include large desk, workspace, and outdoor deck. Visual artists live and work in the twelve-sided barn (heated with wood-burning stoves). Artists' Barn also houses choreography studio with video camera/monitor, color and black-and-white photography darkroom, and composer's studio equipped with baby grand piano, MIDI keyboard, and playback equipment. Also available: woodshop with table saw and other hand and power tools, kiln, welding equipment, outdoor sculpture walk, rehearsal space, exhibition space, library, and Macintosh computers with Microsoft Word, e-mail stations, and Internet access.

HOUSING/MEALS/ACCESSIBILITY

Housing/Services: Sleeping quarters are in the Artists' House and in small lofts in the Artists' Barn. Most bathrooms shared. Linens provided; residents do their own laundry. Public transportation is not available. Rides to town provided on a regular basis. Common areas include a library, media entertainment room, dining area, and laundry room. Hiking trails on and adjacent to the property. Guests are welcome as day visitors only. No pets allowed.
Meals: Evening meals provided Monday–Friday; weekend and other meals are prepared by residents from food supplied by the program.
Accessibility: Artists in wheelchairs cannot be accommodated. Artists with hearing impairment, MS, and Chronic Fatigue Syndrome have been accommodated in the past. Plans for improving accessibility.

RESIDENCY STATISTICS

Application deadline: February 15.
Resident season: Late-March–mid-November.
Average length of residencies: 30–31 days.
Number of artists in 1998 (and total applicant pool): 60 (560).
Average number of artists present at one time: 9.
Selection process: Outside panels of professionals from the San Francisco Bay Area review each discipline. Panel members change each year.

ARTIST PAYS FOR Application fee $25, travel, materials.

INSTITUTION PAYS FOR Housing, studios, food, facilities, program administration, transportation from and to local airport or transportation hub.

FOR CURRENT APPLICATION REQUIREMENTS:

SEND S.A.S.E. TO:
2325 Bear Gulch Road
Woodside, CA 94062-4405

TEL
(650) 747-1250

FAX
(650) 747-0105

E-MAIL
drap@djerassi.org

WEB
www.djerassi.org

"This has been the most intensely productive month in my writing life . . . The contemplative stillness of the landscape was counterbalanced by a lively exchange of thoughts and ideas with other writers and artists." —Dorothy Hickson

ARTIST ELIGIBLE FOR Gerald Oshita Memorial Fellowship of $2,500 for composer of color. Other awards on occasion. Many residencies are supported by named annual or endowed fellowships (call for current opportunities).

ARTIST DUTIES Minor domestic chores.

PUBLIC PROGRAMS Other Minds Music Festival. Off-site: salon, festivals, concerts. On-site: sculpture hikes, annual open house.

HISTORY The program was founded in 1979 by Carl Djerassi in memory of his daugher Pamela (1950–1978), a poet and painter. Although originally a retreat for women artists only, since 1982, it has been open to both women and men of many disciplines. A large cattle shelter on the ranch was enclosed to make attractive, but rustic, studio space and accommodations for composers, choreographers, and visual artists (writers live and work in the ranch house). The organization was originally a private family foundation but, in 1994, it became a 501(c)(3) organization and now welcomes donations, large or small, from individuals, corporations, and foundations. In 1999, as the program celebrates its 20th anniversary, the 1,000th resident artist will receive the "gift of time" to pursue their artistic vision.

MISSION To support and enhance the creativity of artists by providing uninterrupted time for work, reflection, and collegial interaction in a setting of great natural beauty, and to preserve the land on which the program is situated.

PAST RESIDENTS INCLUDE Douglas Dunn, Margaret Fisher, Wayne Peterson, Julia Wolfe, Nora Ligorano, Marshall Reese, Denise Levertov, Carmen Lomas Garza, David Nash, Miriam Schapiro, Henry Brant, Nancy Karp, Stephen Pelton, Janet Sternburg, Joyce Kozloff, Helene Aylon, Evelyn Conlon, Robert Pinsky, Mauro Staccioli.

FROM THE DIRECTOR "Time at the Djerassi program allows artists to work unencumbered by the distractions of daily life. Artists are encouraged to explore new avenues in their work and to stretch their thinking in new directions. There are several sessions each year and artists from each group pursue their own projects in a supportive environment, with great food and an atmosphere of collegial fellowship. During each session a diverse group of writers, poets, choreographers, composers, painters, and sculptors comes together in this remote and spectacular setting. As they interact and get to know one another, the experience leads to some extraordinary interrelations, collaborations, and inspiration for the exploration of new ideas." —*Dennis O'Leary*

Dorland Mountain Arts Colony

FOUNDED Organization 1979, Residency 1979.

LOCATION 300-acre nature preserve in the foothills of Palomar Mountain, overlooking the Temecula Valley, 60 miles north of San Diego, 100 miles southeast of Los Angeles.

ELIGIBILITY Writers, visual artists, composers (see indices for more specific types of artists served) who do not require electricity. Repeat residencies permitted.

FACILITIES 300-acre site. 6 cottages with workspace, kitchen, bathroom, living/sleeping areas. There is no electricity. Wood stoves heat cottages in the winter, and propane provides for apartment-sized stoves, refrigerators, and hot-water heaters. There are 3 pianos (including 2 Steinway Grands and 1 Chickering Grand) provided in 3 of the cottages. Library. Internet access possible for artists with their own equipment.

HOUSING/MEALS/ACCESSIBILITY

Housing/Services: Each artist has their own cottage with linens and kitchen accessories. A town trip is provided for grocery shopping and laundry, once a week. Spouse is welcome provided he or she has also been accepted through the application process.

Meals: Artists purchase own food and prepare own meals; transportation for groceries provided.

Accessibility: No special facilities for artists with disabilities. Remote area with rough terrain; very difficult for wheelchairs.

RESIDENCY STATISTICS

Application deadlines: March 1, September 1.
Resident season: Year-round.
Average length of residencies: 4–6 weeks.
Number of artists in 1998 (and total applicant pool): 70 (90).
Average number of artists present at one time: 6.
Selection process: Outside panel of three professionals in each category.

ARTIST PAYS FOR Fixed residency fee $300 per month, $50 processing fee upon acceptance, food, travel, materials.

INSTITUTION PAYS FOR Housing, studios, facilities, program administration.

ARTIST ELIGIBLE FOR Occasionally stipends or fellowships have been available through outside funders, though none were available at time of publication (artists may enquire about possible current opportunities).

ARTIST DUTIES To cook and clean for themselves.

PUBLIC PROGRAMS A Dorland Evening (annual fundraiser), Works-in-Progress (a monthly presentation/reading by Dorland residents), monthly tours.

HISTORY The Dorland land was homesteaded in the 1930s by the mathematician Robert Dorland and his wife, Ellen Babcock Dorland, who at the time was a world-traveled concert pianist. Wanting to create an artists' community similar to those she'd visited on the East Coast, Ellen Babcock Dorland and environmentalist Bar-

FOR CURRENT APPLICATION REQUIREMENTS:

P.O. Box 6
Temecula, CA 92593

TEL
(909) 302-3837

FAX
(909) 696-2855

E-MAIL
dorland@ez2.net

WEB
www.ez2.net/DORLAND

> *"Dorland is attractive in a way no other artists' colony in my experience can rival: verdant mountains in the midst of desert-ranch country, with a fascinating population of birds, animals, wild flowers, ponds, orchards, abundant sunlight, clear air. I will always remember with pleasure my stay there as one of the first colonists."* —May Swenson

bara Horton, in concert with the Nature Conservancy, opened the community in 1979.

MISSION To provide writers, visual artists, and composers with simple living facilities for concentrated work within a setting of natural beauty. The unspoiled environment and undisturbed solitude foster creativity.

PAST RESIDENTS INCLUDE Vernon Taranto, Leon Levitch, Ed Cansino, Maria Neiderberger, Millie Burns, Jane Culp, Russell Christofferson, Joel Sokolov, Noelle Sickels, Robert Willis, Jim Reiss, May Swenson.

FROM THE DIRECTOR "Residents find that the benefits of Dorland usually exceed that of their preconceptions. Once artists settle in (and this can take up to a week) to the lack of noise and interruptions, the natural rhythm of their daily lives can lead them to their innermost selves, that which is frequently forgotten or set aside in their busy lives. This provides an opportunity to expand their talents in new and exciting directions. Dorland gives a chance for change not only at an artistic level, but also on a spiritual level."
—*Karen Parrott*

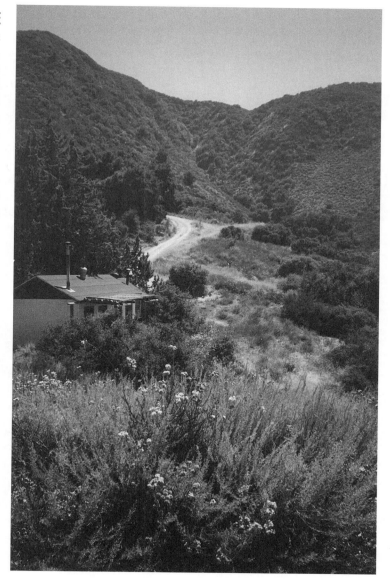

Dorset Colony House

FOUNDED Organization 1976, Residency 1980.

LOCATION In the Green Mountains of Southern Vermont in the village of Dorset, which is listed on the National Register of Historic Places, about four hours from New York.

ELIGIBILITY Writers of all kinds and interdisciplinary artists, multi-media artists, and collaborative groups. Repeat residencies permitted.

FACILITIES 8 studios. Large 3-floor house, library.

HOUSING/MEALS/ACCESSIBILITY

Housing/Services: Private rooms in house.
Meals: Artists purchase own food and prepare own meals.
Accessibility: No wheelchair accessibility currently, though Dorset House is engaged in a large capital campaign that will lead to improved accessibility. Artists with vision or hearing impairment can be accommodated, though no special facilities currently.

RESIDENCY STATISTICS

Application deadline: Ongoing.
Resident season: Spring and fall.
Average length of residencies: 2 weeks–1 month.

FOR CURRENT APPLICATION REQUIREMENTS:

P.O. Box 519
Dorset, VT 05251

TEL
(802) 867-2223

FAX
(802) 867-0144

E-MAIL
theatre@sover.net

WEB
www.theatredirectories.com/colony.htm

Number of artists in 1998 (and total applicant pool): 60 (100).
Average number of artists present at one time: 7.
Selection process: Outside panel of professionals.

ARTIST PAYS FOR Voluntary residency fee $125 per week, food, travel, materials. Artist pays part of the housing cost.

INSTITUTION PAYS FOR Studios, facilities, program administration, part of housing costs.

ARTIST ELIGIBLE FOR No stipends or special fellowships available.

ARTIST DUTIES None.

PUBLIC PROGRAMS Readings.

HISTORY Built in the early 1800s, the Colony house was renovated in the 1920s by the Sheldon family. From 1960–1978, the Sheldon-Salmon family rented the house to Dorset's professional theatre company. In 1979, the house was purchased by Dr. and Mrs. John Nassivera, with the assistance of the Clarence Geiger Trust.

MISSION To provide an opportunity for writers to set aside periods of time to work intensely on given projects away from the distractions of everyday life.

PAST RESIDENTS INCLUDE Stephen McCauley, Paul D'Andrea, Donald Donnellan, Susan Dworkin, Ellen McLaughlin, Maude Meehan, Jacquelyn Reingold, Lloyd Rose, Edward Tick, Mark Weston, Matthew Witten, Dana Yeaton.

FROM THE DIRECTOR "We are an informal place. It's very quiet and intimate here. We take unpublished people and people just getting started, as well as published writers. 50 percent of our residents are returnees." —*John Nassivera*

"*The informality of the Dorset House allowed me to get more work done than I have at other colonies. There are no evening readings to eat up valuable time, and if you work late at night you don't have to worry about missing breakfast because no one serves breakfast. The friendly staff is helpful when you need them, and invisible when you don't.*" —Mark Weston

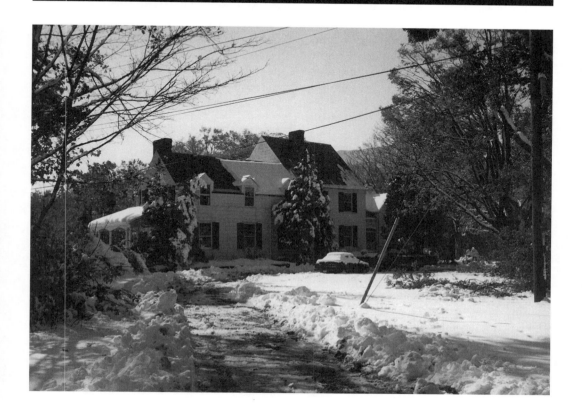

Edward F. Albee Foundation/William Flanagan Memorial Creative Persons Center

FOUNDED Organization 1966, Residency 1966.

LOCATION In Montauk, Long Island.

ELIGIBILITY Painters, sculptors, playwrights, fiction writers, poets (see indices for more specific types of artists served). No restrictions. Repeat residencies permitted.

FACILITIES 5 studios. Visual artists work in studios; writers work in their bedrooms.

HOUSING/MEALS/ACCESSIBILITY
Housing/Services: Renovated barn with communal living arrangements (kitchen and bathrooms).
Meals: Artists purchase own food and prepare own meals.
Accessibility: Residents with disabilities have been accommodated. The Center supports each artist with a disability on an individual basis. Housing, housing bathrooms, and studios are wheelchair accessible. No special facilities for artists with vision or hearing impairment.

FOR CURRENT APPLICATION REQUIREMENTS:

14 Harrison Street
New York, NY 10013

TEL
(212) 226-2020

FAX
(212) 226-5166

RESIDENCY STATISTICS
Application deadline: April 1.
Resident season: June–September.
Average length of residencies: 1 month.
Number of artists in 1998 (and total applicant pool): 20 (250).
Average number of artists present at one time: 5.
Selection process: Outside panel of professionals in each category.

ARTIST PAYS FOR Food, travel, materials.

INSTITUTION PAYS FOR Housing, studios, facilities, program administration.

ARTIST ELIGIBLE FOR No stipends or special fellowships available.

ARTIST DUTIES None.

PUBLIC PROGRAMS None.

HISTORY Founded by playwright Edward Albee in 1966 in memory of composer William Flanagan.

MISSION To meet the needs of artists in their formative years and to provide them with time and freedom to work.

PAST RESIDENTS INCLUDE Donna de Salvo, Katherine Bowling, Carol Hepper, A. M. Homes, Spaulding Gray, Scott Kelley, Heide Fasnacht, Carl Capotorto, David Greenspan, Jacquelyn Reingold, Sherry Kramer, David Simpatico.

FROM THE DIRECTOR "After *Who's Afraid of Virginia Woolf,* it occurred to me to do something useful with the money rather than give it to the government . . . We want to take a chance on people." —*Edward Albee*

"My studio at Albee's had what seemed like forty-foot-high ceilings, with huge barn doors open to the woods. It was pure luxury simply to have the time to think and to give the paintings a chance to breathe." —Robert Farber

Exploratorium

FOUNDED Organization 1969, Residency 1974.

LOCATION In San Francisco's Marina district, housed in the Palace of Fine Arts, a building constructed for the Panama Pacific Exposition of 1915.

ELIGIBILITY Exhibit-based, performance, film/video, multi-disciplinary artists (see indices for more specific types of artists served). No restrictions. Repeat residencies permitted.

FACILITIES Workspace inside the museum, full wood and metal shop, access to video editing equipment and the Internet, performance space, rehearsal space, exhibition space.

HOUSING/MEALS/ACCESSIBILITY

Housing/Services: Living space in the city by arrangement. Exploratorium is flexible regarding group residencies or accommodation for spouse and children.
Meals: Artists purchase own food and prepare own meals. Out-of-town artists receive per diem to help with meals.
Accessibility: Artists in wheelchairs can be accommodated; studios and public bathrooms are wheelchair accessible, and accessible hous-ing can be arranged. Artists with vision and hearing impairment can be accommodated, though there are no special facilities. Exploratorium will make an effort to accommodate artists with disabilities as needed.

RESIDENCY STATISTICS

Application deadline: Ongoing.
Resident season: Year-round.
Average length of residencies: Varies, depending on scope of project.
Number of artists in 1998 (and total applicant pool): 11 (104).
Average number of artists present at one time: 3.
Selection process: Staff panel and/or professional panel review.

ARTIST PAYS FOR Food (though out-of-town artists receive per diem for food).

INSTITUTION PAYS FOR Housing, studios, travel, materials, facilities, program administration.

ARTIST ELIGIBLE FOR Stipends for travel, meals, and materials. Out-of-town artists receive per diem to help with meals. On an individual basis, negotiated payment for commissioned work.

ARTIST DUTIES None, other than agreed-upon project, new work, or research.

PUBLIC PROGRAMS Teacher training, High School Explainers, the Learning Studio, exhibitions, performances, international exchanges.

HISTORY Founded in 1969 by Dr. Frank Oppenheimer as a museum of science, art, and human perception, the Exploratorium is located within the Palace of Fine Arts, the last remaining building of the 1915 Panama Pacific Exposition.

MISSION To communicate the conviction that both nature and people can be understandable and full of new and exciting insights. To provide learning experiences that will stimulate people of all ages to want to know about the world and its phenomena.

FOR CURRENT APPLICATION REQUIREMENTS:

3601 Lyon Street
San Francisco, CA 94123

TEL
(415) 561-0309

FAX
(415) 563-0370

E-MAIL
pamw@exploratorium.edu

WEB
www.exploratorium.edu

PAST RESIDENTS INCLUDE Doug Hollis, George Gessert, Carl Cheug, Paul De Marinis, Anna Valentina Murch, Laurie Lundquist, Ruth Asawa, Muriel Rukyeser, Dian Stockler, Toshio Iwai, Zaccho Dance Theatre, Chico Mac-Murtrie, Brian Eno, Rhodessa Jones.

FROM THE DIRECTOR "There are cognitive aspects of art, just as there are aesthetic aspects of science, and the focus on cognition reveals the overlap between the two disciplines. At the same time, artists and scientists provide windows of understanding and experience of the world around us." —*Dr. Goery Delacote*

Fabric Workshop and Museum

FOUNDED Organization 1977, Residency 1977.

LOCATION Downtown Philadelphia.

ELIGIBILITY Visual artists (fabric and other materials—call for details), performance, architects/designers, art conservators/educators (see indices for more specific types of artists served). No repeat residencies.

FACILITIES Buildings 28,000 square feet. Production studio, visiting artist studio, lecture/media area, silk-screen printing tables, exhibition/installation space, Internet access for artists with own computers.

HOUSING/MEALS/ACCESSIBILITY
Housing/Services: Local apartments.
Meals: Artists receive a per diem and purchase/prepare their own meals.
Accessibility: Artists with disabilities cannot be accommodated. Studios and public bathrooms are wheelchair accessible, but not housing. Elevator. Plans to improve accessibility.

RESIDENCY STATISTICS
Application deadline: By invitation only.
Resident season: Year-round.
Average length of residencies: 3 months–1 year.
Number of artists in 1998 (and total applicant pool): 13 (13).
Average number of artists present at one time: 6 (not all on site at once).
Selection process: Outside panel of professionals and advisors recommends and selects artists for participation.

ARTIST PAYS FOR Nothing.

INSTITUTION PAYS FOR Housing, studios, food, travel, materials, facilities, program administration.

ARTIST ELIGIBLE FOR Per diem for food.

ARTIST DUTIES Resident artists are asked to present a lecture to the Fabric Workshop and Museum's staff and students.

PUBLIC PROGRAMS Exhibitions, lectures, workshops, open house/tours, international exchanges, performances with regional, national, and international artists.

HISTORY Founded in 1977 by Marion B. Stroud.

MISSION Through its artist-in-residence program, the Fabric Workshop and Museum collaborates with emerging nationally and internationally recognized artists to create new work in fabric and other new materials.

PAST RESIDENTS INCLUDE Louise Bourgeois, Chris Burden, Ann Hamilton, Mike Kelley, Lorna Simpson, Jene Highstein, Alison Saar, Mel Chin, Scott Burton, Louise Nevelson, Mona Hatoum, Jim Hodges, Marina Abramovic, Richard Tuttle, Tristan Lowe.

FOR CURRENT APPLICATION REQUIREMENTS:

1315 Cherry Street, 5th floor
Philadelphia, PA 19107-2026

TEL
(215) 568-1111

FAX
(215) 568-8211

E-MAIL
fw&m@libertynet.org

WEB
www.libertynet.org/fw&m

"Working at the Fabric Workshop and Museum was a true collaboration—it was a wonderful experience and perhaps the greatest challenge of my career. It was an honor to be a part of the legacy of artists who have preceded me here." —Gabriel Martinez

FROM THE DIRECTOR "The Fabric Workshop and Museum has developed from an ambitious experiment to a renowned institution with a widely recognized artist-in-residence program, an extensive permanent collection of new work created by artists at the Workshop, in-house and touring exhibitions, and comprehensive educational programming, including lectures, tours, in-school presentations, and student apprenticeships." —*Marion B. Stroud*

Fine Arts Work Center in Provincetown

ALLIANCE OF ARTISTS' COMMUNITIES MEMBER

FOUNDED Organization 1968, Residency 1969.

LOCATION Located in the center of Provincetown, Massachusetts at the tip of Cape Cod, two hours from both Boston and Providence, Rhode Island. Many historic structures, including some of the oldest artist studios in America.

ELIGIBILITY Fine arts, fiction, poetry, photography, sculpture (see indices for more specific types of artists served). Focuses on emerging artists and writers. Repeat residencies permitted.

FACILITIES 1-acre site. 9 buildings, 24 apartments, 11 studios. Visual artists provided with apartments and separate studio. Darkroom, printshop, and woodworking equipment available. Writers provided with 1–3 room apartments. Also, gallery and common room available. Internet access if artists have own computer.

HOUSING/MEALS/ACCESSIBILITY

Housing/Services: Apartments, all with kitchens. Laundry facilities on the premises. Residents can bring their immediate families. Limited number of units where pets are allowed.

Meals: Artists purchase own food and prepare own meals.

Accessibility: Artists in wheelchairs or with vision or hearing impairment can be accommodated. Housing, housing bathrooms, studios, and public bathrooms are wheelchair accessible. Ramps. The Work Center has a number of units that are accessible to residents with disabilities.

RESIDENCY STATISTICS

Application deadline: Writers and poets, December 1 (postmark). Visual artists, February 1 (postmark).
Resident season: October 1–May 1.
Average length of residencies: 7 months.
Number of artists in 1998 (and total applicant pool): 18 (1,100).
Average number of artists present at one time: 20.
Selection process: Outside panel of professionals in each category, along with the members of the writing and visual arts committees.

ARTIST PAYS FOR Application fee $35, food, travel, materials.

INSTITUTION PAYS FOR Housing, studios, facilities, program administration, some materials.

ARTIST ELIGIBLE FOR The Work Center's Winter Program is a fellowship program. Stipends provided range from $375 per month (visual artists receive an additional $75 per month for supplies) up to $600 per month depending on funding.

ARTIST DUTIES None.

PUBLIC PROGRAMS *Winter Fellowship Program:* Extensive connection between Work Center residents (called Fellows) and local community's artists, including interaction with local schools and many public readings, lectures, and gallery exhibitions. Writing Fellows may perform a public reading, and Visual Arts Fellows may exhibit at the Hudson D. Walker Gallery. *Visiting Artists and Writers Program:* Brings vi-

FOR CURRENT APPLICATION REQUIREMENTS:

24 Pearl Street
Provincetown, MA 02657

TEL
(508) 487-9960

FAX
(508) 487-8873

E-MAIL
fawc@capecod.net

WEB
capecodaccess.com/fineartsworkcenter

sual artists and writers of national stature to Provincetown for lectures, readings, and studio tours. The Work Center also has exchange opportunities with organizations throughout the country and world. *Summer Workshop Program*: Week-long classes in creative writing and visual arts. Maine College of Art offers BFA credits for the visual arts courses.

HISTORY Provincetown has provided workspace for artists and writers since the late 18th century, and the Work Center, founded in 1968 by a group of eminent artists and writers, plays a key role in maintaining that heritage. Before the Center acquired the site, artists such as Robert Motherwell, Myron Stout, Helen Frankenthaler, and Hans Hofmann rented studio space on the grounds of what was then Days Lumber Yard. Jack Tworkov, Fritz Bultman, Hudson D. Walker, Alan Dugan, and Stanley Kunitz were among the Center's founding members.

MISSION To provide for the establishment and maintenance of . . . a center for artists and writers, consisting of resident Fellows, program committee members, employees, and visiting artists, writers, and patrons from all relevant fields of the arts and humanities . . . (and) primarily dedicated to supporting emerging artists and writers at the crucial early stages of their careers.

PAST RESIDENTS INCLUDE Richard Baker, Michael Cunningham, Ellen Driscoll, Portia Munson, Jack Pierson, Sharon Horvath, Charles Spurrier, Louise Gluck, Michael Collier, Yusef Komunyakaa, Denis Johnson, Jayne Anne Philips, Carole Maso, Ellen Gallagher.

FROM THE DIRECTOR

"We are proud to offer the largest, most comprehensive fellowship program for emerging visual artists and writers in the nation. The strength of the Winter Fellowship Program is evidenced by the inquiries received from around the world and the prizes and awards bestowed upon our Fellows. Through other programs, such as the Summer Workshops, Returning Residency, and Senior Writers, we remain committed to providing year-round opportunities to the maximum number of visual artists and writers." —*Hunter O'Hanian*

Friends of Weymouth

FOUNDED Organization 1978, Residency 1978.

LOCATION 20-acre, 22-room Georgian manor house in Southern Pines, North Carolina. The "Board House" is within easy walking distance to town. It is listed on the National Register of Historic Places.

ELIGIBILITY Writers of all kinds, but only with strong North Carolina connection. Repeat residencies permitted.

FACILITIES 20-acre site. 22-room Georgian manor house.

HOUSING/MEALS/ACCESSIBILITY
Housing/Services: 3 single bedrooms, 1 double bedroom, 1 room with twin beds, 3 baths. Can accommodate very small collaborative groups.
Meals: Artists purchase own food and prepare own meals.
Accessibility: No wheelchair accessibility or special facilities for artists with disabilities, but would make every effort to accommodate them should they apply (call to see if it can be arranged). Artists with vision or hearing impairment could be accommodated, though no special facilities.

FOR CURRENT APPLICATION REQUIREMENTS:

P.O. Box 939
Southern Pines, NC 28388

TEL
(910) 692-6261

RESIDENCY STATISTICS
Application deadline: Ongoing.
Resident season: Year-round.
Average length of residencies: 2–10 days.
Number of artists in 1998 (and total applicant pool): 80 (93).
Average number of artists present at one time: 2–3.
Selection process: Reviewed by committee of Director and Board of Directors.

ARTIST PAYS FOR Food, travel, materials.

INSTITUTION PAYS FOR Housing, workspace, facilities, program administration.

ARTIST ELIGIBLE FOR No stipends or special fellowships available.

ARTIST DUTIES None.

PUBLIC PROGRAMS Concerts, lectures, readings, symposiums.

HISTORY Founded in 1978 on former estate of novelist James Boyd.

MISSION To provide a quiet, creative atmosphere for productive writing.

PAST RESIDENTS INCLUDE Reynolds Price, Lee Smith, Doris Betts, Fred Chappell, James Applewhite, Ann Deagon, Sally Buckner, Shelby Stephenson, Guy Owen, Paul Green, Thad Stem, Jr., Kaye Gibbons.

FROM THE DIRECTOR "Friends of Weymouth offers a year-round program in the arts and humanities." —*Lois Wistrand*

"*I think the air of casual welcome is important—everyone is made to feel at home, rather than like a guest or client. This really helps the juices flow. The generosity of this place is marvelous, as is the fact that it honors work-in-progress rather than just work that's proven and successful. I hope it never loses its warmth and air of trust in the writer's work.*" —Florence Nash

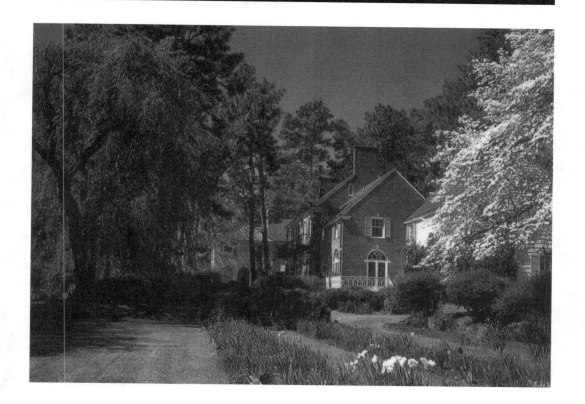

FOUNDED Organization 1980, Residency 1988.

LOCATION 25 acres on Canandaigua Lake, in the center of the Finger Lakes region.

ELIGIBILITY Writers only, who may also be performance artists, interdisciplinary artists, book artists, environmentalists (see indices for more specific types of artists served). Repeat residencies permitted.

FACILITIES Letterpress printshop, library/archive/collection.

HOUSING/MEALS/ACCESSIBILITY

Housing/Services: Two-bedroom house, with separate work, kitchen, bathroom, and dining space. Collaborative groups of up to four possible. Spouse and children possible; children must be supervised at all times by parents.
Meals: Artists purchase own food and prepare own meals.
Accessibility: Not fully accessible to artists in wheelchairs (call for details). Housing, housing bathrooms, and letterpress printshop are wheelchair accessible. Artists with hearing impairment can be accommodated. All alarm systems flash as well as sound. No special facilities for artists with vision impairment.

RESIDENCY STATISTICS

Application deadline: Ongoing.
Resident season: Year-round.
Average length of residencies: 7–10 days.
Number of artists in 1998 (and total applicant pool): 36 (46).
Average number of artists present at one time: 2.
Selection process: Staff committee.

ARTIST PAYS FOR Fixed residency fee $35 per day, food, travel, materials.

INSTITUTION PAYS FOR Housing, workspace, facilities, program administration.

ARTIST ELIGIBLE FOR No stipends or special fellowships available.

ARTIST DUTIES None, except their own housekeeping.

PUBLIC PROGRAMS Readings, workshop.

HISTORY Established in 1988 by Writers & Books, a community literary center in Rochester, when Dr. Kenneth and Geraldine Gell deeded the organization twenty-five acres of land and a house in the Finger Lakes.

MISSION To foster and promote the creation, understanding, and appreciation of contemporary literature within a setting of serene natural beauty.

PAST RESIDENTS INCLUDE Bob Holman, Anne Waldman, Fielding Dawson, Diane Gallo, Amy Guggenheim, David Matlin, Anne LaBastille, Clayton Eshleman, Sharon Strange, Dennis Nurske, William Least-Heat Moon, Bei Dao.

FOR CURRENT APPLICATION REQUIREMENTS:

Writers & Books
740 University Avenue
Rochester, NY 14607

TEL
(716) 473-2590

FAX
(716) 442-9333

WEB
www.wab.org

FROM THE DIRECTOR "The Gell Writers' Center offers writers an opportunity and a setting in which to focus upon their writing away from the distractions of their everyday lives. We are especially interested in providing opportunities to emerging or mid-career writers." —*Joe Flaherty*

FOUNDED Organization 1934, Residency 1988.

LOCATION 600 acres in extreme northeastern Georgia, nestled in the Blue Ridge Mountains, 120 miles from Atlanta, 90 miles from Asheville, North Carolina. The Center is involved in environmental conservation and provides a natural habitat for area wildlife. The site and certain structures are listed on the National Register of Historic Places.

ELIGIBILITY Creative arts: writing, poetry, visual arts, music composition, performance, and dance, environmental arts (see indices for more specific types of artists served). Repeat residencies permitted.

FACILITIES 600-acre site. Seven cottages/studios; main "Rock House" with 2 guest rooms, dining room, library/archive, screened porch and dining pavilion; functioning Grist Mill; ceramic studio with 2 electric kilns and an outdoor anagama kiln (several kick wheels and two electric wheels); performance studio with a Steinway grand; original weaving shed, housing a gallery for folk/fine art and crafts. Various nature trails on the property lead to streams, waterfalls, and wildflower coves.

FOR CURRENT APPLICATION REQUIREMENTS:

P.O. Box 339
Rabun Gap, GA 30568

TEL
(706) 746-5718

FAX
(706) 746-9933

E-MAIL
hambidge@rabun.net

WEB
www.rabun.net/~hambidge

HOUSING/MEALS/ACCESSIBILITY

Housing/Services: Seven cottage/studios for residents and main "Rock House" for group gatherings, dinner, slides presentations, etc. Laundry facilities in Rock House. Hambidge discourages visits by guests during the week, but welcomes them on weekends. Families and pets cannot be accommodated.

Meals: Evening meals are provided Monday–Friday (May–October) and are primarily vegetarian (no meat, but fish). Residents purchase and prepare own food at other times. Each studio has a full kitchen.

Accessibility: Accessibility for artists with disabilities is limited at this time, but it is an important consideration in our ongoing facility upgrade.

RESIDENCY STATISTICS

Application deadline: November 1 for March–August residencies. May 1 for September–December residencies. Applications submitted beyond deadlines will be reviewed and considered on a first-come, first-served basis and as space becomes available.

Resident season: March–December. (Limited residencies available January and February).

Average length of residencies: 3–4 weeks.

Number of artists in 1998 (and total applicant pool): 86 (163).

Average number of artists present at one time: 7+.

Selection process: Outside panel of peer professionals in each category.

ARTIST PAYS FOR Application fee $20, fixed residency/housing fee $125 per week, travel, materials, some food (see Meals above).

INSTITUTION PAYS FOR Facilities, program administration, some food (see Meals above).

ARTIST ELIGIBLE FOR Hambidge offers a limited number of resident scholarships which are listed in the material sent to applicants.

ARTIST DUTIES None, except attend dinner in the evenings. Open studio presentations and com-

munity in-school programs can be arranged if the resident expresses an interest, but is not expected.

PUBLIC PROGRAMS Hambidge Gallery, nature walks, lectures, exhibitions and fundraising celebrations. Any program sponsored by the Center and presented during the residents' stay is available to them should they choose to participate.

HISTORY Founded by artist, visionary, and Georgia native Mary Crovatt Hambidge, the Center was established in 1934 as a cottage weaving industry. In 1937, Mary Hambidge won a gold medal at the Paris Exposition for her weaving and design, and she established a shop on Madison Avenue called "Weavers of Rabun" during the same year. Her hand-woven fabrics were in demand by such notables as Georgia O'Keeffe and Presidents Roosevelt and Truman. Today's Hambidge Center was created in 1973, and in 1988 shifted its energies to focus almost entirely on the artist-in-residence program, which was an important part of Mary Hambidge's dream.

MISSION To create, protect, sustain and improve upon facilities and an environment in which creativity and a dynamic interchange between artists from different fields may take place; to provide periods of residency in this environment for artists of exceptional talent in which they may contemplate, conceive, and ultimately create without demands or distractions.

PAST RESIDENTS INCLUDE Olive Ann Burns, Mary Hood, Jean Hanff Korelitz, Lynna Williams, Emma Diamond, Martin Herman, Annette Cone-Skelton, Kevin Cole, Michael Liddle, Ben Owen III, M. C. Richards, Lucinda Bunnen.

FROM THE FOUNDER "Man's creative genius is a delicate plant that must be planted and tended in congenial soil till it becomes strong enough to withstand the rough winds of the world. In creating we must have both leisure to think and dream and means to execute. Theory without practice is worthless, execution without dreams is soulless." —*Mary Hambidge,* from *Apprentice in Creation*

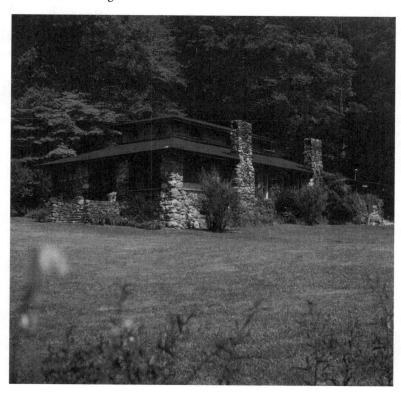

Headlands Center for the Arts

ALLIANCE OF ARTISTS' COMMUNITIES MEMBER

FOUNDED Organization 1982, Residency 1987.

LOCATION On 13,000 coastal acres in Marin County, north of San Francisco, just a few minutes across the Golden Gate Bridge. Headlands Center for the Arts is housed in historic, former military buildings in a national park, surrounded by low coastal hills and scenic ocean bluffs at the northern edge of the entrance to the San Francisco Bay.

ELIGIBILITY Installation, painting, and performance artists; writers (poetry, fiction, non-fiction) and film/video artists (see indices for more specific types of artists served). Headlands Center offers fully-sponsored residencies through special programs for artists from California, North Carolina, Ohio, Brazil, Taiwan, the Czech Republic, and Slovakia and invitational residencies for artists from all regions. Artists from all other states or countries should contact the Center for application guidelines.

FACILITIES 13,000-acre site. Buildings 71,000 square feet. 16 studios, 3 live/work spaces for writers. Darkroom, woodshop, rehearsal space, exhibition/installation space, Internet access for artists with own computers. Artists have shared access to a Macintosh computer for e-mail and Internet access.

HOUSING/MEALS/ACCESSIBILITY

Housing/Services: 4 houses, each shared among 1–3 other artists. Visitors, including spouse and children, can be accommodated for limited stays by special arrangement. Collaborative groups possible.

Meals: Dinner provided 5 times per week; for all other meals, artists purchase and prepare their own food. Spouses and children pay $6 each for dinners at the Center. Children under 5 are free.

Accessibility: Artists in wheelchairs can be accommodated. Housing, housing bathrooms, studios, and public bathrooms are wheelchair accessible. No special facilities for artists with vision or hearing impairment. Headlands Center is in the midst of a $2 million capital campaign to bring its Fort Barry campus up to a standard of excellence to better serve artists and the public. Through 2002, the Center will upgrade its facilities and grounds, including installing elevators and expanding wheelchair access.

RESIDENCY STATISTICS

Application deadline: Early June for California, North Carolina, and Ohio; international program deadlines vary; artists from all other regions should contact Headlands Center for more information.

Resident season: February–November.

Average length of residencies: 3 months. (Some 11-month, live-out residencies offered for local artists).

Number of artists in 1998 (and total applicant pool): 39 (350).

Average number of artists present at one time: In residence 7–10, living off-site 15–20.

Selection process: An outside panel of artists and art professionals review artists' submissions and make recommendations to the Center's selection committee of distinguished local artists and arts professionals. Bridge Residents are nominated, invited to apply, and juried by outside panel.

FOR CURRENT APPLICATION REQUIREMENTS:

944 Fort Barry
Sausalito, CA 94965

TEL
(415) 331-2787

FAX
(415) 331-3857

E-MAIL
kreasoner@headlands.org

WEB
www.headlands.org

60

> *"The spirit of exploration—the openness to new ideas and to new ways of seeing and being in the world—is one of the strongest lessons and greatest gifts Headlands has given to visiting artists and, through these artists, to the world."* —le thi diem thuy

ARTIST PAYS FOR Materials, some food (see Meals above).

INSTITUTION PAYS FOR Housing, studios, travel, facilities, program administration, some food (see Meals above).

ARTIST ELIGIBLE FOR Stipends $500 per month for live-in residents; $2,500 one-time stipend for California non-live-in residents. Airfare is covered for non-California residents. Invitational Bridge Residencies are offered to artist-activists throughout the U.S.

ARTIST DUTIES 1 public, open-studio event (Headlands Center hosts 3 open houses a year). Opportunities also exist to participate in public programs and salons, and collaborations with other artists are encouraged.

PUBLIC PROGRAMS Headlands hosts an array of public programs including lectures, artists in conversation, concerts, workshops, exhibitions, performances, and open houses (see Artist Duties above). Our public programs bring artists together with scholars, activists, and other professionals. By facilitating interaction across traditional boundaries, Headlands works to introduce artists and audiences to new creative processes, and to broaden the range of possibilities for art's function in our society.

HISTORY Located on 13,000 acres of open space in the Marin Headlands on what was once Miwok land, Headlands Center for the Arts was conceived through the transfer of former military property to the National Park Service. The Center was incorporated in 1982 by a board of directors comprised primarily of local artists. In creating the Center, the founders sought to reconfigure the role of the artist from a marginalized position to that of a central participant in our society.

MISSION Headlands Center for the Arts serves as a laboratory for creative investigation and the development of new work. We offer artists encouragment and opportunities for reflective thought, dialogue and collaboration with others. Through residencies and interdisciplinary public programs, we seek to explore and interpret the relationship between place and creative process, and to extend appreciation for the role of artists in society.

PAST RESIDENTS INCLUDE David Ireland, Ann Hamilton, Fenton Johnson, Beth Custer, Valerie Soe, Zig Jackson, Stephanie Johnson, Wang Po Shu, Lewis Hyde, Mildred Howard, Tony Cragg, Rebecca Solnit, Mei-Ling Hom, Lewis de Soto, Guillermo Gomez-Pena, Tania Bruegera, Mark Dion, Maria Porges, Paul DeMarinis, Chico MacMurtrie, Margaret Kilgallen, Pat Ferrero, Ned Kahn, Kathryn Spence.

FROM THE DIRECTOR "Our inspiring site—rich with wartime history, biological diversity and breathtaking open space—is quietly removed, yet minutes away from the cultural mecca of downtown San Francisco. This, together with the international diversity of the artists and audiences who come here, make Headlands a truly unique and nurturing environment for the creative process." *—Kathryn Reasoner*

Hedgebrook

ALLIANCE OF ARTISTS' COMMUNITIES MEMBER

FOUNDED Organization 1990, Residency 1988.

LOCATION 33-acre farm on Whidbey Island, Washington State, about an hour north of Seattle.

ELIGIBILITY Women only. Writers in all literary genres, regardless of publication history. No repeat residencies.

FACILITIES 33-acre site. 6 fully furnished cottages, including efficiency kitchen, bathroom, desk, and loft. Communal bathhouse, performance space, library.

HOUSING/MEALS/ACCESSIBILITY

Housing/Services: Own cottage. Bathhouse facilities include laundry facilities. Residents bring own linens. If residents do not drive to Hedgebrook, they arrange for transport from airport to ferry, and Hedgebrook staff pick them up from ferry.
Meals: Breakfast is self-serve (food provided), lunch is brought to residents' cottages, dinner is a communal meal in farmhouse dining room.
Accessibility: Artists in wheelchairs cannot be accommodated. Artists with vision or hearing impairment should call for details of accommodations.

RESIDENCY STATISTICS

Application deadlines: October 1; April 1.
Resident season: Mid-January–May 31; late June–early December.
Average length of residencies: 4–5 weeks.
Number of artists in 1998 (and total applicant pool): 67 (352).
Average number of artists present at one time: 6.
Selection process: Outside panel of writers and editors.

ARTIST PAYS FOR Application fee $15, travel, materials.

INSTITUTION PAYS FOR Housing, food, facilities, program administration, some travel (travel scholarships are available upon application).

ARTIST ELIGIBLE FOR Fellowships/awards and travel scholarships (please write for details).

ARTIST DUTIES None.

PUBLIC PROGRAMS Annual Women Playwrights Festival in Seattle and occasional readings in local libraries and bookstores, locally, regionally, and nationally. On-site open houses for funders (2 times per year) and for the community (once per year) plus occasional readings and celebrations (up to 3 times per year).

HISTORY Hedgebrook was founded in 1988 by Nancy Skinner Nordhoff, a Seattle-area philanthropist. From August 1988 through 1998, 536 women have come from all over the U.S. and abroad to live and write at Hedgebrook.

MISSION Hedgebrook exists to strengthen the voices of women writers of all ages and from diverse backgrounds by providing a place where they can find connections with one another and with the earth, and the words to build community in the world.

FOR CURRENT APPLICATION REQUIREMENTS:

2197 East Millman Road
Langley, WA 98260

TEL
(360) 321-4786

> *"Hedgebrook healed me. I found a home, a family of remarkable, supportive women. I learned to give. And I wrote like a demon."* —Kiana Davenport

PAST RESIDENTS INCLUDE Randy Sue Coburn, Terri del Pena, Barbara Neely, Susan Zwinger, Ursula K. Le Guin, Mary Kay Blakely, Leslie Li, Mei Ng, A. J. Verdelle, Stephanie Grant, Tillie Olsen, Thalia Zepatos, Gloria Steinem.

FROM THE DIRECTOR "At Hedgebrook, women's many and varied voices are honored and nurtured. For most of them, it's a unique, even life-changing experience. Here, six writers at a time live in woodframe cottages on land that's part farm and part nature preserve. From the views outside their windows to the freshly picked salads in their lunch baskets, they receive the message: 'Your voice matters. Find the words.'" —*Linda Bowers*

FOUNDED Organization 1993, Residency 1998.

LOCATION Located in Tucson, Arizona, in an area that is transforming from an urban warehouse district to an arts district, several blocks from the University of Arizona and the downtown area.

ELIGIBILITY Open to all disciplines and all stages of career (see indices for specific types of artists served).

FACILITIES 2-acre site. Buildings 55,000 square feet. 30 studios. Darkroom, film/video editing facility, metalshop, pottery/ceramics facility, printshop, woodshop, theatre, rehearsal space, exhibition/installation space. Some facilities are not located on site; however, all are available through relationships with other community organizations. Internet access for artists with own computers. Computer animation and editing access is available through a community organization.

HOUSING/MEALS/ACCESSIBILITY

Housing/Services: Individual bedroom and studio space. Each bedroom has a small refrigerator. Bathrooms, kitchen, lounge, dining room, and laundry facilities are shared. Double rooms are available to house an artist couple; both must apply to program.

Meals: Artists purchase own food and prepare own meals. Some communal cooking possible/likely.

Accessibility: Artists in wheelchairs can be accommodated. One studio/living space (including bathroom and kitchen), public bathrooms, dance studio, and alternative theatre space are wheelchair accessible. Ramps. Automatic doors. Plan to have an elevator installed by 2001. Plans for making all areas of the facility accessible to residents with disabilities. Contact the International Art Center for accommodation details for artists with vision and hearing impairment.

RESIDENCY STATISTICS

Application deadline: Ongoing.
Resident season: Year-round.
Average length of residencies: 6 months–1 year.
Number of artists in 1998 (and total applicant pool): 8 (20).
Average number of artists present at one time: 20.
Selection process: International Art Center representative and an outside panel of professionals.

ARTIST PAYS FOR Application fee ($20 by electronically applying over the Internet; $30 if manually mailed), variable residency fee (contact the Center for details), food, travel, materials, telecommunications.

INSTITUTION PAYS FOR Studios, facilities, program administration.

ARTIST ELIGIBLE FOR Sponsorships by local and international organizations. Scholarship opportunities. Also developing programs to provide teaching stipends.

ARTIST DUTIES Required to volunteer 3 hours of community service per week. Give the Center 10–20 slides of work finished or in-progress during residency. Donate to the Center one piece of artwork made while in residence.

FOR CURRENT APPLICATION REQUIREMENTS:

516 N. 5th Avenue
Tucson, AZ 85702

TEL
(520) 903-0918

FAX
(520) 620-1395

E-MAIL
director@tucson-iac.com

WEB
www.intl-artscenter.com

> *"Let's face it: Universities provide everything for the developing artist, except heart and soul. The International Art Center has provided me with a diverse and eclectic peer group of artists who are active in the community as social workers and teachers, as well as practitioners of art. Artists living in the community is what the International Art Center is all about."* —Charles Gillispie

PUBLIC PROGRAMS The International Art Center is in the process of developing educational programs, community outreach, exhibitions and presentations, workshops, festivals, etc.

HISTORY The International Art Center was launched in 1993 and opened its doors in late September of 1998.

MISSION The mission of the International Art Center is to provide a nurturing, supportive, and sustaining environment that promotes the development of contemporary creative expression and international understanding and goodwill in the cultural, artistic, creative, and wider community. Our vision is based on the conviction that exceptional international, creative talent with its global variety can enhance and enrich all communities. This enrichment can be achieved through direct contact with communities and other creative people. It is the intent of the Center to enable creative people of all career levels to come to, work with, find support in, go out from, experiment, collaborate, cooperate, and share with public spirited, independent, and like-minded people. In effect, the International Art Center seeks to provide a bridge for cultural understanding and human development.

PAST RESIDENTS INCLUDE Kelly Morris, Charles Gillispie, Jim Leedy, Amanda Ralph.

FROM THE DIRECTOR "The dedication of many people internationally warranted that a center for the promotion of global and community awareness through the arts be made available. Here, people from around the world work independently to develop as individuals and as artists, and have the opportunity to work together on community projects. The result is a better understanding of cultures through the arts." —*Paul Schock*

Jacob's Pillow Dance Festival and School

ALLIANCE OF ARTISTS' COMMUNITIES MEMBER

FOUNDED Organization 1931, Residency 1983.

LOCATION In the Berkshire Mountains in the town of Becket, Massachusetts.

ELIGIBILITY By invitation only, based on quality of dance company. Dancers, choreographers, performance artists, dance historians/scholars (see indices for more specific types of artists served). Repeat residencies permitted.

FACILITIES 15-acre site. 3 dance studios, one choreographic studio, proscenium theatre, blackbox theatre, outdoor stage, library/archive/collection, computer/Internet access.

HOUSING/MEALS/ACCESSIBILITY

Housing/Services: Clusters of heated cabins, each with common bathroom. Accommodates dance companies that apply as a group.
Meals: Artists purchase own food and prepare own meals.
Accessibility: Artists with disabilities cannot be accommodated. Studios and public bathrooms are wheelchair accessible.

FOR CURRENT APPLICATION REQUIREMENTS:

P.O. Box 287
Lee, MA 01238

TEL
(413) 637-1322

FAX
(413) 243-4744

E-MAIL
jacobspillow@taconic.net

WEB
www.jacobspillow.org

RESIDENCY STATISTICS

Application deadline: Ongoing.
Resident season: March–October.
Average length of residencies: 2 weeks.
Number of artists in 1998: 50 companies.
Average number of artists present at one time: 2–4 companies.
Selection process: By invitation only.

ARTIST PAYS FOR Food, travel, materials.

INSTITUTION PAYS FOR Housing, studios, facilities, program administration.

ARTIST ELIGIBLE FOR No stipends or fellowships/awards.

ARTIST DUTIES None, though there are opportunities for voluntary presentations, performances, discussions, moderating panels, serving as guest faculty, and attending receptions. These opportunities vary from year to year.

PUBLIC PROGRAMS Internships, assistantships, the Presenter and Artist Forum, the Ted Shawn Theatre, studio/theatre, the Inside/Out Program, archives, exhibits, workshops, open house/tours, international exchanges, festivals, lectures.

HISTORY In 1930, modern dance pioneer Ted Shawn purchased a historic farm in the Berkshires named Jacob's Pillow to serve as a home and training ground for male dancers. The artist-in-residence program was established in 1983.

MISSION To support the creation, development, preservation, and appreciation of dance as an art form for artists and audiences. To create and assist a community of artists from the United States and abroad whose work encompasses diverse artistic and cultural genres.

PAST RESIDENTS INCLUDE Trisha Brown, Liz Lerman Dance Exchange, Urban Bush Women,

Pat Graney Dance Company, David Dorfman, Cambodian Artists Project, Paula Josa-Jones/ Performance Works, Bill T. Jones/Arnie Zane Dance Company, Eiko and Koma, Joanna Haigood, Margaret Jenkins, Ralph Lemon.

FROM THE DIRECTOR

"Jacob's Pillow provides artists access to its physical, technical, and intellectual resources to experiment, create, and develop their aesthetic skills." —*Ella Baff*

John Michael Kohler Arts Center, Arts/Industry Program

FOUNDED Organization 1967, Residency 1974.

LOCATION In Kohler, Wisconsin, in the Kohler Company factory, the nation's leading manufacturer of plumbing products.

ELIGIBILITY Metal workers, ceramicists (see indices for more specific types of artists served). Repeat residencies permitted.

FACILITIES The residency program takes place in the industrial foundry (cast-iron brass). Pottery facilities, enamel shop, and photographic services are available. The John Michael Kohler Arts Center, located 4 miles east of the factory, is a 1-acre site which comprises a newly expanded 100,000-square-foot facility, including 9 galleries, a multi-arts studio/performance space, an intimate theatre, 4 classroom/studios, a gallery shop, and a café.

HOUSING/MEALS/ACCESSIBILITY

Housing/Services: 4-bedroom house in the Village of Kohler.
Meals: Artists purchase own food and prepare own meals.
Accessibility: It would be very difficult to navigate the site in a wheelchair. No special facilities for artists with vision or hearing impairment. However, the Center will consider each individual according to his/her needs and the extent of his/her disability.

RESIDENCY STATISTICS

Application deadline: August 1.
Resident season: Year-round.
Average length of residencies: 3 months.
Number of artists in 1998 (and total applicant pool): 14 (200).
Average number of artists present at one time: 4.
Selection process: Panel of professionals familiar with the program. Panel changes each year.

ARTIST PAYS FOR Food.

INSTITUTION PAYS FOR Housing, studios, travel, materials, facilities, program administration.

ARTIST ELIGIBLE FOR Stipends $120 per week, travel reimbursement (within continental United States), materials reimbursement.

ARTIST DUTIES To be available 1 day per month for educational programs, donation of 1 piece to John Michael Kohler Arts Center, donation of 1 piece to Kohler Company.

PUBLIC PROGRAMS Exhibitions, performing arts productions, eduational programs, lectures, workshops, classes, outreach, open house/tours.

HISTORY The Arts/Industry Program was founded in 1974, under the auspices of the John Michael Kohler Arts Center.

MISSION To encourage and support innovative explorations in the arts and to foster an exchange between a national community of artists and a broad public that will help realize the power of art to inspire and transform our world.

PAST RESIDENTS INCLUDE Jack Earl, Joyce Kozloff, Ken Little, Joel Otterson, Nancy Dwyer, Arnie

FOR CURRENT APPLICATION REQUIREMENTS:

608 New York Avenue, Box 489
Sheboygan, WI 53082-0489

TEL
(920) 458-6144

FAX
(920) 458-4473

WEB
www.kohlerartscenter.org

" *I don't think I have ever pushed myself quite as hard to get something done . . . My time here has expanded my reach as an artist . . . The program allowed me to do work that I would not have ever been able to contemplate in real-world circumstances.*" —Andy Yoder

Zimmerman, Win Knowlton, Indira Freitas Johnson, Clarice Dreyer, Ming Fay, Martha Heaverston, Carter Kustera, Matt Nolen, Yolande McKay, Yoshiko Kanai, Ann Agee.

FROM THE DIRECTOR "Working side by side with industrial staff who are producing plumbing ware and engines, the artists use the materials and technologies to create sculpture, installa- tions, murals, and public commissions not oth- erwise possible. For many years Arts/Industry has been hailed as one of the most unusual and fruitful collaborations between the arts and in- dustry in twentieth-century America, and has been featured in media from Japan to Chicago, such as the *Wall Street Journal, CBS Sunday Morning* with Charles Osgood, and the *Sunday London Times.*" —*Ruth DeYoung Kohler*

FOUNDED Organization 1974, Residency 1984.

LOCATION In Berkeley, California, near the University of California.

ELIGIBILITY Printmaking, multimedia, book artists (see indices for more specific types of artists served). No repeat residencies.

FACILITIES Buildings 8,500 square feet. Complete printmaking studio; equipment for lithography, etching, aquatint, relief, letterpress, silk-screen, darkroom; etching room; editioning areas; Macintosh workstations, including digital-imaging hardware and software, high-resolution scanners, digital sound- and video-editing equipment, and CD-ROM recorder.

HOUSING/MEALS/ACCESSIBILITY

Housing/Services: Local apartments.
Meals: Artists purchase own food and prepare own meals; full kitchen provided.
Accessibility: Artists with disabilities cannot be accommodated (housing is not wheelchair-accessible). Studios, public bathrooms, kitchen, and Electronic Media Center with 7 Macintosh workstations are wheelchair accessible. Ramps,

FOR CURRENT APPLICATION REQUIREMENTS:

1060 Heinz Avenue
Berkeley, CA 94710

TEL
(510) 549-2977

FAX
(510) 540-6914

E-MAIL
kala@kala.org

WEB
www.kala.org

elevators. No special facilities for artists with vision or hearing impairment. Work improving access is underway.

RESIDENCY STATISTICS

Application deadline: April 26 for fellowship applications; others ongoing.
Resident season: Year-round.
Average length of residencies: 6 months for fellowship recipients; indefinitely for regular artists-in-residence.
Number of artists in 1998 (and total applicant pool): 9 fellowship artists, 72 regular artists-in-residence (65 fellowship applicants, 140 regular applicants).
Average number of artists present at one time: 35–40.
Selection process: Selections made by executive director, artistic director, and programs director.

ARTIST PAYS FOR Sliding scale residency fee for artists-in-residence ranges from $125–$340 per month (fellowship artists pay no fee); housing, food, travel, some materials.

INSTITUTION PAYS FOR Studios, facilities, program administration, some materials.

ARTIST ELIGIBLE FOR Stipends, fellowships/awards (please call for details). Phelan Awards for California-born printmakers given by the San Francisco Foundation every two years.

ARTIST DUTIES None.

PUBLIC PROGRAMS Outreach, gallery, classes, Disadvantaged Youth and Political Refugee programs, Latin American Refugee Workshop, open house/tours, international exchanges, exhibitions/presentations.

HISTORY Founded in 1974 by Archana Horsting and Yuzo Nakano as a direct response to the strengths and weaknesses of Stanley Hayter's Atelier 17 in Paris. Originally located in Oakland, Kala moved to Berkeley in 1980 and ex-

> "*What is unusual about Kala is that there is so much space for the creative aspects of art making, and there are so many large presses and pieces of technical equipment. The Media Center is unique compared to . . . [media facilities in] Europe and New York.*"
> —Josephine Ganter

panded facilities in 1995 to include an Electronic Media Center.

MISSION To provide a diverse, international body of artists with the tools, techniques, and well-organized professional facilities necessary to create high-quality works of art.

PAST RESIDENTS INCLUDE Jim Melchert, Rachel Rosenthal, Misch Kohn, Roy DeForest, Krishna Reddy, Nancy Genn, Josephine Ganter, Claudia Bernardi, Richard Misrach, Bob Blackburn, Deborah Oropallo.

FROM THE DIRECTOR "The physical production of art in a shared facility such as Kala naturally leads to an exchange of ideas among artists, and presentations of their work in Kala's gallery allows us to share these ideas with the greater public." —*Archana Horsting*

FOUNDED Organization 1974, Residency 1980.

LOCATION 113 acres of secluded forest and coastline on the Big Island of Hawaii, 45 minutes from Hilo, 5 minutes from the ocean entrance to Volcanoes National Park. As the only coastal lodging in Hawaii's largest conservation area, artists who come here are profoundly inspired by nature.

ELIGIBILITY Writing, performing arts, visual arts (see indices for more specific types of artists served). Main criteria for selection are quality of application, examples of work, references, verification of professional accomplishment. Repeat residencies permitted.

FACILITIES 113-acre site. Buildings 37,000 square feet. 6 studios. Studio space for visual and performance artists; writers work in their private rooms. Performance space, library/archive/collection, rehearsal space, exhibition space. PC computers with Microsoft Word, Netscape, Internet access.

HOUSING/MEALS/ACCESSIBILITY

Housing/Services: 4 two-story lodges with private rooms, 8 private cottages, full meal service, partial maid service. Rental cars recommended for transport, touring, and laundering. Collaborative groups, spouse, children possible. Single, double, queen beds in lodge or cottage rooms, shared or private baths.

Meals: 3 wholesome, abundant meals served daily on our dining terrace (artists pay for the meals).

Accessibility: Artists in wheelchairs or with vision or hearing impairment can be accommodated. Housing, housing bathrooms, studios, public bathrooms, kitchen, 3,000-square-foot multipurpose Rainbow Room, and computer and copy machine area are wheelchair accessible, though entire site is rural and interfacility trails are rough. Ramps, roll-in shower. Night lighting is minimal.

RESIDENCY STATISTICS

Application deadline: Ongoing.
Resident season: Year-round.
Average length of residencies: 2–8 weeks.
Number of artists in 1998 (and total applicant pool): 73 (79).
Average number of artists present at one time: 5.
Selection process: Panel of professionals.

ARTIST PAYS FOR Application fee $10, fixed residency/lodging fee $65–145 per day (though a 50 percent discount is available for those who need and apply for it), food, travel, materials.

INSTITUTION PAYS FOR 50 percent of residency/lodging fee for artists who need and apply for it; studios, facilities, program administration.

ARTIST ELIGIBLE FOR 50 percent of residency/lodging fee for artists who need and apply for it.

ARTIST DUTIES None.

PUBLIC PROGRAMS Hawaiian culture and arts presentations/exhibitions. Courses in yoga, Hawaiian culture, and dance. Special programs for men, women, and Pacific Islanders. Open house/tours, international exchanges, festivals, readings/lectures.

FOR CURRENT APPLICATION REQUIREMENTS:

RR #2, Box 4500
Pahoa, HI 96778

TEL
(808) 965-7828 or 1-800-800-6886

FAX
(808) 965-0527

E-MAIL
kalani@kalani.com

WEB
www.kalani.com

HISTORY Kalani Honua, which means "the harmony of Heaven and Earth" in Hawaiian, was founded in 1980 by Richard Koob and Earnest Morgan as an intercultural conference center devoted to the arts, healing, and Hawaiian culture.

MISSION Kalani Honua welcomes all in the spirit of *aloha*. We are guided by the Hawaiian tradition of *ohana*, "the extended family," respecting our diversity yet sharing in unity.

PAST RESIDENTS INCLUDE Garrett Hongo, Richie Havens, Judith Jamison, Shirley Jenkins, Roger Montoya, Mark Kadota, Katherine Yvinskas, Aida Nelson, Paul Horn, Ram Dass, Nona Beamer, Margaret Machado, Cleo Parker Robinson, Katherine Dunham.

FROM THE DIRECTOR "Kalani Honua brings together creative people from around the world, in a comfortable, yet culturally and artistically stimulating environment, where our earth home is actively recreating itself as molten lava dances in a palette of land, sea, fire, and air. *E komo mai,* 'welcome.'" —*Richard Koob*

FOUNDED Organization 1973, Residency 1973.

LOCATION At Syracuse University.

ELIGIBILITY Photographers, digital imaging, art historians, critics, collaborative groups. Repeat residencies permitted.

FACILITIES 2 studios. Private darkroom equipment includes complete black-and-white needs, Hope RA-4 20-inch color processor, Macintosh Quadra 950, 660AV, and PowerMac 8100, equipped with flatbed/film scanners, and CD-ROM recorder, Photoshop, Painter, Quark Xpress, and Director software. Library/archive/collection.

HOUSING/MEALS/ACCESSIBILITY
Housing/Services: A furnished apartment, all linens provided, laundry facility on premises.
Meals: Artists purchase own food and prepare own meals.
Accessibility: Artists in wheelchairs can be accommodated. Studios, the apartment, and the building that houses Light Work are wheelchair accessible. No special facilities for artists with vision or hearing impairment.

FOR CURRENT APPLICATION REQUIREMENTS:

316 Waverly Avenue
Syracuse, NY 13244

TEL
(315) 443-1300

FAX
(315) 443-9516

E-MAIL
cdlight@summon2.syr.edu

WEB
www.lightwork.org

RESIDENCY STATISTICS
Application deadline: Ongoing.
Resident season: Year-round.
Average length of residencies: 1 month.
Number of artists in 1998 (and total applicant pool): 12 (300–400).
Average number of artists present at one time: 1–2.
Selection process: Decisions made by artistic staff.

ARTIST PAYS FOR Food, travel, materials.

INSTITUTION PAYS FOR Housing, studios, all darkroom chemicals, facilities, program administration.

ARTIST ELIGIBLE FOR Stipend $2,000.

ARTIST DUTIES Artists donate one print made during residency to the Light Work collection.

PUBLIC PROGRAMS Exhibitions and publications, including the journal *Contact Sheet,* featuring fine reproductions of new work by artists who participate in the program. Artists may also work on special projects and exhibitions.

HISTORY Founded in 1973 as an artist-run photography and imaging center, Light Work has been supporting artists for 25 years through its internationally renowned artist-in-residence program.

MISSION To support emerging and under-recognized visual artists working in photography and related media through exhibitions, residencies, and publications.

PAST RESIDENTS INCLUDE Laura Aguilar, Zeke Berman, Judith Black, Lynn Cohen, John Fago, Peter Goin, Martina Lopez, Tim Maul, Sybil Miller, Yong Soon Min, Shelly Niro, Hulleah Tsinhahjinnie.

FROM THE DIRECTOR "We interpret the field of photography in broad terms and encourage . . . all

types of work. The idea that we could support artists by giving them the opportunity to do what they do best—make art—turned out to be our most important contribution to the field."
—*Jeffrey Hoone*

MacDowell Colony

FOUNDED Organization 1907, Residency 1907.

LOCATION 450 acres of woodlands and fields near Mt. Monadnock, in southern New Hampshire in the town of Peterborough, and 2 hours by car from Boston.

ELIGIBILITY Visual artists, writers, composers, filmmakers, interdisciplinary artists (see indices for more specific types of artists served). Main criteria for acceptance is quality of work. Repeat residencies permitted.

FACILITIES 450-acre site. 32 studios: 7 live-in studios, 25 studios assigned with separate bedroom in common building. Studios are assigned according to project description. Equipped studios include darkrooms (2); pianos (8); mixing board, synthesizer, amp, and speakers (1); 16mm film editing suite (1); litho and plate printing press (1); welding and air tools and overhead crane (1).

HOUSING/MEALS/ACCESSIBILITY

Housing/Services: In addition to the live-in studios, other artists have private bedrooms in one of 3 residence buildings.

FOR CURRENT APPLICATION REQUIREMENTS:

163 East 81st Street
New York, NY 10028

TEL
(212) 535-9690

FAX
(212) 737-3803

E-MAIL
info@macdowellcolony.org

WEB
www.macdowellcolony.org

Meals: All meals provided.
Accessibility: Artists in wheelchairs or with vision or hearing impairment can be accommodated. Housing, housing bathrooms, studios, public bathrooms, film editing room, darkroom, printmaking studio, and composers' studio with piano are wheelchair accessible. All buildings include considerations for wheelchair accessibility. No special facilities for vision-, speech-, or hearing-impaired residents, but MacDowell has accommodated artists with these disabilities and allows Seeing Eye dogs and cell phones for emergencies. Staff adapts to needs of each resident.

RESIDENCY STATISTICS

Application deadline: January 15 for May–August residencies; April 15 for September–December residencies; September 15 for January–April residencies.
Resident season: Year-round.
Average length of residencies: 4 weeks, with maximum of 2 months.
Number of artists in 1998 (and total applicant pool): 196 (1182).
Average number of artists present at one time: 32 summer, 22 other seasons.
Selection process: Panels of professionals in each discipline.

ARTIST PAYS FOR Application fee $20 (one application per person per year), materials, travel (unless artist applies for and receives travel assistance). Voluntary residency fees accepted.

INSTITUTION PAYS FOR Housing, studios, food, facilities, program administration, travel (based on need).

ARTIST ELIGIBLE FOR Stipend during 1998–2001 that will provide financial aid to writers as part of pilot program. Some fellowships/awards and travel grants.

ARTIST DUTIES None, though voluntary participation in community outreach, such as readings or visits to local schools, is possible.

> *"To enter one's assigned studio in the morning in expectation of a whole day with no distractions to intrude on the project in hand, and to look forward to a succession of such days for the continuity that is so hard to obtain elsewhere, is to feel oneself in the possession of a kingdom. Cheney, my studio in the woods, was a kingdom of happiness where I completed more work than I ever have before in a comparable period. I know of no other place that so perfectly fulfills its purpose as does MacDowell."* —Barbara Tuchman

PUBLIC PROGRAMS Edward MacDowell Medal awarded annually for outstanding achievement in the arts (award ceremony in August includes open house and studio tours). Community outreach all year round with various local organizations.

HISTORY In 1896 the composer Edward MacDowell and his wife, pianist Marian Nevins MacDowell, bought a farm in Peterborough, New Hampshire, where they could rest and work in tranquillity. There, MacDowell said, he was able to triple his creative activity. By expanding the facilities, he hoped to invite other artists to enjoy his farm as a workplace. Using a small fund created in Edward's honor by prominent citizens of his time, the MacDowells carried out their plan. The first colonists arrived before Edward MacDowell died in 1908. Until her death in 1956, Marian was responsible for the Colony's growth and survival. Under her guidance most of the thirty-two artists' studios were built.

MISSION To provide an environment in which creative artists are free to pursue their work without distraction.

PAST RESIDENTS INCLUDE Leonard Bernstein, Willa Cather, Alice Walker, Frances Fitzgerald, Aaron Copland, Milton Avery, Thornton Wilder, Barbara Tuchman, Meredith Monk, E. A. Robinson, Studs Terkel.

FROM THE DIRECTOR "The MacDowell Colony is probably best known as the first and oldest artist colony in America. We are proudest, however, of the reputation we have for being a great place to work. The simple formula that Edward and Marian MacDowell developed has changed little in the 90 years that the Colony has operated. The spirit of the place is refreshed each year by the variety and vitaliy of the artists themselves. The solitude, uninterrupted time, and an appropriate workspace, all within a small community of other creative people, makes for the perfect environment." —*Cheryl Young*

FOUNDED Organization 1989, Residency 1989.

LOCATION 400 acres of rolling woodlands and wildlife sanctuary, 15 minutes north of downtown Louisville, Kentucky.

ELIGIBILITY Writing, visual arts, musicians—all genres (see indices for more specific types of artists served). Repeat residencies permitted.

FACILITIES 400-acre site. 2 studios. Separate studios for visual artists; writers work in live/work spaces. Potters' wheel, kiln, printshop with 2 VanderCook presses, darkroom, performance space, library/archive/collection, Internet access for artists with own computers.

HOUSING/MEALS/ACCESSIBILITY

Housing/Services: Up to 6 residents can live in private rooms in Loftus House, an 11-room house that also includes the Center's offices, residents' kitchen, meeting and living room, and 1 multipurpose studio. Collaborative groups possible, depending on availability of space.
Meals: All meals provided or reimbursed. Breakfast is do-it-yourself, lunch and dinner prepared. Sunday and Monday nights are do-it-

yourself dinners, though the Center will reimburse restaurant receipts up to $6.50.
Accessibility: Artists in wheelchairs cannot be accommodated. Studios, kiln, and 2 Vander-Cook printing presses are wheelchair accessible, but housing and general facilities are not. No special facilities for artists with vision or hearing impairment. Plans for improving accessibility.

RESIDENCY STATISTICS

Application deadline: Ongoing, except for specific fellowships (call for information).
Resident season: Year-round.
Average length of residencies: 1 month.
Number of artists in 1998 (and total applicant pool): 80 (175).
Average number of artists present at one time: 4.
Selection process: Three-person panel convened every six weeks, comprised of a writer, visual artist, and arts advocate/administrator. Fellowship panels comprised of specialists within the area in which award is made.

ARTIST PAYS FOR Application fee $15, sliding scale residency fee $30-per-day suggested minimum, deposit of 20 percent of total fee due to secure residency after notification of acceptance; travel, materials.

INSTITUTION PAYS FOR Housing, studios, food, facilities, program administration.

ARTIST ELIGIBLE FOR Mary Foote Fellowship for Visual Arts (30 days); Dorothy Norton Clay Music Fellowship (30 days); Felhoelter Poetry Fellowship (10 days); Kentucky Foundation for Women Fellowship in Visual Arts and Writing (30 days, limited to female residents of Kentucky).

ARTIST DUTIES None, unless resident receives Indiana Connection Series fellowship.

PUBLIC PROGRAMS Workshops, Summer Children's Visual Art Day Camp, Salmagundi Sunday Arts Festival, symposia, pot luck dinners (food

FOR CURRENT APPLICATION REQUIREMENTS:

101 Mount St. Francis Drive
Mount Saint Francis, IN 47146

TEL
(812) 923-8602

FAX
(812) 923-0294

E-MAIL
maca@iglou.com

for thought), open house/tours, international exchanges, readings/lectures, exhibitions/presentations.

HISTORY The MAC began as a joint venture between the Conventual Friars of Our Lady of Consolation Province, several of whom are artists, and a group of southern Indiana and Greater Louisville artists who believed that the four hundred rural acres that comprise Mount St. Francis could serve artists in search of a place to work in privacy. The Franciscans, who also operate a retreat center on this property, were the primary financial patrons during the Center's early years. Despite the Franciscan's involvement in the creation of the community, the MAC is not affiliated with the Catholic Church or the Franciscan Order.

MISSION To provide time and place where artists can concentrate and work.

PAST RESIDENTS INCLUDE Constance Garcia-Barrio, Laura Foreman, Anthony Mendoza, Jane Bernstein, Stuart Lisbon, Star Black, Iris Adler, Rita Magdaleno, Jerry Noe, Patricia Hampl, Harry Brown, Ingrid Wendt, Doreen Rappaport, Lois Templeton, Sarah Frederick.

FROM THE DIRECTOR "Tranquility, this is the unique gift that Mary Anderson offers its residents. Over and over I hear from our residents their comments of gratitude for this peaceful and tranquil environment." —*Debra Carmody*

FOUNDED Organization 1977, Residency 1982.

LOCATION In the historic Mexican War streets of Pittsburgh's North Side.

ELIGIBILITY Visual artists, audio/performance, landscape architects, interdisciplinary artists, installation artists, mixed-media artists, collaborative groups. No repeat residencies.

FACILITIES 11 studios/galleries. Printshop, performance space, library/archive/collection, rehearsal space, exhibition space, Macintosh computers with Internet access and various software, such as Photoshop and Quark.

HOUSING/MEALS/ACCESSIBILITY

Housing/Services: 2 living spaces. Please contact the Mattress Factory for any specific housing needs.
Meals: Artists are given per diem for food and purchase/prepare own meals.
Accessibility: Artists in wheelchairs cannot be accommodated (housing not accessible). Mattress Factory has not had artists with disabilities as residents in the past, but staff will make all possible arrangements that they can to accommodate any future artists with vision or hearing impairment (though no special facilities). Studios and public bathrooms are wheelchair accessible. Mattress Factory's long-term plans include adding more housing, some of which will be accessible for residents with disabilities.

RESIDENCY STATISTICS

Application deadline: Ongoing.
Resident season: Year-round.
Average length of residencies: 1 month.
Number of artists in 1998 (and total applicant pool): 9 (140).
Average number of artists present at one time: 3.
Selection process: Selections made by the curator and the director.

ARTIST PAYS FOR Nothing.

INSTITUTION PAYS FOR Housing, studios, food, travel, materials, facilities, program administration.

ARTIST ELIGIBLE FOR Stipend $500–$1,000, per diem for meals.

ARTIST DUTIES To create and present site-specific installations or performance art in a choice of venue space: residential, industrial, or outdoor.

PUBLIC PROGRAMS Exhibitions, printmaking program, exhibition discussion forums, lectures, educational programming that includes use of the Web, open house/tours.

HISTORY Founded in 1977 in a six-story warehouse.

MISSION To commission new site-specific works, present them to the widest possible audience, and maintain selected individual installations in a growing—and distinctive—permanent collection.

PAST RESIDENTS INCLUDE James Turrell, Barbara

FOR CURRENT APPLICATION REQUIREMENTS:

500 Sampsonia Way
Pittsburgh, PA 15212-4444

TEL
(412) 231-3169

FAX
(412) 322-2231

E-MAIL
info@mattress.org

WEB
www.mattress.org

Ess, Eiko and Koma, Jessica Stockholder, Cady Noland, Buzz Spector, John Cage, Alison Wilding, Tracy Emin, Monika Kulicka.

FROM THE DIRECTOR "Mattress Factory is a research and development lab for artists . . . Mattress Factory's physical and organizational environments have grown out of and in response to a central focus on creativity." —*Barbara Luderowski*

FOUNDED Organization 1990, Residency 1991.

LOCATION Camp Collier, near Gardner, Massachusetts. 600 acres of woodland on Lake Massapoaq. Within 90 minutes of Boston.

ELIGIBILITY Painters, fiction writers, drawing, photographers, poets (see indices for more specific types of artists served). Must be over 18 years old. Repeat residencies permitted.

FACILITIES 600-acre site. 10 studios. Rehearsal space.

HOUSING/MEALS/ACCESSIBILITY

Housing/Services: Single rooms in individual cabins or in a house, in private bedrooms, with one other artist. Platform tent camping also possible. No laundry facilities. Some cabins have showers and toilets. All have electricity. Bathhouse for all others. Collaborative groups possible. Spouse possible if he or she is also an artist.
Meals: All meals provided (vegetarian selection included).
Accessibility: Artists in wheelchairs or with vision or hearing impairment cannot be accommodated. Medicine Wheel leases the facility and does not have control over improving accessibility.

RESIDENCY STATISTICS

Application deadline: Ongoing.
Resident season: May and September–early October.
Average length of residencies: 2 weeks.
Number of artists in 1998 (and total applicant pool): 24 (42).
Average number of artists present at one time: 10.
Selection process: Applications reviewed by outside panel of professionals in each category.

ARTIST PAYS FOR Sliding scale residency fee $60–$250 per week, travel, materials.

INSTITUTION PAYS FOR Housing, studios, food, facilities, program administration.

ARTIST ELIGIBLE FOR No stipends or fellowships/awards available.

ARTIST DUTIES Cleanup for two meals. Artists may also elect to do kitchen chores in exchange for part of residency fee.

PUBLIC PROGRAMS None.

HISTORY Founded in 1990.

MISSION To support new works of art by supporting the artist in production of new work. To provide a retreat opportunity for artists of all disciplines to develop and complete new work.

PAST RESIDENTS INCLUDE John McDonald, Cornell Coley, Patricia Meier, Kate Carney, Jonathan Aibel, Richard Griswald, Bob Cohen, Mona Jimenez, Robert Goss, Kelly Rappuchi, Paula Archer, Patricia Platt.

FROM THE DIRECTOR "The Medicine Wheel Artists' Retreat's purpose is to encourage artists to schedule an extended, uninterrupted time in which to create. We suggest that artists go on retreat at least once a year." —*Cheri Amarna*

FOR CURRENT APPLICATION REQUIREMENTS:

P.O. Box 1088
Groton, MA 01450-3088

TEL
(978) 448-3717

FAX
(978) 448-3717 (call first)

E-MAIL
medwheel@hotmail.com

"My stay was filled with new insights about my art. The balance of talking with others about their process and art making in general has been wonderful . . . Every artist needs an experience like this to nurture creativity, to rest, and to let the spirit flourish."
—Marion Turner

Mesa Refuge, c/o Common Counsel Foundation

FOUNDED Organization 1998, Residency 1998.

LOCATION The Mesa Refuge is located on a bluff overlooking the edge of Tomales Bay and a dairy ranch that will soon be restored to wetlands. The town of Point Reyes Station is a 10-minute walk away. The refuge is located 1½ hours north of San Francisco.

ELIGIBILITY Writers, including journalists, environmentalists, fiction/literary nonfiction writers, poets, essayists (see indices for more specific types of artists served). No repeat residencies.

FACILITIES 3 studios. Each resident has access to a full writing workspace. Computer printer, Internet access (though residents need to bring their own computers and writing supplies). Library/archive/collection.

HOUSING/MEALS/ACCESSIBILITY

Housing/Services: Private room in a spacious house. Some assistance with transportation to and from the San Francisco International airport available if necessary.
Meals: Kitchen stocked with basic breakfast and lunch makings for residents to prepare. Dinners provided five nights per week by Tomales Bay Foods, which specializes in fresh local organic food.
Accessibility: Artists with disabilities cannot be accommodated.

RESIDENCY STATISTICS

Application deadline: February 15. June 15.
Resident season: April–July; August–November.
Average length of residencies: 2 or 4 weeks.
Number of artists in 1998 (and total applicant pool): 25 (50).
Average number of artists present at one time: 3.
Selection process: Applicant submits materials by February 15 or June 15 deadline. The selection committee pays close attention to the potential impact of the applicant's writing, whether or not the proposed work is related to the relationships among environment, economics, and social justice, and the applicant's access to the natural world.

ARTIST PAYS FOR Travel, materials, e-mail.

INSTITUTION PAYS FOR Housing, studios, food, facilities, program administration.

ARTIST ELIGIBLE FOR No stipend or fellowships/awards available.

ARTIST DUTIES Residents have an opportunity to donate work and participate in community events, readings, or radio programs. None are required.

PUBLIC PROGRAMS Past Mesa Refuge events have included readings and community discussions in the Point Reyes area.

HISTORY Located in Point Reyes, California, the Mesa Refuge opened in July 1998 and offers 2- or 4-week sessions to 3 writers at a time. Room and most meals are provided at no cost.

MISSION The Mesa Refuge invites people to think and write about the edges between human activity—capitalism in particular—and the natu-

FOR CURRENT APPLICATION REQUIREMENTS:

1221 Preservation Park Way, Suite 101
Oakland, CA 94612

TEL
(510) 834-2995

FAX
(510) 834-2998

E-MAIL
ccounsel@igc.apc.org

WEB
www.commoncounsel.org/mesa.html

> *"These days a blessing, the safety and security of this shed, this chair on the porch looking out, so I could look in. After seven years a book completed. A leap. Thank you. Thank you."* —Terry Tempest Williams

ral world we are obliged to preserve. The Refuge welcomes writers who need the solitude essential to creative work.

PAST RESIDENTS INCLUDE Phil Klasky, Bay Area Nuclear Waste Coalition; Terry Tempest Williams; Carl Anthony, Urban Habitat Institute; Lacey Phillabaum, *Earth First!* journal.

FROM THE FOUNDERS "We started the Mesa Refuge as a way to share the inspirational beauty of Point Reyes. It is a place where magic is in the air, and creativity can flourish." —*Peter and Leyna Bernstein, co-founders*

Millay Colony for the Arts

FOUNDED Organization 1973, Residency 1974.

LOCATION 600-acre historic estate, 3 hours from both Boston and New York.

ELIGIBILITY Writers, composers, visual artists (see indices for more specific types of artists served). Selection based on quality of work. Repeat residencies permitted.

FACILITIES 600-acre site. 6 studios. Separate living and studio rooms. One piano for a composer, darkroom, library/archive/collection, Internet access for artists who bring computers.

HOUSING/MEALS/ACCESSIBILITY

Housing/Services: Each artist has a private bedroom. Two artists have private baths, and four share bathrooms. Linens are provided, and a washer and dryer are on the premises.
Meals: All food provided. Dinners prepared weeknights; artists prepare other meals.
Accessibility: Artists in wheelchairs or with vision, hearing, or speech impairment can be accommodated. Housing, housing bathrooms, studios, public bathrooms, kitchen, and main building (which is at ground level and includes 2 studio/living complexes in addition to common areas for all artists) are fully wheelchair accessible. Roll-in shower. Millay is in the final stages of a major campaign to make its facilities universally accessible.

RESIDENCY STATISTICS

Application deadline: February 1 for June–September residencies; May 1 for October–January residencies; September 1 for February–May residencies.
Resident season: Year-round.
Average length of residencies: 1 month.
Number of artists in 1998 (and total applicant pool): 72 (500+).
Average number of artists present at one time: 6.
Selection process: Outside panel of artists in each category.

ARTIST PAYS FOR Travel, materials.

INSTITUTION PAYS FOR Housing, studios, food, facilities, program administration.

ARTIST ELIGIBLE FOR No stipends or fellowships/awards available.

ARTIST DUTIES None.

PUBLIC PROGRAMS None.

HISTORY The Millay Colony for the Arts was begun in 1973 by Norma Millay, sister of the poet Edna St. Vincent Millay, at the poet's home, Steepletop.

MISSION To give one-month residencies to talented writers, composers, and visual artists.

PAST RESIDENTS INCLUDE Millay welcomes artists of all ages and at all points in their career.

FOR CURRENT APPLICATION REQUIREMENTS:

444 East Hill Road
Austerlitz, NY 12017

TEL
(518) 392-4144

FAX
(518) 392-7664

E-MAIL
application@millaycolony.org

WEB
www.millaycolony.org

Montana Artists Refuge

FOUNDED Organization 1993, Residency 1994.

LOCATION In a small, gold-mining town near the Continental Divide.

ELIGIBILITY Visual artists, writers, composers, performers, collaborative groups (see indices for more specific types of artists served). No restrictions. Residency Committee will consider any genre and new, emerging, or established artists. Repeat residencies permitted.

FACILITIES Four studio/living spaces. Performance space, rehearsal space, exhibition space, Internet access for artists with own computers.

HOUSING/MEALS/ACCESSIBILITY

Housing/Services: Four studio/living spaces. Spouse and children may be possible but in living quarters that all have single bedrooms. No pets allowed. Non-smoking.
Meals: Artists purchase own food and prepare own meals.
Accessibility: Artists with disabilities cannot be accommodated. Montana Artists Refuge has long-term plans to develop accessible facilities.

FOR CURRENT APPLICATION REQUIREMENTS:

P.O. Box 8
Basin, MT 59631

TEL
(406) 225-3500

FAX
(406) 225-9225

RESIDENCY STATISTICS

Application deadline: Ongoing, except summer residencies deadline is November 1.
Resident season: Year-round.
Average length of residencies: 3 months–1 year.
Number of artists in 1998 (and total applicant pool): 14 (30).
Average number of artists present at one time: 4.
Selection process: Selection committee, Montana Artists Refuge board of directors.

ARTIST PAYS FOR Residency/housing/studio fee ranging from $260 to $450 per month (though some financial assistance is available), utilities varying by season, $200 cleaning deposit, food, travel, materials.

INSTITUTION PAYS FOR Facilities, program administration.

ARTIST ELIGIBLE FOR Financial assistance. May be some financial support for collaborative efforts (e.g., a recently sponsored program involved a composer-in-residence, regional musicians, a local poet, a Refuge painter, and other area arts organizations in a public performance of new music). Some work-exchange possible.

ARTIST DUTIES None.

PUBLIC PROGRAMS Shows, readings, performances, lectures, workshops, Siteworks Community Art Project. Community outreach encouraged and facilitated but not required.

HISTORY Founded in 1993 by four local artists and area residents for the purpose of providing living and work space to artists in all mediums.

MISSION To further the creative work of artists, to create residencies for artists, and to provide arts programs and arts education for both artists and community members.

PAST RESIDENTS INCLUDE Martha Shade, Pamela Hartvig, McCarthy Coyle, Nikki Schrager, Patricia Thomas, Holly Fisher, Mary Carrothers, Jen-

> *"In the light, space, simple community, and breadth of the landscape, my art work took hold of me and led me to a new creative dimension and connection with myself."*
> —Jennifer L. Thompson

nifer Thompson, Karen Land, Margaret Baldwin.

FROM THE DIRECTOR

"The natural beauty and quiet rugged vistas are profound influences on most everyone who vis- its or lives here. Self-motivated individuals have found the time and space here to focus in an amplified way on new directions, or to refine and clarify current projects." —*M. J. Williams*

Nantucket Island School of Design and the Arts

FOUNDED Organization 1973, Residency 1982.

LOCATION On Nantucket Island, 30 miles to sea off the coast of Cape Cod, Massachusetts.

ELIGIBILITY Painting, writing, ceramics (see indices for more specific types of artists served). Interdisciplinary with no restrictions. Repeat residencies permitted.

FACILITIES 2.5-acre site. Buildings 18,000 square feet. Studio space including open 2D, 3D, and performance studio; rehearsal space; ceramics studio; Skutt electronic kiln; electric wheels; pit firing equipment; gas kiln; black-and-white darkrooms; textile studio; woodshop; outdoor studio; exhibition space; library/archive/collection; PowerMac computers with Internet access, laser printer, scanner; AV equipment; projectors.

HOUSING/MEALS/ACCESSIBILITY

Housing/Services: Private and shared cottages, with full kitchenette and bath. Linens and towels are provided. Cleaning can be arranged. Public transportation May 1–September 30. A car is strongly advised in order to explore land-scape in particular remote areas and to experience the full advantage of the residency and the island. Spouse welcome at all times. Accommodation for collaborative groups and children may be arranged at dedicated times; please call for year's schedule. Dedicated schedule ensures continuity and "quiet" studio for individual residents.

Meals: Artists purchase own food and prepare own meals; kitchen is available at Seaview Farm Studios. Each cottage has a small kitchen with full oven/stove, refrigerator, and small dining table.

Accessibility: Artists in wheelchairs or with vision or hearing impairment can be accommodated; staff will make efforts to accommodate artists with other disabilities. Studios, public bathrooms, and two cottages are wheelchair accessible (work in progress to improve access in cottage bathrooms). NISDA has simple wheelchair ramp, and studios are on one floor. NISDA has excellent cooperation with local EMT. NISDA's 5-year plan for facilities includes substantial projects to improve accessibility.

RESIDENCY STATISTICS

Application deadline: Ongoing.
Resident season: Spring, March–June; Fall, September–December.
Average length of residencies: 3 weeks–2 months, occasionally longer.
Number of artists in 1998 (and total applicant pool): 25 (36).
Average number of artists present at one time: 6–10.
Selection process: Outside panel of professional artists, curators, in varied disciplines.

ARTIST PAYS FOR Application fee $20, various levels of residency fees (please call for details) in payment for housing, food, travel, materials.

INSTITUTION PAYS FOR Studios, facilities, program administration.

ARTIST ELIGIBLE FOR Some financial assistantships/work exchanges are available (call for details).

FOR CURRENT APPLICATION REQUIREMENTS:

P.O. Box 1848
Nantucket Island, MA 02554

TEL
(508) 228-9248

FAX
(508) 228-2451

ARTIST DUTIES Housekeeping for one's own cottage and studio space. Optional opportunities to lead slide lecture, talk, or performance in Nantucket community.

PUBLIC PROGRAMS Cultural Arts Lecture Series offers opportunities to be inspired by renowned artists, visionaries, and creative thinkers. Artists also have opportunity to show at NISDA Silo Gallery. Exhibitions, events, workshops.

HISTORY Founded in 1973, when artists were housed in the Nantucket Lightship Museum or in private homes. Sea View Barn established in 1978, Harbor Cottages in 1982.

MISSION To explore the interrelationship of arts, sciences, humanities, the environment, and art as social voice and conveyor of human spirit . . . To provide the isolation necessary for focus, the inspiration to create, and artists' dialogue.

PAST RESIDENTS INCLUDE Robert Rindler, James Pierce, Brenda Miller, Michelle Stewart, Kevin Lee Milligan, Tom Holden, Corinne Loeh, Aileen Cox, Tammy Wold, Toni Feldman, Susan Van Pelt, Glen Pihl, Aria Edry, Judith Harold Steinhauser, Jeff DeCastro, Judith Balft, Larry Behr, John Bay, Bread and Puppet Theatre.

FROM THE DIRECTOR "Our artist residency program wholly focuses on personal work and is often the strongest experience and ultimately the most meaningful path. The quiet, contemplative winters and bustling summer provide opportunities for personal perspective as well as invigorating dialogue. Nantucket's distinctive and dramatic environment encourages new links to nature's nuances and forces, inspiring possibilities for creating works interdependent with natural phenomena." —*Kathy Kelm*

National Playwrights Conference at the Eugene O'Neill Theater Center

FOUNDED Organization 1965, Residency 1965.

LOCATION At the Eugene O'Neill Theatre Center in Waterford, Connecticut.

ELIGIBILITY Playwrights, screenwriters. Repeat residencies permitted.

FACILITIES 4 studios. Theatre, rehearsal space, modular sets, no costumes, minimal lights and props. Professional theatre and media artists available to work with script in hand. Library/archive/collection, Internet access for artists with own computers.

HOUSING/MEALS/ACCESSIBILITY
Housing/Services: Private rooms at Mitchell and Connecticut College; O'Neill Center housing.
Meals: All meals provided.
Accessibility: Artists in wheelchairs or with vision or hearing impairment can be accommodated. Housing, housing bathrooms, studios, and public bathrooms are wheelchair accessible.

FOR CURRENT APPLICATION REQUIREMENTS:

234 West 44th, Suite 901
New York, NY 10036

TEL
(212) 382-2790

FAX
(212) 921-5538

RESIDENCY STATISTICS
Application deadline: December 1.
Resident season: July.
Average length of residencies: 1 month.
Number of artists in 1998 (and total applicant pool): 12 (1,500).
Average number of artists present at one time: 30.
Selection process: Outside panel of professionals.

ARTIST PAYS FOR Application fee $15, travel, some materials.

INSTITUTION PAYS FOR Housing, studios, food, some materials, facilities, program administration.

ARTIST ELIGIBLE FOR Stipend $1,000, Herbert and Patricia Brodkin Scholarship Award, Charles MacArthur Fellowship, Eric Kocher Playwrights Award, Edith Oliver Fellowship, Steinber Prize.

ARTIST DUTIES None.

PUBLIC PROGRAMS Performances, community outreach, educational programs, international exchanges.

HISTORY Founded in 1965 by George C. White. Under the artistic direction of Lloyd Richards since 1968.

MISSION To develop talented writers for the American Theater.

PAST RESIDENTS INCLUDE Israel Horowitz, Jefferey Hatcher, Laura Harrington, Nancy Grome, Tom Griffin, Amlin Gray, Patricia Goldstone, Lucky Gold, Jonas Gardell, Kermit Frazier, Rolf Fjelde, Ken Eulo, John Redwood, Keith Redding, Edwen Sanchez, Wendy Wasserstein.

FROM THE DIRECTOR "In 1964, the National Playwrights Conference was born out of necessity.

"*There is intense pressure [at the National Playwrights Conference]. No one imposes it. It imposes itself because it was there before anybody arrived. It is there—on the walls where plaques proclaim the names of conference playwrights from the past: John Guare, Lanford Wilson, David Rabe, August Wilson . . . There is little pretense. There is precision, there is imagination, and there is hard work.*" —Richard Kalinoski

The commercial theatre was barren of new and compelling work by American playwrights. . . . One has only to look to the Broadway season to know that the cycle is repeating itself. New play-wrights with perception, conscience, imagination, and craft are needed. The National Playwrights Conference is needed." —*Lloyd Richards*

Norcroft: A Writing Retreat for Women

FOUNDED Organization 1990, Residency 1993.

LOCATION 10 acres in the pine and birch woods along the north shore of Lake Superior in Michigan.

ELIGIBILITY Women (who would be described as feminist) only. Writers of all disciplines. No repeat residencies.

FACILITIES Lodge: 2,500 square feet. Writing sheds: 64 square feet. 4 studios. Rooms in main lodge, with fully-stocked and equipped kitchen. Writers work in individual writing sheds, separate from lodge. Library.

HOUSING/MEALS/ACCESSIBILITY

Housing/Services: Private bedrooms. Linens provided and laundered. Once at Norcroft, residents are responsible for their own transportation, though transportation is provided from Duluth to the retreat and back again to Duluth (airport or bus station).
Meals: Food provided, but artists prepare their own meals.
Accessibility: Artists in wheelchairs can be accommodated. Housing, housing bathrooms, studios, and route from housing to studio are wheelchair accessible. No special facilities for artists with vision or hearing impairment. Plans for improving accessibility.

RESIDENCY STATISTICS

Application deadline: October 1.
Resident season: May 1–October 31.
Average length of residencies: 1–4 weeks.
Number of artists in 1998 (and total applicant pool): 48 (124).
Average number of artists present at one time: 4.
Selection process: Three-member outside panel.

ARTIST PAYS FOR Travel, materials.

INSTITUTION PAYS FOR Housing, studios, food, facilities, program administration.

ARTIST ELIGIBLE FOR Accessibility Fund—can apply for up to $200 for transportation or other costs.

ARTIST DUTIES None.

PUBLIC PROGRAMS None.

HISTORY Founded in 1993 by the Joan Drury and Harmony Women's Fund.

MISSION To nurture and support women's writing to provide more choices and opportunities for women and enabling feminist change.

PAST RESIDENTS INCLUDE Martha Roth, Mary Saracino, Rosalie Maggio, Denice Leverett, Pat Francisco, Kim Hines, Maya Sharma, Cindra Halm, Cherry Hartman, Patricia Romney, Marie-Elise Wheatwind.

FROM THE DIRECTOR "Criteria for coming here are a commitment to feminism and a commitment to writing. We want to honor women and their words." —*Joan Drury*

FOR CURRENT APPLICATION REQUIREMENTS:

32 East 1st Street
Duluth, MN 55802

TEL
(218) 727-5199

FAX
(218) 727-3119

"Norcroft has given me exactly what I needed and more . . . At Norcroft I captured the vision." —Pat Romney

Northwood University, Alden B. Dow Creativity Center

FOUNDED Organization 1978, Residency 1979.

LOCATION On the campus of Northwood University, Midland, Michigan.

ELIGIBILITY Visual artists, writers, musicians/dancers/performers, architects/designers, collaborative groups (see indices for more specific types of artists served). No repeat residencies.

FACILITIES 4 studios. Large apartment/workspace with kitchen in a wooded environment.

HOUSING/MEALS/ACCESSIBILITY
Housing/Services: Linens, kitchenware (pots, pans, dishes, etc.) provided.
Meals: Lunch provided Monday through Friday at the Creativity Center; residents (called fellows) purchase own food and prepare all other meals. Stipend offered to help with purchase of food (see "Artist Eligible For").
Accessibility: Artists with disabilities cannot be accommodated.

RESIDENCY STATISTICS
Application deadline: December 31.
Resident season: June–August.

FOR CURRENT APPLICATION REQUIREMENTS:

3225 Cook Road
Midland, MI 48640

TEL
(517) 837-4478

FAX
(517) 837-4468

E-MAIL
creativity@northwood.edu

Average length of residencies: 10 weeks.
Number of artists in 1998 (and total applicant pool): 4 (65).
Average number of artists present at one time: 4.
Selection process: Panel of professionals in each category make recommendations to Creativity Center board, which makes final selections.

ARTIST PAYS FOR Application fee $10, travel, materials, some food.

INSTITUTION PAYS FOR Housing, studios, facilities, program administration, some food.

ARTIST ELIGIBLE FOR Stipend $750 to be used on project costs or personal needs.

ARTIST DUTIES Upon completion of the residency, fellows will make oral presentations of their projects to a selected audience of Creativity Center board members, evaluators, Northwood University staff, invited guests, and the public.

PUBLIC PROGRAMS Artists' presentations (see "Artist Duties" above).

HISTORY Northwood University was founded in 1959 by Dr. Arthur E. Turner and Dr. R. Gary Stauffer, as a private, business management college, dedicated to a partnership between business and the arts. The association between Alden Dow and the university began with the design by Dow of the Northwood campus. The Creativity Center was founded in 1978.

MISSION To encourage individual creativity and to preserve the work and philosophy of Alden Dow.

PAST RESIDENTS INCLUDE Pam Becker, Peter Francis, Peter Josyph, Barb and Doug Roesch, Michael Tom, Caroll Michels, Philis Alvic, Leslie Friedman, Stanley Hollingsworth, Marilyn Lanfear, Jane Leister, Ben Shedd.

FROM THE DIRECTOR "With our Creativity fellowship program, we look for creative ideas in any

> *"I now recognize that the Creativity fellowship sets in motion a lifelong venture, and I am most grateful to be on this journey."* —Ben Shedd

area of the arts, sciences, and humanities. A typical residency is four to five individuals that might include a visual or performing artist, a writer or composer, a mathematician or chemist, a philosopher or theologian. We hope for synergy among the Fellows and their projects."
—*Ron Koenig*

Oregon College of Art and Craft

FOUNDED Organization 1907, Residency 1979.

LOCATION 8 acres on a wooded hillside in Portland's Northwest District.

ELIGIBILITY Visual artists (see indices for more specific types of artists served). No repeat residencies.

FACILITIES 8-acre site. Residents have access to book arts, drawing/painting, fibres studio, and all materials on campus, including darkroom, metalshop, pottery/ceramics facility, printshop, woodshop, library, exhibition space. Internet access for artists with own computers.

HOUSING/MEALS/ACCESSIBILITY

Housing/Services: House for single residents only. Private bedrooms, shared kitchen and living area with basic furnishings and utensils. No pets allowed.
Meals: Artists purchase own food and prepare own meals; café available on campus.
Accessibility: Artists in wheelchairs or with vision or hearing impairment can be accommodated. Housing, housing bathrooms, studios, and public bathrooms are wheelchair accessible. Staff will make special arrangements for residents with disabilities, and OCAC continually works to improve accessibility.

RESIDENCY STATISTICS

Application deadline: April 15 for emerging artists. Midcareer artists by invitation only.
Resident season: Year-round.
Average length of residencies: Emerging artists: 4-month residency during academic year. Midcareer artists: summer months.
Number of artists in 1998 (and total applicant pool): 8 (90).
Average number of artists present at one time: 2–4.
Selection process: Panel of professionals in each category.

ARTIST PAYS FOR Food, some travel.

INSTITUTION PAYS FOR Housing, studios, materials, facilities, program administration, some travel.

ARTIST ELIGIBLE FOR Stipend $400 per month, plus travel and materials allowance.

ARTIST DUTIES Emerging artists: 12 hours per week of assigned work.

PUBLIC PROGRAMS BFA Program, Certificate Program, Independent Wood Study Program, open classes and workshops, open house/tours, international exchanges, readings/lectures, exhibitions/presentations, children's programming.

HISTORY The Oregon College of Art and Craft began as an arts and crafts society during the American Arts and Crafts Movement. Today it is the only accredited college in the nation to focus solely on the crafts.

MISSION The Junior Residency Program provides post-graduate artists an opportunity to pursue a proposed body of work over a four-month period in a stimulating arts environment. The Senior Residency Fellowship Program encourages outstanding midcareer

FOR CURRENT APPLICATION REQUIREMENTS:

8245 S.W. Barnes Road
Portland, OR 97225

TEL
(503) 297-5544

FAX
(503) 297-9651

E-MAIL
residency@ocac.edu

WEB
www.ocac.edu

> *"I spent the summer working on a group of small sculptures made from a variety of materials, including metal. I don't know if they ever would have happened without the residency. I am thankful for both the financial and psychological support that the residency gave to my efforts."* —Lisa Gralnick

artists to take time away from their teaching or their studio careers to pursue a focused project.

PAST RESIDENTS INCLUDE John McQueen, Karen Tossavainen, Judy Hill, Lisa Gralnick, Vernon Theiss, John Eric Byers, Sharon Marcus, Whitney Nye, Horatio Law, Dana Louis, Brian Shannon, Mary Stewart, Ana Siems, Maria Phillips, Caryl Herfort, Barbara Tetenbaum, Lauri Twitchell, Shannon Williams.

FROM THE DIRECTOR "The beauty of the OCAC residency is that it provides a place and time for artists to create that body of work that strengthens both the artist and the heritage of arts and crafts, with total freedom, within an energetic educational community." *—Joe Wedding, President*

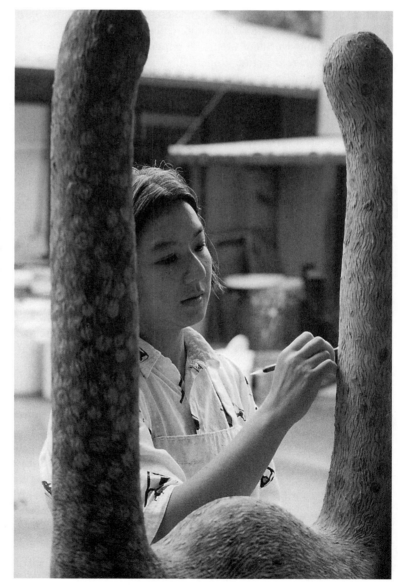

Ox-Bow

FOUNDED Organization 1910, Residency 1990.

LOCATION 110 acres of wooded dunes, between the Kalamazoo River and the Ox-Bow lagoon, in Saugatuck, Michigan.

ELIGIBILITY Visual artists, fiction writers, poets, performance artists (see indices for more specific types of artists served). No repeat residencies.

FACILITIES 110-acre site. Studio space and access to printshop with intaglio lithograph, collagraph, relief, and woodcut facilities; papermaking studio; ceramic studio; open-air glass blowing facility; metal sculpture studio; exhibition space.

HOUSING/MEALS/ACCESSIBILITY

Housing/Services: In a pre–Civil War inn or cabin. Residents bring their own linens and provide their own transportation to and from Ox-Bow. Guest are allowed, but not overnight.
Meals: All meals provided.
Accessibility: Artists in wheelchairs can be accommodated. Housing, housing bathrooms, studios, and public bathrooms are wheelchair accessible. No special facilities for artists with vision or hearing impairment. Plans for expanding accessibility.

RESIDENCY STATISTICS
Application deadline: May 15.
Resident season: June–August.
Average length of residencies: 1 week.
Number of artists in 1998 (and total applicant pool): 12 (35).
Average number of artists present at one time: 1–3.
Selection process: Internal panel of faculty and the director.

ARTIST PAYS FOR Fixed residency/studio fee $348 per week, travel, materials.

INSTITUTION PAYS FOR Housing, food, travel, facilities, program administration.

ARTIST ELIGIBLE FOR No stipends or fellowships/ awards are available.

ARTIST DUTIES Artists are encouraged to present a slide lecture or reading and to participate in discussions.

PUBLIC PROGRAMS Lectures, courses, workshops, exhibitions, open house.

HISTORY Founded in 1910 by two artists, Marshall Clute and Frederick Frary Fursman, who were faculty at the School of the Art Institute of Chicago.

MISSION To provide professional and beginning artists with lifelong learning opportunities and to foster an appreciation for art in the surrounding community, while preserving the natural environment that has energized Ox-Bow since its founding.

PAST RESIDENTS INCLUDE Robyn Levine, Cynthia Weiss, Carmella Rago, Tom Robinson, Julie Jankowski, Mary Hart, Wayne Forbes, Henry Feely, Christine French, Roberta Busard, Carmel Crane, Monica Bauer.

FOR CURRENT APPLICATION REQUIREMENTS:

c/o School of the Art Institute of Chicago
Continuing Studies and Special Programs
Chicago, IL 60603

TEL
(312) 899-7455

FAX
(312) 899-1453

WEB
www.artic.edu/saic/specprog/residencies.html

FROM THE DIRECTOR "This program is designed for the professional artist to reside and work in a secluded, natural environment, unencumbered by the outside world." —*E. W. Ross*

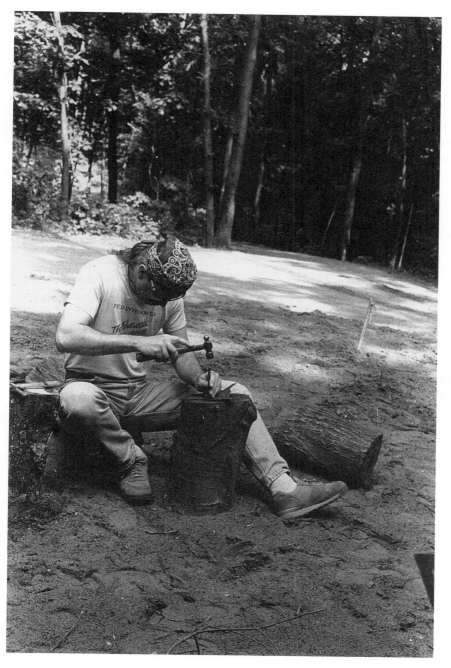

P.S. 1 Contemporary Art Center

FOUNDED Organization 1971, Residency 1976.

LOCATION International artists work at P.S. 1's Museum, located in Long Island City, Queens. National artists work at the Clocktower Gallery, located in Manhattan.

ELIGIBILITY Visual artists, performance artists, conceptual, media, new genres (see indices for more specific types of artists served). Midcareer and emerging. Repeat residencies permitted.

FACILITIES 24 studios. P.S. 1 houses 16 studios for international artists; the Clocktower Gallery includes 8 studios for national artists. Exhibition space, collection, rehearsal space. Basic Windows 95 "office equipment" available to residents, only casually, if staff members permit. Internet access for artists with own computers.

HOUSING/MEALS/ACCESSIBILITY

Housing/Services: Arranged and paid by international artists through mandatory grants from their respective governments. National artists arrange and pay for their own housing.
Meals: Artists purchase own food and prepare own meals.

FOR CURRENT APPLICATION REQUIREMENTS:

22–25 Jackson Avenue
Long Island City, NY 11101-5324

TEL
(718) 784-2084

FAX
(718) 482-9454

E-MAIL
mail@ps1.org

Accessibility: Artists in wheelchairs can be accommodated. Studios and public bathrooms are wheelchair accessible. Elevator. Housing situations vary since they are arranged by artist. No special facilities for artists with vision or hearing impairment. Plans to expand accessibility.

RESIDENCY STATISTICS

Application deadline: April 15.
Resident season: Year-round.
Average length of residencies: 1 year.
Number of artists in 1998 (and total applicant pool): 20 (600).
Average number of artists present at one time: 20.
Selection process: Foreign government organizations must submit applications for international artists, who are then selected by a rotating panel of artists, curators, and art critics. National artists are individually selected.

ARTIST PAYS FOR International artists: nothing— all expenses paid by sponsoring government (see "Artist Eligible For"). National artists: receive studio for free and pay for housing, food, travel, and materials.

INSTITUTION PAYS FOR Studios, facilities, program administration.

ARTIST ELIGIBLE FOR International artists: stipend sponsored by participating governments which includes $18,000 for annual living expenses, $2,000 for travel, and $1,000 for materials.

ARTIST DUTIES None.

PUBLIC PROGRAMS Open studio sessions, annual studio artist exhibition and catalogue, lectures, possibility for working with P.S. 1's education and community coordinator.

HISTORY Beginning in 1976, the Institute for Contemporary Art, through its National and International Studio Program, has awarded workspace annually to artists working in a variety of media. The Institute produces a cata-

> *"The opportunity to participate in the studio artist program couldn't have come at a better time for me. I had just moved to New York and was living and working in a tiny space. At P.S. 1 my work was seen by many fellow artists, dealers, and critics at the open studios and later during the studio artist exhibition. I am grateful for the opportunity provided by this program."* —Jessica Stockholder

logue of the participants' work and organizes an exhibition for the artists. P.S. 1 is currently in the process of merging with the Museum of Modern Art.

MISSION To provide workspace for emerging contemporary artists of exceptional quality . . . to foster a vibrant supportive community of artists from varied backgrounds and disciplines, and to utilize the resources of the program, and P.S. 1.

PAST RESIDENTS INCLUDE Lynda Benglis, Martin Puryear, Annette Messager, Kenny Scharf, David Wojnarowicz, Mike Bidlo, Terry Adkins, Andres Serrano, Lorna Simpson, Jessica Stockholder, Katy Schimert, Ken Chu, Collier Schorr, Ugo Rondinone.

FROM THE DIRECTOR "The National and International Studio Program is one of the few urban artist communities in the country offering precious workspace, exhibition opportunities, publicity, and support in a city where studio rent and access to decision makers is often out of reach for artists early in their careers. The program's location in New York City, combined with its excellent track record have made it one of the most prestigious awards an emerging artist may receive." —*Alanna Heiss*

Penland School of Crafts

FOUNDED Organization 1929, Residency 1963.

LOCATION In the Blue Ridge Mountains, 55 miles northeast of Asheville, North Carolina.

ELIGIBILITY Clay, glass, iron, metals, textiles, books and paper, drawing/painting, photography, printmaking, wood.

FACILITIES Unfurnished studios and unfurnished apartments. Studios are frequented by visitors to the school and artists usually set up exhibition areas within their studios. All equipment is provided by the artist; Penland School equipment is not available for use by residents.

HOUSING/MEALS/ACCESSIBILITY

Housing/Services: Unfurnished apartments.
Meals: Artists purchase own food and prepare own meals. Meals in the Penland School Dining Hall are available for a fee.
Accessibility: No special facilities for artists with disabilities; please call before applying to discuss specific needs.

RESIDENCY STATISTICS

Application deadline: October 28.

FOR CURRENT APPLICATION REQUIREMENTS:

Program Director
Penland Road, P.O. Box 37
Penland, NC 28765-0037

TEL
(828) 765-2359

FAX
(828) 765-7389

E-MAIL
office@penland.org

WEB
www.penland.org

Resident season: Year-round.
Average length of residencies: 3 years.
Number of artists in 1998 (and total applicant pool): 7 (30).
Average number of artists present at one time: 7.
Selection process: Selected by director in consultation with selection committee.

ARTIST PAYS FOR Application fee $25; residency fees $50 per month for housing and $50 per month for studios; food; travel; materials. Artists also pay utilities.

INSTITUTION PAYS FOR One class at Penland School free of charge during residency.

ARTIST ELIGIBLE FOR No stipends or fellowships/awards are available.

ARTIST DUTIES Provide open house for students of Penland School once each session, avail themselves to public.

PUBLIC PROGRAMS None associated with this residency.

HISTORY The school was founded in 1929 by primary school teacher Lucy Morgan to revitalize Appalachian craft traditions. Residency program was founded in 1963 by director Bill Brown to support contemporary craft artists.

MISSION To provide a stimulating, supportive environment for persons at transitional points in their careers.

PAST RESIDENTS INCLUDE Cynthia Bringle, Jane Peiser, Mark Peiser, Richard Ritter, Debra Frasier, Jim Lawton, Rob Levin, Douglas Harling, Christina Schmigel, Terry Gess.

FROM THE DIRECTOR "Penland is a literal and symbolic refuge for artists . . . We provide resident artists with a beautiful, stimulating, and egalitarian atmosphere in which to experiment and make new work." —*Jean McLaughlin*

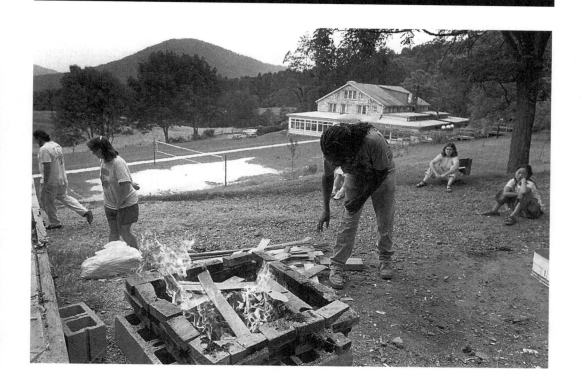

FOUNDED Organization 1970, Residency 1970.

LOCATION In the northwest corner of New Jersey, by the Delaware River. Located within the Delaware Water Gap National Recreation Area. 14 of the 35 buildings are on the National Historic Register.

ELIGIBILITY Blacksmithing, ceramics, fine metals, fiber, photographers, visual artists, weavers, wood, and special topics (see indices for more specific types of artists served). Eligibility varies for the three residency programs: the Professional Residency Program, the Associate Residency Program, and the Assistantship Residency Program. Please contact the Center for details. A complete description and application form is available for each residency.

FACILITIES 3,500-acre site. 8 studios. Fiber studio, weaving studio, blacksmithing studio, salt kiln, double-chambered wood kiln, anagama kiln, darkroom, fine metal studios, printshop, woodshop, library/archive/collection, exhibition space, PC computers with Quark, MS Word, Internet access.

FOR CURRENT APPLICATION REQUIREMENTS:

19 Kuhn Road
Layton, NJ 07851

TEL
(973) 948-5200

FAX
(973) 948-0011

E-MAIL
pv@warwick.net

WEB
www.pvcrafts.org

HOUSING/MEALS/ACCESSIBILITY

Housing/Services: Accommodations vary but include room in house (with kitchen, bath, living room) or full house, depending on number of residents at a given time. Laundry facility at the Center; linens must be provided by resident. No public transportation to town, but public transportation to New York City from Newton, New Jersey (15 miles away from the Center). Spouse/partner possible.

Meals: Artists purchase own food and prepare own meals.

Accessibility: Artists with disabilities cannot be accommodated. The Center plans to develop accessibility.

RESIDENCY STATISTICS

Application deadline: Professional Residency Program: ongoing. Associate Residency Program: July 15 for fall and full-season residency; December 15 for winter/spring residency. Assistantship Residency Program: March 31.

Resident season: Professional and Associate programs: October–April. Assistant program: mid-May–mid-September.

Average length of residencies: 1–8 months.

Number of artists in 1998 (and total applicant pool): 18 (30).

Average number of artists present at one time: 10.

Selection process: Several types of residencies. Contact the Center for details.

ARTIST PAYS FOR Associate program: residency fee $325 per month, food, travel, materials. Professional program: food, travel. Assistantship program: Minimal cost (call for details).

INSTITUTION PAYS FOR Housing, studio, facilities, program administration. Materials for Professional program. Call for details about the Assistantship program.

ARTIST ELIGIBLE FOR Stipends for Assistantship program. Opportunities for paid work available.

> "My residency at Peters Valley was great . . . I tried many new things . . . accomplished what I set out to do, and allowed for exploration of new ground . . . It's so rare to have such freedom." —Debbie Reichard

ARTIST DUTIES Residents from both the Associate and Professional programs are expected to donate one piece of work to the permanent collection at Peters Valley.

PUBLIC PROGRAMS Workshops in 8 studios are ongoing. School outreach, community college courses at Peters Valley throughout the year. Annual craft fair last weekend in September. Open house 2 times a year. Weekly slide show by staff and faculty during the summer season.

HISTORY Peters Valley Craft Education Center is a nationally recognized center for craft. Formed in 1970 as a nonprofit organization, Peters Valley currently focuses on eight disciplines—blacksmithing, ceramics, fibers, fine metals, photography, special topics, weaving, and woodworking—by supporting artists and offering a variety of educational experiences.

MISSION Peters Valley, an education center with resident and visiting artists, is dedicated to quality education through the cultivation of the individual's artistic appreciation, exploration, and participation in the evolving tradition of craft.

PAST RESIDENTS INCLUDE Daniel Radven, Annu Matthew, James Jewell, Mark Wilkins, Debra Stark, John Graney, Sandra Ward, Kenneth Fisher, Bob Natalini, William Abranowicz, David VanHoff.

FROM THE DIRECTOR "Each of our eight studios presents a creative and diverse offering of workshops and programs throughout the year. Expression, creativity, and critical thinking underscore the artistic explorations of our students. We bring together leading instructors, talented artists, and motivated students who share an irreplaceable and memorable experience." —*Kenn Jones*

Pilchuck Glass School

FOUNDED Organization 1971, Residency 1971.

LOCATION Tree farm, 50 miles north of Seattle.

ELIGIBILITY Glass, installation, mixed media, printmakers, sculptors. No repeat residencies.

FACILITIES 64-acre site. Studios include wood and metal shop and a glass-plate printmaking shop. Equipment includes fusing, slumping, and pâte-de-verre kilns. Artists must bring their own hand or flame working tools. Excellent facilities and equipment for experimental projects and research. Computer available with Windows 98, Office 95.

HOUSING/MEALS/ACCESSIBILITY

Housing/Services: 12 double-occupancy rooms, with shared bathroom in attached cottages.
Meals: Artists purchase own food and prepare own meals in a community kitchen.
Accessibility: No special facilities for artists in wheelchairs, except public bathroom is accessible and has roll-in shower; housing and studios are not wheelchair accessible. New construction at Pilchuk is accessible for artists in wheelchairs; old facilities are not adaptable

for the most part. Call for details. No special facilities for artists with vision or hearing impairment.

RESIDENCY STATISTICS

Application deadline: March 1 (call for confirmation).
Resident season: September 16–November 8.
Average length of residencies: 7 weeks.
Number of artists in 1998 (and total applicant pool): 6 (60).
Average number of artists present at one time: 6.
Selection process: Outside panel of professionals who jury from slides and by written proposal.

ARTIST PAYS FOR Application fee $25, food, travel, some materials.

INSTITUTION PAYS FOR Housing, studios, facilities, program administration, some materials.

ARTIST ELIGIBLE FOR Stipend $1,000.

ARTIST DUTIES None.

PUBLIC PROGRAMS Workshops May–September in studio glass. Open houses and tours May–September. Facilitated exhibitions periodically, year round. Lectures and presentations at special events year round.

HISTORY Founded in 1971 by Dale Chihuly, with the support of patrons Anne Gould Hauberg and John H. Hauberg.

MISSION To provide an opportunity for artists with prior achievement in glass and other visual arts media who seek a place and time to develop a particular idea or project involving glass.

PAST RESIDENTS INCLUDE Lillian Ball, Nick Cave, Mary Carlson, Lelsie Dill, Joe Marioni, Pat Oleszko, John Scott, Lorna Simpson, TODT, Albert Paley, Wendel Castle, Judy Pfaff, Joyce Scott.

FOR CURRENT APPLICATION REQUIREMENTS:

315 Second Avenue South
Seattle, WA 98104

TEL
(206) 621-8422

FAX
(206) 621-0713

E-MAIL
info@pilchuck.com

WEB
www.pilchuck.com

FROM THE ARTISTIC PROGRAM DIRECTOR "The time at Pilchuck is both very long and rich in possibilities, yet seemingly fleeting. It is a place where artistic failures can be as important as successes." —*Pike Powers*

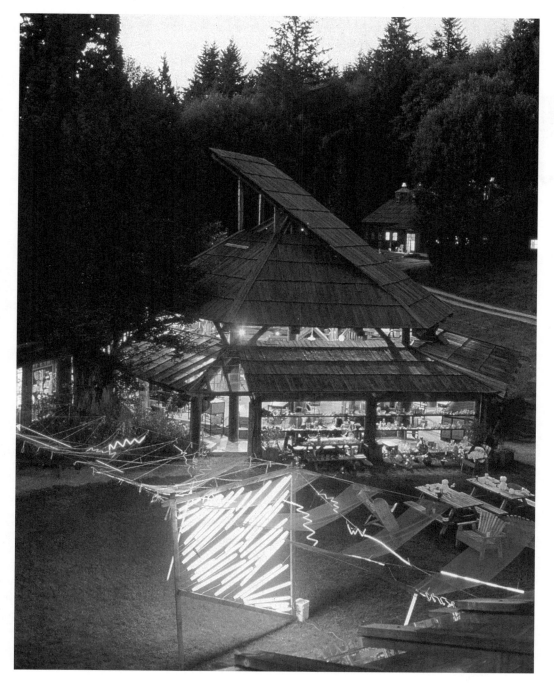

Portland Institute for Contemporary Art (PICA)

FOUNDED Organization 1995, Residency 1996.

LOCATION Portland, Oregon. Until the fall of 1999, PICA had no permanent facility. Local theaters, artists' studios, and warehouses housed its programs. PICA's new facility is located in Portland's Pearl District near the downtown area, in an up-and-coming retail, residential, and gallery area.

ELIGIBILITY Contemporary/experimental art in any discipline (with an emphasis on visual and performance artists). See indices for more specific types of artists served. No repeat residencies.

FACILITIES Buildings 8,000 square feet. PICA can provide access to darkrooms, film/video editing facilities, metalshops, potter or ceramics facilities, printshops, woodshops, theatre and performance spaces, rehearsal spaces, and exhibitions or installation space in the Portland community. PICA provides equipment as necessary on a case-by-case basis.

HOUSING/MEALS/ACCESSIBILITY

Housing/Services: PICA provides either hotel or private residences as appropriate for each artist. Spouse, children, or pets possible.
Meals: Artists purchase their own food and prepare their own meals.
Accessibility: Artists with disabilities can be accommodated. All facilities are accessible to artists in wheelchairs, and artists with vision or hearing impairment can be accommodated. Ramps, elevators, automatic doors, roll-in shower.

RESIDENCY STATISTICS

Application deadline: None. Residencies are curated by PICA.
Season: Year-round.
Average length of residencies: 2–4 weeks.
Number of artists in 1998 (and total applicant pool): 4 (unknown).
Average number of artists present at one time: 1–2 or collaborative groups.
Selection process: Residencies are curated by PICA's curator.

ARTIST PAYS FOR Food and materials.

INSTITUTION PAYS FOR Housing, studio, travel, modest materials stipend, facilities, program administration.

ARTIST DUTIES Informal sharing of work or formal exhibition.

PUBLIC PROGRAMS Workshops, educational programs, open house/tours, community outreach, international exchanges, readings/lectures, exhibitions/presentations.

HISTORY PICA's residency program began in 1996. Since that time, nine artists have been in residence. The majority of the artists-in-residence have been visual artists who created a specific body of work to be exhibited by PICA as part of PICA's exhibition program, which is documented in a publication on PICA's website. The performing artists have all worked on pieces that have been or will be presented in their entirety as part of PICA's performance

FOR CURRENT APPLICATION REQUIREMENTS:

219 N.W. 12th Avenue
Portland, OR 97209

TEL
(503) 242-1419

FAX
(503) 243-1167

E-MAIL
pica@pica.org

WEB
www.pica.org

> "*Of all the presenting organizations I have worked with, PICA has given me the most freedom to work eclectically and without restriction . . . the hospitality, involvement, and excitement of this organization assures me the finest presentation of my life's work.*"
> —Diamanda Galás

series. In addition to the residencies, PICA has also commissioned five performance works.

MISSION PICA acknowledges and advances the emerging ideas in new art by fostering the creative explorations of contemporary artists.

PAST RESIDENTS INCLUDE Marta Maria Perez Bravo, Carol Hepper, Roland Brener, Frédéric Robert Bouché, Valeska Soares, David Greenberger, Francis Alys, Ann Carlson, Bebe Miller (and her company), Jean Michel Othoniel. PICA has also commissioned performance pieces by Coco Fusco, Drew Pisarra, Miranda July, and Mary Oslund and was a co-commissioner of *Monsters of Grace* by Philip Glass and Robert Wilson.

FROM THE DIRECTOR "PICA's residencies are designed in collaboration with the artist to meet his or her individual needs and interests. In some cases this includes lively participation from Portland's arts community, while other residencies take place much more behind the scenes. We bring our resources as an organization to bear on an independent artist's project, process, or practice, which may involve investing in the early phases of a project, or helping a project come to completion. And while PICA's residencies aren't commissions, they have frequently resulted in our long-term involvement with a project." —*Kristy Edmunds*

FOUNDED Organization 1976, Residency 1976.

LOCATION 30 miles north of Chicago near Lake Michigan, in the suburb of Lake Forest.

ELIGIBILITY Fiction writers, visual artists, poets, creative nonfiction writers, composers (see indices for more specific types of artists served). Artists of all career levels welcome. Repeat residencies permitted.

FACILITIES 55-acre site. Buildings 14,000 square feet. 13 studios. Ragdale House has 5 rooms for writers; Barnhouse has 3 rooms for writers and 2 for visual artists; Friends' Studio has living and working space for 1 visual artist and 1 composer. Facilities include a baby grand piano. Beyond workspace, there are no additional visual arts facilities, and no major power tools are allowed (due to noise disturbance). Library/archive/collection. Computers can be rented and delivered. Residents must furnish their own software.

HOUSING/MEALS/ACCESSIBILITY

Housing/Services: Bedrooms within Ragdale's various historic buildings, weekly linen change, laundry rooms, bicycles, cross-country skis.

FOR CURRENT APPLICATION REQUIREMENTS:

1260 North Green Bay
Lake Forest, IL 60045

TEL
(847) 234-1063

FAX
(847) 234-1075

E-MAIL
ragdale1@aol.com

WEB
nsn.nslsilus.org/lfkhome/ragdale

Ragdale is a 15-minute walk from downtown Lake Forest where use of public library, personal check-cashing, local college pool are available. Lake Forest Beach permits also available. 1-hour train to Chicago.

Meals: All meals provided. Occasionally guests of the Foundation are invited to dinner for development or educational purposes.

Accessibility: Artists in wheelchairs can be accommodated. Housing, housing bathrooms, and studios are wheelchair accessible. Ramps. No special facilities for artists with vision or hearing impairment. Plans have been drawn up for a more universally accessible space. Fundraising is underway for targeted completion in 2001.

RESIDENCY STATISTICS

Application deadline: January 15 for June–December residencies. June 1 for January–April residencies. (Latter season is less competitive.)
Resident season: All year, except May and last half of December.
Average length of residencies: 2 weeks–2 months.
Number of artists in 1998 (and total applicant pool): 163 (429).
Average number of artists present at one time: 12.
Selection process: Outside panel of professionals in each discipline. Anonymous review. Applicants juried in following categories: originality of work, technical mastery, quality of proposal, significance of work.

ARTIST PAYS FOR Application fee $20, fixed residency fee $15 per day (which is a contribution towards food costs), $75 non-refundable deposit (applied toward residency fee), travel, materials.

INSTITUTION PAYS FOR Housing, studios, food, facilities, program administration.

ARTIST ELIGIBLE FOR Frances Shaw Fellowship for women writers over 55, need-based Friend of Ragdale Scholarship, and other opportunities dependent on funding (please call to inquire).

> "At Ragdale, more than any place I've ever been, the individual voice and vision of the artist is still important, and indeed essential. It is not always easy to believe that our lone voices matter or are being heard in the modern age. Ragdale gives the artist the confidence that anything, all things, are possible." —Jane Hamilton

ARTIST DUTIES None.

PUBLIC PROGRAMS Weekly tours in summer, weekly on-site workshop, open houses, readings, lectures, exhibitions, presentations. Approximately 90 public events annually, mainly held off-site or during May when residency program is closed. Artists may make a public presentation if they are qualified and willing, and if appropriate opportunity exists.

HISTORY The Ragdale House and Barnhouse were designed and built in 1897 by the Chicago architect Howard Van Doren Shaw. In 1976, Shaw's granddaughter, Alice Judson Hayes, created the Ragdale Foundation to provide a peaceful place for artists of all disciplines.

MISSION Ragdale is a place for artists and writers to work. The Ragdale Foundation is committed to preserving the unique character of the Ragdale house and grounds and the spirit embodied in them to foster creative work by those in need of uninterrupted time to work.

PAST RESIDENTS INCLUDE Alex Kotlowitz, Stanley Crouch, Barbara Cooper, Lynda Barry, Lawrence Block, Ola Rotimi, Carol Anshaw, Jane Hamilton, Sarah Paretsky, Jacquelyn Mitchard, Joelle Wallach, Maurice Weddington, A. Manette Ansay, David Haynes.

FROM THE DIRECTOR "Located forty-five minutes north of Chicago, Ragdale offers twelve artists a homey atmosphere in an antique-filled arts and crafts setting. Featuring two buildings on the National Register of Historic Places, Ragdale adjoins fifty-five acres of virgin prairie, ideal for peaceful contemplation. Delicious communal dinners provide stimulating conversation and a convivial close to each day." —*Sonja D. Carlborg*

Roswell Artist-in-Residence Program

FOUNDED Organization 1967, Residency 1967.

LOCATION 5 acres of land in the high plains of southeastern New Mexico, just outside the city limits of Roswell (population 45,000), and 200 miles from Albuquerque, Santa Fe, and El Paso.

ELIGIBILITY Painters, sculptors, mixed media, printmakers—fine art, studio-based visual arts; no performance or production crafts. (See indices for more specific types of artists served.) No repeat residencies.

FACILITIES 5-acre site. 5 studios. Small electric kiln, basic woodshop machines, etching and lithography press, air compressor, arc welder. Darkroom available nearby at the Roswell Museum.

HOUSING/MEALS/ACCESSIBILITY

Housing/Services: 6 modestly furnished houses (with family accommodations), central laundry room (2 washers/2 dryers). Utilities paid except phone. Artists provide own transportation. Houses have 2 or 3 bedrooms to fit families. Two houses have two studios to accommodate spouses who are artists. Children of all ages welcome (swing-set on premise).

FOR CURRENT APPLICATION REQUIREMENTS:

P.O. Box #1
Roswell, NM 88202

TEL
(505) 622-6037

FAX
(505) 623-5603

E-MAIL
rswelair@dfn.com

WEB
www.astepabove.com/rair

Meals: Artists purchase own food and prepare own meals.

Accessibility: Artists in wheelchairs cannot be accommodated. Artists with hearing impairment can be accommodated, though no special facilities. No special facilities for artists with vision impairment. Roswell will try to accommodate each individual's special needs, and has long-term plans to improve accessibility.

RESIDENCY STATISTICS

Application deadline: Varies (contact Roswell for current application and details).
Resident season: Year-round.
Average length of residencies: 1 year.
Number of artists in 1998 (and total applicant pool): 7 (100+).
Average number of artists present at one time: 5.
Selection process: 6-member panels of local and visiting artists and curators choose grant recipients from a slide review process.

ARTIST PAYS FOR Application fee $20, food, travel, materials, phone.

INSTITUTION PAYS FOR Housing, studios, utilities (except phone), facilities, program administration.

ARTIST ELIGIBLE FOR Stipend $500 per month; $100 per month per dependent living at the community.

ARTIST DUTIES None.

PUBLIC PROGRAMS Exhibitions, lectures at the Roswell Museum and Art Center.

HISTORY The program began in 1967 through the philanthropic efforts of businessman and artist Donald Anderson (with implementation by the Roswell Museum and Art Center), whose vision it was to bring artists of national importance to live and work in the tranquillity of the high plains of southeastern New Mexico.

> *"The Roswell grant gave me the opportunity for a totally pure focus on my work, telescoping in a single year what might have taken three—and I suspect the questions that got asked here will sustain my work for years."* —Julia Couzens

MISSION To provide professional studio artists with the unique opportunity to concentrate on their work in a supportive communal environment for one full year, allowing artists of vision and technical merit to work without distraction.

PAST RESIDENTS INCLUDE Luis Jimenez, Colleen Sterritt, Alison Saar, Robert Colescott, Richard Schaffer, Stuart Arends, Julia Couzens, Milton Resnick, Eddie Dominguez, Diane Marsh, Robert Jessup, Susan Dopp.

FROM THE DIRECTOR "Artists need time away from the struggle of daily sustenance. They need free time to think, to experiment, to work through their ideas . . . and time to grow [and] . . . to make their vision real. The Roswell artist-in-residence program is one of the very rare places that offers visual artists this opportunity to work freely and undisturbed for a full year. It is truly a 'gift of time.'" —*Stephen Fleming*

Saltonstall Arts Colony/The Constance Saltonstall Foundation for the Arts

FOUNDED Organization 1994, Residency 1996.

LOCATION In the Finger Lakes region in a serene and rural setting with sweeping vistas and hiking trails. Five miles from Ithaca, New York.

ELIGIBILITY New York state artists only, working in poetry, creative prose, painting, and photography (see indices for more specific types of artists served). Repeat residencies after four years.

FACILITIES 200-acre site. 5 studios. Darkroom.

HOUSING/MEALS/ACCESSIBILITY

Housing/Services: Private living and working spaces, large studios for painters, and a fully equipped black-and-white darkroom.
Meals: Food provided. Vegetarian dinners prepared on weeknights. Artists prepare own breakfast, lunch, and weekend dinners in shared kitchen.
Accessibility: One artist's apartment and studio is wheelchair accessible, but elevator to the common spaces has not yet been built. Artists with special needs should inquire about our plans for better accessibility.

FOR CURRENT APPLICATION REQUIREMENTS:

120 Brindley Street
Ithaca, NY 14850

TEL
(607) 277-4933

FAX
(607) 277-4933

E-MAIL
artsfound@clarityconnect.com

RESIDENCY STATISTICS

Application deadline: January 15.
Resident season: Summer.
Average length of residencies: 1 month.
Number of artists in 1998 (and total applicant pool): 15 (45).
Average number of artists present at one time: 5.
Selection process: Outside panel of professionals in each category.

ARTIST PAYS FOR Travel, materials.

INSTITUTION PAYS FOR Housing, studios, food, facilities, program administration.

ARTIST ELIGIBLE FOR No stipend or fellowships/awards are available.

ARTIST DUTIES None, though we suggest that the artists hold an "open house" near the end of their residencies.

PUBLIC PROGRAMS Annual exhibit and reading series by residents/award recipients, held in Ithaca.

HISTORY Established in 1994 according to the wishes of Constance Saltonstall, a painter and photographer, who asked that her estate be used to benefit the arts. Her home became the Saltonstall Arts Colony.

MISSION To support visual and literary artists in New York State, especially in the Finger Lakes region.

PAST RESIDENTS INCLUDE Zena Collier, Laura Foreman, Richard Shpuntoff, Sara Eichner, Ruth Kessler, Francine Perlman.

FROM THE DIRECTOR "The goal of the Saltonstall Arts Foundation is to provide artists with the best working conditions possible and plenty of quiet time to focus on work. We accomplish this by hosting just five artists each month. The in-

> "Not only are the physical accommodations and the meals exceptional, but the ambiance is one of focused creativity with the gentle healing that comes with self-acceptance. I felt Connie Saltonstall's spirit helping me to shape, exercise, and refine my process. This is indeed an oasis and I was glad to have rejuvenated myself here." —Hope Brennan

terdisciplinary blend of writers and artists sometimes leads to lasting collaborative efforts, and the surrounding countryside is often a great source of inspiration." —Lee-Ellen Marvin

Sculpture Space, Inc.

FOUNDED Organization 1975, Residency 1975.

LOCATION On the site of the old Utica Steam Engine & Boiler Works in downtown Utica, New York, in proximity to light industry and material resources.

ELIGIBILITY Professional artists whose focus is sculpture, installation, metalwork, woodwork, conceptual, environmental, or media. No restrictions on geography, gender, or style. Working knowledge of English language highly recommended. One repeat residency permitted.

FACILITIES 2-acre site. 6,000 square feet of open building space, 1 private studio can accommodate four artists at a time. Extensive array of equipment available (contact Sculpture Space for detailed list). PowerMac computer with Photoshop, Alias 3D, Quark, Claris Works, Net Objects Fusion, Internet access.

HOUSING/MEALS/ACCESSIBILITY

Housing/Services: Subsidized 3-bedroom apartment shared with other artists. Spouses and/or children accommodated by special arrangement. No smoking. 3-bedroom, furnished apartment with kitchen is a 10-minute walk from the studio.

Meals: Artists purchase own food and prepare own meals. Kitchen in both the studio and apartment. Plenty of inexpensive, good ethnic restaurants in the vicinity.

Accessibility: Artists in wheelchairs may be accommodated (call for details about housing). Studios and public bathrooms are wheelchair accessible. Artists with hearing impairment can be accommodated, though no special facilities. No special facilities for artists with vision impairment. Staff is flexible and willing to do what they can to accommodate residents with disabilities.

RESIDENCY STATISTICS

Application deadline: December 15.
Resident season: Year-round.
Average length of residencies: 2 months.
Number of artists in 1998 (and total applicant pool): 22 (68).
Average number of artists present at one time: 3.
Selection process: Review committee of artists with one outside panelist.

ARTIST PAYS FOR Food, travel, materials, and low-cost housing.

INSTITUTION PAYS FOR Studios, equipment, facilities, program administration.

ARTIST ELIGIBLE FOR Stipends of $2,000 are available for 10–20 artists-in-residence annually.

ARTIST DUTIES To promote the organization as appropriate, provide good slides of work at the end of stay.

PUBLIC PROGRAMS Exhibitions in partnership with other organizations, open houses, tours.

HISTORY Founded in 1975 by a group of sculptors.

FOR CURRENT APPLICATION REQUIREMENTS:

SEND S.A.S.E. TO:
12 Gates Street
Utica, NY 13502

TEL
(315) 724-8381

FAX
(315) 724-8381

E-MAIL
sculptur@borg.com

WEB
www.borg.com/~sculptur

"Sculpture Space is a perfect marriage between thinking and working. The community provides a special international climate which enabled me to feel free to experiment and to check my ideas over and over." —Marjetica Potrc

MISSION To provide professional artists with the opportunity and space to create sculptural works on a scale they otherwise could not afford and in an environment conducive to experimentation.

PAST RESIDENTS INCLUDE Jennifer Pepper, Tomasz Domanski, Yasufumi Takahashi, Kim Waale, Tim Merrick, Ann Reichlin, Kenseth Armstead,

Maki Hajikano, Renee Ridgway, Juan and Jean Ormaza.

FROM THE DIRECTOR "By providing access to a well-equipped workspace and a supportive environment—that includes the special expertise of the studio manager—we support the creative process that produces contemporary works of art." —*Gina Murtagh*

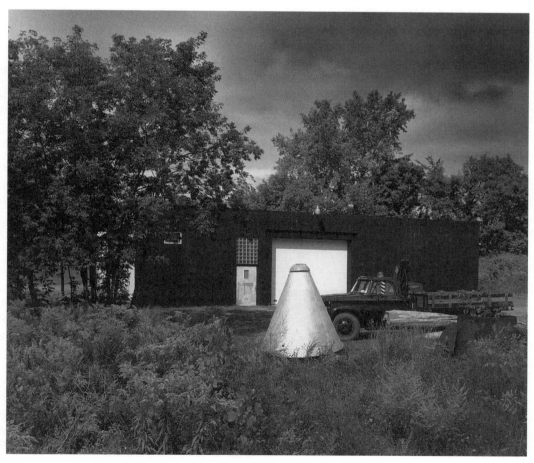

Shenandoah International Playwrights Retreat

FOUNDED Organization 1981, Residency 1976.

LOCATION On historic Pennyroyal Farm, north of Staunton, in the Shenandoah Valley of Virginia.

ELIGIBILITY Playwrights/screenwriters, actors, directors, musicians, radio, interdisciplinary (see indices for more specific types of artists served). Repeat residencies permitted.

FACILITIES Four performance/rehearsal spaces, library/archive/collection, Internet access for artists with own computers.

HOUSING/MEALS/ACCESSIBILITY

Housing/Services: Housing at local college or in local homes. Spouse possible.
Meals: Breakfast supplies provided at residence. Lunch and dinner are prepared by a resident chatelaine and served at Pennyroyal Farm.
Accessibility: Artists in wheelchairs cannot be accommodated, though housing and housing bathrooms are wheelchair accessible. As renovation and construction takes place, wheelchair accessibility will be addressed. Artists with vision or hearing impairment can be accommodated.

FOR CURRENT APPLICATION REQUIREMENTS:

Route 5, Box 167-F
Staunton, VA 24401

TEL
(540) 248-1868

FAX
(540) 248-7728

E-MAIL
shenarts@cfw.com

RESIDENCY STATISTICS
Application deadline: February 1.
Resident season: August–September.
Average length of residencies: 3–6 weeks.
Number of artists in 1998 (and total applicant pool): 7 (160).
Average number of artists present at one time: 8.
Selection process: Outside panel of professionals, along with artistic staff.

ARTIST PAYS FOR Any special materials needed.

INSTITUTION PAYS FOR Housing, performance/rehearsal space, food, travel, general facilities, program administration.

ARTIST ELIGIBLE FOR No stipends or fellowships/awards are available.

ARTIST DUTIES To work with company of actors, directors, and staff on play project for which they were accepted, including attending workshops, rehearsals, and performances.

PUBLIC PROGRAMS Public performances.

HISTORY Founded in 1976.

MISSION To provide young and established writers with a stimulating, challenging environment to test and develop new work in a safe haven, free from the pressures of everyday living.

PAST RESIDENTS INCLUDE Karim Alrawi, Michael Henry Brown, Tat Ming Cheung, Sean Clark, Tom Dunn, Julie Jenson, Carol Wright Krause, Oliver Mayer, Kirk Read, Phoef Sutton, Yo-Huei Wang, Jeff Wanshel.

FROM THE DIRECTOR "At Shenandoah, we see the universal, the common thread that links us all. Playwrights from different regions of this world come to live and work with our multicultural company of theatre artists. We explore together the unique vision and voice of each writer . . . by walking one collaborative mile in their shoes." *—Robert Graham Small*

66 "No critical encounter was ever as valuable as Shenandoah, none ever more challenging, none ever more ultimately useful to me as a playwright, an artist, and human being."
—Julie Jensen

Sitka Center for Art and Ecology

FOUNDED Organization 1970, Residency 1981.

LOCATION In the Cascade Head National Scenic Research Area in Oregon, overlooking the Salmon River estuary and Pacific Ocean. 100 miles down the coast from Astoria.

ELIGIBILITY Visual artists, writers, musicians/dancers/performers, architects/designers, scholars (see indices for more specific types of artists served). No repeat residencies.

FACILITIES 1-acre site. Buildings 3,800 square feet. Residence 2,250 square feet. 4 studios. Printshop, 36-inch-by-72-inch etching press, sculpture studio, Skutt kiln, one mechanical wheel, exhibition space. Macintosh and Power Mac computers with Photoshop, Premiere, After Effects, PageMaker, Quark, and Internet access. Research room (to become library) available. Completion of digital imaging studio projected for 2001.

HOUSING/MEALS/ACCESSIBILITY

Housing/Services: Three residences, with kitchens and baths. One residence has second sleeping area and a larger living area so it can accommodate spouse and one child.

FOR CURRENT APPLICATION REQUIREMENTS:

P.O. Box 65
Otis, OR 97368

TEL
(541) 994-5485

FAX
(541) 994-8024

E-MAIL
sitka@oregonvos.net

WEB
www.oregonvos.net/~sitka

Meals: Artists purchase own food and prepare own meals.

Accessibility: Not yet wheelchair accessible, though Sitka is in the process of changing this. Currently, studios, public bathrooms, kiln, potter's wheel, slide projection, and printing press (etching) facilities are wheelchair accessible. Ramps. Artists with vision or hearing impairment can be accommodated—1 studio and bathroom will accommodate residents with vision impairment; no specific facilities for artists with hearing impairment.

RESIDENCY STATISTICS

Application deadline: April 15.
Resident season: October 1–January 21; February 1–May 21.
Average length of residencies: 3–4 months.
Number of artists in 1998 (and total applicant pool): 14 (18).
Average number of artists present at one time: 2–3.
Selection process: Outside panel of professionals in each category, together with residency committee and executive director.

ARTIST PAYS FOR Food, travel, materials.

INSTITUTION PAYS FOR Housing, studios, facilities, program administration.

ARTIST ELIGIBLE FOR Founders' Series award of $500 monthly stipend to one of the four artists-in-residence each year. Founders Series Invitational opportunity for artists of international stature, which provides a modest stipend and covers travel and materials costs (since 1993).

ARTIST DUTIES Up to 20 hours of community service through presentations, workshops, work with schools, and some maintenance responsibilities.

PUBLIC PROGRAMS Workshops, presentations, exhibitions, lectures, seminars, open house, tours (these may serve as community service).

HISTORY The Neskowin Coast Foundation was founded in 1970 to promote interest in and provide the opportunity to study various forms of art, music, and the ecology on the central Oregon coast. In 1971, the foundation built the Sitka Center at Cascade Head Ranch in Otis in order to create a program that explores the relationship between fine arts, crafts, and natural science.

MISSION To expand the relationship between art, nature, and humanity . . . in harmony with the inspirational coast environment of Cascade Head.

PAST RESIDENTS INCLUDE Damian Manuhwa, Debra Loew, Dawne Douglas, Michael Liddle, Landa Townsend, Kirk Tatom, Vladimir Tsivin, Larry Thomas, Mark Derby, Marlana Stoddard, Weishu Hsu, Catherine Murray, Ferida Durakovic, Jindra Vikova, Pavel Banka, Charles Chu, Andrey Noda, Kim Stafford, Robin Coty, Deb DeWit.

FROM THE DIRECTOR "At Sitka you have nature surrounding you, a trust to pursue your vision, and time to see your work take form." —*Randall Koch*

Skowhegan School of Painting and Sculpture

FOUNDED Organization 1946, Residency 1946.

LOCATION Forested lake district of central Maine.

ELIGIBILITY Visual artists in all media—painting, sculpture, performance, installation, video (see indices for more specific types of artists served). No repeat residencies.

FACILITIES 300-acre site. 65 studios. Darkroom, metalshop, pottery/ceramics facility, woodshop, 16,000-book library, digital video-editing facility, Medin 100 computer system for video editing, wide range of imaging software, and Internet access.

HOUSING/MEALS/ACCESSIBILITY

Housing/Services: Dorm-style rooms. Married participants may be accompanied by their spouse but they must live off campus.
Meals: Three meals provided each day.
Accessibility: Artists in wheelchairs cannot be accommodated currently. Ramps are included in all new construction and have been built for most public facilities including the auditorium and the library. No facilities for artists with vision impairment. Artists with hearing impairment can be accommodated (though no signers available or special facilities). Plans for improving accessibility.

RESIDENCY STATISTICS
Application deadline: February 1.
Resident season: June–August.
Average length of residencies: 9 weeks.
Number of artists in 1998 (and total applicant pool): 65 (800).
Average number of artists present at one time: 65 plus 10 senior artists.
Selection process: Reviewed and selected by upcoming faculty and board of governors.

ARTIST PAYS FOR Application fee $35; fixed residency fee (tuition) $5,200 per summer (however, 94% of residents receive fellowships to help with this fee), travel, materials.

INSTITUTION PAYS FOR Housing, studios, food, tuition, facilities, program administration.

ARTIST ELIGIBLE FOR Examples of fellowships offered toward tuition: Camille Hanks Cosby Fellowships for African American artists (3); Payson Governors Fund Fellowships for artists of Asian or Pacific descent and artists of Central or South American or Caribbean descent; Fellowships for artists from Kansas, Maine, Ohio, California.

ARTIST DUTIES 6 hours per week of service to the school.

PUBLIC PROGRAMS Weekly lectures by visiting artists.

HISTORY Founded in 1946.

MISSION To provide an extended and concentrated period of independent work, made with the critical assistance and camaraderie of residents and visiting artists.

PAST RESIDENTS INCLUDE Ellen Gallagher, Tobi Khedoori, Ross Bleckner, David Reed, Janet

FOR CURRENT APPLICATION REQUIREMENTS:

200 Park Avenue South, Suite 1116
New York, NY 10003

TEL
(212) 529-0505

FAX
(212) 473-1342

> "Skowhegan helped instill in me a sense of artistic esteem and cultural competency that I did not have before coming to study there." —David Driskell

Fish, Nari Ward, Ellsworth Kelly, Alex Katz, Bill King, Byron Kim.

FROM THE DIRECTOR "Skowhegan is an intense nine-week program that provides the space to work and a unique opportunity for artistic interaction around the clock." —*Tom Finkelpearl*

STUDIO for Creative Inquiry

FOUNDED Organization 1989, Residency 1990.

LOCATION Campus of Carnegie Mellon University.

ELIGIBILITY Interdisciplinary artists, conceptual, multimedia, media, and new genre (see indices for more specific types of artists served). Repeat residencies permitted.

FACILITIES 12 studios. Video-editing and recording equipment in studios, as well as access to multimedia labs, computing resources (Apple, Mac, and PC computers with word processing, database, and graphic programs as well as Internet access), sculpture studios, and MIDI equipment. Darkroom, theatre/performance space, rehearsal space, library/archive/collection, exhibition/installation space.

HOUSING/MEALS/ACCESSIBILITY

Housing/Services: Stipends provided will cover nearby, affordable rentals. Collaborative groups, spouse, children possible.
Meals: Artists purchase own food (which stipend covers) and prepare own meals, except for monthly meetings and special events.

FOR CURRENT APPLICATION REQUIREMENTS:

Carnegie Mellon University
College of Fine Arts
Pittsburgh, PA 15213-3890

TEL
(412) 268-3454

FAX
(412) 268-2829

E-MAIL
mmbm@andrew.cmu.edu

WEB
www.cmu.edu/studio/

Accessibility: Facilities are not completely wheelchair accessible, but the STUDIO staff will make any special arrangements they can to accommodate artists in wheelchairs. Studios, public bathrooms, and some other facilities are wheelchair accessible. Ramps, elevators. Artists with vision or hearing impairment can be accommodated—the STUDIO has access to technologies for sight-impaired residents and access to signers for hearing-impaired residents. Plans for improving accessibility.

RESIDENCY STATISTICS
Application deadline: Ongoing.
Resident season: Year-round.
Average length of residencies: 1 year.
Number of artists in 1998 (and total applicant pool): 10 (20).
Average number of artists present at one time: 3 full-time, 10 part-time.
Selection process: Committee (comprised of artists and staff) makes recommendations to the director.

ARTIST PAYS FOR Nothing.

INSTITUTION PAYS FOR Studios, facilities, program administration, and a stipend to cover housing, food, travel, and materials costs (see "Artist Eligible For").

ARTIST ELIGIBLE FOR Stipend $30,000 per year plus extensive benefits program. Some artists receive a small project fund. No fellowships/awards, though artists are appointed as research fellows with special faculty status during residency.

ARTIST DUTIES One public presentation.

PUBLIC PROGRAMS Open house, special events, workshops, performances, exhibitions, international exchanges, K–12 school visits/tours.

HISTORY Funded by Apple Computer, the community began as the Center for Art and Technology. In 1989, in an effort to broaden its

> ❝ *"The STUDIO for Creative Inquiry is an exciting and rich interdisciplinary environment in which to develop artwork. In collaboration with artists, art historians, actors, videographers, audio engineers, and electrical engineers, I was able to accomplish the goals I set for my residency, which focused on the creation of interactive, computer-based artwork . . . in the technoculture. The STUDIO's understanding of artists' working processes and receptiveness to experimentation and exploration created an ideal climate in which to work."* —George Roland

mission, the Center became the STUDIO for Creative Inquiry.

MISSION To support cross-disciplinary and exploratory work in the arts by providing artists residencies with stipends, commissions, and studio space, establishing an environment of interdisciplinary practitioners. Within this framework, a focus of activity has emerged which includes work in biology, ecology, and robotics.

PAST RESIDENTS INCLUDE Lowry Burgess, Ping Cao, Agnes Denes, Rob Fisher, Paul Glabicki, Xavier Perrot, Seth Riskin, Julian Thayer, Patricia Villalobos, Regi Allen, Portia Cobb, Tim Collins, George Roland, Demetria Royals, Carolyn Speranza.

FROM THE DIRECTOR "Technology is transforming the way we learn and experience the world. This transformation impacts significantly upon the work of the artist. To remain up-to-date with current technology, artists require access to new tools and techniques. They need supportive environments which connect their talents with the skills and interests of practitioners from disciplines outside of art. Art making, like most endeavors in our culture, has become a more complex undertaking. Artists need innovative organizations like the STUDIO for Creative Inquiry to supply the support structure for today's art making." —*Bryan Rogers*

Studios Midwest

FOUNDED Organization 1986, Residency 1986.

LOCATION In a town of 33,000 served by Amtrak, in Illinois farm country, 3 hours drive to Chicago, 30 miles from Mississippi River.

ELIGIBILITY Sculpture, painting, photography (see indices for more specific types of artists served). Repeat residencies permitted.

FACILITIES Buildings 4,000 square feet. 5 studios. Darkroom, exhibition space.

HOUSING/MEALS/ACCESSIBILITY

Housing/Services: Separate apartment for each resident (furnished). Resident provides linens. Laundry facilities nearby. Residents can walk to studios and downtown Galesburg; public bus system available.
Meals: Artists purchase own food and prepare own meals.
Accessibility: Artists with disabilities cannot be accommodated.

RESIDENCY STATISTICS

Application deadline: Third Friday in February.
Resident season: June–August.

FOR CURRENT APPLICATION REQUIREMENTS:

P.O. Box 291
Galesburg, IL 61402

TEL
(309) 344-8923

FAX
(309) 344-7437

E-MAIL
mps@galesburg.net

Average length of residencies: 2 months.
Number of artists in 1998 (and total applicant pool): 3 (30).
Average number of artists present at one time: 5.
Selection process: Outside panel of professionals in visual art.

ARTIST PAYS FOR $50 refundable damage deposit, food, travel, materials.

INSTITUTION PAYS FOR Housing, studios, facilities, program administration.

ARTIST ELIGIBLE FOR No stipends or fellowships/awards are available.

ARTIST DUTIES Prepare slides of work for informal presentation, participate in media publicity, show results of summer work, complete a short program evaluation upon departure.

PUBLIC PROGRAMS Exhibitions, receptions, dinners with community, sponsors, and local artists. Slide show and talk by residents (open to community).

HISTORY Founded in 1986 as a way to bring artists to Galesburg.

MISSION To provide free housing and studio space for two months for five visiting artists, with a short exhibit, and occasional informal presentations and receptions, in order to introduce new art to Galesburg.

PAST RESIDENTS INCLUDE Denice Tschumi, Scott Greenig, Nan Wollman, Carole Spelic, Albert Liu, Michael Albright, Allan Montgomery, Susan Wink, Carla Rae Johnson, Shawne Major, Carla Markwart, Chris Verene.

FROM THE DIRECTOR "The Galesburg community looks forward to meeting and welcoming the residents each summer, and we are glad to learn about each artist's work." —*Mona Tourlentes*

"It will always be with fondness and good memories that I think about Galesburg, Illinois! The summer was delightful, productive, and so necessary for my creative survival." —Carla Rae Johnson

Sundance Institute

FOUNDED Organization 1981, Residency 1981.

LOCATION At the Sundance Resort in Utah.

ELIGIBILITY Film-/videomakers, playwrights, screenwriters, composers. Artists may participate in Screenwriters Lab, Filmmakers Lab, Producers Conference, Playwrights Lab, Composers Lab. Repeat residencies permitted.

FACILITIES Film-/video-editing facility with AVID editing system and digital video, library/archive/collection, rehearsal space, exhibition space.

HOUSING/MEALS/ACCESSIBILITY

Housing/Services: Private room in resort.
Meals: All meals provided.
Accessibility: Artists in wheelchairs or with vision or hearing impairment can be accommodated. Housing, housing bathrooms, and public bathrooms are wheelchair accessible. Ramps. Call to see if accommodations can be made for specific needs.

RESIDENCY STATISTICS

Application deadline: First week of May for all programs.

FOR CURRENT APPLICATION REQUIREMENTS:

SEND S.A.S.E. TO:
225 Santa Monica Boulevard, 8th Floor
Santa Moncia, CA 90401

TEL
(310) 394-4662

FAX
(310) 394-8353

E-MAIL
la@sundance.org

WEB
www.sundance.org

Resident season: Screenwriters in January and June. Filmmakers in June.
Average length of residencies: Screenwriters, 5 days. Filmmakers, 3 weeks.
Number of artists in 1998 (and total applicant pool): 20 (2,500).
Average number of artists present at one time: 10–12.
Selection process: Staff review, then finalists are sent to outside panel of professionals that form selection committee.

ARTIST PAYS FOR Application fee $30.

INSTITUTION PAYS FOR Housing, food, travel, materials, facilities, program administration.

ARTIST ELIGIBLE FOR No stipend or fellowships/awards are available.

ARTIST DUTIES Meetings and production work.

PUBLIC PROGRAMS Sundance Film Festival, International Program, Sundance Children's Theatre, New Media Initiative, Theatre Lab, Composers Lab, Screenplay Reading Series.

HISTORY Founded in 1981 by Robert Redford and other filmmakers.

MISSION To support the development of emerging screenwriters and directors of vision and the national and international exhibition of independent dramatic and documentary films.

PAST RESIDENTS INCLUDE Tony Bui, Tom DiCillo, Chris Eyle, Sherman Alexie, Tamara Jenkins, Allison Anders, Paul T. Anderson, Miguel Arteta, Lisa Krueger, James Mangold, Darnell Martin, Walter Mosely, Christopher Munch, Quentin Tarantino, Boaz Yakin.

FROM THE DIRECTOR "Sundance offers screenwriters and filmmakers a safe environment in which to work, think, and talk about the craft of writing and directing, a place to take risks, experiment, and push the boundaries of their

> *"I was surrounded by piles of scenes that made no sense . . . [Working with actors at Sundance], being able to actually workshop scenes with living flesh, as opposed to pen or computer, was really beneficial."* —Tamara Jenkins

work, and a place to develop what is often their first feature project." —*Michelle Satter*

FOUNDED Organization 1982, Residency 1982.

LOCATION From 1982 to 1993 the New York Triangle Workshop took place at Pine Plains, New York. Since then it has regularly changed venues: Most recently in 1998 and 1999, it was held in the upper floors of the World Trade Center. In 1997, it was held in Monroe, New York. In the future, it will be in the vicinity of New York City. [Note: The Triangle Arts Association, Ltd. (New York) is affiliated with the Triangle Arts Trust (London) and Triangle-France (Marseille). A year-round residency and exhibition program is run in London and Marseille. The Triangle Arts Trust in London coordinates workshops in Great Britain, several African countries, Australia, India, Trinidad, and Jamaica. Year-round residencies exist in South Africa and others are currently in the process of being set up.]

ELIGIBILITY Painters, sculptors, mixed media artists, installation artists (see indices for more specific types of artists served). Quality of work is main criteria for selection. No restrictions of age or career status or profile. However, no students may apply. No repeat residencies.

FOR CURRENT APPLICATION REQUIREMENTS:

110 Greene Street, #8R
New York, NY 10012

TEL
(212) 431-5895

FAX
(212) 431-4159

E-MAIL
willyard@inch.com

WEB
www.inch.com/~willyard/triangle.html

FACILITIES 30 studios. Metalshop, woodshop, exhibition/installation space, in-house art materials store, slide projector, presentation facilities, cafeteria. Computer available to residents but only for text, communication purposes, Internet access.

HOUSING/MEALS/ACCESSIBILITY

Housing/Services: These facilities vary from year to year but in every case full housing and meals are provided with hotel standard linen service, and transportation when needed within local radius. The Triangle Artists' Workshop is an intensive two-week retreat-like situation. Visitors are actively discouraged until the open studios day.
Meals: All meals are provided.
Accessibility: Depends on the venue used. In 1998 and 1999, the World Trade Center provided good accessibility with full elevator service, etc. Triangle is committed to doing all they can to accommodate artists with disabilities.

RESIDENCY STATISTICS

Application deadline: February 1 or May 1.
Resident season: Two weeks in October.
Average length of residencies: Two weeks.
Number of artists in 1998 (and total applicant pool): 22 (300).
Average number of artists present at one time: 25.
Selection process: Selection is made by a jury whose composition changes annually, made up of artists, critics, art historians, and curators.

ARTIST PAYS FOR Fixed residency fee $400, travel, materials.

INSTITUTION PAYS FOR Housing, studios, food, facilities, program administration. Often pays for exhibition, catalogue, etc.

ARTIST ELIGIBLE FOR No stipend or specific fellowships/awards, though many participants obtain funding from sponsors (or their respective governments).

ARTIST DUTIES None.

> *"Having domestic things taken care of is a great luxury. You get to the 'front line' much sooner, which is both exciting, frightening, and perhaps telling."* —Robert Welch

PUBLIC PROGRAMS International exchanges, open studios day, lectures by visiting critics during residency; exhibitions subsequent to the residency.

HISTORY The Triangle Artists' Workshop was founded in 1982 by the British sculptor Anthony Caro and the collector Robert Loder. Since then, it has continued to offer annual sessions of intensive work for a selected group of artists. Affiliated organizations offering workshops and residencies now exist in many countries.

MISSION Since 1982 The Triangle Artists' Workshop has brought together artists from around the world to participate in an intensive two-week session of work, experimentation, and exchange. Triangle is neither an artists' colony nor a school but a unique haven for professional artists seeking an open environment and dialogue with their peers.

PAST RESIDENTS INCLUDE Basil Beattie, Anthony Caro, John Gibbons, Andrea Belag, Friedel Dzubas, Frank Gehry, Saul Ostrow, Larry Poons, Guy Limone, Stefan Sehler, Susana Solano.

FROM THE DIRECTORS "The best artists are those who never cease to question their own practice and to view the world with curiosity and astonishment, even in the face of their own achievements, however impressive these may be. In a similar way, the strength and success of each Triangle Artists' Workshop must depend on the ability of its participants to respond to the intensity of two weeks of constructive turmoil, in order perhaps to explore new artistic avenues within their own practice."
—*Triangle Board of Directors*

FOUNDED Organization 1997, Residency 1999.

LOCATION Uptown Charlotte, North Carolina. Tryon Center's artist-in-residence program facility is a historic, 1926 neo-Gothic church built of brick and stone. The structure burned in a fire in 1985 and was renovated for the residency program in 1998.

ELIGIBILITY Sculpture, painting, technology/media, photography, ceramics, installation, community art (see indices for more specific types of artists served). Emerging, midcareer, and senior/mature artists; local, national, and international nomination and jurying process. (Tryon also offers local artists studios for 18-month periods at subsidized rates, through its Affiliate Artists Program. Call for details.) Repeat residencies permitted.

FACILITIES Buildings 30,000 square feet. 15 studios. Darkroom, film-/video-editing facility, metalshop, pottery/ceramics facility, printshop, woodshop, exhibition/installation space, media lab. Mac G3 platform computers with media graphic programs; Photoshop, Quark, scanners, large format printers; T-1 line; Internet access.

FOR CURRENT APPLICATION REQUIREMENTS:

721 North Tryon Street
Charlotte, NC 28202

TEL
(704) 332-5535

FAX
(704) 377-9808

E-MAIL
info@tryoncenter.org

HOUSING/MEALS/ACCESSIBILITY

Housing/Services: Fully furnished one- and two-bedroom apartments located a few blocks from studios and in the uptown cultural district of Charlotte. Spouse, children possible.

Meals: Per diem is provided with which artists purchase own food and prepare own meals on a daily basis with communal dinners once a week.

Accessibility: Artists in wheelchairs can be accommodated. Housing, housing bathrooms, studios, public bathrooms, and kitchens are wheelchair accessible. Elevators, automatic doors. No special facilities for artists with vision or hearing impairment.

RESIDENCY STATISTICS

Application deadline: By nomination only.
Resident season: Year-round.
Average length of residencies: 3 months.
Number of artists in 1998 (and total applicant pool): 12 (100).
Average number of artists present at one time: 6.
Selection process: 50 percent curatorial, 50 percent recommendation/panel review. Panel changes annually.

ARTIST PAYS FOR Nothing.

INSTITUTION PAYS FOR Housing, studios, food, travel, materials, facilities, program administration.

ARTIST ELIGIBLE FOR Stipends, per diem for food.

ARTIST DUTIES For those interested, lectures, critiques, panel discussion, etc., in local community.

PUBLIC PROGRAMS Adult studio classes, master classes by nationally respected artists (for local artists), symposia and lectures, exhibitions in three gallery spaces, international exchanges.

HISTORY Tryon Center for Visual Art evolved from the melding of two predecessor visual arts organizations in Charlotte: Spirit Square and

> *"Tryon Center offered me the unique experience of working at a creative center in a city eager to build its cultural identity. This atmosphere in Charlotte creates a sense of possibility that is concentrated within the experience of the residency. The space, tools, and community of artists working there produce an environment that is animated by the process of experimentation and the potential to engage a broad public."* —Alison Sant

Context. The history and experience of both of these organizations, combined with Tryon's artists' residency program, offer new opportunities for local artists and strengthen the overall health of the visual arts in Charlotte. The structure that houses the Tryon Center is an old Associate Reformed Presbyterian (ARP) Church which was acquired by NationsBank (now Bank of America) in 1995 for the purpose of establishing an artists' community.

MISSION Tryon Center for Visual Art is a progressive, not-for-profit organization committed to nurturing the visual arts in Mecklenburg County and building the Charlotte Region into a significant visual arts center in the southeast. Its main efforts are to attract regional, national, and international artists to the area to maintain a working artists' community; provide deserving artists with support and professional services; develop exhibitions and audiences for a diverse range of artists' work; and offer continuing education opportunities for artists and the public.

PAST RESIDENTS INCLUDE Willie Little, Susan Hagan, Lisa Esherick, Ali Sant, Kristaps Gulbis, Marcus Schubert.

FROM THE DIRECTOR "Tryon Center for Visual Art provides visual artists, as well as creative thinkers from other fields, opportunities to immerse themselves in their work for periods of three months. Tryon Center offers an atmosphere that encourages collaboration, formal and informal forums for exchanging ideas, and interaction between artists of this region and artists from other places and other cultures. Tyron Center is located in Uptown Charlotte, a vital, progressive, and growing city that is excited to host this new urban laboratory." —*Suzanne Fetscher*

Ucross Foundation Residency Program

ALLIANCE OF ARTISTS' COMMUNITIES MEMBER

FOUNDED Organization 1981, Residency 1983.

LOCATION On a 22,000-acre working cattle ranch in northeast Wyoming, in the foothills of the Big Horn Mountains, 27 miles southeast of Sheridan.

ELIGIBILITY Writers and visual artists of all disciplines, composers, musicians, dancers, choreographers, general scholars and historians, filmmakers, environmentalists and naturalists (see indices for more specific types of artists served).

FACILITIES 8 studios, including 4 writing studios and 4 visual artist studios (including one printmaking studio with etching press).

HOUSING/MEALS/ACCESSIBILITY

Housing/Services: Separate, private bedrooms, shared bathrooms.
Meals: All meals provided (lunch delivered to studios) Monday–Friday; food provided for artists to prepare their meals on weekends.
Accessibility: Artists in wheelchairs can be accommodated. Housing, bathrooms, studios, and public bathrooms are wheelchair accessible. Ramps. No special facilities for artists with vision or hearing impairment, but will make every attempt to serve these artists.

RESIDENCY STATISTICS

Application deadline: March 1, October 1.
Resident season: August–early December, February–early June.
Average length of residencies: 2–8 weeks.
Number of artists in 1998 (and total applicant pool): 60 (300).
Average number of artists present at one time: 8 (maximum).
Selection process: Outside, rotating panel of professionals in each category.

ARTIST PAYS FOR Application fee $20, travel, materials.

INSTITUTION PAYS FOR Housing, studios, food.

ARTIST ELIGIBLE FOR No stipends or fellowships/awards are available.

ARTIST DUTIES None.

PUBLIC PROGRAMS Conference facilities, exhibitions.

HISTORY Founded in 1981, Ucross is at "Big Red," a complex of buildings built in 1882, and once the headquarters of the Pratt and Ferris Cattle Company.

MISSION To encourage exceptional creative work and foster the careers of serious artists.

PAST RESIDENTS INCLUDE Annie Proulx, Ann Patchett, Debra Spark, Hugh Ogden, Stephanie Heyl, David Bungay, Josip Novakovich, Ha Jin, Sigrid Nunez, Rafi Zabor, Catherine McCarthy, A. J. Verdelle, Rosemary Daniell.

FROM THE DIRECTOR "Ucross is a magical place. Our goal is to enhance the environment in which individuals can realize their fullest potential." —*Elizabeth Guheen*

FOR CURRENT APPLICATION REQUIREMENTS:

30 Big Red Lane
Clearmont, WY 82835

TEL
(307) 737-2291

FAX
(307) 737-2322

E-MAIL
ucross@wyoming.com

Vermont Studio Center

FOUNDED Organization 1984, Residency 1984.

LOCATION Northern Vermont, in the town of Johnson, population 2,500.

ELIGIBILITY Painters, sculptors, printmakers, photographers, mixed media, writers, poets (see indices for more specific types of artists served). Repeat residencies permitted.

FACILITIES 60 private studios. 36 painting studios, 12 rooms for writers, 12 sculpture studios, sculpture shop, metalshop, woodshop, pottery/ceramics facility, printmaking studio for 4 printmakers, darkroom, 16 rooms for writers, lecture hall, exhibition space, print station and copy room, studio supply store, book and video libraries. Computers located in the print station for use by writing residents; no e-mail, though Vermont Studio receives e-mails for residents. Internet access for artists with own computers.

HOUSING/MEALS/ACCESSIBILITY

Housing/Services: 6 residence houses, dining hall, complete linen service, housekeeping service.
Meals: All meals provided, renowned food from on-site organic gardens in season.

FOR CURRENT APPLICATION REQUIREMENTS:

P.O. Box 613
Johnson, VT 05656

TEL
(802) 635-2727

FAX
(802) 635-2730

E-MAIL
vscvt@pwshift.com

WEB
www.vermontstudiocenter.com

Accessibility: Artists in wheelchairs can be accommodated. Housing, housing bathrooms, studios, public bathrooms, lecture hall, and Red Mill Center are wheelchair accessible. Ramps. Artists with vision or hearing impairment can be accommodated, though there are no special facilities.

RESIDENCY STATISTICS
Application deadline: February 15, June 15, and September 30.
Resident season: Year-round.
Average length of residencies: 1 month.
Number of artists in 1998 (and total applicant pool): 500 (2,220).
Average number of artists present at one time: 50 (24 painters, 12 sculptors, 12 writers, 2 printmakers/photographers).
Selection process: Outside panel of professionals in each category.

ARTIST PAYS FOR Application fee $25, residency fee $1,300 per month, travel, materials.

INSTITUTION PAYS FOR Housing, studios, food, facilities, program administration.

ARTIST ELIGIBLE FOR 150 full fellowships per year awarded on a competitive basis. Numerous international, regional, and statewide fellowship programs (call Vermont Studio for details). 250 partial grants and work exchange available. Stipend of $10 per day for international artists.

ARTIST DUTIES None for full-fellowship or Vermont Studio Center Residency Grant residents. 5–10 hours per week of physical plant work for Work-Exchange Aid residents.

PUBLIC PROGRAMS Visual artists slide lectures, reading series, gallery exhibitions (these programs provide Vermont Studio residents with year-round access to monthly roster of visiting artists and writers). International exchanges, Saturday community art program, Vermont artists weeks, weekly community life drawing sessions, community photography program.

> *"One of the greatest experiences of my life! It was a rare opportunity to be able to paint all day in a wonderful studio, in a wonderful environment, and I am everlastingly grateful for this marvelous happening."* —Elise Goll

HISTORY Founded in 1984 by artists Jon Gregg, Louise von Weise, and Fred Osborne, the Vermont Studio Center was inspired by the Cedar Tavern in Greenwich Village of the early 1950s, which fostered friendships between such artists and writers as Jackson Pollock and Frank O'Hara. Since its founding, Vermont Studio has expanded from a four-building to a twenty-three–building art colony, providing year-round workspaces and uninterrupted time to painters, sculptors, and writers from all over the world. The buildings have been redesigned to promote concentrated work and allow for optimum use of light. Over the years, Vermont Studio has also developed a broad range of fellowship opportunites to encourage a diverse mix of artists.

MISSION To build an ideal international creative community that supports serious artists and writers by providing them with the seclusion of distraction-free working time, the companionship of professional peers, and the option of the counsel of inspired visitors.

PAST RESIDENTS INCLUDE Jake Berthot, John Walker, William Bailey, Joan Snyder, Louise Fishman, Grace Hartigan, Neil Welliver, Joel Shapiro, Bill Jensen, Grace Paley, Donald Hall, Galway Kinnell, Maxine Kumin.

FROM THE FOUNDER "The Vermont Studio Center is an international creative, contemplative community that offers a unique format that provides artists with the independent, distraction-free studio time found in a colony, plus the added option of studio visits from a roster of prominent visiting artists and writers, available weekly on a year-round basis." —*Jonathan T. Gregg*

FOUNDED Organization 1995, Residency 1996.

LOCATION Villa Aurora is located in Pacific Palisades overlooking the Pacific Ocean, minutes away from downtown Santa Monica. Villa Aurora was awarded the City of Los Angeles Historic Preservation Award of Excellence in October 1996. The business office for Villa Aurora is located in Berlin, Germany, and all inquiries and applications should be sent to this office. (*See address below.*) Residency location: 520 Paseo Miramar, Pacific Palisades, CA 90272; TEL (310) 454-4231; E-MAIL aurora@net.net; WEB www.usc.edu/isd/aurora

ELIGIBILITY European citizens only. Writers, artists, filmmakers, musicians (see indices for more specific types of artists served). Emerging/midcareer, all genres. No repeat residencies.

FACILITIES Library/archive/collection, exhibition space, Macintosh Performa 6116CD computer with basic programs and Internet access.

HOUSING/MEALS/ACCESSIBILITY

Housing/Services: Each resident has their own room with bathroom. Linens provided. Laundry facilities. 2 kitchens. Residents may rent

FOR CURRENT APPLICATION REQUIREMENTS:

Kreis der Freunde und Förderer
 der Villa Aurora e.V.
Jägerstr. 23, Zimmer 347
10117 Berlin, GERMANY

TEL
49-302-0370-359

FAX
49-302-0370-360

E-MAIL
villaaurora@berlin.sireco.net

WEB
www.resartis.org

transportation from Villa Aurora. Spouse possible. 2 bedrooms have queen-size beds.
Meals: Artists purchase their own food (with monthly stipend) and prepare their own meals.
Accessibility: Artists with disabilities cannot be accommodated.

RESIDENCY STATISTICS

Application deadline: Ongoing.
Resident season: Year-round.
Average length of residencies: 3 months.
Number of artists in 1998 (and total applicant pool): 11 (100).
Average number of artists present at one time: 3.
Selection process: Panel of experts/professionals in each category.

ARTIST PAYS FOR Food (stipend provided).

INSTITUTION PAYS FOR Housing, studios, travel, materials.

ARTIST ELIGIBLE FOR Monthly stipend. Also available is a 9-month fellowship for a writer who lives in exile or under pressure in his/her country.

ARTIST DUTIES Readings, lectures, show work.

PUBLIC PROGRAMS Workshops, open house/tours, readings/lectures, exhibitions/presentations. All programs correspond to a resident's field, i.e., a writer reads from work, etc. Workshops are also run this way. 1998's theme was film, and Villa Aurora ran a film workshop in the Summer of 1998.

HISTORY Villa Aurora was the home of Lion and Marta Feuchtwanger from 1943 until Lion's death in 1958. During these fifteen years, he wrote six novels in his study on the top floor. Villa Aurora became a meeting place for the German émigrés and artists in Los Angeles, including Thomas Mann, Ludwig Marcuse, Gina Kaus, and Bertolt Brecht. The Villa was sold to the Friends of Villa Aurora, Inc., a German consortium interested in preserving this historic

monument. Now fully restored to its original splendor, the Villa is home of the California Institute for European-American Relations. A large portion of Feuchtwanger's library remains on permanent loan at Villa Aurora from the University of Southern California.

MISSION A cultural monument to German exiles on the West Coast, Villa Aurora's aim is to keep alive the memory of a time when representatives of both cultural and intellectual life were forced to flee from Nazi regime, seeking and finding refuge in the Pacific Palisades. Villa Aurora's purpose as a European-American Foundation is to foster an understanding of current European and American developments in the arts and literature. The house is a meeting place for intellectuals and artists from both Europe and the United States, a venue for the lively exchange of ideas in the fields of literature, art, culture, academia, and politics.

PAST RESIDENTS INCLUDE Peter Lilienthal, Irene Dische, Elfi Mikesch, Durs Grunbein, Julian Benedikt, SAID, Detlef Glanert, Volker Staub, Kemal Kurt.

FROM THE DIRECTOR "Until the early fifties, Villa Aurora was the preferred meeting place for German and European exiles in Los Angeles, making it a unique crossroads of European and American culture in the twentieth century. With our program for artists and writers in residence we now would like to continue this tradition." —*Joachim Bernauer*

Villa Montalvo

FOUNDED Organization 1930, Residency 1942.

LOCATION 175 acres in the eastern foothills of the Santa Cruz Mountains, 16 miles from San Jose, 50 miles from San Francisco, located on a historic site (the estate of former Senator James D. Phelan).

ELIGIBILITY Writers, painters, sculptors, musicians, composers, playwrights, architects, multidisciplinary artists (see indices for more specific types of artists served). No repeat residencies.

FACILITIES 175-acre site. 3,750 square feet of building space dedicated to artists' accommodations and studios. 5 furnished apartments, with private bath and kitchen. 2 apartments have living rooms with desks for writers. The composer's apartment has a baby grand piano (3 other apartments have upright pianos). 1 visual artist's apartment has an attached studio, while the other uses the Barn Studio. Theater, rehearsal space, exhibition space. Three of the apartments have designated modem lines for artists bringing their own computers and who wish to maintain Internet access.

FOR CURRENT APPLICATION REQUIREMENTS:

P.O. Box 158
Saratoga, CA 95071

TEL
(408) 961-5818

FAX
(408) 961-5850

E-MAIL
kfunk@villamontalvo.org

WEB
www.villamontalvo.org

HOUSING/MEALS/ACCESSIBILITY

Housing/Services: 5 fully furnished apartments are provided (including cooking utensils and linens). For artists without vehicles, transportation is provided for grocery and supply runs. Two bicycles are provided to residents to share. Spouse possible. Three apartments are large enough to accommodate couples.
Meals: Artists purchase own food and prepare own meals; once-a-week potluck.
Accessibility: Artists with disabilities cannot be accommodated yet. Public bathrooms and theater are now wheelchair accessible. New facility (opening in 2002) with greater accessibility is being built; its community center and 3 (of 10) of the new cottages/studios will be accessible.

RESIDENCY STATISTICS

Application deadline: March 1, September 1.
Resident season: Year-round.
Average length of residencies: 6 weeks.
Number of artists in 1998 (and total applicant pool): 36 (293).
Average number of artists present at one time: 3–5 depending on time of year.
Selection process: Outside panel of professionals in each category.

ARTIST PAYS FOR Application fee $20, refundable security deposit $100, food, travel, materials.

INSTITUTION PAYS FOR Housing, studios, facilities, program administration.

ARTIST ELIGIBLE FOR Seven $400 fellowships given each year, based on merit. $75 honoraria for artists' presentations given as part of Villa Montalvo's outreach program.

ARTIST DUTIES None required. On a voluntary basis, artists may participate in the outreach program, open studios, public readings, or other special programs.

PUBLIC PROGRAMS Performing Arts Season, Young Writer's Competition, Montalvo Biennial Poetry Competition, gallery exhibitions, open

> *"When it is so difficult to find the peace and quiet to create art, it is very important to know that places like Villa Montalvo are dedicated to this purpose."* —Federico Ibarra

house, readings, international exchanges, workshops, lectures, presentations. The New America Playwright Festival is an annual event co-sponsored by the San Jose Repertory Theater. Public readings are held in the Carriage House Theater at end of residency. Outreach program provides opportunities to interested artists to work with students.

HISTORY Built in 1912 by former San Francisco Mayor and U.S. Senator James Duval Phelan, the estate's Mediterranean flavor reflects Phelan's love for the Villa Medici in Rome. The estate was named for the sixteenth-century Spanish writer Garci Ordonez de Montalvo. Upon the Senator's death he left the estate to the people of California.

MISSION Villa Montalvo's artist residency program offers artists the gift of time for artistic exploration and creation. By providing a nurturing community environment, Montalvo fosters dialogue across boundaries of cultures and artistic disciplines enabling artists to dedicate themselves to their work.

PAST RESIDENTS INCLUDE Georges Bensoussan, Nguyen Qui Duc, M'Hamed Benguettaf, Rene Yung, Andrew Schultz, Santa Barraza, Roberto Mannino, Loida Martiza Perez, Chris Komater, James Kasebere, Tsippi Fleisher, Mokhtar Paki Pudeniic, Gronk, Joelle Wallach, Ernesto Diaz-Infante, Eddie Sanchez, Laura DiMeo, Denise Duchamel, Barbara DiGenevieve, Federico Ibarra.

FROM THE DIRECTOR "The residency program offers solitude for reflection and time for artistic exploration and creation to a small interdisciplinary community of artists. Currently thirty to thirty-five artists are offered residencies annually. This number will expand to around sixty artists annually upon completion of a new complex being built on an old orchard site of the property. Uniquely situated, Montalvo offers both an expanse of 175 acres of parkland for inspiration, as well as nearby urban and suburban areas that provide a wide range of cultural events." —*Kathryn Funk*

Virginia Center for the Creative Arts

FOUNDED Organization 1971, Residency 1971.

LOCATION 450 acres in the foothills of the Blue Ridge Mountains of central Virginia, 160 miles southwest of Washington, DC.

ELIGIBILITY Painters, sculptors, printmakers, poets, fiction writers, screenwriters, playwrights, composers, performance artists, video artists (see indices for more specific types of artists served). Repeat residencies permitted.

FACILITIES 450-acre site. Buildings 25,000 square feet. 24 studios, including 12 studios for writers, 9 for visual artists, 3 for composers. Darkroom, press, pianos in composers studios, library, collection, exhibition/installation space, swimming pool, Internet access for artists with own computers. Good libraries available at Sweet Briar College one mile away.

HOUSING/MEALS/ACCESSIBILITY

Housing/Services: 22 bedrooms, shared bathrooms. Bed linens and towels provided and laundered weekly. Transportation to town and Sweet Briar College twice weekly. Two bedrooms will accommodate double occupancy (if both people are accepted for residency).

FOR CURRENT APPLICATION REQUIREMENTS:

Mount San Angelo
Sweet Briar, VA 24595

TEL
(804) 946-7236

FAX
(804) 946-7239

E-MAIL
vcca@vcca.com

WEB
www.vcca.com

Meals: All meals provided. Breakfast and dinner served in dining room. Lunches delivered to studios.

Accessibility: Artists in wheelchairs or with vision or hearing impairment can be accommodated. Housing, housing bathrooms, studios, and public bathrooms are wheelchair accessible. Ramps. Wheelchair-friendly bath facilities, including roll-in shower, will be complete by summer 2000.

RESIDENCY STATISTICS

Application deadline: January 15, May 15, and September 15.
Resident season: Year-round.
Average length of residencies: 4 weeks.
Number of artists in 1998 (and total applicant pool): 329 (562).
Average number of artists present at one time: 22.
Selection process: Outside panel of professionals in each category.

ARTIST PAYS FOR Application fee $20, voluntary residency fee $30 per day (suggested), travel, materials.

INSTITUTION PAYS FOR Housing, studios, food, facilities, program administration.

ARTIST ELIGIBLE FOR Occasional fully funded residencies or stipends. For instance, from 1987 to 1998, the Kentucky Foundation for Women funded residencies for women artists from Kentucky, and the Geraldine R. Dodge Foundation funded residencies for artists from New Jersey. Call for details of possible upcoming opportunities.

ARTIST DUTIES None.

PUBLIC PROGRAMS Art exhibits, readings, concerts. A few artists are paid an honorarium to make presentations in local schools or libraries. Voluntary exchanges with organizations in France, Germany, Ireland, and Austria.

"*I have been to the Virginia Center a number of times, . . . and as always, find it extremely well run and an excellent place to write and tackle creative problems I would not ordinarily be able to do at home . . . I made significant breakthroughs on my libretto to* Harvey Milk, *an opera, as well as on my new project,* Doll, *the script of which I drafted here. It has just won a Richard Rodgers Production Award administered by the American Academy of Arts and Letters. The calm and focus I found here greatly contributed to my success so far with that project.*" —Michael Korie

HISTORY The Virginia Center for the Creative Arts was founded in 1971 by Charlottesville writers Nancy Hale and Elizabeth Langhorne. The Virginia Center moved to Mt. San Angelo, adjacent to and owned by Sweet Briar College in 1977.

MISSION The Virginia Center for the Creative Arts is a year-round community that provides a supportive environment for superior national and international visual artists, writers, and composers of all cultural and economic backgrounds to pursue their creative work without distraction in a pastoral residential setting.

PAST RESIDENTS INCLUDE David Del Tredici, Michael Torke, John Casey, Naomi Wolf, Aileen Ward, W. D. Snodgrass, Alice McDermott, Yuriko Yamaguchi, Eileen Simpson, Ellen Driscoll, Jacque Hnizdovsky, Mona Simpson, Cy Twombly, Lorraine O'Grady, Sharon Greytak, Lewis Nordan.

FROM THE DIRECTOR "Mt. San Angelo, the home of the Virginia Center for the Creative Arts, combines the serenity of a tranquil environment with the energy generated by twenty-four creative, focused, and purposeful fellows-in-residence. While providing rural isolation, the proximity of Sweet Briar College offers access to libraries, recreational, and cultural activities. The community of fellows allows each person to choose the amount of isolation or interaction he/she prefers and minimizes hierarchy or competitiveness. Fellows consider Mt. San Angelo a home away from home." —*Suny Monk*

Watershed Center for the Ceramic Arts

FOUNDED Organization 1986, Residency 1986.

LOCATION 32 acres of open, wooded, and rolling hills, surrounded by a sheep farm, nature conservancy land, and the Sheepscot River. 3 hours from Boston, 1 hour from Portland.

ELIGIBILITY Artists working in clay: sculpture, pottery, mixed media (see indices for more specific types of artists served). Repeat residencies permitted.

FACILITIES 32-acre site. Buildings 20,000 plus square feet. 25 studios. 2-level studio, 2 low-fire propane car kilns, high-fire gas kiln, wood-fire kiln, electric kilns, raku, pit-firing, potter's wheels, Soldner clay mixer, Walker pug mill, extruder, slab rollers, exhibition space, Macintosh 6100/66 computers with basic word processing and Internet software (no graphics/photo).

HOUSING/MEALS/ACCESSIBILITY

Housing/Services: Dorm-style rooms (4–5 beds per room), with central living area and dining room. Nearby laundry. No mass transit, but good carpools. Collaborative groups welcomed.

FOR CURRENT APPLICATION REQUIREMENTS:

19 Brick Hill Road
Newcastle, ME 04553-9716

TEL
(207) 882-6075

FAX
(207) 882-6075

E-MAIL
lgipson@SATURN.caps.maine.edu

Spouse possible, though private accommodations not likely.
Meals: All meals provided. Family style. Largely vegetarian, made from Watershed's gardens.
Accessibility: Artists in wheelchairs can be accommodated. Housing, housing bathrooms, and studios are wheelchair accessible. No special facilities for artists with vision or hearing impairment. Plans to develop accessibility.

RESIDENCY STATISTICS

Application deadline: April 1 for funded residencies. Proposals for "Artists Invite Artists" program are accepted on an ongoing basis.
Resident season: Summer: June–August; Winter: September–May (nine-month residencies for two artists).
Average length of residencies: 2 weeks–3 months.
Number of artists in 1998 (and total applicant pool): 56 (70).
Average number of artists present at one time: 12.
Selection process: Jurying by past residents, professors in MFA programs, and Watershed Board Program committee.

ARTIST PAYS FOR Application fee $20, residency fee $790 per 2 weeks, food, travel, materials, firing fees.

INSTITUTION PAYS FOR Housing, studios, facilities, program administration.

ARTIST ELIGIBLE FOR Some fully and partially funded residencies (call for details). "Artists Invite Artists" sessions allow one or two artists to invite up to 12 other artists of their choosing to work together in a 2- or 3-week session at discounted residency rate.

ARTIST DUTIES None, unless on assistantship (10–15 hours per week). Resident artists show slides and talk about their work informally on a voluntary basis.

PUBLIC PROGRAMS Open studio, slide-talk evenings, community classes in clay, workshop for people with AIDS.

"Watershed appears so unassumming, no frills. The studios, the gravel lane, meadows, ponds, and woods . . . the vast night sky. The artists of all ages form temporary families. Staffed by artists, the food is divine, the work fruitful. Watershed is a magical, inspired place where the artist . . . is nourished." —Christina Bertoni

HISTORY Founded after the Watershed Brick and Clay Products Company closed and investor Margaret Griggs approached artist George Mason to initiate a residency program for artists in clay.

MISSION To provide serious artists with time and space to create in clay.

PAST RESIDENTS INCLUDE Linda Arbuckle, John Chalke, Karon Doherty, Peter Gourfain, John Glick, Chris Gustin, Anne Kraus, Judy Moonelis, Matt Nolen, Henry Pim, Chris Staley, Arnie Zimmerman.

FROM THE DIRECTOR "Watershed encourages the exchange of ideas, collaboration, experimentation, and self-inquiry." —*Lynn Thompson*

FOUNDED Organization 1989, Residency 1998.

LOCATION The Weir Farm Trust is located on the border between Wilton and Ridgefield, Connecticut, about 1½ hours from New York City. The Trust works in partnership with the National Park Service at Weir Farm National Historic Site, the former home and workplace of the American Impressionist J. Alden Weir. The site is comprised of rolling meadows outlined with stone walls; there are woods, wetlands, and a pond.

ELIGIBILITY Painting, drawing, sculpture, mixed media (see indices for more specific types of artists served). Primary criteria is quality of artist's body of work and the ability to work well in a somewhat isolated environment. Repeat residencies permitted.

FACILITIES 60-acre site. Buildings 2,000 square feet. Performance space, library/archive/collection.

HOUSING/MEALS/ACCESSIBILITY

Housing/Services: Comfortable, fully furnished apartment adjacent to studio with laundry facilities. Within walking distance of market and train, but car is desirable. Linens are furnished. Spouse and occasional guest can be accommodated in residence, but not for studio.

Meals: Until the program is expanded, artists are responsible for the preparation of their own meals. The apartment has a well furnished kitchen with all appliances including microwave and dishwasher.

Accessibility: Artists in wheelchairs or with vision impairment cannot be accommodated. Artists with hearing impairment can be accommodated—executive director is fluent in American Sign Language. When new studios are built and current visitor center for the Park residency renovated, facilities will be accessible to residents with some disabilities. Terrain of landscape, however, will not be appropriate for wheelchairs. (The park's new visitor center will be complete in approximately 4 years; new studios in 2 years.) Please call for specific advice.

RESIDENCY STATISTICS

Application deadline: January 15, July 15.
Resident season: Year-round.
Average length of residencies: 1 month.
Number of artists in 1998 (and total applicant pool): 5 (unknown).
Average number of artists present at one time: 1–2.
Selection process: Artists are selected through a competitive panel process.

ARTIST PAYS FOR Application fee $25, deposit of $75 (returned to artists upon arrival), food, travel, materials.

INSTITUTION PAYS FOR Housing, studios, local phone, facilities, program administration.

ARTIST ELIGIBLE FOR Stipend $500 per month (pro-rated for more or less time).

ARTIST DUTIES None, but resident may have open studio session, give slide talk, or donate work if he or she wishes.

FOR CURRENT APPLICATION REQUIREMENTS:

735 Nod Hill Road
Wilton, CT 06897

TEL
(203) 761-9945

FAX
(203) 761-9116

> "I cannot speak highly enough about my stay at Weir Farm and my excitement over the work I did while there. Often an artist needs to be at a colony-type situation to exchange ideas with fellow artists, but equally as often, an artist needs the opportunity to hibernate and just work and process the work. This was just what I needed—quiet, uninterrupted time to work and explore nature. Evenings I would sit and watch all the green fields turn to gold in late sunlight and would then work on writing poetry—something I have not done for years. I feel I did months of work in my stay there!" —Blair Folts

PUBLIC PROGRAMS Visiting artists program which includes an annual exhibition for 3–5 artists selected through competitive process, workshops for children and adults, historic and contemporary exhibitions, lecture series with leading American artists. The Trust works in partnership with the National Park Service and has collaborating programs with area museums.

HISTORY The Weir Farm Trust was founded in 1989 as an outgrowth of the efforts to save the historic Weir Farm. The preservation of an extraordinary facet of America's artistic heritage is half of the equation in citing the significance of Weir Farm. Equally important is the preservation of an environment where contemporary artists can thrive. Since its inception, it has been the combined mandate of the Trust and Weir Farm National Historic Site to establish a nationally significant residency program for advanced visual artists.

MISSION The Program's mission is to provide outstanding opportunities for advanced visual artists in an atmosphere in which the creative spirit is both fostered and nurtured. These artists, representing many artistic points of view, are also given an opportunity to share the rich artistic history of Weir Farm.

PAST RESIDENTS INCLUDE John Gruen, Suzanne Benton, Blair Folts, Michael Torlen. (Historically: J. Alden Weir, Childe Hassam, John Twachtman, John Singer Sargent, Albert Pinkham Ryder.)

FROM THE DIRECTOR "The Weir Farm Trust's artists-in-residence program is the cornerstone of the Trust's programs for professional artists. Affording artists total artistic freedom and immersion in their work in a peaceful environment is the principle attraction to the program. While working independently, artists will also have the opportunity to present their work to the public through open studios or lectures." —*Constance Evans*

Women's Art Colony Farm

ALLIANCE OF ARTISTS' COMMUNITIES MEMBER

FOUNDED Organization 1978, Residency 1978.

LOCATION 85-acre tree farm with large swimming pond.

ELIGIBILITY Women only. Visual artists, writers, performers, scholars (see indices for more specific types of artists served). Repeat residencies permitted.

FACILITIES 85-acre site. 10 studios. Studio space in renovated barns, video-/filmmaking equipment, woodshop, darkroom, silk-screen studio, library/archive/collection, exhibition space, swimming pond. Internet access for artists with own computers.

HOUSING/MEALS/ACCESSIBILITY

Housing/Services: Private room in farm house or renovated barn. Only female partners are accommodated.
Meals: Artists contribute $80 per week for food and prepare meals and eat together.
Accessibility: Artists in wheelchairs and with hearing impairment can be accommodated. Artists with vision impairment cannot be accommodated. Housing, housing bathrooms, and studios are wheelchair accessible. Ramps and/or other aids will be constructed as needed and upon request to accommodate residents in wheelchairs.

RESIDENCY STATISTICS
Application deadline: Ongoing.
Resident season: June–August.
Average length of residencies: 1–3 months.
Number of artists in 1998 (and total applicant pool): 10 (250).
Average number of artists present at one time: 10.
Selection process: Selections made by director.

ARTIST PAYS FOR Travel, materials, $80 per week for food.

INSTITUTION PAYS FOR Housing, studios, facilities, program administration.

ARTIST ELIGIBLE FOR No stipends or fellowships/awards are available.

ARTIST DUTIES 4 hours per day of farming.

PUBLIC PROGRAMS Readings are held throughout the summer. In August, exhibitions are held and the Obon Festival (the Japanese Harvest Festival) is put on.

HISTORY Founded in 1978 by Kate Millet in order to make an empowering and encouraging atmosphere for women artists.

MISSION To provide a self-supporting and economically independent colony for women.

PAST RESIDENTS INCLUDE Jane Winter, Anne Keating, Phyllis Chesler, Sophie Keir, Suzanne Zuckerman, Stephanie Schroeder, Cynthia MacAdams, Janet Melvin, Mary Christian McEwen, Linda Clarke, Meredith Males, Anne Wilson.

FROM THE DIRECTOR "The farm is about the work you bring to the place, the paintings and prose you do here, readings in the evening, afternoons

FOR CURRENT APPLICATION REQUIREMENTS:

20 Overlook Road
Poughkeepsie, NY 12603

TEL
(914) 473-9267

"Some women come to the farm with valuable skills to share, others come with little or no experience. We put an emphasis on learning new skills and literally want everyone to learn everything. By the end of the summer we all catch the 'fever' and we start to believe that we really can do anything and everything." —Tamara Bower

in the studios, mornings in the fields, the place itself, its beauty and shelter . . . a commitment to an ongoing community of women." —*Kate Millett*

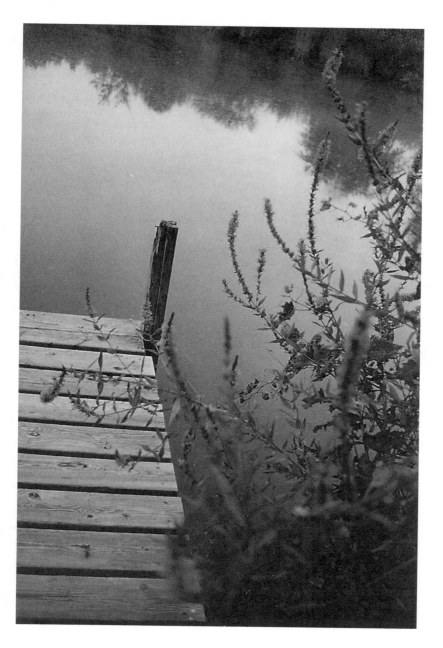

Women's Studio Workshop

FOUNDED Organization 1974, Residency 1979.

LOCATION Among marsh and woodland in the rolling Shawangunk Mountains of mid-Hudson River valley, 2 hours north of New York City.

ELIGIBILITY Women only. Printmakers, photographers, paper artists, book artists (see indices for more specific types of artists served). Repeat residencies permitted.

FACILITIES Buildings 7,200 square feet. 6 studios. Printshop: screenprinting power washer, textile and paper printing surface, squeegees. Papermaking: 2 custom Hollander beaters, vats, hydraulic press, stainless steel vacuum table, moulds and deckles. Darkroom: 4 enlargers, separate finishing room, dry mount facilities, copy camera, photostat processor. Intaglio: 2 brand presses, rollers, hotplate. Letterpress: Chamder & Price, VanderCook presses, miscellaneous type, photo polymer exposing unit, 11-inch-by-17-inch offset press. Pottery/ceramics facility, library/archive/collection, exhibition space, IBM compatible computers with Photoshop, WordPerfect, Illustrator, PageMaker, Internet access.

HOUSING/MEALS/ACCESSIBILITY

Housing/Services: Private rooms in shared, on-site apartment.
Meals: Artists purchase own food and prepare own meals, daily potlucks.
Accessibility: Artists with disabilities cannot be accommodated. Public bathrooms are wheelchair accessible. Plans for developing accessibility.

RESIDENCY STATISTICS

Application deadline: July 1 and November 1 for Fall and Spring Fellowships. November 15 for Artist's Book Residency Grant.
Resident season: September–June.
Average length of residencies: 3 weeks.
Number of artists in 1998 (and total applicant pool): 3 artists-in-residence (80), 14 Fellowship awardees (180).
Average number of artists present at one time: 2 visiting, 6 local, 4 staff.
Selection process: Committee for Fellowship Grants, jury of previous years' recipients of Artist's Book Residency Grant.

ARTIST PAYS FOR Fixed fellowship fee $200 per week, deposit of $100, food, travel, materials.

INSTITUTION PAYS FOR Housing, studios, facilities, program administration.

ARTIST ELIGIBLE FOR Artist's Book Grants $1,800 for 6 weeks, materials up to $450.

ARTIST DUTIES Slide presentation.

PUBLIC PROGRAMS Workshops, open house/tours, international exchanges, exhibitions/presentations. Public programming is conducted during season when artists are not in residence.

HISTORY Founded in 1979 as a center for contemporary art activities, based in the visual arts.

MISSION Founded and run by women to serve as a supportive working environment for all persons interested in the arts . . . To create profes-

> *"Beyond the beautiful surrounds of the Hudson River Valley, I found the energy of this place to be inspirational."* —Joan Morris

sional opportunities and employment for women, to encourage women of diverse cultural backgrounds to work at the studios, and to encourage the general public's involvement with the arts.

PAST RESIDENTS INCLUDE Susan Mills, Kumi Korf, Clarissa Sligh, Susan Amons, Binda Colebrook, Valerie Maynard, Mei Ling Hom, Susan E. King, Alison Knowles, Margarita Becerra-Cano,

Rose Marasco, Jean Sanders, Joshua Beckman, Maureen Cummins, Irene Chan, Ann Marie Kennedy, Leslie Eliet.

FROM THE DIRECTOR "Women's Studio Workshop's facilities are unparalleled in the breadth and range of equipment available to artists, and the staff can provide technical support and problem-solving expertise." —*Tatana Kellner*

Woodstock Guild's Byrdcliffe Arts Colony

FOUNDED Organization 1902, Residency 1988.

LOCATION 600 acres of mountains, pines, meadows, forests, and streams in Woodstock, New York.

ELIGIBILITY Painting, writing, theatre companies, potters/ceramicists, composers (see indices for more specific types of artists served). Rental facilities also available for 1–3 month residencies for dance, music, or theatre companies. Repeat residencies permitted.

FACILITIES 600-acre site. 10 private studios. Pottery/ceramics facility, kilns, piano, performance space, exhibition space.

HOUSING/MEALS/ACCESSIBILITY

Housing/Services: Private room at the Inn. Linens provided. Washing machine and dryer available.
Meals: Artists purchase own food and prepare own meals.
Accessibility: Artists with disabilities cannot be accommodated. The major performance facility in the center of Woodstock is wheelchair accessible, with a ramp and an accessible bathroom, but the Colony cannot accommodate wheelchairs. No special facilities for artists with vision or hearing impairment. Plans for developing accessibility.

RESIDENCY STATISTICS

Application deadline: April 1.
Resident season: June–September.
Average length of residencies: 4 weeks.
Number of artists in 1998 (and total applicant pool): 40 (75).
Average number of artists present at one time: 10.
Selection process: Outside jury of professionals in each category.

ARTIST PAYS FOR Application fee $5, fixed residency fee $500 per month (covers housing), food, travel.

INSTITUTION PAYS FOR Facilities, program administration.

ARTIST ELIGIBLE FOR $100 scholarship for writers under 35 who need financial assistance. The Patterson Fund Scholarship.

ARTIST DUTIES Residents are invited to participate in an open studio tour and reading each session.

PUBLIC PROGRAMS Lectures, exhibitions, presentations, classes, workshops, theatre and music performances of all types, open house/tours.

HISTORY Founded in 1902 by Ralph Radcliffe Whitehead, to create a utopian arts community. Today the artist-in-residence program at Byrdcliffe is housed in the Villetta Inn built in 1903. Byrdcliffe produced furniture, ironworks, textiles, and ceramics that are now in major museums in the United States.

MISSION To provide opportunity for people to discover and develop their creative spirit; preserve the historic Byrdcliffe Colony as an arts

FOR CURRENT APPLICATION REQUIREMENTS:

Woodstock Guild, 34 Tinker Street
Woodstock, NY 12498

TEL
(914) 679-2079

FAX
(914) 679-4529

E-MAIL
wguild@ulster.net

WEB
www.woodstockguild.org

"...Byrdcliffe offers the gift of unstructured time to do one's work; a supportive community; and a beautiful setting. The most important part of being at an art colony, I believe, is it validates the often difficult task of being an artist . . . I found Byrdcliffe especially conducive to both getting work done and finding a community of like-minded people. There is a timeless, soothing quality in the landscape; the house is deeply comfortable. People seem to relax at Byrdcliffe, creating both friendships and art." —Katherine Burger

haven and natural environment; present and foster the creative arts for the enjoyment and education of the people of Woodstock, the Hudson Valley, and beyond.

PAST RESIDENTS INCLUDE Mariella Bisson, Richard Peabody, J. B. Miller, Peter McCaffrey, Sarah Burnham, Katherine Burger, Sapphire, Tom Grady.

FROM THE DIRECTOR "Byrdcliffe brings together a diverse group of artists to a mountainside with a magical atmosphere located at a special altitude that stimulates creativity." —*Carla Smith*

Yaddo

FOUNDED Organization 1900, Residency 1926.

LOCATION 400 acres of lakes, woodlands, and gardens in Saratoga Springs, New York, 3 hours from New York City.

ELIGIBILITY Fiction and nonfiction writers, poets, playwrights, painters, composers, choreographers, performance artists, filmmakers, videographers (see indices for more specific types of artists served). Artists must be working at the professional level in their fields. Repeat residencies permitted.

FACILITIES 400-acre site. Buildings 100,000 square feet. 40 private studios, darkroom, pianos, welding equipment, intaglio printmaking studios, sculpture studio, and lithograph. Portable mirrors and barres available for choreographers, who also may request that the floors of their studios be covered with marley. Limited Internet access possible for artists who bring computers.

HOUSING/MEALS/ACCESSIBILITY

Housing/Services: Private bedrooms. Artists who wish to work collaboratively are encouraged to apply (only small collaborative groups, 2–3 people, can be accommodated). Spouses possible if they apply separately and gain admission separately. Seeing Eye dogs are the only pets allowed.

Meals: All meals provided. Breakfast and dinner are served family style, lunch is packed in lunch pails.

Accessibility: Artists in wheelchairs or with vision or hearing impairment can be accommodated. Housing, housing bathrooms, darkroom, and writers' and visual artists' studios are wheelchair accessible. All the primary buildings contain ramps, and some studios and other buildings contain ramps. Fire alarms have flashing light and sound. Yaddo will do all they can to accommodate any disability, and they continue to look at ways to improve accessibility.

RESIDENCY STATISTICS

Application deadline: January 15, August 1.
Resident season: Year-round.
Average length of residencies: 5 weeks.
Number of artists in 1998 (and total applicant pool): 195 (949).
Average number of artists present at one time: 35 during summers, 15 during other seasons.
Selection process: Outside panel of professionals in each category.

ARTIST PAYS FOR Application fee $20, travel, materials.

INSTITUTION PAYS FOR Housing, studios, food, travel, facilities, program administration.

ARTIST ELIGIBLE FOR A small fund exists to provide limited help toward travel expenses for persons invited who otherwise might not be able to visit. Another small fund is anticipated to provide limited financial aid to writers who otherwise would not be able to visit.

ARTIST DUTIES None.

PUBLIC PROGRAMS None.

FOR CURRENT APPLICATION REQUIREMENTS:

P.O. Box 395
Saratoga Springs, NY 12866

TEL
(518) 584-0746

FAX
(518) 584-1312

WEB
www.yaddo.org

HISTORY

Originally a farm, gristmill, and tavern operated by a Revolutionary War veteran, the Yaddo estate was eventually purchased by investment banker Spencer Trask and his wife, the poet Katrina Trask. After the deaths of their four children, the Trasks decided to make their estate a creative haven for artists, writers, and composers. The corporation of Yaddo was formed in 1900, and Yaddo welcomed its first guests in 1926.

MISSION

To support professional working artists, chosen by panels of their peers, by providing them with the space, uninterrupted time and supportive community they need to work at their best. Maintaining and enhancing a climate of diversity within its community of artists remains one of Yaddo's primary objectives.

PAST RESIDENTS INCLUDE

Milton Avery, James Baldwin, Truman Capote, John Cheever, Aaron Copland, Patricia Highsmith, Langston Hughes, Ulysses Kay, Alfred Kazin, Flannery O'Conner, Sylvia Plath, Katherine Anne Porter, Clyfford Still, and William Carlos Williams.

FROM THE FOUNDERS

"In order to insure for Yaddo a larger influence and . . . in the hope that it may continue as a practical force in the world for all time, we desire to found here a permanent Home to which shall come from time to time . . . authors, painters, sculptors, musicians and other artists both men and women, few in number but chosen for creative gifts and besides and not less for the power and the will and the purpose to make these gifts useful to the world . . . It is such as these whom we would have enjoy the hospitality of Yaddo, their sole qualification being that they have done, or are doing, or give promise of doing good and earnest work." —*Spencer and Katrina Trask, founders, 1900*

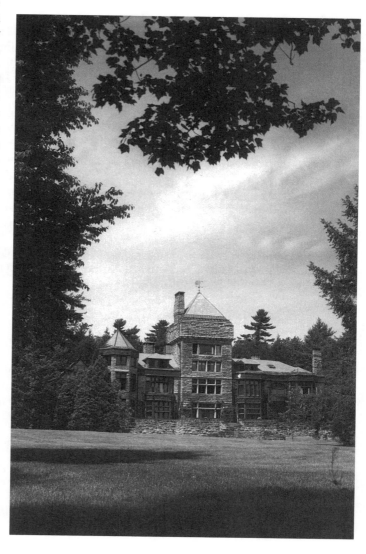

The Yard

FOUNDED Organization 1973, Residency 1973.

LOCATION On the island of Martha's Vineyard.

ELIGIBILITY Contemporary dance artists (see indices for more specific types of artists served). There are a number of different residencies with different requirements. Please call the The Yard, Inc. for detailed guidelines. Repeat residencies permitted.

FACILITIES 2.6-acre site. 2 studios. Theatre and housing complex, rehearsal and performance space, video equipment.

HOUSING/MEALS/ACCESSIBILITY

Housing/Services: Semi-private bedrooms in comfortable houses, full kitchen. Laundry facilities and passenger van. Collaborative groups possible.
Meals: Artists purchase own food and prepare own meals.
Accessibility: Limited accessibility. Studios and theatre are wheelchair accessible (housing is not). Ramps.

FOR CURRENT APPLICATION REQUIREMENTS:

P.O. Box 405
Chilmark, MA 02535

TEL
(508) 645-9662

FAX
(508) 645-3176

E-MAIL
theyard@tiac.net

WEB
www.tiac.net/users/theyard

RESIDENCY STATISTICS
Application deadline: December 15.
Resident season: April–October.
Average length of residencies: 5 weeks.
Number of artists in 1998 (and total applicant pool): 55 (134).
Average number of artists present at one time: 12.
Selection process: Outside panel of professionals in each category, as well as The Yard's artistic director and artistic advisor, followed by interviews with final candidates.

ARTIST PAYS FOR Application fee $20 per choreographer, food, travel.

INSTITUTION PAYS FOR Housing, studios, facilities, program administration.

ARTIST ELIGIBLE FOR Stipend $240 per week per resident.

ARTIST DUTIES Performers are expected to create and develop new works by resident choreographers, adhere to daily schedule of classes, rehearse, and perform, teach company and/or community dance classes, as requested by The Yard, take part in special events, and participate fully in all phases of the residency program.

PUBLIC PROGRAMS Performances, community classes, Behind the Scene program.

HISTORY Founded in 1973 by Patricia N. Nanon.

MISSION To promote growth and experimentation in theatre arts . . . to give professional artists the time and space to create and perform dance, music, and theater pieces in a concentrated, supportive environment while in residence.

PAST RESIDENTS INCLUDE Martha Bowers, Ann Carlson, Carolyn Dorfman, David Dorfman, Paula Josa-Jones, Tony Kushner, Jack Moore, Danial Shapiro, Joanie Smith, Jawole Willa Jo Zollar, Doug Varone, Roxanne D'Orleans Juste.

"I think of the Yard as being my artistic nurturing ground. Having spent three summers as a dancer and two as a choreorgapher, I can state . . . that the environment of The Yard is truly exhilarating." —David Dorfman

FROM THE DIRECTOR "The Yard . . . [is] a playground without walls, a place to explore, experiment, construct, a place of possibility, joy, love, anger, frustrations, a place of mutual stimulation, sharing, testing, a space in which to come together and to be alone." —*Patricia N. Nanon*

Other Venues

The following is a list of single-person residencies, fellowship grants, studio collectives, workshops, apprenticeships, and other valuable programs that support artists' creativity. It also includes up-and-coming communities that will soon open their doors to artists. However, this list does not represent focused research into these areas of artist support. Rather, it includes organizations that we have learned about during the course of our research into the artists' communities listed in the directory but that did not fully fit the four criteria listed in the preface to this book.

For each organization, the types of artists eligible for their programs are shown in italics after the address/contact information, and a short description of their organization follows. Membership in the Alliance of Artists' Communities is designated by the ◑ symbol.

13th Colony ◑
403 W. Ponce de Leon Ave.
Decatur, GA 30030
TEL (404) 373-3603
E-MAIL joeyorr@mindspring.com
Visual artists, writers, video and multidisciplinary artists
> 13th Colony is a community for artists at New Manchester, a neo-traditional community in metro Atlanta. In addition to 13th Colony's year-round artists' residencies, their Emergence program offers a two-week, juried residency to middle and high school students.

A Gallery in the Woods ◑
13401 River Road
New Orleans, LA 70131-3204
TEL (504) 392-5359
Visual artists
> A Gallery in the Woods is on a forested, eight-acre site within the city limits of New Orleans. The site has a pottery studio, wood studio, outdoor metals studio, and a gallery, and hosts cooperative shows and workshops.

Alaska Residencies, Island Institute
P.O. Box 2420
Sitka, AK 99835
TEL (907) 7473-794
E-MAIL island@ptialaska.net
WEB www.ptialaska.net/~island/intlex.html
Writers

August 15 application deadline for single one-month residencies in November, January, and April. Program includes community involvement. Private accommodations with kitchens and a food stipend.

ALTER Park ◑
1354 Elm Street
Plymouth, MI 48170
TEL (734) 453-3404
Visual artists
> ALTER Park is a restored, historic 1914 car factory. It will be the site of an artists' community and gallery (currently in the planning stages).

Art in General
79 Walker Street
New York, NY 10013
TEL (212) 219-0473
All disciplines
> Art in General, founded by artists in 1981, offers a six- to eight-week residency program providing an opportunity for national and international artists to create new work on-site, and for the artists to have a dialogue with the surrounding community.

The Art Studio, Inc.
720 Franklin Street
Beaumont, TX 77701
TEL (409) 838-5393
WEB www.artstudio.org
Visual artists (emphasis on clay)
> The purpose of The Art Studio, Inc. is to provide opportunities for interaction between the general public and the community of artists. The Studio offers work and exhibition space to artists and crafts people so that they may share their labor, ideas, and enthusiasm with each other.

Artspace
325 West Pierpont Avenue
Salt Lake City, UT 84101
TEL (801) 531-9378
E-MAIL skinbine@artspaceutah.org
WEB www.artspaceutah.org
Visual and creative movement artists who qualify for affordable living and/or studio space.
> Artspace is an arts- and community-building nonprofit organization developing vital and diverse neighborhoods by creating affordable housing and workspace. Artspace creates facilities, programs, and activities for adults and children integral to cultural and neighborhood sustainability.

Arts Habitat
P.O. Box 64
Monterey, CA 93942

TEL (831) 626-6959
All disciplines
 Arts Habitat, at the former Fort Ord on California's Monterey Peninsula, provides space for studio, production, and administrative facilities for all arts disciplines.

ArtsLink Residencies/CEC International Partners ⊙
12 West 31st Street, 4th Floor
New York, NY 10001-4415
TEL (212) 643-1985
 ArtsLink enables United States artists and arts organizations to work collaboratively with counterparts in central and eastern Europe on projects that benefit artists and audiences in these countries. The two program areas that enable this exchange are: Collaborative Projects which support projects by United States artists and arts organizations in central and eastern Europe; and Residencies which support United States organizations so that they may host artists, known as "ArtsLink Fellows," from central and eastern Europe.

AS220 ⊙
115 Empire Street
Providence, RI 02903
TEL (401) 831-9327
E-MAIL info@as220.org
WEB www.as220.org
Musicians, performance artists, visual artists, film-makers, writers
 AS220 is a three-story building committed to providing a permanent venue for Rhode Island artists. AS220 has a stage, galleries, and live and work space for artists, as well as a community-accessible darkroom, computer lab, and print shop.

Badlands National Park, Artist-in-Residence Program
P.O. Box 6
Interior, SD 57750
TEL (605) 433-5242
E-MAIL julie_athman@nps.gov
WEB www.nps.gov/badl
Visual artists, writers, performance artists
 Located in southwestern South Dakota, Badlands National Park is a land of great extremes: many-colored buttes and vivid sunsets, hot, arid prairie, and bitterly cold, windswept tables. Residencies are available only from March 15 to May 10 and from September 7 to October 10.

Baltimore Clayworks
5706 Smith Avenue
Baltimore, MD 21209
TEL (410) 578-1919
E-MAIL clayworks@erols.com
WEB www.baltimoreclayworks.org
Visual artists working primarily in clay
 Baltimore Clayworks is an artists' space with twelve studios for residents (juried), one fellowship annu-

ally, and opportunities for teaching and exhibiting. Large gas- and wood-firing kilns are especially attractive.

Bates Dance Festival ⊙
163 Wood Street
Bates College
Lewiston, ME 04240-6016
Contemporary dance artists and musicians.
 Now in its 17th year, the festival provides residencies to an international community of dancers and musicians, as well as conducts professional training programs, public events, and performances.

Bernheim Arboretum and Research Forest
General Delivery Highway 245
Clermont, KY 40110
TEL (502) 543-2451
Visual artists, installation artists
 Bernheim accepts residents whose work is inspired by and helps to strengthen the bond between people and nature. The recipient of the residency fellowship may live at Bernheim for up to three months. Bernheim provides housing in a beautiful wooded setting, and a stipend of $2,500 to cover travel, materials, and expenses.

Block Island Foundation for the Arts ⊙
P.O. Box 1258
Block Island, RI 02807
TEL (401) 466-2207
 Block Island Foundation for the Arts is an artists' community in the planning stages that, upon completion, will host residencies and workshops.

Bogliasco Foundation/Liguria Study Center for the Arts and Humanities
885 Second Avenue, Room 3100
New York, NY 10017-2299
E-MAIL bogfound@mindspring.com
Artists in all disciplines, scholars
 Located in the Italian Riviera in the small town of Bogliasco, the Liguria Study Center offers residential fellowships for artists and scholars in the arts and humanities.

Border Art Residency ⊙
Route 1, Box 545
Anthony, NM 88021
TEL (915) 747-5181
Visual artists
 Border Art Residency is housed in a converted cotton gin that now offers a gallery and a spacious live/work space for an artist in residence.

Bread Loaf Writers' Conference
Middlebury College
Middlebury, VT 05753
TEL (802) 443-5286
E-MAIL blwc@middlebury.edu
WEB www.middlebury.com/~blwc
Writers: fiction, poetry, creative nonfiction

In an eleven-day conference, Bread Loaf offers small workshops, classes, lectures, readings by distinguished faculty, and meetings with editors and agents. Bread Loaf is the oldest writers conference in America.

Buffalo National River, Artist-in-Residence Program
402 N. Walnut, Suite 136
Harrison, AR 72601
TEL (501) 741-5443
WEB www.nps.gov/Buff
Visual artists, performance artists, writers, video-/film-makers, composers
Opportunities exist for professional artists throughout the nation to pursue their art surrounded by the inspiring landscape of the Buffalo National River. Up to four three-week residencies offered each year.

Byrd Hoffman Foundation/The Watermill Center ☉
155 Wooster Street, Suite 4F
New York, NY 10012
TEL (212) 253-7484
Theatre artists, filmmakers, dancers, musicians, visual artists
The Byrd Hoffman Foundation/Watermill Center is an international, multidisciplinary institute for the creation and development of new work in theater, music, film, dance, and the visual arts.

Capp Street Project, c/o California College of Arts & Craft (CCAC) ☉
450 Irwin Street
San Francisco, CA 94107
Visual artists, craft artists, architects, designers
In 1998 Capp Street Project merged with CCAC, after fifteen years of independent operation, first in San Francisco's Mission District then in the city's South Park neighborhood. The program now provides a residency for one artist at a time in an art school setting (CCAC), on either the Oakland or the San Francisco campus. An apartment is provided, and available facilities include a darkroom, printshop, film-/video-editing facility, woodshop, metalshop, pottery/ceramics facility, exhibition space, and a library. Teaching opportunities are available, and residents are asked to create a site-specific installation for public viewing as well as conduct one public presentation.

Center for Craft, Creativity, and Design ☉
P.O. Box 1127
Hendersonville, NC 28793-1127
TEL (828) 253-9100
Center is still in development; it will take a cross-disciplinary approach to creativity.

Center for Photography at Woodstock
59 Tinker Street
Woodstock, NY 12498
TEL (914) 679-9957
E-MAIL cpwphoto@aol.com
WEB www.cpw.org
Photographers
The Center for Photography at Woodstock provides an artistic home for contemporary creative photography with programs in education, exhibition, publication, archives, collections, fellowships, library, and workspace.

The Clay Studio
139 North 2nd Street
Philadelphia, PA 19106
TEL (215) 925-3453
E-MAIL claystdo@libertynet.org
WEB www.libertynet.org/claystdo
Ceramic artists
The Clay Studio is a thriving ceramic art center in Philadelphia's gallery district, offering short- and long-term residencies, a one-year fellowship, and teaching and exhibition opportunities.

Contemporary Crafts Association
3934 SW Corbett Avenue
Portland, OR 97201
TEL (503) 223-2654
E-MAIL ccg3934@aol.com
Visual artists (three-dimensional only)
A nonprofit organization established in 1937, the Contemporary Crafts Association promotes creativity in contemporary craft disciplines through educational experiences, residencies, and exhibitions.

Contemporary Culture, Inc.
5501 Columbia Avenue
Dallas, TX 75214
TEL (214) 823-8955
WEB www.5501.com
Visual artists, performing artists, installation artists, book artists
Contemporary Culture, Inc., is a nonprofit organization for the advancement of culturally diverse artists in the above listed disciplines.

Copland Heritage Association, Inc.
P.O. Box 2177
Cortlandt Manor, NY 10567
TEL (914) 788-4659
E-MAIL info@coplandhouse.org
WEB www.coplandhouse.org
Composers
Rock Hill, former residence of Aaron Copland, houses one composer at a time for one- to three-month residencies.

Creative Arts Community at Menucha
P.O. Box 4958/15209 SE Gladstone St.
Portland, OR 97236
TEL (503) 760-5837
E-MAIL bgconyne@pacifier.com
Visual artists, writers
For thirty-three years the Creative Arts Community at Menucha has held workshops for two weeks in

August on a ninety-six-acre wooded estate overlooking the Columbia Gorge.

Crow's Shadow Institute
48004 St. Andrews Road
Pendleton, OR 97801
TEL (541) 276-3954
E-MAIL crow@oregontrail.net
WEB www.umatilla.nsn.us/crow.html
Visual artists
A nonprofit arts facility on the Umatilla Indian Reservation providing workshops in printmaking, photography, marketing, and traditional Native American arts.

Deep Creek Arts
P.O. Box 171
Telluride, CO 81435
TEL (970) 728-5266; (480) 894-6211 before May 25
E-MAIL dan.collins@asu.edu
WEB www.asu.edu/cfa/art/events/deepcreek/
Visual artists, installation artists, multimedia artists
Deep Creek is in the Rocky Mountains of Colorado. Affiliated with the School of Art at Arizona State University, it provides an alternative to the usual way of learning about art. The unique environment of Deep Creek allows students to pursue projects in ways that would be difficult in an academic setting.

Dieu Donne Papermill
433 Broome Street
New York, NY 10013
TEL (212) 226-0573
E-MAIL ddpaper@cybernex.net
WEB www.colophon.com/dieudonne
Visual artists
Dieu Donne Papermill is a nonprofit hand-papermaking studio located in the Soho art district of New York City.

Dillmans Creative Arts Foundation
P.O. Box 98
Lac du Flambeau, WI 54538
TEL (715) 588-3142
E-MAIL dillmans@newnorth.net
WEB www.dillmans.com
Visual artists, writers
Creative workshops, offered in a northern Wisconsin lakeside resort setting, include state-of-the-art studios and distinguished instructors.

Doghaven Center for the Arts
P.O. Box 283
Three Oaks, MI 49128
All disciplines (must bring own equipment)
Doghaven Center for the Arts provides residencies of varying lengths to artists who need both accessibility to a metropolitan area (Chicago) and to a rural area in which to immerse themselves in their work. For more information please send SASE to above address.

Experimental Television Center
109 Lower Fairfield Road
Newark Valley, NY 13811
TEL (607) 687-4341
E-MAIL etc@servtech.com
WEB www.experimentaltvcenter.org
Media artists (must have prior experience with media production tools and techniques)
Founded in 1971, the Center provides self-directed residencies to media artists, along with personalized instruction, access to facilities, and most importantly, space and time for creative exploration. The Center also provides support services to individuals, a grants program (New York State only) and directs a video history research project.

Fishtrap
P.O. Box 38
Enterprise, OR 97828
TEL (541) 426-3623
E-MAIL rich@fishtrap.org
WEB www.fishtrap.org
Writers who have participated in a previous Fishtrap event
Fishtrap is a twelve-year-old nonprofit organization that produces writing conferences, workshops, school and community residencies, and a writers' retreat. Residency applicants must have participated in a previous Fishtrap event. The facility is a remote four-bedroom log house on the Imnaha River in northeast Oregon. Fishtrap provides all groceries and prepares evening meals. Writers are required to participate in a brief community reading.

George Bennet Fellowship Program
Phillips Exeter Academy
20 Main Street
Exeter, NH 03833
WEB www.exeter.edu
Writers (preferably one who has not yet published a book-length work with a major publisher)
Stipend, room, and board for a writer with a manuscript in progress. The fellow must be in residence for the academic year. Please send SASE for details.

Grand Arts
(Alliance of Artists' Communities Member)
1819 Grand Boulevard
Kansas City, MO 64108
TEL (816) 421-6887
E-MAIL grandart@gvi.net
WEB www.grandart.com
Visual artists
Grand Arts provides specific project support for artists through its gallery and studio space, giving artists the opportunity to pursue a new direction and interact with the community.

Hallwalls Contemporary Arts Center
2495 Main Street, Suite 425
Buffalo, NY 14214

TEL (716) 835-7362
E-MAIL hallwall@pce.net
WEB www.pce.net/hallwall
Visual artists, videomakers, digital artists

Hallwalls is Buffalo's major contemporary arts center, with programs in visual art, film, video, music, performance, and literature. Hallwalls hosts approximately six artist residencies per year.

Harvestworks
596 Broadway, Suite 602
New York, NY 10012
TEL (212) 431-1130
E-MAIL harvestw@dti.net
WEB www.harvestworks.org
Recording artists, composers, film-/videomakers, performance artists, dancers, theater artists, computer-based multimedia artists, radio production, audio installation artists

Harvestworks is a nonprofit arts organization founded in 1977 to provide support services to artists who use technology as a creative medium. The residency program annually awards artists production grants to realize projects intended for public performance or broadcast, and studio grants for instruction in computer, music, and multimedia programs.

Henry Street Settlement/Abrons Art Center ☻
466 Grand Street
New York, NY 10002
TEL (212) 598-0400
E-MAIL sfnarts@aol.com
Visual artists

A nonprofit arts and social service institution founded in 1893, Henry Street provides art classes, workshops, and a residency program through the Abrons Art Center in which artists share a large, communal studio space. Abrons Art Center also has a theater, recital hall, galleries, and a performance space.

International Residencies for Artists ☻
c/o William Smart
222 W. 14th Street
New York, NY 10011
E-MAIL wsmart@earthlink.com
Artists of all disciplines

International Residencies for Artists provides artists with travel grants (at 50 percent of the cost of the most economical form of transportation) to help them attend residencies at artists' communities abroad. It also assists visual artists and composers in attending their own exhibitions/performances abroad.

International School of Art in Umbria ☻
Piazza Garibaldi, 1
06057 Montecastello di Vibio PG,
TEL (212) 386-2705
E-MAIL mservin@giotto.org
WEB www.giotto.org/

Visual artists

The School is an intensive six- to thirteen-week studio program in drawing, painting, and sculpture. The School serves developing painters and sculptors from around the world by offering a residency program as well as lectures, classes, and critiques by internationally distinguished artists.

Intersection for the Arts
446 Valencia Street
San Francisco, CA 94103
TEL (415) 626-2787
E-MAIL intrsect@wenet.net
Writers, visual artists, dancers, performance artists, musicians, actors, directors, designers, choreographers

Intersection for the Arts is San Francisco's oldest alternative art space. Intersection hosts residencies and presents new works in literature, theater, visual, and interdisciplinary arts. Intersection provides a place where provocative ideas, diverse art forms, artists, and audiences intersect one another. At Intersection, experimentation and risk are possible, debate and critical inquiry are embraced, community is essential, resources and experience are democratized, and today's issues are thrashed about in the heat and immediacy of live art.

Isle Royale National Park, Artist-in-Residence Program
800 East Lakeshore Drive
Houghton, MI 49931
TEL (906) 482-0984
WEB www.nps.gov/isro/
All disciplines

Isle Royale National Park offers five two- to three-week residencies. Applications must be postmarked by February 16. Period of residence is June through mid-September.

Jamaica Center for Arts and Learning
161-04 Jamaica Avenue
Jamaica, NY 11432
TEL (718) 658-6400
Visual artists

The Jamaica Center for Arts and Learning (JCAL) presents exhibitions of local and nationally known artists in its gallery. JCAL hosts an artist-in-residence from either Queens, Brooklyn, or Nassau County, who is given a private studio and complete access to all JCAL's facilities (computer, ceramics equipment, photography) for a period of 12 months.

Louisiana ArtWorks/Arts Council of New Orleans ☻
225 Baronne Street, Suite 1712
New Orleans, LA 70112-1712
TEL 504-523-1465
E-MAIL acno@acadiacom.net
WEB http://gnofn.org/~acno
All disciplines

The mission of Louisiana ArtWorks is to inspire artistic growth, enhance technical skills, provide marketing opportunities and economic development for Louisiana artists in a unique arts environment, and to offer public opportunities to see and understand the process involved in the creation of art.

Mill Atelier Residency Program ☀

530 Canyon Road
Santa Fe, NM 87501
TEL (505) 989-9213
Visual artists

The Mill Atelier Residency Program hosts three-month residencies in its fully furnished live/work spaces.

Mosaic Colony

1735 York Avenue, Suite 32F
New York, NY 10128
TEL (212) 996-3524
All disciplines

The Mosaic Colony was established in 1997 by members of the Jewish community who care about the arts and Jewish identity. Its mission is to provide an environment in which creative artists from across disciplines are free to pursue a project relating to their cultural and spiritual identity. Resident artists present their work to the larger community through exhibition, performance, and educational programs.

National Foundation for Advancement in the Arts

800 Brickell Avenue
Miami, FL 33131
TEL (305) 377-1147
E-MAIL nfaa@nfaa.org
WEB www.nfaa.org
Visual artists (over eighteen and under forty who have been practicing in the field for between three and five years)

Fellows live in Miami beach for four months at a time. The residency is renewable for three years. At the end of the residency, the fellows exhibit at the Corcoran Gallery in Washington, D.C.

New Arts Program

173 West Main Street, P.O. Box 82
Kuztown, PA 19530
TEL (610) 683-6440
E-MAIL napconn@hotmail.com
WEB www.napconn.org
Visual artists, performance artists, writers

The New Arts Program is a nonprofit art resource organization dedicated to providing a forum for the public to interact with today's most provocative, unique, and insightful artists.

New York Mills Arts Retreat

P. O. Box 246
New York Mills, MN 56567
TEL (218) 385-3339
E-MAIL nymills@uslink.net
WEB http://uslink.net/~nymills/residency.html
All disciplines (must bring own equipment)

The New York Mills Arts Retreat is a residency program that provides a unique taste of life in a small town. It immerses emerging artists in the culture of rural Minnesota while allowing ample time for them to focus on their work.

Noyes School of Rhythm Foundation ☀

245 Penfield Hill Road
Portland, CT 06480
TEL (860) 342-0328
Dancers, performing artists, visual artists, multidisciplinary artists (women artists only)

The Noyes School, founded by Florence Fleming Noyes, is a creative arts camp located in the Connecticut River Valley. During the eight-week summer session, guest artists teach special classes to residents. For over seventy-five years the Noyes Camp has offered a tradition of self-discovery for women by exploring creativity and humanness through the arts.

Pictured Rocks National Lakeshore, Artist-in-Residence Program

P.O. Box 40
Munising, MI 49862-0040
TEL (906) 387-2607
WEB www.hps.gov/piro
Visual artists (two-dimensional only)

Pictured Rocks National Lakeshore encompasses forty-two miles of the southern Lake Superior shoreline. The park is known for its cliffs, dunes, hardwood forests, and a rich cultural history.

Pikes Peak Writers' Retreat

4400 Martindale Avenue
Cascade, CO 80809
TEL (719) 684-0953
E-MAIL cotlanza@ix.netcom.com
WEB www.WritersRetreat.com
Writers, editors, publishers

Year-round residency program. Pikes Peak Writers' Retreat offers 15 private studios in a peaceful mountain setting (phone and modem lines in each studio). Evan Marshall is the in-house literary agent.

The Provincetown Community Compact, Inc.

P.O. Box 819
Provincetown, MA 02657-0819
TEL (508) 487-3684
E-MAIL reroot@tiac.net
WEB www.ptownlib.com/swim.html
All disciplines

The mission of the Provincetown Community Compact, Inc. is to advance the cultural well-being of the Provincetown community, act as a catalyst for community projects and events, and support public and private art projects that preserve and enhance the unique historic, cultural, and aesthetic dynamics of the area.

Red Rock Mesa ☉
2839 Glenmare Street
Salt Lake City, UT 84106
Individuals conducting creative work in the arts and humanities, including writers, visual artists, and composers
Red Rock Mesa is a newly forming community near Springdale, Utah, south of the main entry to Zion National Park. The program, which will open within the next few years, will provide the opportunity for artists and other creative individuals to create their work within the spectacular environment of the Utah canyon lands.

Rocky Mountain National Park, Artist-in-Residence Program
Estes Park, CO 80517
TEL (303) 586-1295
Visual artists, writers, photographers, multidisciplinary artists, performance artists
The artist-in-residence program at Rocky Mountain National Park offers professional writers, composers, and visual artists the opportunity to pursue their art. The park provides the use of a rustic, historic cabin to selected residents for two-week periods.

Saint-Gaudens National Historic Site, Artist-in-Residence Program
Rural Route 3, Box 73
Cornish, NH 03745-9704
TEL (603) 675-2175
E-MAIL saga@valley.net
WEB www.sgnhs.org/sculpt.html
Representational sculptors only
Home, studios, and gardens of the sculptor Augustus Saint-Gaudens (1848–1907). The 150-acre site includes exhibits or original artwork by Saint-Gaudens, formal gardens, nature trails, and a summer concert series.

Sanitary Fill Company
501 Tunnel Avenue
San Francisco, CA 94134-2939
TEL (415) 330-1400
Visual artists, photo journalists, writers, multimedia artists (Bay Area residents only)
The program provides a unique opportunity for environmental activists to create their works by transforming materials from the waste stream into art. A monthly stipend, studio, and twenty-four-hour access to the waste stream is provided.

Seaside Institute/Escape to Create
P.O. Box 4730
Seaside, FL 32459
TEL (850) 231-2421
E-MAIL institute@seasidefl.com
WEB www.seasidefl.com/institute
Writers, visual artists, composers, cinematographers, choreographers, scholars in architecture and urban planning
Escape to Create is a residency program for a se-
lected group of emerging artists for the month of January in the community of Seaside, Florida.

Sleeping Bear Dunes National Lakeshore, Artists-in-Residency Program
9922 Front Street (Highway M-72)
Empire, MI 49630
TEL (616) 326-5134
Writers, composers, visual artists, photographers
Two residencies of three weeks each; one in September and one in October. The park furnishes a free residence and reimbursement for mileage traveled within the park during the residency. In return the artist donates a piece of work to the park and conducts a program for park visitors (slide talk, demonstration, etc.).

Snug Harbor Cultural Center, Inc.
1000 Richmond Terrace
Staten Island, NY 10301
TEL (718) 448-2500
Visual artists, interdisciplinary artists
The Newhouse Center at the Snug Harbor Cultural Center, Inc. is dedicated to supporting emerging and midcareer national and international artists from all disciplines and encouraging the development and exhibition of new, innovative work.

Soapstone
622 SE 29th Avenue
Portland, OR 97214
TEL (503) 233-3936
E-MAIL soapstone@teleport.com
WEB www.soapstone.org
Writers (women only)
Soapstone is in Oregon's coast range, in twenty-two acres of forest, along the banks of Soapstone Creek. It can accommodate two writers at a time, each with a private space. Please send SASE for further information.

Southwest School of Art and Craft ☉
300 Augusta
San Antonio, TX 78205
TEL (210) 224-1848
E-MAIL ssac@dcci.com
Visual artists
The School is a professional level, non-degree-granting institution serving a diverse audience locally, regionally, and nationally. The visiting artist program supports twenty-five accomplished artists for either residencies or master classes.

Stone Quarry Hill Art Park
Stone Quarry Road
Cazenovia, NY 13035
TEL (315) 655-3196
E-MAIL stonequarry@juno.com
Visual artists
Stone Quarry Hill Art Park is an educational organization pledged to protecting the environment while offering exhibition and creation space to art-

ists and sculptors. The Park provides three major exhibitions each year.

Ten Chimneys Foundation, Inc. ☻
Box 225
Genesee Depot, WI 53127
TEL (414) 968-4161

Ten Chimneys Foundation, Inc., the estate of the late Broadway acting duo Alfred Lunt and Lynn Fontanne, is a masterpiece of interior design and decorative arts. The buildings are being restored in anticipation of an opening to the public in 2001, upon which workshops, residencies, classes, and conferences will be held.

Visual Studies Workshop
31 Prince Street
Rochester, NY 14607
TEL (716) 442-8676
E-MAIL info@vsw.org
WEB www.vsw.org
Photographers, video artists, digital media artists, book artists

Visual Studies Workshop is a media center offering an MFA degree and workshop programs, exhibitions, a publishing program, research, and studio facilities for residents in photography, artists' books, film/video, and digital media.

Wadastick Artist Residency and Cultural Center ☻
22180 Polar Ridge Rd.
Laurelhill, NC 28351
TEL (910) 462-3610
E-MAIL wadastick@aol.com
All disciplines

The focus of the residency program and cultural center is primarily on African diaspora and Native American art and culture. Additionally the residency supports and encourages interdisciplinary modes of artistic expression, particularly those pushing the boundaries between science and art, and the traditional and contemporary.

Writer's Colony at Dairy Hollow ☻
515 Spring Street
Eureka Springs, AR 72632-3032
TEL (501) 253-7444
E-MAIL frontdesk@dairyhollow.com
WEB www.dairyhollow.com
Writers

Writer's Colony at Dairy Hollow offers temporary residencies of one to three months to working writers by selected application.

Writers' Center at Chautauqua
June to August:
P.O. Box 408
Chautauqua, NY 14722
September to May:
953 Forest Ave. Ext.
Jamestown, NY 14701
TEL (716) 483-0381 (year-round)

E-MAIL blsaid@madbbs.com
Writers

The Writers' Center offers programs in poetry, fiction, and nonfiction, providing a high-level common ground for the advancement of writers of all degrees of accomplishment, of all geographical, educational, racial, and cultural backgrounds.

Yosemite National Park, Artist-in-Residence Program
P.O. Box 100
Yosemite National Park, CA 95389
TEL/FAX (209) 372-4024
Visual artists

Yosemite's artist-in-residence program encourages artists to create diverse artistic interpretations of Yosemite and the Sierra. It provides up to one month of lodging to established visual artists.

Res Artis: The International Association of Residential Arts Centres and Networks is the global equivalent to the United States' Alliance of Artists' Communities. The following is the most current list of Res Artis members (as of June 18, 1998) sent to us from Res Artis headquarters in Berlin, Germany, with several international members of the Alliance of Artists' Communities added, as well as a few more of which we happen to know. The list does not represent focused or extensive research, because for the most part it does not include international programs that are not Res Artis members, and because this directory's primary purpose is to profile United States artists' communities. However, we did not want to pass up the chance of publicizing these international residencies, which offer invaluable opportunities for artists to immerse themselves in different cultures.

Although every effort was made to check spellings, addresses, and phone/fax numbers, there may be errors or omissions. If you have trouble reaching one of these programs, contact Res Artis directly:

Michael Haerdter, Res Artis President
Künstlerhaus Bethanien
Mariannenplatz 2
10997 Berlin
Germany
TEL 49 30 6169030
FAX 49 30 61690330
E-MAIL resartis@bethanien.de
WEB www.resartis.org

Membership in the Alliance of Artists' Communities is designated by the ✪ symbol.

AUSTRALIA

Director
Gertrude Street Artist's Space
200 Gertrude Street Fitzroy
Victoria 3065
Australia
TEL 61-3-9419-3406
FAX 61-3-9419-2519
E-MAIL info@200GertrudeStreet.com
WEB www.200GertrudeStreet.com

Nicholas Tsoutas
Artspace
43–51 Cowper Wharf Road
Woolloomooloo 2011
Sydney, New South Wales
Australia
TEL 61-2-368-1899
FAX 61-2-368-1705

AUSTRIA

Werner Hartmann
Artists In Residence
Federal Chancellery
Freyung 1
AU 1014 Vienna
Austria
TEL 43-1-531-207-510
FAX 43-1-531-207-620
E-MAIL werner.hartmann@bmwf.gv.at
E-MAIL Karl.Hufnagel@bmwf.gv.at

CANADA

Jim Baird
Pouch Cove Foundation, Inc.
James Baird Gallery
221 Duckworth Street
St. John's, New Foundland A1C 1G7
Canada
TEL (709) 726-9193
FAX (709) 726-9190
E-MAIL director@pouchcove.org
WEB www.pouchcove.org

Banff Center for the Arts—Leighton Studios ✪
Box 1020, Station 28
Banff, Alberta TOL OCO
Canada
TEL (403) 762-8100
FAX (403) 762-6345
E-MAIL arts_info@banffcentre.ab.ca
WEB www.banffcentre.ab.ca/registrar/leighton/
 HPleighton.html

Chantal Boulanger
Centre de Sculpture Est-Nord-Est
333 avenue de Gaspé-Ouest
Saint-Jean-Port-Joli, Quebec GOR 360
Canada
TEL (418) 598-6363
FAX (418) 598-7071

Dolgian House Artists' Colony, Inc. ◐
Rural Route 4
Meaford, Ontario N41 LW7
Canada
TEL (519) 538-4882

Two Planks and a Passion Theatre ◐
Box 413
Canning, Novia Scotia BOP 1HO
Canada
TEL (902) 582-3073

Saskatchewan Writers/Artists Colonies and Retreats
P.O. Box 3986
Regina, Saskatchewan S4P 3R9
Canada
WEB www.skiwriter.com/colonies

CHINA (Peoples Republic of China)
Prof. Dr. Zhu Quingsheng LaoZhu
Art Institute
Peking University
100871 Beijing
China
TEL 86-10-6275-7452
FAX 86-10-6275-7452
E-MAIL laozhu@pku.edu.cn

CYPRUS
Richard Sale
The Monagri Foundation
 Centre for Contemporary Art
Archangelos Monastery
CY 4746 Monagri
Cyprus
TEL 357-5-434 165
FAX 357-5-434 166
E-MAIL rsale@cylink.com.cy; aliside@cylink.com.cy
WEB www.monagri.org.cy

CZECH REPUBLIC
Pavla Niklova
Soros Center For Contemporary Arts
Jeleni 9
118 00 Prague 1
Czech Republic
TEL 420-2-2437-3178
FAX 420-2-2437-3178
E-MAIL scca@ecn.cz
WEB www.ecn.cz/osf/scca

Milos Vojtechovsky
Hermit Foundation
Center for Metamedia—Plasy
P.O. Box 25
33101 Plasy
Czech Republic

TEL 42-018-232-2909
FAX 42-018-232-2909
E-MAIL hermit@iol.cz
WEB www.hermit.cz

DENMARK
Ulf Horak
National Workshop for Arts And Crafts
Strandgade 27 B
DK 1401 Copenhagen K
Denmark
TEL 45-32-960-510
FAX 45-32-570-252
E-MAIL uh@arts-crafts.dk

Kresten Thomsen
Kulturfabrikken
Sundholmsvej 14 Y
DK 2300 Copenhagen S
Denmark
TEL 45-32-549 424
FAX 45-32-543 245
E-MAIL kulturfb@inform.dk

ENGLAND
Triangle Arts Trust ◐
 *(Triangle's New York Program is an
 Alliance of Artists' Communities' Member)*
The Gasworks
155 Vauxhall Street
London SE11 5RH
England
TEL 44-171-587-5202

LOCUS+
Room 17, 3rd Floor Wards Building
31–99 High Bridge
High Bridge
Newcastle-upon-Tyne
NEI UK
TEL 44-0191-233-1450
E-MAIL locusplus@newart.demon.co.uk
WEB www.locusplus.org.uk

ESTONIA
Marika Blossfeldt
Polli Talu Arts Center
Rame Küla
EE 3185 Vatla
Estonia
TEL 372-5-235-217
FAX 372-5-235-217

Anu Liivak
Estonian Artists Association
c/o Tallinn Art Hall
EE 0001 Vabaduse Väljak 6
Estonia
TEL 372-644-8747
TEL 372-644-2818

FAX 372-644-6483
E-MAIL anu@khf.kl.ee

FINLAND

Maria Hirvi
Kiasma—Museum of Contemporary Art
Mannerheiminaukio 2
FIN-00100 Helsinki
Finland
TEL 358-9-17-336-500
FAX 358-9-17-336-503
E-MAIL maria.hirvi@fng.fi
WEB www.kiasma.fng.fi

Irmeli Kokko
Cable Factory International Studio Programme
Tallberginkatu 1 C/15
FIN-00180 Helsinki
Finland
TEL 358-9-685-6730
FAX 358-9-685-6730
E-MAIL cable@kaapeli.fi
WEB www.kaapeli.fi/cablefactory

Anders Kreuger
Nordic Institute for Contemporary Art/Nifka
Suomenlinna/Sveaborg
FIN-00190 Helsinki
Finland
TEL 358-9-668-546
FAX 358-9-668-594
E-MAIL anders.kreuger@nifca.org

Kari Ruokola
**The Aland Archipelago Guest Artist Residence—
 Kökarkultur**
FIN-22730 Kökar
Åland Islands
Finland
TEL 358-18-55942
FAX 358-18-55941
E-MAIL kokar@skk.inet.fi
WEB www.abo.fi/!gnordlun/kokarkultur

Esko Vesikansa
Finnish Artists' Studio Foundation
Yrjönkatu 11 F
FIN-00120 Helsinki
Finland
TEL 358-9-607-181
FAX 358-9-607-561
E-MAIL studio@artists.fi
WEB www.artists.fi/studio

FRANCE

Anne Regaud-Wildenstein
Association Francaise d'Action Artistique/AFAA
1 Avenue de Villars
F-75007 Paris
France

TEL 33-1-53-69-83-00
FAX 33-1-53-69-33-00
E-MAIL residences@afaa.asso.fr

The Camargo Foundation
BP 75
13714 Cassis Cedex
France
TEL 04-42-01-11-57
FAX 04-42-01-36-57

Mercedes Giovinazzo
Council of Europe
Cultural Policy and Action Division
F-67075 Strasbourg Cedex
France
TEL 33-3-88-41-26-85/38-24
FAX 33-3-88-41-27-50/37-82

Alexandra Keim
Centre D'art de Marnay Arts Centre/CAMAC
1 Grande Rue
F-10400 Marnay-sur-Seine
France
TEL 33-3-25-39-20-61
FAX 33-3-25-24-82-43
E-MAIL camac@club-internet.fr
WEB www.camac.org

Friches Belle de Mai
14 rue Jobin
13003 Marseilles
France
TEL 33-91-42-07-02
FAX 33-91-05-89-28

Helena Michie
La Belle Auriole
F-66600 Opoule
France
TEL 33-4-68-29-19-26
FAX 33-4-68-29-19-26/68-64-51-64
E-MAIL 101622.3641@compuserve.com

Nicola Russell and Teddy Hutton
La Maison Verte
31 avenue Henri Mas
34320 Roujan
France
TEL 33-4-67-24-88-52
FAX 33-4-67-24-69-98
E-MAIL NicolaRussell@compuserve.com
WEB www.mygale.org/~maisonve

Pascale Fougère
Pépinières Européennes pour Jeunes Artistes
BP 13, rue Paul Leplat 9/11
F-78164 Marly-Le-Roi Cedex
France
TEL 33-1-39-17-11-00
FAX 33-1-39-17-11-09
E-MAIL peja@wanadoo.fr

Triangle France ☉
*(Triangle's New York Program is an
Alliance of Artists' Communities Member)*
Friche Belle de Mai
13331 Marseille Cedex 03
France
TEL 33-49-1-11-45-61

Cécile Duvelle
**UNESCO—International Fund for the Promotion
of Culture**
rue Miollis 1
F-75015 Paris
France
TEL 33-1-45-68-42-81
FAX 33-1-45-68-57-37
E-MAIL yr.isar@unesco.org

GERMANY
Dr. Mechthild Borries-Knopp
Kreis der Freunde der Förderer und Villa Aurora E.V.
Jägerstr. 23
D-10117 Berlin
Germany
TEL 49-30-20-37-03-59
FAX 49-30-20-37-03-60
E-MAIL villaaurora@berlin.sireco.net
*(see also Villa Aurora's 2-page spread, in body of
directory, describing their California site)*

Rudolf Brünger
International Cultural Center Ufa-Fabrik Berlin
Victoriastr. 13
D-12105 Berlin
Germany
TEL 49-307-55-031-50
FAX 49-307-52-902-9
E-MAIL CULT@ufafabrik.de
WEB www.ufafabrik.de

Dr. Bernd Goldmann
Internationales Künstlerhaus Villa Concordia
Unterer Kaulberg 4
D-96049 Bamberg
Germany
TEL 49-951-95-501-0
FAX 49-951-95-501-29

Michael Haerdter
Künstlerhaus Bethanien
Mariannenplatz 2
D-10997 Berlin
Germany
TEL 49-306-16-903-0
FAX 49-306-16-903-30
E-MAIL resartis@bethanien.de
WEB www.bethanien.de

Annette Hulek
Künstlerhäuser Worpswede
Bergstr. 1

D-27726 Worpswede
Germany
TEL 49-4792-1380
FAX 49-4792-2112

Jean-Baptiste Joly
Akademie Schloss Solitude
Solitude 3
D-70197 Stuttgart
Germany
TEL 49-711-99-619-0
FAX 49-711-99-619-50
E-MAIL mr@akademie-solitude.de
WEB www.akademie-solitude.de

Sabine Jung
Kunstlerhaus Schloss Balmoral
Villenpromenade 11
D-56130 Bad Ems
Germany
TEL 49-260-39-419-0
FAX 49-260-39-419-16
E-MAIL balmoral@uni-koblenz.de
WEB www.balmoral.de

Peter Legemann
**Schloss Bröllin International Theatre Research
Location**
Dorfstr. 3
D-17309 Bröllin
Germany
TEL 49-397-47-502-35
FAX 49-397-47-503-02
E-MAIL schloss.broellin@t-online.de

Andreas von Randow
Künstlerhaus Kloster Cismar
c/o Ministerium für BWFK
Brunswiker Str. 16–22
D-24105 Kiel
Germany
TEL 49-431-98-858-45
FAX 49-431-98-858-57

Barbara Reinhart
Künstlerinnenhof die Höge
Högenhausen 2
D-27211 Bassum
Germany
TEL 49-4249-1377
FAX 49-4249-1332
E-MAIL Hoege@t-online.de
WEB www.hoege.org

Heiner Riepl
Oberpfälzer Künstlerhaus
Fronberger Strasse 31
D-92421 Schwandorf
Germany
TEL 49-9431-9716
FAX 49-9431-96311

Miro Zahra
Schloss Plüschow
Mecklenburgisches Künstlerhaus
Am Park 6
D-23936 Plüschow
Germany
TEL 49-384-16-174-0
FAX 49-384-16-174-17
E-MAIL office@plueschow.de
WEB www.plueschow.de

HUNGARY

Bencsik Barnabas
League of Nonprofit Art Spaces Studio Gallery
Kepiro u. 6.
1053 Budapest
Hungary
TEL 36-1-267-2033
FAX 36-1-266-6502
E-MAIL studgal@c3.hu

Andrea Szekeres
C3-Centre for Culture and Communication
Orszaghaz utca 9, P.O. Box 419
H 1014 Budapest
Hungary
TEL 36-1-214-68-56
FAX 36-1-214-68-72
E-MAIL info@c3.hu
WEB www.c3.hu

ICELAND

Sverrir Olafsson
Straumur International Art Commune
P.O. Box 33
222 Hafnarfjordur
Iceland
TEL 354-565-0128
FAX 354-565-0655
E-MAIL solart@tv.is

INDIA

Tapas Bhatt
Kala Khoj Prathana Community
Auroville 605101
Tamilnadu
South India
TEL 91-413-622-887
FAX 91-413-622-274
E-MAIL tapas@auroville.org.in

O.P. Jain
Sanskriti Foundation
C-6/53 Safdarjung Development Area
110016 New Delhi
India
TEL 91-11-696-3226/696-1757
FAX 91-11-685-3383
E-MAIL opjain@satyam.net.in

Vasudevan
Tasara—Centre for Creative Weaving
Beypore North
673015 Calcutta
India
TEL 91-495-414-832/233
FAX 91-495-201-861
EMAIL thetextiles@mail.isis.de

IRELAND

Sue Booth-Forbes
Anam Cara Writer's and Artist's Retreat
Inches, Eyeries
Beara, West County Cork
Ireland
TEL 353-27-74441
FAX 353-27-74448
E-MAIL anamcararetreat@tinet.ie
WEB www.ugr.com/anamcararetreat/

Orla Dukes
The Irish Museum of Modern Art (IMMA)
8 Military Road
Dublin
Ireland
TEL 353-1-612-9900
FAX 353-1-612-9999
E-MAIL info@modernart.ie

Mary Grehan
Tallaght Community Arts Centre
Virginia House
Old Blessington Rd.
D 24 Tallaght
Ireland
TEL 353-46-21501
FAX 353-46 21640
E-MAIL tcacart@itw.ie

Director
The Tyrone Guthrie Centre
Annaghmakerrig
Newbliss
County Monaghan
Ireland
TEL 353-47-54003
FAX 353-47-54380
E-MAIL thetgc@indigo.ie

ISRAEL

Herzliya Center for Creative Arts
Mishkan-Amanim
7 Yodffat St., Herliya 46583
Israel
TEL 972-9-9510606
FAX 972-9-950602

Mishkenot Sha'ananim
P.O. Box 8215
Jerusalem 91081

Israel
TEL 972-2-254321
FAX 972-2-246015

ITALY

Gordon Knox
Civitella Ranieri Center ☉
I-06019 Umbertide (PG)
Italy
TEL 39-75-941-7612
FAX 39-75-941-7613
E-MAIL civitella@civitella.org
WEB www.civitella.org

Projetto Civitella d'Agliano
CP 120
01023 Bolsena
Italy
TEL 39-761-799750

Villa Medici: Acadamie de France a Rome
1 Piazza Trinita dei Monti
00187 Rome
Italy
TEL 39-6-6761253
FAX 39-6-6761305

JAPAN

Kimura Mashashi
Akiyoshidai International Art Village ☉
50 Nakayamada, Akiyoshi
Shuho-cho Mine-gun
Yamaguchi 754-0511
Japan
TEL 011-81-8376-3-0020
FAX 011-81-8376-3-0021
WEB www.pref.yamaguchi.jp/e3top1f.htm

KENYA

Phillda Ragland Njau
Paa Ya Paa Arts Centre
Ridgeways Rd. off Kiambu Rd.
P.O. Box 49646
Nairobi
Kenya
TEL 254-2-512421
FAX 254-2-512421
E-MAIL sternjm@maf.org

LITHUANIA

Gintaras Karosas
Europos Parkas
Joneikiskiu Kaimas
Azulaukes Pastas
LT-4013 Vilnius
Lithuania
TEL 370-2-502-242
FAX 370-2-652-368

THE NETHERLANDS

Tijmen van Grootheest
Amsterdam Fund for the Arts
Herengracht 609
NL 1017 CE Amsterdam
The Netherlands
TEL 31-20-520-0535
FAX 31-20-623-8389
E-MAIL AFK@AFK.NL

Janwillem Schrofer
Rijksakademie van Beeldende Kunsten
Sarphatistraat 470
NL-1018 GW Amsterdam
The Netherlands
TEL 31-20-527-0300
FAX 31-20-527-0301
E-MAIL info@rijksakademie.nl
WEB www.rijksakademie.nl

Laurens Schumacher
Jan Van Eyck Akademie
Academieplein 1
NL 6211 KM Maastricht
The Netherlands
TEL 31-43-3503737/22
FAX 31-43-3503799
E-MAIL info@janvaneyck.nl
WEB www.janvaneyck.nl

Maria Tuerlings
**Trans Artists—Information Centre
 for Visual Artists** ☉
Postbus 14763
1001 LG Amsterdam
The Netherlands
TEL 31-20-626-6740
FAX 31-20-626-5341
E-MAIL info@transartists.nl
WEB www.transartists.nl

POLAND

Tomasz Palacz
Centre of Polish Sculpture
ul. Topolowa 1
PL-26681 Oronsko
Poland
TEL 48-48-362-1916
FAX 48-48-362-1916

Aneta Szylak
The Bathhouse—Centre of Contemporary Art
ul. Jaskóleza 1
PL-80767 Gdansk
Poland
TEL 48-58-305-2680
FAX 48-58-305-2680
E-MAIL laznia@friko6.onet.pl
WEB friko6.onet.pl/gd/laznia

PORTUGAL

Fernado de Sousa Bothelho de Albuquerque
Fundaçao da Casa de Mateus—Residéncia de Artistas
Casa de Mateus
P-5000 Vila Real
Portugal
TEL 351-59-323-121
FAX 351-59-326-553
E-MAIL casa.mateus@utad.pt
WEB www.utad.geira.pt/casamateus

ROMANIA

Elena Bulai
Centrul de Cultura George Enescu
5481 Teskani
RO 5500 Tescani Bacau
Romania
TEL 40-34-36-2727
FAX 40-34-36-2727

SOUTH AFRICA

Malcolm Christian
Caversham Press ◑
P.O. Box 87 Balgowan, 3275
Kwazulu, Natal
South Africa
TEL/FAX 27-33-23-44080
E-MAIL caversham@pixie.co.za

SPAIN

Centre D'art I Natura
25595 Farrera de Pallars, Lleida
Catalunya
Spain
TEL 34-73-622106

Morten Vilhelm Keller
Fundación Valparaiso
Apartado de correos 836
E-04638 Mojácar Playa
Almeria
Spain
TEL 34-950-472380
FAX 34-950-472607
E-MAIL vparaiso@futurnet.es

Fundación Comillas
Tantín, 25
39001 Santander
Cantabria
Spain
TEL 34-42-36-2575
E-MAIL project@kcomillas.es

SWEDEN

Daniel Birnbaum
International Artists Studio Program in Sweden (IASPIS)
Box 1610
Fredsgatan 12
S-11186 Stockholm
Sweden
TEL 46-8-402-3577/88
FAX 46-8-402-3592
E-MAIL mm@iaspis.com
WEB www.iaspis.com

Maria Lundberg
Konstepidemin in Gothenburg
Konstepidemins väg 6
S-41314 Göteborg
Sweden
TEL 46-31-828558/96
FAX 46-31-828568
E-MAIL konstep@tripnet.se
WEB www.konstepidemin.com

Johan Pousette
Baltic Art Centre
Gotland kommun
Ryska gränd 13
S-62181 Visby
Sweden
TEL 46-498-204161/62
FAX 46-498-204156
E-MAIL pousette@gotlandica.se
WEB www.marebalticum.com/artcentre

SWITZERLAND

Hanneke Frühauf
Stiftung Binz39
Seegartenstrasse 32
CH-8810 Horgen
Switzerland
TEL 41-1-725-7606
FAX 41-1-725-7608

TAIWAN (Republic of China)

Margaret Shiu Tan
Taiwan International Artists' Village ◑
No. 19-1 Chinhwa Street
Taipei
Taiwan (Republic of China)
TEL 886-2-2392-9674
FAX 886-2-2392-9694
E-MAIL bamcur@ms15.hinet.net

Indices

Artistic Categories

Visual Arts

Organization Name	VISUAL ARTS	Arts & Crafts	Book Artists	Ceramicists	Clay Artists/Potters	Digital Imaging	Drawing	Fiber/Textile Artists	Film/Videomakers	Folk Artists	Glass Artists	Industrial Artists	Installation Artists	Jewelry Makers/Fine Metal	Metalworkers/Blacksmiths	Mixed Media Artists	Painters	Paper Artists	Photographers	Printmakers	Sculptors	Weavers	Woodworkers
18th Street Arts Complex	X	X	X	X	X	X	X	X	X	X	X	X	X	X	X	X	X		X	X	X	X	
American Academy in Berlin	X	X	X	X	X	X										X	X	X		X			
American Academy in Rome	X	X	X	X	X	X	X	X	X	X	X	X	X	X	X	X	X	X	X	X	X	X	
Anderson Center for Interdisciplinary Studies	X	X	X	X	X	X						X			X	X	X	X	X	X		X	
Anderson Ranch Arts Center	X	X	X	X	X	X						X			X	X	X	X	X	X		X	
Archie Bray Foundation for the Ceramic Arts	X		X	X	X											X				X			
Arrowmont School of Arts and Crafts	X	X	X	X	X	X	X				X	X		X	X	X	X	X	X	X	X	X	
ArtCenter/South Florida	X	X	X			X	X	X			X	X			X	X	X	X	X	X		X	
Art Farm	X		X	X	X	X				X	X				X	X	X			X		X	
ART/OMI International Arts Center	X	X	X	X	X	X	X	X			X	X	X	X	X	X	X	X	X	X	X	X	
ArtPace	X	X	X	X	X	X	X	X	X		X	X	X		X	X	X	X	X	X		X	
Atlantic Center for the Arts	X	X	X	X	X	X	X	X	X	X	X	X	X		X	X	X	X	X	X		X	
Bemis Center for Contemporary Arts	X	X	X	X	X	X	X	X	X		X	X	X		X	X	X	X	X	X		X	
Blue Mountain Center	X	X	X		X	X	X	X	X			X			X	X	X	X	X	X			
Brandywine Graphic Workshop	X																		X				
Carving Studio and Sculpture Center	X						X					X		X	X	X	X	X		X	X		
Centrum	X	X	X		X		X	X	X	X		X	X	X	X	X	X	X	X	X		X	
Contemporary Artists Center	X	X	X		X	X	X	X	X			X	X		X	X	X	X	X	X		X	
Creative Glass Center of America/Wheaton Village	X									X	X												
Djerassi Resident Artists Program	X	X	X	X	X	X	X	X	X		X	X			X	X	X	X	X	X		X	
Dorland Mountain Arts Colony	X	X	X		X	X	X	X	X			X	X		X	X	X	X	X	X			
Dorset Colony House																							
Edward F. Albee Foundation/William Flanagan Memorial Creative Persons Center	X							X	X						X	X	X	X	X	X		X	
Exploratorium	X							X	X														
Fabric Workshop and Museum	X		X	X	X	X	X	X		X		X		X	X	X	X	X	X	X	X	X	
Fine Arts Work Center in Provincetown	X	X		X	X	X	X	X			X	X			X	X	X	X	X	X			X

Friends of Weymouth

Gell Writers' Center of the Finger Lakes

Hambidge Center for Creative Arts and Sciences

Headlands Center for the Arts

Hedgebrook

International Art Center, c/o Arts for All

Jacob's Pillow Dance Festival and School

John Michael Kohler Arts Center, Arts/Industry Program

Kala Institute

Kalani Oceanside Eco-Resort, Institute for Culture/Wellness

Light Work Visual Studies

MacDowell Colony

Mary Anderson Center for the Arts

Mattress Factory

Medicine Wheel Artists' Retreat

Mesa Refuge, c/o Common Counsel Foundation

Millay Colony for the Arts

Montana Artists Refuge

Nantucket Island School of Design and the Arts

National Playwrights Conference at the Eugene O'Neill Theater Center

Norcroft: A Writing Retreat for Women

Northwood University, Alden B. Dow Creativity Center

Oregon College of Art and Craft

Ox-Bow

P.S. 1 Contemporary Art Center

Penland School of Crafts

Peters Valley Craft Education Center

Organization Name	VISUAL ARTS	Arts & Crafts	Book Artists	Ceramicists	Clay Artists/Potters	Digital Imaging	Drawing	Fiber/Textile Artists	Film/Videomakers	Folk Artists	Glass Artists	Industrial Artists	Installation Artists	Jewelry Makers/Fine Metal	Metalworkers/Blacksmiths	Mixed Media Artists	Painters	Paper Artists	Photographers	Printmakers	Sculptors	Weavers	Woodworkers
Pilchuck Glass School	X									X	X	X			X	X			X	X			
Portland Institute for Contemporary Art	X	X	X	X	X	X	X	X		X	X	X			X	X	X	X	X	X		X	X
Ragdale Foundation	X	X	X	X		X	X					X			X	X	X			X		X	
Roswell Artist-in-Residence Program	X	X	X	X	X	X	X					X			X	X	X	X	X	X		X	X
Saltonstall Arts Colony/The Constance Saltonstall Foundation for the Arts	X	X			X	X										X	X	X	X	X			
Sculpture Space, Inc.	X				X							X	X	X						X		X	
Shenandoah International Playwrights Retreat	X								X											X			
Sitka Center for Art and Ecology	X	X	X	X		X	X	X			X	X			X	X	X	X	X	X		X	X
Skowhegan School of Painting and Sculpture	X	X	X		X	X	X	X				X	X		X	X	X	X		X			X
STUDIO for Creative Inquiry	X	X			X	X	X	X				X	X		X	X	X	X	X	X			
Studios Midwest	X	X				X	X					X	X		X	X	X	X	X	X			
Sundance Institute	X					X			X			X											
Triangle Artists' Workshop (New York)	X	X	X	X	X	X	X		X		X	X	X	X	X	X	X	X	X	X	X		X
Tryon Center for Visual Art	X	X	X	X	X	X	X		X			X	X		X	X	X	X	X	X		X	X
Ucross Foundation Residency Program	X	X	X		X	X	X	X	X			X	X		X	X	X	X	X	X			
Vermont Studio Center	X				X	X	X	X			X	X			X	X	X	X	X	X			
Villa Aurora	X					X	X	X				X	X		X	X	X	X	X	X			
Villa Montalvo	X	X			X	X	X		X			X	X		X	X	X	X	X	X			
Virginia Center for the Creative Arts	X	X	X		X	X	X	X	X			X			X	X	X	X	X	X		X	X
Watershed Center for the Ceramic Arts	X	X	X	X		X	X		X		X	X			X	X	X	X	X	X		X	
Weir Farm Trust	X				X	X	X	X				X			X	X	X	X	X	X			
Women's Art Colony Farm	X	X			X	X	X	X			X	X			X	X	X	X	X	X	X	X	X
Women's Studio Workshop	X	X				X											X	X	X	X			
Woodstock Guild's Byrdcliffe Arts Colony	X	X	X	X		X						X			X	X	X	X		X			
Yaddo	X					X	X			X		X			X			X	X	X			X
The Yard																				X			

Artistic Categories

Writing, Music, Dance, Performance

Organization Name	WRITING							MUSIC/DANCE/PERFORMANCE											
	Fiction Writers	Journalists	Literary Nonfiction Writers	Playwrights	Poets	Screenwriters	Translators	Actors	Audio Artists	Choreographers	Composers	Dancers	Directors (Film)	Directors (Theatre)	Electronic Artists	Musicians	Performance Artists	Storytellers	Radio Artists
18th Street Arts Complex	X	X	X	X	X	X	X	X	X	X	X	X	X	X	X	X	X	X	
American Academy in Berlin	X	X	X	X	X		X			X			X		X				
American Academy in Rome	X	X	X	X	X		X			X	X					X			
Anderson Center for Interdisciplinary Studies	X		X	X	X	X	X		X		X	X	X	X		X	X	X	
Anderson Ranch Arts Center							X						X			X	X		
Archie Bray Foundation for the Ceramic Arts							X			X	X					X			
Arrowmont School of Arts and Crafts																			
ArtCenter/South Florida																			
Art Farm																			
ART/OMI International Arts Center	X	X	X	X	X	X	X		X	X	X		X	X	X	X	X		
ArtPace							X	X		X		X				X			
Atlantic Center for the Arts	X	X	X	X	X	X	X	X	X	X	X	X	X	X		X	X		
Bemis Center for Contemporary Arts	X	X	X	X	X	X	X	X	X	X	X	X	X		X	X	X	X	
Blue Mountain Center	X	X	X	X	X	X	X		X	X	X	X	X	X	X	X	X		
Brandywine Graphic Workshop																			
Carving Studio and Sculpture Center																			
Centrum	X	X	X	X	X	X	X	X	X	X	X	X	X	X	X	X	X	X	
Contemporary Artists Center							X			X					X	X			
Creative Glass Center of America/Wheaton Village																			
Djerassi Resident Artists Program	X	X	X	X	X	X	X	X	X	X	X		X	X	X	X	X	X	
Dorland Mountain Arts Colony	X	X	X	X	X	X	X	X	X	X	X	X	X	X	X	X	X		
Dorset Colony House	X	X	X	X	X	X													
Edward F. Albee Foundation/William Flanagan Memorial Creative Persons Center	X	X	X	X	X	X			X					X		X	X	X	
Exploratorium	X		X				X		X					X		X			
Fabric Workshop and Museum																X	X		
Fine Arts Work Center in Provincetown	X	X	X	X	X														

183

Artistic Categories

Writing, Music, Dance, Performance, *continued*

Organization Name	WRITING							MUSIC/DANCE/PERFORMANCE											
	Fiction Writers	Journalists	Literary/Nonfiction Writers	Playwrights	Poets	Screenwriters	Translators	Actors	Audio Artists	Choreographers	Composers	Dancers	Directors (Film)	Directors (Theatre)	Electronic Artists	Musicians	Performance Artists	Storytellers	Radio Artists
Friends of Weymouth	X	X	X	X	X	X	X												
Gell Writers' Center of the Finger Lakes	X	X	X	X	X	X	X									X	X	X	
Hambidge Center for Creative Arts and Sciences	X	X	X	X	X	X	X	X	X	X	X	X	X	X	X	X	X	X	
Headlands Center for the Arts	X	X	X	X	X	X	X	X	X	X	X	X	X	X	X	X	X		
Hedgebrook	X	X	X	X	X	X													
International Art Center, c/o Arts for All	X	X	X	X	X	X	X	X	X	X	X	X	X	X	X	X	X	X	
Jacob's Pillow Dance Festival and School									X	X	X	X		X	X	X			
John Michael Kohler Arts Center, Arts/Industry Program																			
Kala Institute																			
Kalani Oceanside Eco-Resort, Institute for Culture/Wellness	X	X	X	X	X	X	X	X	X	X	X	X	X	X	X	X	X	X	
Light Work Visual Studies	X	X	X	X	X	X	X		X	X	X	X	X		X	X	X		
MacDowell Colony	X	X	X	X	X	X	X	X	X	X	X	X	X	X	X	X	X	X	
Mary Anderson Center for the Arts	X	X	X	X	X	X	X		X	X	X	X	X		X	X	X		
Mattress Factory								X		X	X					X			
Medicine Wheel Artists' Retreat	X	X	X	X	X	X	X	X	X	X	X	X	X	X	X	X	X	X	
Mesa Refuge, c/o Common Counsel Foundation	X	X	X	X	X	X	X										X	X	
Millay Colony for the Arts	X	X	X	X	X	X	X			X	X	X				X			
Montana Artists Refuge	X	X	X	X	X	X	X			X	X				X	X			
Nantucket Island School of Design and the Arts	X	X	X	X	X	X	X	X	X	X	X	X	X	X	X	X	X	X	
National Playwrights Conference at the Eugene O'Neill Theater Center			X	X	X	X		X						X					
Norcroft: A Writing Retreat for Women	X	X	X	X	X	X													
Northwood University, Alden B. Dow Creativity Center	X	X	X	X	X	X	X	X	X	X	X	X	X	X	X	X	X	X	
Oregon College of Art and Craft				X							X		X			X			
Ox-Bow	X															X			
P.S. 1 Contemporary Art Center																X	X		
Penland School of Crafts																X			

184

Peters Valley Craft Education Center

Pilchuck Glass School

Portland Institute for Contemporary Art

Ragdale Foundation

Roswell Artist-in-Residence Program

Saltonstall Arts Colony/The Constance Saltonstall Foundation for the Arts

Sculpture Space, Inc.

Shenandoah International Playwrights Retreat

Sitka Center for Art and Ecology

Skowhegan School of Painting and Sculpture

STUDIO for Creative Inquiry

Studios Midwest

Sundance Institute

Triangle Artists' Workshop (New York)

Tryon Center for Visual Art

Ucross Foundation Residency Program

Vermont Studio Center

Villa Aurora

Villa Montalvo

Virginia Center for the Creative Arts

Watershed Center for the Ceramic Arts

Weir Farm Trust

Women's Art Colony Farm

Women's Studio Workshop

Woodstock Guild's Byrdcliffe Arts Colony

Yaddo

The Yard

185

Artistic Categories

Architecture, Design, Scholarship

Organization Name	Architects	Clothing Designers	Graphic Designers	Industrial Designers	Landscape Architects	Set Designers	Urban Designers	Art Conservationists	Art Educators	Art Historians	Art Professionals	Computer Scientists	Critics	Environmentalists/Naturalists	General Scholarship	Historians	Historic Preservationists	Linguists	Mathematicians	Philosophers	Scientists
18th Street Arts Complex	X	X	X	X	X	X	X	X	X	X	X	X	X	X	X	X	X	X	X	X	
American Academy in Berlin	X	X	X	X	X	X	X	X	X	X	X	X	X	X	X	X	X	X	X		
American Academy in Rome	X	X	X	X	X	X	X	X	X					X	X	X					
Anderson Center for Interdisciplinary Studies							X	X	X	X	X		X	X	X		X	X	X	X	
Anderson Ranch Arts Center																					
Archie Bray Foundation for the Ceramic Arts																					
Arrowmont School of Arts and Crafts																					
ArtCenter/South Florida																					
Art Farm																					
ART/OMI International Arts Center	X	X					X														
ArtPace	X	X										X									
Atlantic Center for the Arts	X	X	X		X	X	X	X	X			X	X	X							
Bemis Center for Contemporary Arts				X																	
Blue Mountain Center													X	X	X						
Brandywine Graphic Workshop																					
Carving Studio and Sculpture Center	X	X	X	X	X	X	X	X	X	X	X		X	X	X	X	X	X			
Centrum	X	X	X	X	X	X	X	X	X	X	X	X	X	X	X	X	X	X	X	X	
Contemporary Artists Center							X	X				X									
Creative Glass Center of America/Wheaton Village				X																	
Djerassi Resident Artists Program	X	X						X	X					X	X						
Dorland Mountain Arts Colony	X	X						X													
Dorset Colony House																					
Edward F. Albee Foundation/William Flanagan Memorial Creative Persons Center											X			X	X	X	X				
Exploratorium								X													
Fabric Workshop and Museum	X	X	X	X	X	X	X	X	X	X	X		X	X	X	X	X	X	X		
Fine Arts Work Center in Provincetown	X							X						X	X	X	X	X	X	X	

186

Organization																		
Friends of Weymouth	X																	
Gell Writers' Center of the Finger Lakes	X	X																
Hambidge Center for Creative Arts and Sciences	X	X							X	X	X	X	X	X	X		X	
Headlands Center for the Arts	X	X	X	X		X	X	X	X	X	X	X	X	X	X	X		X
Hedgebrook				X	X								X	X	X	X	X	
International Art Center, c/o Arts for All	X	X	X	X	X	X	X	X	X	X	X	X	X	X	X	X	X	X
Jacob's Pillow Dance Festival and School					X	X						X	X	X				
John Michael Kohler Arts Center, Arts/Industry Program	X	X	X	X	X							X	X	X	X			
Kala Institute			X	X	X													
Kalani Oceanside Eco-Resort, Institute for Culture/Wellness	X	X	X	X	X	X	X	X	X	X	X	X	X	X	X	X	X	X
Light Work Visual Studies					X	X	X		X									
MacDowell Colony	X	X	X	X	X													
Mary Anderson Center for the Arts	X	X	X	X	X	X	X	X	X	X	X	X	X					
Mattress Factory	X		X															
Medicine Wheel Artists' Retreat	X	X	X	X	X	X	X	X	X	X	X	X	X	X	X	X		X
Mesa Refuge, c/o Common Counsel Foundation	X			X	X	X			X									
Millay Colony for the Arts							X											
Montana Artists Refuge	X	X	X	X	X		X						X					
Nantucket Island School of Design and the Arts	X	X	X	X	X	X	X	X	X	X	X	X	X	X	X	X	X	X
National Playwrights Conference at the Eugene O'Neill Theater Center															X	X	X	
Norcroft: A Writing Retreat for Women				X	X	X												
Northwood University, Alden B. Dow Creativity Center	X	X	X	X	X	X	X	X	X	X	X	X	X	X	X	X		X
Oregon College of Art and Craft										X	X	X	X	X	X	X		
Ox-Bow																		
P.S. 1 Contemporary Art Center																		
Penland School of Crafts																		
Peters Valley Craft Education Center																		
Pilchuck Glass School																		

Artistic Categories

Architecture, Design, Scholarship, *continued*

Organization Name	Architects	Clothing Designers	Graphic Designers	Industrial Designers	Landscape Designers	Set Designers	Urban Designers	Art Conservationists	Art Educators	Art Historians	Art Professionals	Computer Scientists	Critics	Environmentalists/Naturalists	General Scholarship	Historians	Historic Preservationists	Linguists	Mathematicians	Philosophers	Scientists
	ARCHITECTURE & DESIGN							**SCHOLARSHIP**													
Portland Institute for Contemporary Art							X			X											
Ragdale Foundation	X		X	X			X	X	X	X	X										
Roswell Artist-in-Residence Program																					
Saltonstall Arts Colony/The Constance Saltonstall Foundation for the Arts								X													
Sculpture Space, Inc.																					
Shenandoah International Playwrights Retreat						X															
Sitka Center for Art and Ecology	X		X	X		X	X	X	X	X	X		X							X	
Skowhegan School of Painting and Sculpture	X		X	X	X			X	X	X	X							X			
STUDIO for Creative Inquiry	X		X	X		X	X	X	X	X	X		X		X	X	X	X		X	
Studios Midwest																					
Sundance Institute																					
Triangle Artists' Workshop (New York)																					
Tryon Center for Visual Art	X		X	X		X	X	X	X	X	X		X	X	X	X		X	X	X	
Ucross Foundation Residency Program	X		X	X		X	X	X	X	X	X		X	X	X	X	X	X	X	X	
Vermont Studio Center					X	X			X				X		X	X			X		
Villa Aurora	X				X																
Villa Montalvo	X		X		X	X							X								
Virginia Center for the Creative Arts	X				X		X														
Watershed Center for the Ceramic Arts	X			X	X			X	X	X	X			X							
Weir Farm Trust						X															
Women's Art Colony Farm	X			X				X	X	X	X		X	X	X	X	X	X	X	X	
Women's Studio Workshop																					
Woodstock Guild's Byrdcliffe Arts Colony																					
Yaddo																					
The Yard																					

Artistic Categories

Unclassifiable, Notes

Organization Name	UNCLASSIFIABLE	Collaborative Teams	Conceptual Artists	Environmental Artists	Interdisciplinary Artists	Media Artists	Multimedia Artists	New Genre Artists (Related to all artistic categories)	NOTES
18th Street Arts Complex	X	X	X	X	X	X	X	X	
American Academy in Berlin	X	X			X	X			Professionals in fields such as law, public policy.
American Academy in Rome	X	X	X	X	X	X	X	X	Writers by nomination only.
Anderson Center for Interdisciplinary Studies	X		X	X	X				Archaeologists, anthropologists, botanists.
Anderson Ranch Arts Center	X			X		X	X		Anderson Ranch accepts all the disciplines checked here for both of their programs. However, they can only accommodate performance artists in the Visiting Artists program.
Archie Bray Foundation for the Ceramic Arts						X			Installation artists only if project is relating to clay.
Arrowmont School of Arts and Crafts	X	X	X	X		X			Stained glass only, no hot glass.
ArtCenter/South Florida	X	X	X	X	X	X	X		
Art Farm	X	X	X		X	X			
ART/OMI International Arts Center	X	X	X	X			X	X	No equipment for film/video. Limited equipment for photographers and printmakers. Art critics only. Jazz musicians only.
ArtPace	X	X	X	X	X	X	X		
Atlantic Center for the Arts	X	X	X	X	X	X	X		
Bemis Center for Contemporary Arts	X	X	X	X		X	X		Printmaking facility offsite. Clay facility to be completed by 2000.
Blue Mountain Center	X	X		X	X	X	X		For digital imaging and film/video, artists need to bring own equipment.
Brandywine Graphic Workshop									We invite serious artists working in any fine art medium to produce limited edition prints.
Carving Studio and Sculpture Center									
Centrum	X	X	X	X	X	X	X	X	Open to all genres, but artists are responsible for providing own equipment. No darkroom and no pottery kiln.
Contemporary Artists Center	X	X	X	X	X	X	X		Digital imaging facility is available nearby.
Creative Glass Center of America/Wheaton Village									
Djerassi Resident Artists Program	X	X		X	X	X	X		
Dorland Mountain Arts Colony	X			X					Dorland has no electricity; kerosene lamps and propane power only. No darkroom available. Collaborating artist must apply individually.
Dorset Colony House	X	X		X		X			
Edward F. Albee Foundation/William Flanagan Memorial Creative Persons Center	X	X							Program provides studio space and silence; artists must provide own equipment.

Artistic Categories

Unclassifiable, Notes, _continued_

Organization Name	UNCLASSIFIABLE	Collaborative Teams	Conceptual Artists	Environmental Artists	Interdisciplinary Artists	Media Artists	Multimedia Artists	New Genre Artists	NOTES (Related to all artistic categories)
Exploratorium	X	X	X	X	X		X	X	Phenomena-based artists. Artists working at the intersection between art, science, and culture.
Fabric Workshop and Museum	X	X	X		X	X	X		Textile designers
Fine Arts Work Center in Provincetown	X	X	X	X		X			
Friends of Weymouth	X			X					
Gell Writers' Center of the Finger Lakes	X						X		
Hambidge Center for Creative Arts and Sciences	X	X	X	X		X	X	X	Electronic Artists must provide own equipment.
Headlands Center for the Arts	X	X	X	X	X	X	X	X	
Hedgebrook	X							X	Women writers only, any genre of writing.
International Art Center, c/o Arts for All	X	X	X	X		X	X	X	All artists are responsible for their own equipment and tools. If International Art Center's facilities do not have space required for a specific type of art, they will work with local organizations to accommodate artists' needs.
Jacob's Pillow Dance Festival and School	X	X	X	X					
John Michael Kohler Arts Center, Arts/Industry Program	X	X	X	X			X		Projects in clay, cast iron, brass, metal. Program especially geared toward those who wish to work in a foundry.
Kala Institute	X			X		X			Traditional printmaking combined with electronic media (interactive CD-ROMs, 2D and 3D animation, digital video and sound). Painters eligible if they are working on monoprints.
Kalani Oceanside Eco-Resort, Institute for Culture and Wellness	X	X	X	X	X	X	X	X	All genres welcome, but artist responsible for providing own equipment.
Light Work Visual Studies	X	X				X			
MacDowell Colony	X	X	X	X	X	X	X	X	Must bring own equipment for digital imaging.
Mary Anderson Center for the Arts	X	X	X	X	X	X	X	X	Encourages collaborative teams. Accepts, but have no special facilities for, dancers and glass artists.
Mattress Factory	X	X	X	X					
Medicine Wheel Artists' Retreat	X	X	X	X	X	X	X	X	Open to all genres, but artists responsible for providing own equipment.
Mesa Refuge, c/o Common Counsel Foundation			X		X				Designers, architects, and visual artists may apply for a session to do the written portion of their projects, or to take on a writing project. Mesa Refuge does not have special facilities for these residents.
Millay Colony for the Arts	X	X	X	X	X	X	X		For many of the visual arts categories residents must bring their own equipment.
Montana Artists Refuge	X	X	X	X		X	X		
Nantucket Island School of Design and the Arts	X	X	X	X	X	X	X	X	Film/video, woodworking, electronic, and multimedia artists need to furnish their own equipment. A special residency program for interdisciplinary artists exists, called AIR (Artists Interdisciplinary Residency).

Organization									Notes
National Playwrights Conference at the Eugene O'Neill Theater Center									
Norcroft: A Writing Retreat for Women									Any woman doing creative writing who would be described as feminist may apply.
Northwood University, Alden B. Dow Creativity Center	X	X	X	X	X	X	X	X	Open to all genres, but artists responsible for providing own equipment.
Oregon College of Art and Craft									Metal-workers.
Ox-Bow									Papermakers.
P.S. 1 Contemporary Art Center	X	X	X	X	X	X	X		
Penland School of Crafts									
Peters Valley Craft Education Center									
Pilchuck Glass School									
Portland Institute for Contemporary Art	X	X	X	X	X	X	X		
Ragdale Foundation	X			X	X				Artists representing nearly every classification have completed residencies at Ragdale. Those who require special equipment either bring it with them or work on some aspect that doesn't require special equipment.
Roswell Artist-in-Residence Program									Roswell accepts applications from all studio based, visual art except performance artists and production crafts.
Saltonstall Arts Colony/The Constance Saltonstall Foundation for the Arts									
Sculpture Space, Inc.	X	X	X	X					
Shenandoah International Playwrights Retreat	X		X						
Sitka Center for Art and Ecology	X	X	X	X	X				Sitka accepts residents in field of computer science only if their work is nature- or arts-related.
Skowhegan School of Painting and Sculpture		X	X	X	X				Video artists.
STUDIO for Creative Inquiry	X	X	X	X	X				Biologists.
Studios Midwest									
Sundance Institute									
Triangle Artists' Workshop (New York)									
Tryon Center for Visual Art	X	X	X	X	X				Public art, community art. Tryon accepts scholars from medical field as well as those indicated here.
Ucross Foundation Residency Program	X	X	X	X	X				Have no equipment for jewelry and digital imaging; artists required to bring own equipment.
Vermont Studio Center									
Villa Aurora									
Villa Montalvo	X	X	X						Directors and set designers in collaboration with theatre company. Film and videomakers have applied and have accepted because they could and did bring their own equipment.

191

Artistic Categories

Unclassifiable, Notes, *continued*

Organization Name	UNCLASSIFIABLE Collaborative Teams	Conceptual Artists	Environmental Artists	Interdisciplinary Artists	Media Artists	Multimedia Artists	New Genre Artists	NOTES (Related to all artistic categories)
Virginia Center for the Creative Arts	X	X	X	X	X	X	X	Fiber/textile artists only if it is one-of-a-kind, non-production kind of work. Wood-worker yes, but not furniture-makers.
Watershed Center for the Ceramic Arts	X	X	X			X		
Weir Farm Trust		X	X					No darkroom, but photographers are able to use the studio quite well. Also, Weir Farm does not have a press but is developing a collaborative program with the Connecticut Creative Arts Center (nearby) for printmakers.
Women's Art Colony Farm	X	X	X	X				
Women's Studio Workshop	X	X	X					
Woodstock Guild's Byrdcliffe Arts Colony		X	X					
Yaddo	X	X	X	X	X	X	X	No special facilities for digital imaging or glass artists.
The Yard	X	X	X		X	X	X	

Regions

Northeast

Midwest

New England

Southeast

Southwest

West (Mountain)

West (Pacific)

193

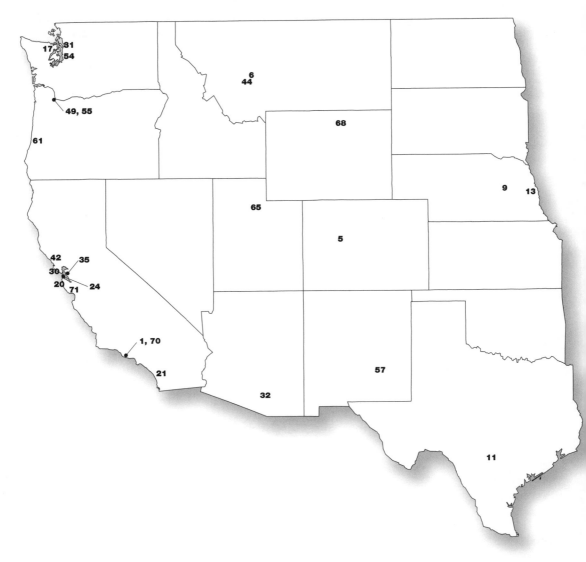

1 18th Street Arts Complex

2 American Academy in Berlin

3 American Academy in Rome

4 Anderson Center for Interdisciplinary Studies

5 Anderson Ranch Arts Center

6 Archie Bray Foundation for the Ceramic Arts

7 Arrowmont School of Arts and Crafts

8 ArtCenter/South Florida

9 Art Farm

10 ART/OMI International Arts Center

11 ArtPace

12 Atlantic Center for the Arts

13 Bemis Center for Contemporary Arts

14 Blue Mountain Center

15 Brandywine Graphic Workshop

16 Carving Studio and Sculpture Center

17 Centrum

18 Contemporary Artists Center

19 Creative Glass Center of America–Wheaton Village

20 Djerassi Resident Artists Program

21 Dorland Mountain Arts Colony

22 Dorset Colony House

23 Edward F. Albee Foundation/William Flanagan Memorial Creative Persons Center

24 Exploratorium

25 Fabric Workshop and Museum

26 Fine Arts Work Center in Provincetown

27 Friends of Weymouth

28 Gell Writers' Center of the Finger Lakes

29 Hambidge Center for Creative Arts and Sciences

30 Headlands Center for the Arts

31 Hedgebrook

32 International Art Center, c/o Arts for All

33 Jacob's Pillow Dance Festival and School

34 John Michael Kohler Arts Center, Arts/Industry Program

35 Kala Institute

36 Kalani Oceanside Eco-Resort, Institute for Culture and Wellness

37 Light Work Visual Studies

38 MacDowell Colony

39 Mary Anderson Center for the Arts

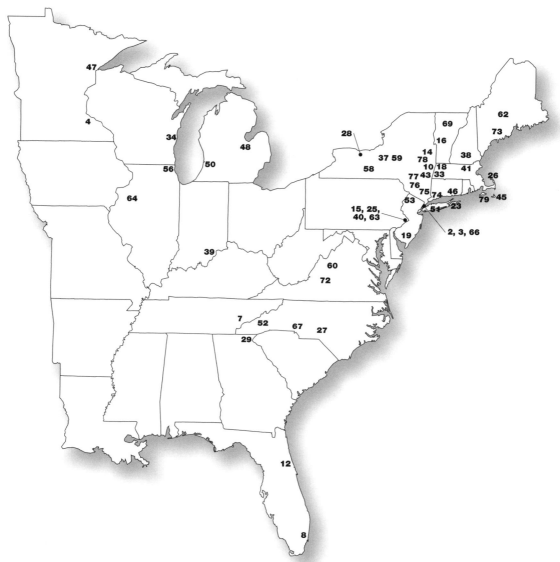

40 Mattress Factory
41 Medicine Wheel Artists' Retreat
42 Mesa Refuge, c/o Common Counsel Foundation
43 Millay Colony for the Arts
44 Montana Artists Refuge
45 Nantucket Island School of Design and the Arts
46 National Playwrights Conference at the Eugene O'Neill Theater Center
47 Norcroft: A Writing Retreat for Women
48 Northwood University, Alden B. Dow Creativity Center
49 Oregon College of Art and Craft
50 Ox-Bow
51 P.S.1 Contemporary Art Center
52 Penland School of Crafts
53 Peters Valley Craft Education Center
54 Pilchuck Glass School
55 Portland Institute for Contemporary Art (PICA)
56 Ragdale Foundation
57 Roswell Artist-in-Residence Program
58 Saltonstall Arts Colony/Constance Saltonstall Foundation for the Arts
59 Sculpture Space

60 Shenandoah International Playwrights Retreat
61 Sitka Center for Art and Ecology
62 Skowhegan School of Painting and Sculpture
63 STUDIO for Creative Inquiry
64 Studios Midwest
65 Sundance Institute
66 Triangle Artists' Workshop (New York)
67 Tryon Center for Visual Art
68 Ucross Foundation Residency Program
69 Vermont Studio Center
70 Villa Aurora
71 Villa Montalvo
72 Virginia Center for the Creative Arts
73 Watershed Center for the Ceramic Arts
74 Weir Farm Trust
75 Women's Art Colony Farm
76 Women's Studio Workshop
77 Woodstock Guild's Byrdcliffe Arts Colony
78 Yaddo
79 The Yard

Organization Name	Summer	Fall	Winter	Spring	Application Deadlines
18th Street Arts Complex	X	X	X	X	Ongoing.
American Academy in Berlin		X	X	X	February 1.
American Academy in Rome	X	X	X	X	November 15.
Anderson Center for Interdisciplinary Studies	X		X	X	March 1.
Anderson Ranch Arts Center	X	X	X	X	Mid-March; exact date varies year to year (call to confirm).
Archie Bray Foundation for the Ceramic Arts	X	X	X	X	March 1 (due in Archie Bray's offices).
Arrowmont School of Arts and Crafts	X	X	X	X	February 1.
Art Center/South Florida	X	X	X	X	Ongoing (call for information).
Art Farm	X	X	X	X	April 1 for residencies between June 1 and November 1. September 1 for fee-based winter residencies.
ART/OMI International Arts Center	X	X	X	X	Visual artists, March 1. Writers, November 30. Musicians, March 1.
ArtPace	X	X	X	X	By nomination only, every 2 years (dates vary).
Atlantic Center for the Arts	X	X	X	X	Varies; approximately 3 months prior to start of residency.
Bemis Center for Contemporary Arts	X	X	X	X	September 30, April 30.
Blue Mountain Center	X	X			February 1.
Brandywine Graphic Workshop	X	X	X		October 15.
Carving Studio and Sculpture Center	X	X	X	X	Ongoing.
Centrum		X	X	X	Early September.
Contemporary Artists Center	X	X	X	X	Ongoing.
Creative Glass Center of America/Wheaton Village	X	X	X	X	September 15.
Djerassi Resident Artists Program	X	X	X		February 15.
Dorland Mountain Arts Colony	X	X	X	X	March 1, September 1.
Dorset Colony House		X	X	X	Ongoing.
Edward F. Albee Foundation/William Flanagan Memorial Creative Persons Center	X	X			April 1.
Exploratorium	X		X	X	Ongoing.
Fabric Workshop and Museum	X	X	X		By invitation only.
Fine Arts Work Center in Provincetown		X	X	X	Writers and poets, December 1 (postmark). Visual artists, February 1 (postmark).

Organization						Deadline
Friends of Weymouth	X	X	X			Ongoing.
Gell Writers' Center of the Finger Lakes	X	X	X			Ongoing.
Hambidge Center for Creative Arts and Sciences	X	X	X			November 1 for March–August residencies. May 1 for September–December residencies. Applications submitted beyond deadlines will be considered on a first-come, first-served basis and as space is available.
Headlands Center for the Arts	X	X	X			Early June for California, North Carolina, and Ohio artists. International program deadlines vary. Artists from all other regions should contact Headlands for information.
Hedgebrook	X	X	X			October 1. April 1.
International Art Center, c/o Arts for All	X	X	X			Ongoing.
Jacob's Pillow Dance Festival and School	X	X	X			Ongoing.
John Michael Kohler Arts Center, Arts/Industry Program	X	X	X			August 1.
Kala Institute	X	X	X			April 26 for fellowship applications; others ongoing.
Kalani Oceanside Retreat, Institute for Culture/Wellness	X	X	X			Ongoing.
Light Work Visual Studies	X	X	X			Ongoing.
MacDowell Colony	X	X	X			January 15 for May–August residencies; April 15 for September–December residencies; September 15 for January–April residencies.
Mary Anderson Center for the Arts	X	X	X			Ongoing, except for specific fellowships (call for information).
Mattress Factory	X		X			Ongoing.
Medicine Wheel Artists' Retreat	X		X			Ongoing.
Mesa Refuge, c/o Common Counsel Foundation	X	X	X			February 15, June 15.
Millay Colony for the Arts	X	X	X			February 1 for June–September residencies; May 1 for October–January residencies; September 1 for February–May residencies.
Montana Artists Refuge	X	X	X			Ongoing, except summer residencies deadline is November 1.
Nantucket Island School of Design and the Arts	X	X	X			Ongoing.
National Playwrights Conference at the Eugene O'Neill Theater Center	X					December 1.
Norcroft: A Writing Retreat for Women	X		X			October 1.
Northwood University, Alden B. Dow Creativity Center	X					December 31.
Oregon College of Art and Craft	X		X			Emerging artists, April 15. Midcareer artists by invitation only.
Ox-Bow	X					May 15.
P.S. 1 Contemporary Art Center	X	X	X			April 15.
Penland School of Crafts	X	X	X			October 28.
Peters Valley Craft Education Center	X	X	X			Professional Residency: ongoing. Associate Residency: July 15 for fall and full season residency, December 15 for winter/spring residency. Assistant Residency: March 31.

Seasons and Deadlines

Organization Name	Summer	Fall	Winter	Spring	Application Deadlines
Pilchuck Glass School	X	X			March 1.
Portland Institute for Contemporary Art	X	X	X	X	None; residencies curated.
Ragdale Foundation	X	X	X	X	January 15 for June–December residencies. June 1 for January–April residencies. (Latter season is less competitive.)
Roswell Artist-in-Residence Program	X	X	X	X	Varies (call for current details).
Saltonstall Arts Colony/The Constance Saltonstall Foundation for the Arts	X				January 15.
Sculpture Space, Inc.	X	X	X		December 15.
Shenandoah International Playwrights Retreat	X	X			February 1.
Sitka Center for Art and Ecology	X	X	X		April 15.
Skowhegan School of Painting and Sculpture	X				February 1.
STUDIO for Creative Inquiry	X	X	X		Ongoing.
Studios Midwest	X				Third Friday in February.
Sundance Institute	X	X			First week of May for all programs.
Triangle Artists' Workshop	X				February 1 or May 1.
Tryon Center for Visual Art	X	X	X		By nomination only.
Ucross Foundation Residency Program	X	X	X		March 1, October 1.
Vermont Studio Center	X	X	X		February 15, June 15, September 30.
Villa Aurora	X	X	X		Ongoing.
Villa Montalvo	X	X	X		March 1, September 1.
Virginia Center for the Creative Arts	X	X	X		January 15, May 15, September 15.
Watershed Center for the Ceramic Arts	X	X	X		April 1 for funded residencies. Proposals for "Artists Invite Artists" program are accepted on an ongoing basis.
Weir Farm Trust	X	X	X		January 15, July 15.
Women's Art Colony Farm	X				Ongoing.
Women's Studio Workshop		X	X		July 1 and November 1 for Fall and Spring Fellowships. November 15 for Artists' Book Residency Grant.
Woodstock Guild's Byrdcliffe Arts Colony	X	X			April 1.
Yaddo	X	X	X		January 15, August 1.
The Yard	X	X	X		December 15.

Fees and Stipends

Organization Name	Application Fee	Residency Fees	Artist's Expenses	Meals	Stipends/Fellowships
18th Street Arts Complex	None	$1,200/mo. for Los Angeles—based artists; International/invitational artists do not pay a fee	Food, materials	Artists purchase own food and prepare own meals	Limited subsidies for international artists only
American Academy in Berlin	None	None	Materials	2 meals/day (breakfast & dinner) provided and served in dining room; fellows who wish to take meals in their rooms can do so; most take lunch at their institutional affiliation, outside the Academy	Stipends; Regular Berlin Prize Fellowships, plus one Emerging Artists Fellowship and one Advanced Studies Fellowship
American Academy in Rome	$40	None	Travel, materials	2 meals/day, except Sunday & holidays, in dining hall	Stipends $9,000–$15,000 depending on length of term
Anderson Center for Interdisciplinary Studies	$15	None	Travel, materials	Breakfast and dinner served; lunch is responsibility of residents; meals served 5 days/wk.; weekends are responsibility of residents	A. P. Anderson award for contributions in literature and arts; fellowship programs with U. of Minnesota, Mankato State U., and The Loft writing departments
Anderson Ranch Arts Center	$10	None	Travel, food other than the 10 meals/wk. provided, any materials above and beyond the $100 materials stipend (benefits for Visiting Artists differ from those of Residents; please call for details)	5 dinners and 5 continental breakfasts provided/wk.; artists make all their other meals	Materials stipend of $100/mo.; Pam Joseph Fellowship for Artists of Color
Archie Bray Foundation for the Ceramic Arts	$20	Fixed fee $75/mo. for long-term and $150/mo. for short-term residencies	Housing, materials, firing fees, food, travel	Artists purchase own food and prepare own meals	The Taunt Fellowship, a $5,000 award for a one-yr. residency
Arrowmont School of Arts and Crafts	$25	Fixed fee $200/mo. for house, studio, and utilities	$175 damage deposit, materials, some food, rental of some equipment	Provided (7 mos. out of the yr.) when school is operating with kitchen use; for all other meals, artists purchase own food and prepare own meals	1 fellowship presently offered for a professional woman resident; other fellowships currently being researched; scholarships available

Fees and Stipends

Organization Name	Application Fee	Residency Fees	Artist's Expenses	Meals	Stipends/Fellowships
ArtCenter/South Florida	$40	Sliding scale $7–10/sq.ft. and energy surcharge	Housing, food, travel, materials	Artists purchase own food and prepare own meals	Subsidized rent (~ 1/10th of average Lincoln Rd. rents); FIVA artists receive monthly stipend plus housing/studio
Art Farm	None	None	Small maintenance fee for use of equipment; food, travel, materials; work exchange for June 1 to Nov. 1 residencies; $450/mo. for winter-rental residencies (call for details)	Artists purchase own food and prepare own meals; vegetable garden grown for residents' use	None
ART/OMI International Arts Center	None	None	Travel, materials	All meals provided	Fellowships may change yearly; fellowships for visual artists in July 1999 supported African-American or Native-American, Polish, Australian, Danish, Korean, and Chinese artists (6 fellowships in all)
ArtPace	None	None	Nothing	Artists responsible for own groceries and meals (but receive living stipend of $500/wk. to cover costs)	Living stipend $500/wk.; Foundation also provides travel, materials, photo-documentation, and exhibition brochure
Atlantic Center for the Arts	None	$100/wk., additional housing fee $25/night (optional)	Food, travel, materials	Artists purchase own food and prepare own meals	Scholarships and fellowships/awards available on a limited basis; exchange program to Far East and Europe
Bemis Center for Contemporary Arts	$25	None	Food, travel, materials	Artists purchase own food and prepare own meals	Stipends $500/mo.
Blue Mountain Center	$20	None required; voluntary contributions welcome	Travel, materials	All meals provided	None
Brandywine Graphic Workshop	None	None	Nothing	Artists receive per diem to purchase own food and prepare own meals	Per diem provided for meals; travel and materials stipend; please call to inquire about fellowship opportunities
Carving Studio and Sculpture Center	None	None	Food, travel, materials	Artists purchase own food and prepare own meals	None.
Centrum	$10	None	Food, travel, materials	Artists purchase own food and prepare own meals	$300 stipends available to approximately 15 artists each yr.

Organization	Application Fee	Residency Fee	Costs to Artist	Meals	Financial Assistance
Contemporary Artists Center	None	Fixed fee $200/wk (+$50 for printmaking studios and 50% off for returning artists)	Housing, food, travel, materials	Artists purchase own food; artists often get together in CAC's dining room or café, or use CAC's kitchen facilities and private kitchens in apartments	Call for details of available financial assistance
Creative Glass Center of America/Wheaton Village	None	None	Food, travel, house phone, shipping costs	Artists purchase own food and prepare own meals	Stipends of $1,500; fellowships (call for details)
Djerassi Resident Artists Program	$25	None	Travel, materials	Evening meals provided weekdays; weekend and other meals prepared by the residents from food supplied by the program	Gerald Oshita Memorial Fellowship of $2,500 for composer of color; other awards on occasion; many residencies are supported by named annual, or endowed fellowships (call for current opportunities)
Dorland Mountain Arts Colony	None	Fixed fee $300/mo.	$50 processing fee upon acceptance, food, travel, materials	Artists purchase own food and prepare own meals; transportation for grocery shopping provided	Occasional stipends or fellowships (call for current opportunities)
Dorset Colony House	None	Voluntary fee $125/wk.	Food, travel, materials, part of housing cost	Artists purchase own food and prepare own meals	None
Edward F. Albee Foundation/William Flanagan Memorial Creative Persons Center	None	None	Food, travel, materials	Artists purchase own food and prepare own meals	None
Exploratorium	None	None	Food (though out-of-town artists receive per diem for food)	Artists purchase own food and prepare own meals (though out-of-town artists receive per diem for food)	Stipends for travel, meals, and materials; on an individual basis, negotiated payment for commissioned work; out-of-town artists receive per diem for meals
Fabric Workshop and Museum	None	None	Nothing	Artists receive per diem for food, purchase own food, and prepare own meals	Artists receive per diem for meals
Fine Arts Work Center in Provincetown	$35	None	Food, travel, materials	Artists purchase own food and prepare own meals	FAWC is a Fellowship Program; stipends provided range $375/mo. (visual artists receiving additional $75/mo. for supplies) to $600/mo. depending on funding
Friends of Weymouth	None	None	Food, travel, materials	Artists purchase own food and prepare own meals	None

Fees and Stipends

Organization Name	Application Fee	Residency Fees	Artist's Expenses	Meals	Stipends/Fellowships
Gell Writers' Center of the Finger Lakes	None	Fixed fee $35/day for members	Food, travel, materials	Artists purchase own food and prepare own meals	None.
Hambidge Center for Creative Arts and Sciences	$20	Fixed fee $125/wk.	Travel, materials, some food	Vegetarian or fish evening dinner provided weekdays May–Oct.; residents purchase and prepare own food other times; each studio has full kitchen	Limited number of scholarships which are listed in application materials
Headlands Center for the Arts	None	None	Materials, some food	Dinner provided five times/wk.; artists purchase food and prepare all other meals; spouses pay $6 each for dinners at the Center while children under 5 yrs. are free	$500/mo. stipend for live-in residents; $2,500 one-time stipend for CA non-live-in residents; airfare covered for non-CA residents; Bridge Residencies for artists-activists (write for details)
Hedgebrook	$15	None	Travel, materials	Breakfast self-serve (food provided); lunch brought to residents' cottages; dinner is a communal meal in farmhouse dining room	Fellowships/awards and travel scholarships (please call for details)
International Art Center, c/o Arts for All	$20 electronically; $30 by mail	Variable residency fee (call for details)	Food, travel, materials, telecommunications	Artists purchase own food and prepare own meals; some communal cooking is possible/likely	Sponsorship by local and international organizations; scholarship opportunities; currently developing program to provide some teaching stipends
Jacob's Pillow Dance Festival and School	None	None	Food, travel, materials	Artists purchase own food and prepare own meals	None.
John Michael Kohler Arts Center, Arts/Industry Program	None	None	Food	Artists purchase own food and prepare own meals	Stipend $120/wk.; travel reimbursement (within continental US); materials reimbursement.
Kala Institute	None	Fellowships pay no fee; Artists in Residents pay sliding scale fee $125–$340/mo.	Housing, food, travel, some materials	Artists purchase own food and prepare own meals; full kitchen provided	Stipends and fellowships/awards (please call for details). Phelan Awards for California-born printmakers given by the San Francisco Foundation every 2 yrs.
Kalani Oceanside Eco-Resort, Institute for Culture and Wellness	$10	Fixed fee $65–145/day	Food, travel, materials	3 meals (which artists pay for) served daily on dining terrace	50% discount on residency/lodging fee available

202

Organization	Application Fee	Fee / Cost	Artist Pays For	Meals	Stipend / Financial Aid
Light Work Visual Studies	None	None	None	Artists purchase own food and prepare own meals	Stipend $2,000
MacDowell Colony	$20 (one application per person per yr.)	Amount is voluntary	Materials, travel (unless artist applies for travel assistance)	All meals provided	Stipend during 1998–2001 that will provide financial aid to writers as part of pilot program; some fellowships/awards and travel grants
Mary Anderson Center for the Arts	$15	Sliding scale fee $30/day suggested minimum	Deposit of 20% of total fee due to secure residency after notification of acceptance, travel, materials	All meals provided or reimbursed; breakfast do-it-yourself; lunch and dinner prepared; Sun. and Mon. nights do-it-yourself dinner, though the Center will reimburse restaurant receipts up to $6.50	Mary Foote Fellowship for Visual Arts, 30 days; Dorothy Norton Clay Music Fellowship, 30 days; Felhoelter Poetry Fellowship, 10 days; Kentucky Foundation for Women Fellowship in Visual Arts & Writing, 30 days (limited to female residents of Kentucky)
Mattress Factory	None	None	Nothing	Artists given per diem for food, purchase own food and prepare own meals	Stipend $500–$1,000; per diem for meals
Medicine Wheel Artists' Retreat	None	Sliding scale $60–$250/wk.	Travel, materials	All meals provided (vegetarian selection included)	None
Mesa Refuge, c/o Common Counsel Foundation	None	None	Travel, materials, e-mail	Breakfast and lunch do-it-yourself from stocked kitchen; dinners provided 5 nights/wk. by Tomales Bay Foods, which specializes in fresh local organic food	None
Millay Colony for the Arts	None	None	Travel, materials	All food provided; dinners prepared weeknights; artists prepare other meals	None
Montana Artists Refuge	None	"Rents" range $260–450/mo. though some financial assistance available	Utilities (which vary by season), $200 cleaning deposit, food, travel, materials	Artists purchase own food and prepare own meals	Financial assistance available (call for details); some work exchange possible; some financial support may be able to be arranged for special collaborative projects

Fees and Stipends

Organization Name	Application Fee	Residency Fees	Artist's Expenses	Meals	Stipends/Fellowships
Nantucket Island School of Design and the Arts	$20	Varies (call for current fee)	Variable residency fee covers housing, food, travel, materials	Artists purchase own food and prepare own meals; kitchen is available at Seaview Farm Studios; each Cottage has a small kitchen with full oven/ stove, refrigerator and small dining table	Some financial assistantships/work exchanges may be available (call for details)
National Playwrights Conference at the Eugene O'Neill Theater Center	$15	None	Travel, some materials	All meals provided	Stipend $1,000; Herbert & Patricia Brodkin Scholarship Award; Charles MacArthur Fellowship;Eric Kocher Playwrights Award; Edith Oliver Fellowship; Steinber Prize
Norcroft: A Writing Retreat for Women	None	None	Travel, materials	Food provided; artists prepare own meals	Accessibility Fund: artists can apply for up to $200 for transport or other costs
Northwood University, Alden B. Dow Creativity Center	$10	None	Travel, materials, some food	Lunch provided weekdays at the Creativity Center; residents (called fellows) purchase own food and prepare all other meals	Stipend $750 to be used on project costs or personal needs
Oregon College of Art and Craft	None	None	Food, some travel	Artists purchase own food and prepare own meals; café available on campus	Stipend $400/mo.; travel and material allowance
Ox-Bow	None	Fixed fee $348/wk.	Travel, materials	All meals provided	None
P.S. 1 Contemporary Art Center	None	None	International artists pay nothing (all expenses paid by sponsoring government); national artists receive studio for free and pay for housing, food, travel, materials	Artists purchase own food and prepare own meals (though international artists receive living stipend)	International artists: stipends sponsored by participating governments which includes $18,000 for annual living expenses, $2,000 for travel, and $1,000 for materials
Penland School of Crafts	$25	$50/mo. housing, $50/mo. studio	Food, travel, materials	Artists purchase own food and prepare own meals; meals available in Penland School dining hall for a fee	None
Peters Valley Craft Education Center	None	Associate Program $325/mo.; Professional Program no fee; Assistantship Program minimal cost	Associate Program: food, travel, materials; Professional Program: food, travel	Artists purchase own food and prepare own meals	Stipends for Assistantship Program; opportunities for paid work available

204

	Application Fee	Residency Fee	Artist Pays For	Meals	Financial Aid / Stipend
Plichuck Glass School	$25	None	Food, travel, some materials	Artists purchase own food and prepare own meals in a community kitchen	Stipend $1,000
Portland Institute for Contemporary Art	None	None	Food, materials	Artists purchase own food and prepare own meals	Housing and travel paid for by Portland Institute for Contemporary Art; modest materials stipend provided
Ragdale Foundation	$20	Fixed fee $15/day (which is a contribution toward food costs)	$75 nonrefundable deposit (applied toward residency fee), travel, materials	All meals provided; occasionally guests of the Foundation are invited to dinner for development or educational purposes	Frances Shaw Fellowship for women writers over 55; need-based Friend of Ragdale Scholarship; other opportunities depending on funding
Roswell Artist-in-Residence Program	$20	None	Food, travel, materials, phone	Artists purchase own food and prepare own meals	Stipend $500/mo.; $100/mo. per dependent living at the community
Saltonstall Arts Colony/The Constance Saltonstall Foundation for the Arts	None	None	Travel, materials	Food provided; vegetarian dinners prepared on weeknights; artists prepare all other meals in shared kitchen	None
Sculpture Space	None	None	Food, travel, materials, low-cost housing	Artists purchase own food and prepare own meals; kitchen in both the studio and apartment; plenty of inexpensive, good ethnic restaurants in the vicinity	Stipends of $2,000 are available for 10–20 residents annually
Shenandoah Int'l. Playwrights Retreat	None	None	Any special materials needed	All meals provided	None
Sitka Center for Art and Ecology	None	None	Food, travel, materials	Artists purchase own food and prepare own meals	Founders' Series award of a $500 monthly stipend to 1 artist each yr.; Founders Series Invitational opportunity for artists of international stature, which provides a modest stipend and covers travel and materials costs
Skowhegan School of Painting and Sculpture	$35	Fixed fee $5,200 for tuition, room, and board (however, 94% of residents receive fellowships to help with this fee)	Travel, materials	3 meals provided each day	94% of residents receive fellowships: e.g., Camille Hanks Cosby Fellowships for African-American artists (3); Payson Governors Fund Fellowships for artists of Asian, Pacific, Central/South American, or Caribbean descent; Fellowships for KS, ME, OH, CA artists

Fees and Stipends

Organization Name	Application Fee	Residency Fees	Artist's Expenses	Meals	Stipends/Fellowships
STUDIO for Creative Inquiry	None	None	Nothing (stipend provided to artist so that he/she may pay for all housing, food, travel, and materials costs)	Artists purchase own food and prepare own meals, except for monthly meetings and special events; stipend covers food/living costs	Stipend $30,000/yr. plus extensive benefits program; some artists receive a small project fund; no fellowships/awards though artists are appointed as research fellows with special faculty status during residency
Studios Midwest	None	None	$50 refundable damage deposit, food, travel, materials	Artists purchase own food and prepare own meals	None
Sundance Institute	$30	None	Nothing	All meals provided	None, though travel, lodging, materials and food are covered by Sundance Institute
Triangle Artists' Workshop (New York)	None	Fixed fee $400	Travel, materials	All meals provided	No stipend or specific fellowships/awards, though many participants obtain funding from sponsors (or their respective governments)
Tryon Center for Visual Art	None	None	Nothing	Artists purchase own food (with per diem provided to cover them) and prepare own meals on a daily basis, with communal dinners once a week	Stipends; per diem provided for food/meals
Ucross Foundation Residency Program	$20	None	Travel, materials	All meals provided (lunch delivered to studios) weekdays; food provided for artists to prepare their own meals on weekends	None
Vermont Studio Center	$25	$1,300/mo.	Travel, materials	All meals provided; organic garden in season	150 full fellowships/yr. awarded on a competitive basis; numerous international, regional, and state-wide fellowship programs (call for details); 250 partial grant & work-exchanges available; stipend $10/day for international artists
Villa Aurora	None	None	Food	Artists purchase own food (with monthly stipend) and prepare own meals	Monthly stipend; 9-mo. fellowship for a writer who lives in exile or under pressure in his/her country

Organization	Application fee	Residency fee	Artist pays for	Meals	Stipends / financial aid
Villa Montalvo	$20	None	Refundable security deposit $100, food, travel, materials	Artists purchase own food and prepare own meals; once-a-week potluck	7 $400 fellowships given each yr., based on merit; $75 honoraria for artists' presentations given as part of Villa Montalvo's Outreach Program
Virginia Center for the Creative Arts	$20	Voluntary fee $30/day suggested	Travel, materials	All meals provided; breakfast & dinner served in dining room; lunches delivered to studios	Occasionally fully funded residencies and stipends (call for available opportunities)
Watershed Center for the Ceramic Arts	$20	$790/2 wks.	Food, travel, materials, firing fees	All meals provided family-style; largely vegetarian, made from Watershed's gardens	Some full and partially funded residencies (call for details); "Artists Invite Artists" sessions (collaborative groups at discounted fees)
Weir Farm Trust	$25	None	Deposit of $75 (returned to artists upon arrival), food, travel, materials	Artists purchase own food and prepare own meals; apartment has kitchen with all appliances including microwave and dishwasher	Stipend $500/mo. (pro-rated for more or less time)
Women's Art Colony Farm	None	$80/wk. that goes directly toward purchase of food	Travel, materials	Artists prepare meals and eat together	None
Women's Studio Workshop	None	Fixed fee $200/wk.	Deposit of $100, food, travel, materials	Artists purchase own food and prepare own meals; daily pot-lucks	Artists' Book Grants $1,800 for 6 weeks; materials up to $450
Woodstock Guild's Byrdcliffe Arts Colony	$5	Fixed fee $500/mo. (covers housing)	Food, travel	Artists purchase own food and prepare own meals	$100 Scholarship for writers under 35 who need financial assistance; The Patterson Fund Scholarship
Yaddo	$20	None	Travel (though some travel assistance may be available), materials	All meals provided; breakfast and dinner served family-style; lunch packed in lunchpails	Small fund exists to provide limited help toward travel expenses for persons invited who otherwise might not be able to visit; another small fund specifically for writers is being developed
The Yard	$20 per choreographer	None	Food, travel	Artists purchase own food and prepare own meals	Stipend $240/wk. per resident

Accessibility

Organization Name

Organization Name	Fully Wheelchair Accessible	Expanding Accessibility	Housing Accessibility	Studios	Public Bathrooms	Housing bathrooms	Kitchen	Wheelchair Ramps	Elevators/Lifts	Automatic Doors	Roll-in Shower	Other Accessible Areas	General Comments on Wheelchair Accessibility	Vision Impairment	Hearing Impairment	Other Facilities or Services
18th Street Arts Complex	yes	X	X	X	X	X	X									
American Academy in Berlin	yes	X	X	X				X								
American Academy in Rome	yes	X	X	X				X								
Anderson Center for Interdisciplinary Studies	no	X	X	X	X			X				darkroom	Center will be providing ramps to main residence house, to screen porch in main house, and in next few years, they will provide accessible entrances, facilities, and equipment	X	X	Fire alarms with flashing lights as well as sound
Anderson Ranch Arts Center	yes	X	X	X				X				woodshop, darkroom, ceramics facilities, painting/printmaking facilities	Elevator in print/paint building; most other buildings accessible at least on 1 floor; most studios and bathrooms accessible, all to be soon			
Archie Bray Foundation for the Ceramic Arts	no	X											Any new facility buildings will be wheelchair accessible; no definite date for construction as yet			
Arrowmont School of Arts and Crafts	yes	X	X	X	X		X									
ArtCenter/South Florida	yes			X	X			X								
Art Farm	no	X											Art Farm is a working farm with turn-of-the-century (19th) buildings that are slowly being renovated and upgraded; as this process progresses, they are attempting to improve accessibility			
ART/OMI International Arts Center	yes	X	X	X			X						Temporary wheelchair ramps installed as needed			
ArtPace	yes	X	X	X	X			X					When an artist is selected, every effort is made to accommodate them	X	X	
Atlantic Center for the Arts	yes	X	X	X	X	X	X						4 living spaces specially equipped for residents with disabilities; Atlantic Center is constantly seeking ways to make facilities more accessible for all artists with disabilities			

208



Facility	(yes/no)						Notes	Accessibility description			Comments	
Bemis Center for Contemporary Arts	yes	X	X	X	X		installation space, fabrication studio spaces					
Blue Mountain Center	no		X	X	X					X	X	Possible to accommodate residents with vision or hearing impairment, but no special facilities
Brandywine Graphic Workshop	no	X	X	X	X	X		All studio facilities wheelchair-accessible except artist apartment	X			
Carving Studio and Sculpture Center	no	X	X	X								
Centrum	no	X						Cottages not yet wheelchair-accessible, however, they are in a state park that does have wheelchair-accessible facilities; every effort is made to accommodate artists with disabilities within constraints of the facilities				
Contemporary Artists Center	no	X	X	X			galleries, café (where lectures, events are held)	CAC to be 100% accessible (except housing) once freight elevator is made into passenger elevator; all public galleries are 100% accessible				
Creative Glass Center of America/Wheaton Village	no	X	X	X	X						Hearing impairment can only be accommodated in the Museum	
Djerassi Resident Artists Program	no	X	X						X		MS, Chronic Fatigue Syndrome	
Dorland Mountain Arts Colony	no							Rough terrain very difficult for wheelchairs	X		None	
Dorset Colony House	no	X	X					Engaged in a large capital campaign which will lead to improved accessibility	X	X		
Edward F. Albee Foundation/William Flanagan Memorial Creative Persons Center	yes	X	X					Residents with disabilities have been accommodated; Center deals with each artist's disability on an individual basis				
Exploratorium	yes	X	X	X	X			Will make an effort to accommodate artists with disabilities as needed	X			
Fabric Workshop and Museum	no	X	X	X	X				X			
Fine Arts Work Center in Provincetown	yes	X	X	X	X	X		Have a number of units accessible to residents with disabilities	X	X		

Accessibility
continued

Organization Name

Organization Name	Fully Wheelchair Accessible	Expanding Accessibility	Housing & Housing Bathrooms	Studios	Public Bathrooms	Kitchen	Wheelchair Ramps	Elevators/Lifts	Automatic Doors	Roll-in Shower	Other Accessible Areas	General Comments on Wheelchair Accessibility	Vison Impairment	Hearing Impairment	Other Facilities or Services
Friends of Weymouth	no											No special facilities for artists with disabilities, but would make every effort to accommodate them should they apply	X	X	
Gell Writers' Center of the Finger Lakes	no	X									letterpress print shop	Not fully accessible to artists in wheelchairs (call for details)	X		All alarm systems flash as well as sound.
Hambidge Center for Creative Arts & Sciences	no	X										Accessibility for artists with disabilities is limited and will be addressed in Hambidge's ongoing facility upgrade			
Headlands Center for the Arts	yes	X	X	X								In beginning stage of a $2 million Capital Campaign to bring their Fort Barry campus up to a standard of excellence; from 1998 to 2002, HCA will be engaged in building new studios and upgrading/expanding accessibility of facilities and grounds			
Hedgebrook	no											Rural retreat not suitable for artists in wheelchairs	X	X	
International Art Center, c/o Arts for All	yes	X	X	X	X	X		X	X		1 studio/living space, dance studio, alternative theatre space	Continuing plans to make all areas of facility accessible; elevator will be added in 2001			
Jacob's Pillow Dance Festival and School	no		X	X											
John Michael Kohler Arts Center, Arts/Industry Program	no											Very difficult to navigate site in wheelchair; however, the Arts Center will consider each individual according to her/his needs and the extent of his/her disability			
Kala Institute	no	X	X	X	X	X	X				Electronic Media Center with seven Mac work stations	Housing not yet accessible, though all other facilities are; work improving access underway			
Kalani Oceanside Eco-Resort, Institute for Culture and Wellness	yes	X	X	X	X	X			X	X	3,000 sq. ft. multi-purpose Rainbow Room, computers, copy machines	Bathrooms designed for wheel-chair access, however entire site is rural and inter-facility trails are rough	X	X	night lighting minimal

Organization	Accessible					Special facilities	Accessibility notes			Additional notes
Light Work Visual Studies	yes	X	X				Both the apartment and the building that houses Lightwork accessible			
MacDowell Colony	yes	X	X	X		film editing facilities, darkroom, printmaking studio, composers' studio with piano	All buildings include considerations for accessibility, and staff adapts to needs of each resident	X	X	Artists with speech impairment accommodated; MacDowell allows seeing-eye dogs and cell phones for emergencies
Mary Anderson Center for the Arts	no	X	X			kiln, 2 VanderCook printing presses				
Mattress Factory	no	X	X	X			Has not had residents with disabilities in the past, but staff will make special accommodations for any future artists with vision or hearing impairment; long-term plans for providing wheelchair-accessible housing			
Medicine Wheel Artists' Retreat	no	X					Lease the facility so have little control over accessibility	X		
Mesa Refuge, c/o Common Counsel	no									
Millay Colony for the Arts	yes	X	X	X	X		Main building (which is all at ground level) is fully accessible: includes 2 studio/living complexes in addition to common areas for all artists; in the final stages of a major campaign to make facilities universally accessible	X		
Montana Artists Refuge	no	X	X							
Nantucket Island School of Design and the Arts	yes	X	X	X	X		2 cottages are wheelchair-accessible; currently working to improve access in bathrooms; studios are on one floor; have excellent cooperation with local EMT; NISDA's 5-year plan for facilities includes substantial projects to improve accessibility	X		Staff will make effort to accommodate artists with other disabilities
National Playwrights Conference at the Eugene O'Neill Theater Center	yes	X	X	X				X		

211

Accessibility

continued

Organization Name	Fully Wheelchair Accessible	Expanding Accessibility	Housing & Housing Accessibility	Studios	Public Bathrooms	Kitchen	Wheelchair Ramps	Elevators/Lifts	Automatic Doors	Roll-in shower	Other Accessible Areas	General Comments on Wheelchair Accessibility	Vison Impairment	Hearing Impairment	Other Facilities or Services
Norcroft: A Writing Retreat for Women	yes	X	X									Route from housing to studio is also wheelchair-friendly			
Northwood University, Alden B. Dow Creativity Center	no														
Oregon College of Art and Craft	yes	X	X	X								Will make accommodations for residents with disabilities	X	X	
Ox-Bow	yes	X	X	X											
P.S. 1 Contemporary Art Center	yes	X	X	X			X					Housing is arranged by artists, so can be chosen according to need			
Penland School of Crafts	no											Call to see if accommodations can be made for specific needs			
Peters Valley Craft Education Center	no	X													
Pilchuck Glass School	no	X		X					X			New construction is accessible; old construction is not adaptable for the most part			
Portland Institute for Contemporary Art	yes	X	X	X	X	X		X	X			Other needs accomodated as requested	X	X	
Ragdale Foundation	yes	X	X	X		X	X					Plans have been drawn up for a more universally accessible space; fundraising underway for targeted completion in 2001			
Roswell Artist-in-Residence Program	no	X										Will try to accommodate each individual's special needs	X		
Saltonstall Arts Colony/The Constance Saltonstall Foundation for the Arts	yes	X	X	X								1 apartment with adjourning studio is wheelchair-accessible; provision of an elevator to public spaces in the plans			
Sculpture Space	yes		X	X								Flexible: will do what they can to accommodate residents with disabilities	X		
Shenandoah International Playwrights Retreat	no	X	X										X	X	
Sitka Center for Art and Ecology	no	X	X	X		X					kiln, potter's wheel, slide projection, printing press (etching)	Residence still not wheelchair-accessible, but Sitka is in process of changing this	X	X	1 studio and bathroom for sight-impaired residents; no specific facilities for hearing-impaired residents

Organization	Accessible?						Venue	Accessibility notes			Comments
Skowhegan School of Painting and Sculpture	no	X								X	No signers available; residents with hearing-impairment rely on lip reading
STUDIO for Creative Inquiry	no	X	X	X	X			While facilities are not fully accessible, STUDIO for Creative Inquiry could make special adjustments that would accommodate artists with disabilities; housing is arranged by artists, so can be chosen according to need	X	X	Have access to technologies for residents with vision impairment and access to signers for residents with hearing impairment
Studios Midwest	no										
Sundance Institute	yes	X	X	X	X			Facilities are accessible; call to see if accommodations can be made for specific needs	X	X	
Triangle Artists' Workshop (New York)	?							Accessibility depends on each venue used (in '98 and '99, World Trade Center provided good accessibility); Triangle is committed to doing all they can to serve artists with disabilities			
Tryon Center for Visual Art	yes	X	X	X	X	X			X		
Ucross Foundation Residency Program	yes	X	X	X	X						No special facilities for residents with vision or hearing impairment, but will make every attempt to serve them
Vermont Studio Center	yes	X	X	X	X		Lecture Hall, Red Mill Center		X		Can accommodate residents with vision and hearing impairment, but no special facilities
Villa Aurora	no										
Villa Montalvo	no	X	X	X			Theatre	A new facility with greater accessibility being built; community center and 3 (of 10) cottages/studios will be accessible (scheduled to open in 2002)			
Virginia Center for the Creative Arts	yes	X	X	X	X			Roll-in shower will be complete in summer 2000	X	X	

Organization Name

Organization Name	Fully Wheelchair Accessible	Expanding Accessibility	Housing & Housing Bathrooms	Studios	Public Bathrooms	Kitchen	Wheelchair Ramps	Elevators/Lifts	Automatic Doors	Roll-in Shower	Other Accessible Areas	General Comments on Wheelchair Accessibility	Vison Impairment	Hearing Impairment	Other Facilities or Services
Watershed Center for the Ceramic Arts	yes														
Weir Farm Trust	no	X	X									When new studios are built (in 2 yrs. time) and current visitor center for Park Bureaus renovated (in 4 yrs. time), facilities will be accessible to residents with some disabilities; terrain of landscape not good for wheelchairs however	X		Executive Director knows American Sign Language
Women's Art Colony Farm	yes	X	X									Ramps and/or other aids can be constructed quickly upon request to accommodate residents	X		
Women's Studio Workshop	no	X		X											
Woodstock Guild's Byrdcliffe Arts Colony	no	X									Woodstock's performance facility (off-site)	Woodstock's own site cannot accommodate artists in wheelchairs			
Yaddo	yes	X	X			X					Darkroom, visual artists' studios	Some studios and buildings contain ramps; all primary buildings contain ramps; continuing to look at ways to improve accessibility; will try to accommodate any disability	X		Fire alarms have flashing light and sound
The Yard	no	X				X					Theatre				

About the Alliance of Artists' Communities

The Alliance of Artists' Communities is a national service organization that supports the field of artists' communities and residency programs. It does this by encouraging collaboration among members of the field, providing leadership on field issues, raising the visibility of the field, promoting philanthropy, and generally encouraging programs that support the creation of art.

The Alliance of Artists' Communities grew out of the John D. and Catherine T. MacArthur Foundation Fellowship Program's 1990 program entitled "Special Initiative on Artists' Colonies, Communities, and Residencies." The eighteen recipients of grants under this one-time program met for the first time in early 1991, at the invitation of Doris Leeper, founder of the Atlantic Center for the Arts in New Smyrna Beach, Florida (the meeting was funded by A Friends Foundation). After several meetings, the group formed the Alliance in September of 1992 with seed money from the John D. and Catherine T. MacArthur Foundation and the National Endowment for the Arts (NEA). The Alliance has continued operation with the support of dues from its members, sales of its publications, further support from the MacArthur Foundation and the NEA, and funding from the Geraldine R. Dodge Foundation, the Andy Warhol Foundation for the Visual Arts, Bank of America, Evelyn S. Nef Foundation, the Pew Charitable Trusts, Elizabeth Firestone-Graham Foundation, the Regional Arts and Culture Council (Portland, Oregon), Fulton County Arts Council (Atlanta, Georgia), Rose E. Tucker Foundation, Lannan Foundation, Nancy Nordhoff, James Pugh, and other foundations and individuals.

Now made up of over a hundred members, primarily from the United States but also from around the world (as far away as Taiwan and South Africa), the Alliance continues to accept new members who provide artists with time, space, facilities, and a community environment in which to create their work. (Please see the preface for the Alliance's four main criteria for institutional membership.)

Alliance Mission Statement

The Alliance of Artists' Communities is a national consortium of organizations and individuals established to improve the environment in which artists' communities support artists and their creative processes. The Alliance promotes the leadership role artists' communities play in enriching the nation's cultural heritage, and seeks to strengthen artists' communities in fulfilling their respective missions.

Alliance Board of Trustees

Alliance National Advisory Board

215

Kim Konikow, *Consultant, Artservices and Company, Minneapolis, MN*

Doris Leeper, *Sculptor, Founder of Atlantic Center for the Arts, New Smyrna Beach, FL*

Evelyn Stefansson Nef, *Nef Foundation, Washington, DC*

Fred Schroeder, *Executive Vice President, Resnicow Schroeder Associates, Inc., New York, NY*

Michael Wilkerson, *(former Chairman of the Alliance and former Executive Director of both Ragdale Foundation and Fine Arts Work Center in Provincetown), Indiana University, Bloomington, IN*

Alliance Staff

Tricia Snell, *Executive Director*
Katherine Deumling, *Membership Director*
Brook K. Gauthier, *Office Manager*

Alliance Members *(as of October 1999)*

INSTITUTIONAL MEMBERS

18th Street Arts Complex, *Santa Monica, CA*

American Academy in Berlin, *New York, NY and Germany*

Anderson Center for Interdisciplinary Studies, *Red Wing, MN*

Anderson Ranch Arts Center, *Snowmass Village, CO*

Archie Bray Foundation for the Ceramic Arts, *Helena, MT*

ART/OMI International Arts Center, *Ghent, NY*

ArtPace, *San Antonio, TX*

Atlantic Center for the Arts, *New Smyrna Beach, FL*

Bemis Center for Contemporary Arts, *Omaha, NE*

Capp Street Project, *San Francisco, CA*

Civitella Ranieri Center, *New York, NY and Italy*

Djerassi Resident Artists Program, *Woodside, CA*

Exploratorium, *San Francisco, CA*

Fine Arts Work Center in Provincetown, *Provincetown, MA*

Gell Writers' Center of the Finger Lakes, *Rochester, NY*

Hambidge Center for Creative Arts and Sciences, *Rabun Gap, GA*

Headlands Center for the Arts, *Sausalito, CA*

Hedgebrook, *Langley, WA*

MacDowell Colony, Inc., *Peterborough, NH and New York, NY*

Mary Anderson Center for the Arts, *Mount Saint Francis, IN*

Mattress Factory, *Pittsburgh, PA*

Millay Colony for the Arts, *Austerlitz, NY*

Northwood University, Alden B. Dow Creativity Center, *Midland, MI*

Portland Institute for Contemporary Art (PICA), *Portland, OR*

P.S. 1 Contemporary Art Center, *Long Island City, NY*

Ragdale Foundation, *Lake Forest, IL*

Roswell Artist-in-Residence Program, *Roswell, NM*

Sitka Center for Art and Ecology, *Otis, OR*

STUDIO for Creative Inquiry, *Pittsburgh, PA*

Tryon Center for Visual Art, *Charlotte, NC*

Ucross Foundation Residency Program, *Clearmont, WY*

Vermont Studio Center, *Johnson, VT*

Villa Montalvo, *Saratoga, CA*

Virginia Center for the Creative Arts, *Sweet Briar, VA*

Yaddo, *Saratoga Springs, NY*

ASSOCIATE MEMBERS

13th Colony, *Decatur, GA*

Akiyoshidai International Art Village, *Yamaguchi, Japan*

Arrowmont School of Arts and Crafts, *Gatlinburg, TN*

ArtCenter/South Florida, *Miami Beach, FL*

Arts Council of Park City/Summit County, *Park City, UT*

ArtsLink Residencies/CEC International Partners, *New York, NY*

AS220, *Providence, RI*

Banff Centre for the Arts–Leighton Studios, *Banff, Alberta, Canada*

Block Island Foundation for the Arts, *Block Island, RI*

Blue Mountain Center, *Blue Mountain Lake, NY*

Border Art Residency, *Anthony, NM*

Byrd Hoffman Foundation/The Watermill Center, *New York, NY*

Caversham Press, *Kwazulu-Natal, South Africa*

Center for Craft, Creativity, and Design, *Hendersonville, NC*

Dorland Mountain Arts Colony, *Temecula, CA*

Edward F. Albee Foundation/William Flanagan Memorial Creative Persons Center, *New York, NY*

EightMile Gardens, *Plantsville, CT*

Alliance of Artists' Communities Publications

The Programs and Management Practices of U.S. Artists' Communities (Research Report)

Provides information to help artists' community staff and boards manage, stabilize, fundraise for, develop, and market their organizations. Includes a 50-page narrative report and 67 statistical tables describing artists' community residents, facilities, residency program structures, outreach and public relations, land use and special projects, local economic and cultural impact, residency budgets, financial stability/fund development, staffing, board structure and responsibilities, program planning and evaluation, artist selection, and technical assistance needs of the field. *Compiled by the Alliance of Artists' Communities, describing the Alliance's research during 1997–99.*

How-To Kit for Artists' Community Administrators

A binder of model administrative documents including: mission statements, articles of incorporation, artists' application forms, artists' contracts, artists' evaluation forms, jurying/selection panel guidelines, organizational charts, basic financial guidelines for accounting, endowments, investments, and audits, and samples of marketing materials from a variety of residency programs. *Compiled by the Alliance of Artists' Communities, 1996: looseleaf binder.*

American Creativity at Risk: Restoring Creativity as a Priority in Public Policy, Cultural Philanthropy, and Education (An Alliance Symposium)

Organized by the Alliance and hosted by Brown University and the Rhode Island School of Design, the American Creativity at Risk symposium explored the nature of creativity and its significance in a wide range of disciplines, taking artists' communities as a model and a metaphor for fostering pure research and innovation in all sectors of our society and culture. The symposium resulted in a call to action addressing the challenges and opportunities of restoring creativity as a priority in public policy, cultural philanthropy, and education. Symposium speakers and panelists included Robert MacNeil, Lewis Hyde, Brendan Gill, Guillermo Gómez-Peña, Mary Schmidt Campbell, Mierle

Laderman Ukeles, Ellen Winner, David Liddle, Mary Catherine Bateson, Ned Hall, and Stewart Brand, among others. *Two publications (summary report and transcripts) compiled by the Alliance of Artists' Communities, 1997.*

To order these titles, learn more about the Alliance, or apply for membership, please contact the Alliance at:

Alliance of Artists' Communities
2311 E. Burnside Street
Portland, OR 97214
TEL (503) 797-6988
FAX (503) 797-9560
E-MAIL aac@teleport.com
WEB www.artistcommunities.org

Books from Allworth Press

The Artist's Quest for Inspiration
by Peggy Hadden (softcover, 6 × 9, 256 pages, $15.95)

The Artist's Guide to New Markets: Opportunities to Show and Sell Art Beyond Galleries
by Peggy Hadden (softcover, 6 × 9, 248 pages, $18.95)

The Fine Artist's Career Guide
by Daniel Grant (softcover, 6 × 9, 304 pages, $18.95)

The Artist's Resource Handbook
by Daniel Grant (softcover, 6 × 9, 248 pages, $18.95)

The Fine Artist's Guide to Marketing and Self-Promotion
by Julius Vitali (softcover, 6 × 9, 224 pages, $18.95)

Uncontrollable Beauty: Towards a New Aesthetics
edited by Bill Beckley with David Shapiro (hardcover, 6 × 9, 448 pages, $24.95)

The End of the Art World
by Robert C. Morgan (paper with flaps, 6 × 9, 256 pages, $18.95)

Sculpture in the Age of Doubt
by Thomas McEvilley (paper with flaps, 6 × 9, 448 pages, $24.95)

Beauty and the Contemporary Sublime
by Jeremy Gilbert-Rolfe (paper with flaps, 6 × 9, 208 pages, $18.95)

Lectures on Art
by John Ruskin (softcover, 6 × 9, 264 pages, $18.95)

The Laws of Fésole: Principles of Drawing and Painting from the Tuscan Masters
by John Ruskin (softcover, 6 × 9, 224 pages, $18.95)

Imaginary Portraits
by Walter Pater (softcover, 6 × 9, 240 pages, $18.95)

Legal Guide for the Visual Artist, Fourth Edition
by Tad Crawford (softcover, 8½ × 11, 272 pages, $19.95)

Business and Legal Forms for Fine Artists, Revised Edition
by Tad Crawford (softcover, includes CD-ROM, 8½ × 11, 144 pages, $19.95)

The Artist-Gallery Partnership: A Practical Guide to Consigning Art, Revised Edition
by Tad Crawford and Susan Mellon (softcover, 6 × 9, 216 pages, $16.95)

Please write to request our free catalog. To order by credit card, call 1-800-491-2808 or send a check or money order to Allworth Press, 10 East 23rd Street, Suite 210, New York, NY 10010. Include $5 for shipping and handling for the first book ordered and $1 for each additional book. Ten dollars plus $1 for each additional book if ordering from Canada. New York State residents must add sales tax.

To see our complete catalog on the World Wide Web, or to order online, you can find us at *www.allworth.com*.